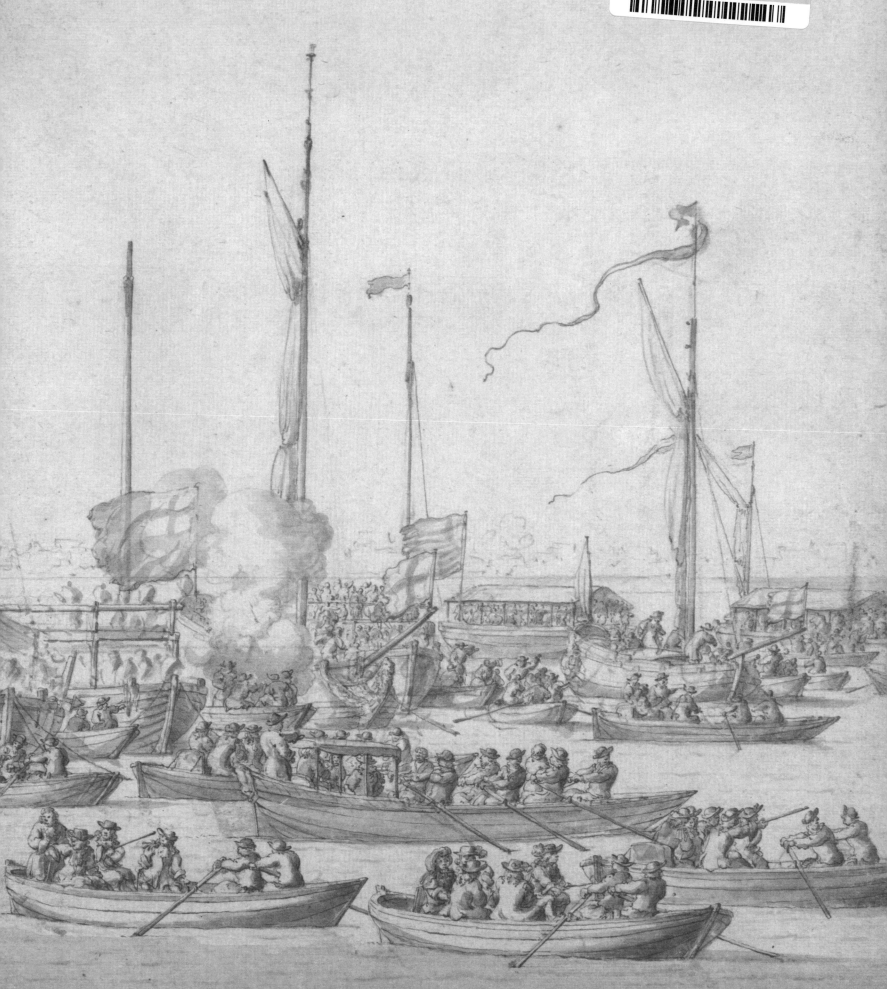

Spreading Canvas

Spreading Canvas

Eighteenth-Century British Marine Painting

EDITED BY ELEANOR HUGHES

with contributions by Eleanor Hughes, Richard Johns,

Sophie Lynford, John McAleer, Geoff Quilley,

Christine Riding, Catherine Roach,

and Pieter van der Merwe

YALE CENTER FOR BRITISH ART, NEW HAVEN | YALE UNIVERSITY PRESS, NEW HAVEN AND LONDON

This publication accompanies the exhibition *Spreading Canvas: Eighteenth-Century British Marine Painting*, organized by the Yale Center for British Art, New Haven, in association with the National Maritime Museum, Greenwich, London, and on view September 15 to December 4, 2016.

Exhibition curated by Eleanor Hughes and in-house curator Matthew Hargraves

Library of Congress Cataloging-in-Publication Data

Names: Hughes, Eleanor, 1971- editor. | Yale Center for British Art, organizer, host institution.
Title: Spreading canvas : eighteenth-century British marine painting / Eleanor Hughes, editor.
Description: New Haven : Yale University Press, 2016. | Includes bibliographical references and index.
Identifiers: LCCN 2016021181 | ISBN 9780300221572 (hardback)
Subjects: LCSH: Marine painting, British—18th century—Exhibitions. | Art and society—Great Britain—History—18th century—Exhibitions.. | BISAC: ART / Collections, Catalogs, Exhibitions / General. | ART / Subjects & Themes / Landscapes. | ART / History / Romanticism. | HISTORY / Modern / 18th Century. | HISTORY / Europe / Great Britain.
Classification: LCC ND1373.G74 S67 2016 | DDC 758/.2094109033—dc23

A catalogue record for this book is available from the British Library.

Designed by Susan Marsh
Typeset in Cardea and National with Caslon display by Matt Mayerchak
Copyedited by Marsha Pomerantz
Printed and bound in Italy by Conti Tipocolor SpA, Florence

JACKET ILLUSTRATION: Charles Brooking, *Shipping in the English Channel* (detail), ca. 1755, oil on canvas. Yale Center for British Art, Paul Mellon Collection

ENDPAPERS: Willem van de Velde the Elder, *Celebration on the Thames near Whitehall* (detail), 1685, pen and ink. Yale Center for British Art, Paul Mellon Collection (cat. 3)

FRONTISPIECE: Peter Monamy, *An English Royal Yacht Standing Offshore in a Calm* (detail), ca. 1730. Yale Center for British Art, The U Collection. In appreciation of Choh Shiu and Man Foo U, loving parents, and Dorothea and Frank Cockett, dear friends (cat. 20)

PAGE VI: John Scarlett Davis, *Interior of the Painted Hall, Greenwich Hospital* (detail), 1830, oil on canvas, 44⅜ x 56½ in. (112.7 x 143.5 cm). Walters Art Museum (cat. 140)

PAGE IX: Charles Brooking, *A Lugger and a Smack in Light Airs* (detail), ca. 1750, oil on copper, 7 x 10 in. (17.8 x 25.4 cm). Yale Center for British Art, Paul Mellon Collection (cat. 43)

PAGE X: Pierre-Charles Canot after Willem van de Velde the Younger, *A Brisk Gale* (detail), 1763, engraving, 14¾ x 19¾ in. (37.5 x 50.2 cm). Yale Center for British Art, Paul Mellon Collection (cat. 15)

PAGE XII: Pierre-Charles Canot after Thomas Milton and (?)John Cleveley the Elder, *A Geometrical Plan, and North Elevation of His Majesty's Dock-Yard, at Woolwich, with Part of the Town, &c.* (detail), 1753, engraving, 18¾ x 25¾ in. (47.6 x 65.4 cm). Yale Center for British Art, Paul Mellon Collection (cat. 70)

PAGE 134: Willem van de Velde the Younger, *An Action between English Ships and Barbary Corsairs* (detail), ca. 1695, oil on canvas, 12⅝ x 19⅜ in. (32.1 x 49.2 cm). Yale Center for British Art, Paul Mellon Collection (cat. 7)

PAGE 154: Charles Brooking, *Shipping in the English Channel* (detail), ca. 1755, oil on canvas, 35½ x 46⅜ in. (90.2 x 117.8 cm). Yale Center for British Art, Paul Mellon Collection (cat. 47)

PAGE 182: Samuel Scott, *Vice Admiral Sir George Anson's Victory off Cape Finisterre* (detail), 1749, oil on canvas, 40 x 71 in. (101.6 x 180.3 cm). Yale Center for British Art, Paul Mellon Collection (cat. 53)

PAGE 194: Thomas Luny, *A Packet Boat under Sail in a Breeze off the South Foreland* (detail), 1780, oil on canvas, 33 x 56 in. (83.8 x 142.2 cm). Yale Center for British Art, Paul Mellon Collection (cat. 76)

PAGE 224: Richard Wright, *The Fishery* (detail), 1764, oil on canvas, 35½ x 53 in. (90.2 x 134.6 cm). Yale Center for British Art, Paul Mellon Collection (cat. 87)

PAGE 236: Dominic Serres, Experiment *Taking the* Télémaque, *1757* (detail), 1769, oil on canvas, 26 x 37 in. (66.1 x 94 cm). National Maritime Museum, Greenwich, London, Greenwich Hospital Collection (cat. 113)

PAGE 254: J. M. W. Turner, *The* Victory *Returning from Trafalgar, in Three Positions* (detail), ca. 1806, oil on canvas, 26⅜ x 39½ in. (67 x 100.3 cm). Yale Center for British Art, Paul Mellon Collection (cat. 129)

PAGE 282: Pierre-Charles Canot after Peter Monamy, *Morning, or Sun Rising* (detail), 1745, engraving, plate 12 x 15⅞ in. (30.3 x 40.2 cm). Yale Center for British Art, Paul Mellon Collection (cat. 32)

Contents

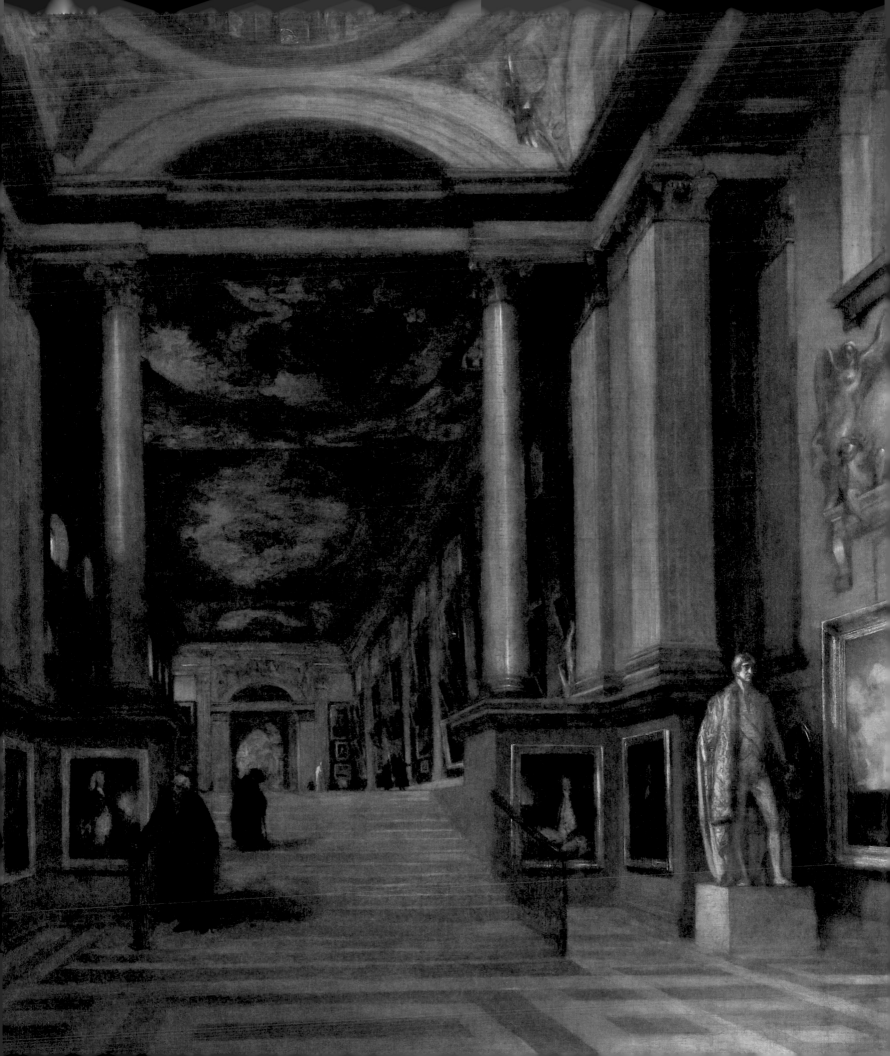

Director's Foreword

ONE OF THE FIRST EXHIBITIONS to be mounted at the Yale Center for British Art was *Seascapes*, a survey of marine painting from the seventeenth to the late nineteenth century, which was on display from October 21, 1977, to April 16, 1978. It showcased the remarkable collection of maritime art assembled and given to the Center by its founder, Paul Mellon (Yale College, Class of 1929). Of the forty-nine works displayed in that exhibition, thirteen are included in *Spreading Canvas: Eighteenth-Century British Marine Painting*. With the Center approaching its fortieth anniversary, *Spreading Canvas* reminds us of the significance of the maritime for Britain's national and imperial identities.

The exhibition and this accompanying publication tell the story of marine painting during the period between the arrival in England of the Willem van de Veldes (Elder and Younger), in the early 1670s, and the decisive Battle of Trafalgar, in 1805, which sealed Britain's naval dominance for the next century. A coda then considers the establishment of the National Gallery of Naval Art in the Painted Hall at Greenwich in 1824 and points toward the lasting impact of the artistic practice of the preceding century. The project also indexes some of the shifts in scholarship on British art during the decades since the Center's opening; many of the developments have been supported and expressed through the activities of the Center and its sister institution, the Paul Mellon Centre for Studies in British Art, London. Using diverse media — including spectacular ship models, preparatory drawings, notebooks, commemorative medals and ceramics, and reproductive prints — and informed by research on artistic networks, postcolonial and transoceanic studies, and institutional histories, this exhibition and publication are the first to explore the circumstances and assumptions behind the production of marine paintings in the century that marked Britain's maritime ascendancy.

Spreading Canvas is the culmination of many years of work by Eleanor Hughes, Deputy Director for Art & Program at the Walters Art Museum and former Associate Director for Exhibitions and Publications at the Center. She has partnered with an international team of scholars to produce the essays and catalogue entries for this book, and I am grateful to them all for their contributions. The resulting volume deepens our understanding and beautifully conveys the persistent resonance of this distinctively British form of art. It also showcases the valuable work of our conservators, whose application of technical expertise has yielded fresh historical insights. As ever, I extend my thanks to Sally Salvesen, publisher at Yale University Press, and to Susan Marsh, whose exquisite design graces this book.

Many colleagues at the Center assisted in the development and implementation of this project, and they are recognized more fully in the Acknowledgments. Here I especially wish to thank Matthew Hargraves, Chief Curator of Art Collections and Head of Collections Information and Access, for partnering with Ellie as in-house curator on the exhibition following her departure for the Walters; Nathan Flis, Acting Head of Exhibitions and Publications and Assistant Curator, and his departmental colleagues for their support of the exhibition and book; and Timothy Goodhue, Museum Registrar, and Corey Myers, Associate Museum Registrar, for their expert management of the loans. I also owe a debt of gratitude to Beth Miller, Deputy Director for Advancement and External Affairs, and Martina Droth, Deputy Director for Research and Education, and their departmental colleagues for their roles in the project.

Finally, I wish to express my gratitude to the institutional and private lenders whose extraordinary works augment and complement a story told primarily through works in the Center's collection. The National Maritime Museum, in Greenwich, London, holds the foremost collection of British marine painting and has been a generous and collegial partner to the Center, hosting an authors' workshop in 2014 and lending over thirty works to the exhibition. It is a special pleasure to see related works from the Maritime Museum and the Center brought together. Some were originally paired with one another or even parts of the same object, and their reunion is indicative of the complementary nature of the two collections. I owe equal thanks to the other lenders to the exhibition: the Bedfordshire Archives; the British Museum; the Trustees of the Foundling Museum; The Huntington Library, Art Collections, and Botanical Gardens; Arnold and Henry Kriegstein; and Stephen K. and Janie Woo Scher. At Yale University, I am particularly grateful to the Beinecke Rare Book & Manuscript Library and the Lewis Walpole Library for their continuing generosity as lenders.

Marine painters often telescoped both time and space, so the genre provides us with a fitting lens through which to view the Center's long history as it approaches its fortieth anniversary. Indeed, *Spreading Canvas* reveals how appropriate it is that marine paintings are a characteristic strength of the largest collection of British art outside the United Kingdom, formed by Paul Mellon and augmented by other generous donors over the years. This exhibition also includes four works from the U Collection, a gift of nine marine paintings and twenty-two watercolors given to the Center in 2008 in appreciation of Choh Shiu and Man Foo U, loving parents, and Dorothea and Frank Cockett, dear friends of the donors. These treasures affirm the centrality of the maritime to the eighteenth-century British imagination and to collectors who have a special interest in British art. Even our coastal location reiterates the power of place as well as the elemental layering of past and present. The sea has always been both the border and the bridge between Britain and the rest of the world, and in *Spreading Canvas* we recognize that potent duality anew.

AMY MEYERS
Director, Yale Center for British Art

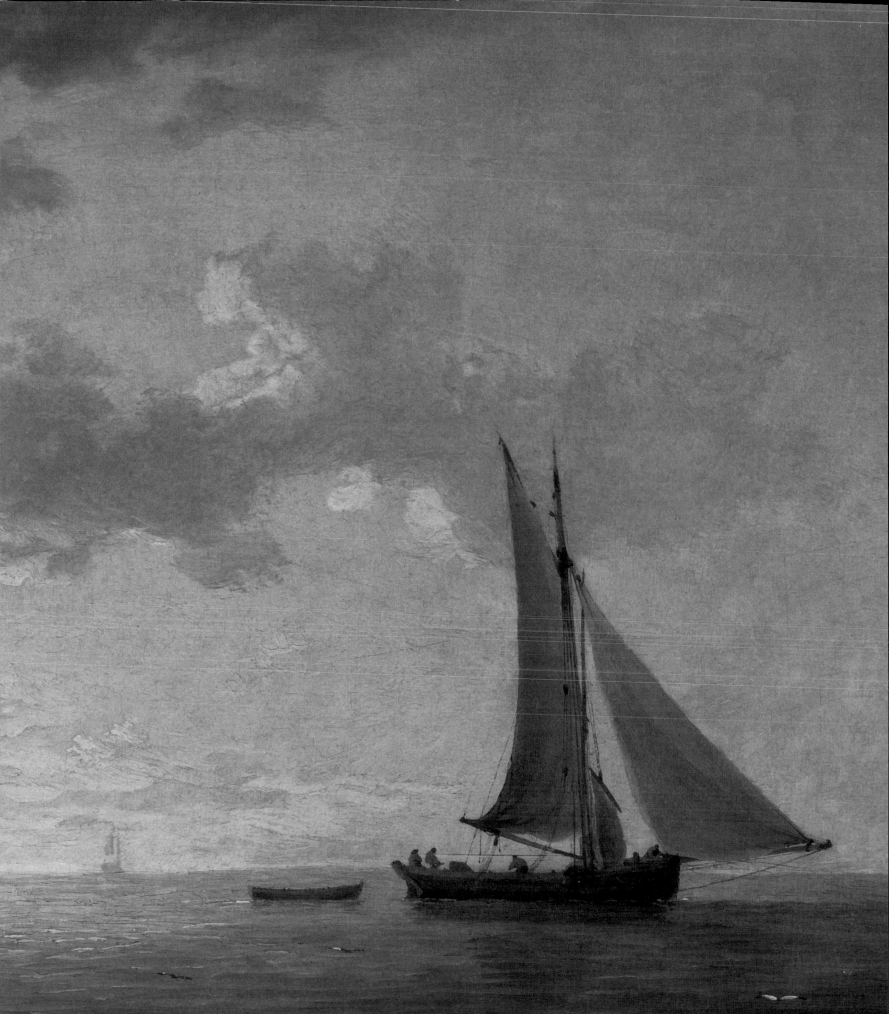

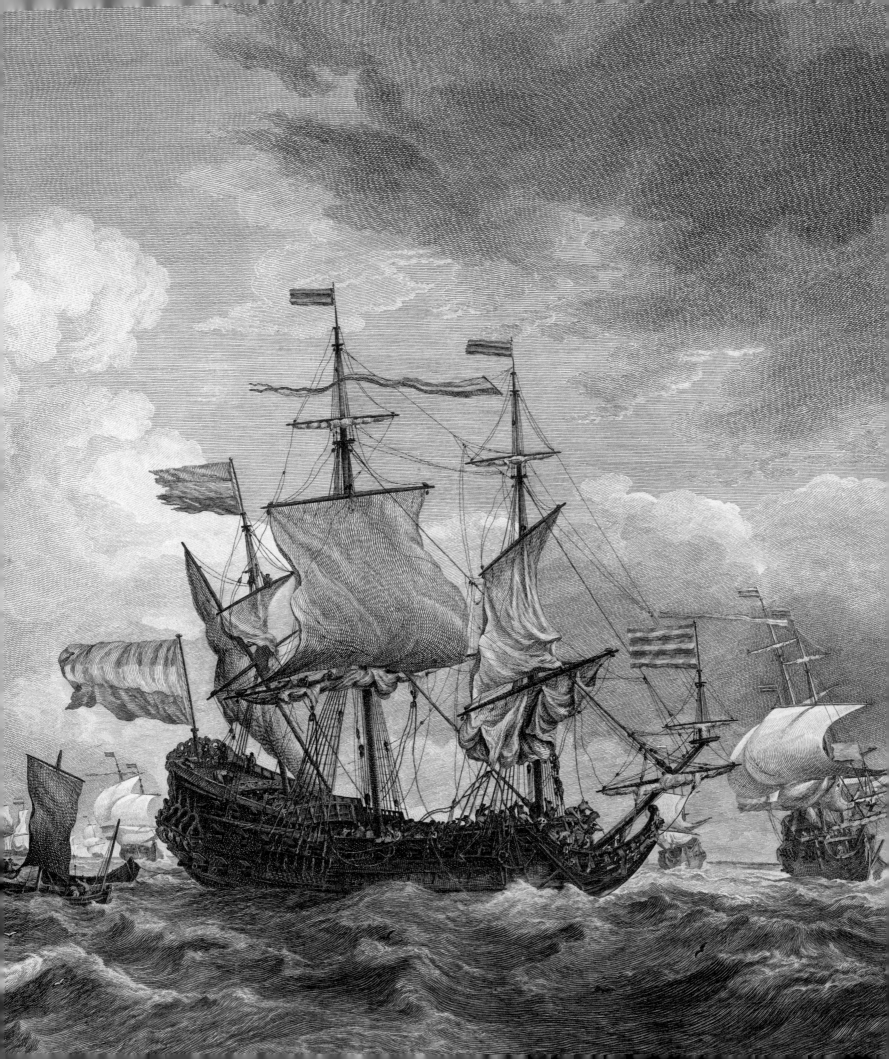

Acknowledgments

I OWE A DEBT OF THANKS first and foremost to all the lenders to the exhibition and to those who facilitated the loans of their precious objects. At the National Maritime Museum, Nigel Rigby has been a stalwart supporter of this project, and I am grateful to him additionally for organizing an authors' workshop in March 2014; my thanks also to Katy Barrett, Melanie Vandebrouck, and Simon Stephens for their assistance with the spectacular array of objects from that extraordinary collection. I also wish to express gratitude to Caro Howell and Stephanie Chapman at the Foundling Museum; Kim Sloan at the British Museum; Pamela Birch at the Bedfordshire Archives; Rebecca Hatcher at the Beinecke Rare Book & Manuscript Library, Yale University; Cynthia Roman and all of her colleagues at Yale's Lewis Walpole Library; Arnold and Henry Kriegstein; and Stephen K. and Janie Woo Scher.

The authors whose work appears in this book not only contributed essays and catalogue entries but, over the years, have also provided collegial support, discussion, and camaraderie, for which I thank them: Richard Johns, Sophie Lynford, John McAleer, Geoff Quilley, Christine Riding, Catherine Roach, and Pieter van der Merwe. I truly regret that Sarah Monks was unable to contribute to the book, but her scholarship has had a profound influence on the project, and I am grateful for her expertise, advice, and friendship. In addition to writing for this publication, Sophie Lynford was my Graduate Research Assistant during the 2014-15 academic year and was instrumental in formulating the exhibition checklist and undertaking research.

At the Yale Center for British Art, my first and deepest thanks are owed to Amy Meyers, Director, for her support and mentorship, and to the Department of Exhibitions and Publications — my forever colleagues — Shaunee Cole, Publications Assistant; Nathan Flis, Acting Head of Exhibitions and Publications, and Assistant Curator; A. Robin Hoffman, Assistant Curator; Chris Lotis, Editor; and Belene Day, Senior Administrative Assistant. I am grateful to everyone at the Center who has been involved in the planning and implementation of this project: Matthew Hargraves, Chief Curator of Art Collections and Head of Collections Information and Access, who stepped in as point curator for the exhibition when I left the Center for the Walters Art Museum in July 2015; Kraig Binkowski, Chief Librarian, and his staff in the Reference Library, Elizabeth Morris, Assistant Librarian, and Christine Andrew, Library Assistant, who dealt with innumerable requests for information once I had departed; Soyeon Choi, Head Conservator, Works on Paper, and Jessica David, Associate Conservator of Paintings, who served as the conservators for the exhibition; Mary Regan-Yttre, Conservation Assistant; Lisa Thornell, Senior Curatorial Assistant,

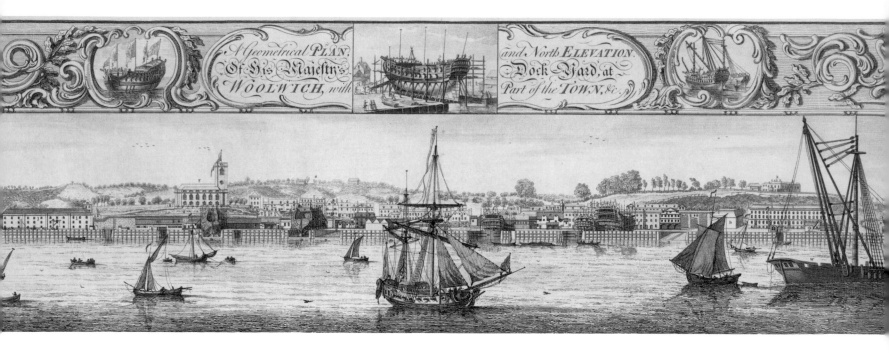

and Sarah Welcome, Assistant Curator of Rare Books and Manuscripts, who kept me organized in the Study Room; Timothy Goodhue, Chief Registrar, and Corey Myers, Associate Museum Registrar; Melissa Gold Fournier, Manager of Imaging Services and Intellectual Property, and her staff, particularly Maria Singer, Imaging and Rights Assistant; Beth Miller, Deputy Director for Advancement and External Affairs; Lyn Bell Rose, Head of Design, and Tracie Cheng, Graphic Designer; Betsy Kim, Head of Communications and Marketing; Richard Johnson, Chief of Installation; Kevin Derken, Associate Installation Manager; Rachel Hellerich and Greg Shea, Senior Museum Preparators; and Abraham Omonte and Dylan Vitale, Museum Technicians. I also wish to express gratitude to Rebecca Sender, Deputy Director for Finance and Administration; Martina Droth, Deputy Director of Research and Education, and Curator of Sculpture; Lisa Ford, Assistant Director of Research; Linda Friedlaender, Senior Curator of Education; Jaime Ursic, Assistant Curator of Education; Jane Nowosadko, Senior Manager of Programs; and Lars Kokkonen, Assistant Curator of Paintings and Sculpture. For their curatorial expertise and advice I am grateful to Elisabeth Fairman, Chief Curator of Rare Books and Manuscripts; Gillian Forrester, Senior Curator of Prints and Drawings; and, as ever, Scott Wilcox, Deputy Director for Collections.

At the Walters Art Museum, Jo Briggs, Associate Curator of Eighteenth- and Nineteenth-Century Art; Eric Gordon, Senior Conservator of Paintings; and Jennifer Harr, Associate Registrar, facilitated the conservation and the loan of John Scarlett Davis's *Interior of the Painted Hall, Greenwich*; and Diane Bockrath, Archivist/Librarian, provided vital research assistance. I am thankful also to Julia Marciari-Alexander, Executive Director; Kathleen Basham, Chief Operating Officer; Kate Burgin, Deputy Director for Museum Advancement; Amanda Kodeck, Director

of Education; Julie Lauffenburger, Director of Conservation; and Rob Mintz, Chief Curator, for their forbearance and support during the completion of this project.

I am particularly grateful to the scholars who attended a workshop at the Yale Center for British Art on May 3, 2012. In addition to staff from the Center, Yale faculty, and the contributors to this book, they included Linda Colley, Daniel Finamore, Sarah Monks, Nigel Rigby, and Sam Smiles. Research during the earlier phases of my work on marine painting was supported by fellowships at The Huntington Library, Art Collections, and Botanical Gardens; the National Maritime Museum, Greenwich; the Paul Mellon Centre for Studies in British Art, London; and the Yale Center for British Art. Throughout the long duration of this project many individuals provided intellectual engagement, expertise, enthusiasm, and information. I owe a deep debt of gratitude to Brian Allen, Tim Barringer, John Bonehill, Mungo Campbell, Edward S. Cooke, Matthew Craske, Frank and Dorothea Cockett, Jason Edwards, Douglas Fordham, Jenny Gaschke, Mark Hallett, Jenny Hare, Imogen Hart, Michael Hatt, Richard and Deborah Hughes, Lucy Kaufman, Margarette Lincoln, Margaretta Lovell and the members of the Berkeley [Britishists and] Americanists Group, Alice Martin, Sarah Miller, Stephen Parissien, Steven Pincus, Jacqueline Riding, Glynis Rigsby, Robert C. Ritchie, Joseph Roach, Mark Sharphouse, María Dolores (Lola) Sánchez-Jáuregui, Robin Simon, Christina Smylitopoulos, Geoff Snell, Michael Snodin, David H. Solkin, Hoi Sang (Ben) U, Andrew Wilton, and Jonathan Yarker. And to my immediate family, Rodger, Rufus, and Edith, for their patience and for being there, thank you.

After working together on so many publications, it has been an utter delight to work with Sally Salvesen on my own book and to have the inimitable Susan Marsh working her exquisite way with its design. The text has benefited enormously from the scrutiny of Marsha Pomerantz, with whom copyediting has been a bracing, collegial, and at times hilarious process. Any remaining mistakes are my own.

ELEANOR HUGHES

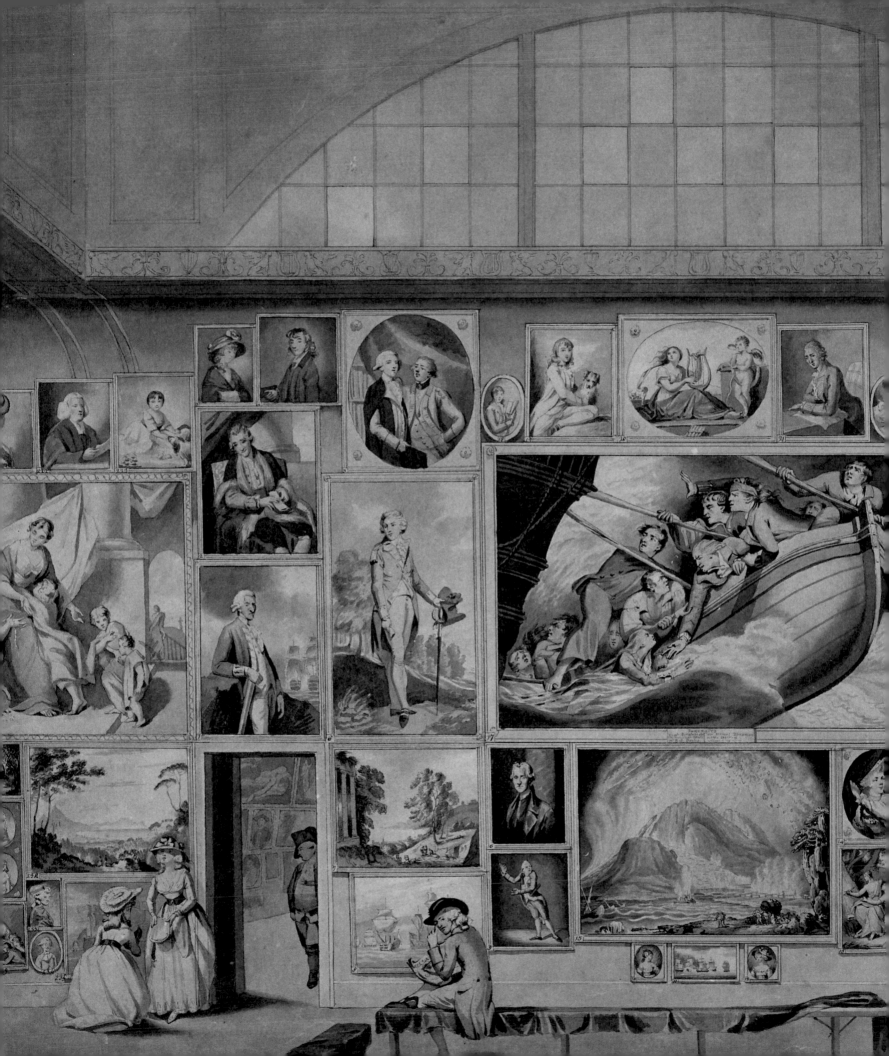

Seaward: An Introduction

ELEANOR HUGHES

Spread, noble Artist, spread thy Canvas wide,
And take thy Pencil with exulting Pride,
Full of the Glory of thy *Britain* fraught,
Truth in thy Hand, and *Freedom* in thy Thought.

—A[ndrew] Marvell, Jr. [pseud.], *Satyrical and Panegyrical Instructions to Mr. William Hogarth, Painter, on Admiral Vernon's Taking Porto Bello with Six Ships of War Only*, 1740

TWO MEN, THEIR WIGS ASKEW, are seated outside a tavern, the Porto Bello. As they contemplate six pieces of broken pipe stem arrayed on the table between them, one of the figures appears to speak with some vehemence, pointing with his own clay pipe, while the other listens intently. The image is from the second plate of William Hogarth's series *An Election* (fig. 1). Both the tavern's name and the exchange taking place before it refer to Admiral Edward Vernon's capture in 1739 of Puerto Bello, the major trading port between Spain and its colonies, on the coast of present-day Panama. Vernon, an opposition member of Parliament and a vociferous campaigner for a war to take over Spanish possessions in the Americas, had claimed that he could seize the seemingly impregnable town with six ships and three hundred men. The outbreak of the War of Jenkins's Ear provided Vernon with the opportunity to fulfill his boast. He set sail from Plymouth in August 1739 with instructions from the Admiralty to "commit all sorts of hostilities against the Spaniards in such manner as you shall think proper" and captured Puerto Bello in late November.[1] In the following months, the celebratory "six ships only" was repeated on commemorative coins, medals, tankards, bowls, and teapots, part of the enthusiastic popular response to the event.[2]

Hogarth was not the only artist to evoke events at Puerto Bello. The marine painter Peter Monamy produced at least three depictions of the port's capture, which had offered the first opportunity to represent a contemporary naval engagement since

Edward Francis Burney, *West Wall, The Great Room, Somerset House* (detail, fig. 9)

1

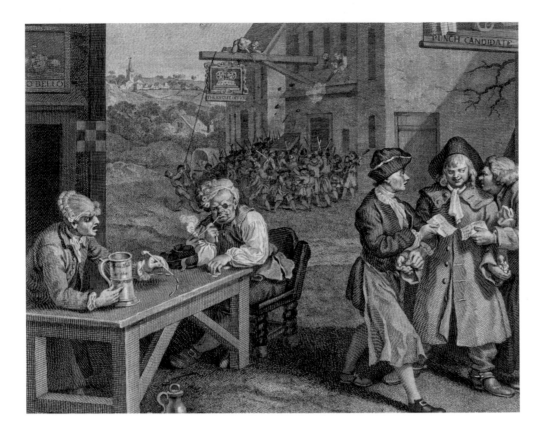

1713, when the Peace of Utrecht ended the War of the Spanish Succession.[3] Monamy's younger contemporary Samuel Scott also painted multiple versions of the capture, collaborating with an as yet unidentified artist on a work commissioned by the Vernon family (fig. 2).[4] This book and the exhibition it accompanies aim to explore what and whom such images were for; as Stephen Deuchar wrote in his introduction to the catalogue of marine paintings at the National Maritime Museum in Greenwich, to ascertain "the extensive range of circumstances and assumptions which lay behind [a painting's] production and helped to shape its original function for its owner."[5]

Hogarth's print effectively provides three representations of the town's capture: a narrative, in this case communicated orally; a "mapping" of the battle with pipe stems; and the truncated inn sign, with its ship, billowing smoke, and identifying name. Monamy and Scott, constructing their images of events that had taken place at some physical and temporal distance, both employed the same kinds of information — narrative, diagrammatic, and pictorial — represented in Hogarth's print. The narrative may have been provided by Vernon himself, although accounts of the action based on his dispatches to the Admiralty appeared, for instance, in the *London Magazine*.[6] A diagram of the harbor made by Captain Philip Durell, commander of the *Burford*, was also published (fig. 3). The painting on which Scott collaborated, like the other versions produced by Scott and Monamy, adheres closely to that diagram, emphasizing the presence of the Iron Castle at the opening to the harbor and the town of Puerto Bello in the distance, and to accounts of the action (see cat. 24). With its bird's-eye

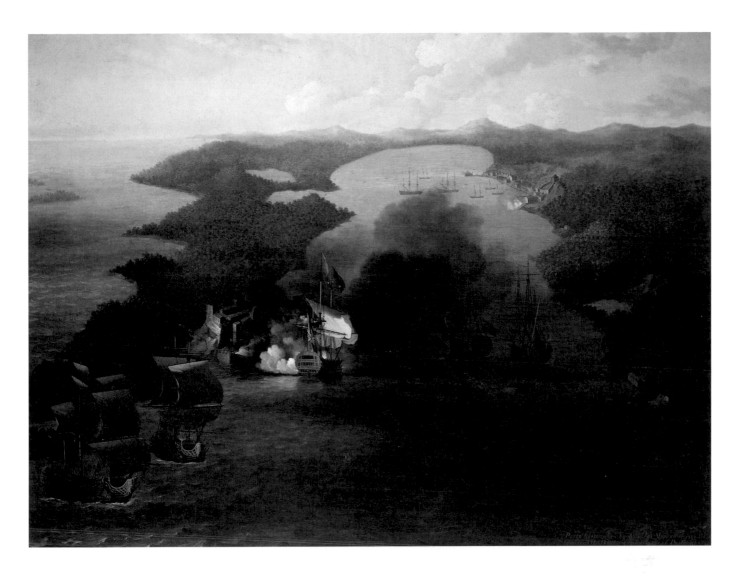

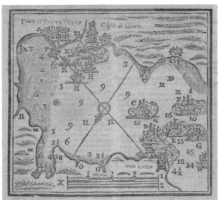

The taking of Porto Bello by Vice Admiral Vernon on the 22.ᵈ of Nov.ʳ 1739 with Six Men of War only.

perspective, the composition reaches back to a seventeenth-century tradition of topo-graphical landscape painting. In a more contemporary vein, one of the paintings pro-duced by Monamy, now known only through an engraving by Remi Parr, articulated current national and patriotic ideologies as part of the decorative scheme at Vauxhall Gardens, a venue for popular entertainment on the south bank of the Thames in Lon-don (fig. 4).[7] Hogarth's work reminds us that, on the one hand, the audiences for such representations, whether visitors to a private house or the public flocking to Vauxhall, had recourse to information on maritime events offered by a burgeoning print culture; and, on the other, that there was public interest not only in the fact of the victory but also in how it happened.

The eighteenth century was a period in which, as Geoff Quilley pointed out in a seminal essay, "the subject of the sea, far from being marginalized, was in fact inte-gral to British society in a variety of material and ideological ways"; and yet marine painting was, until well into the twenty-first century, written out of mainstream art history.[8] "How," Quilley asked, "can one account for the historical anomaly between the obvious national importance of all activities connected with the sea, expressed visually in art of the highest rank, and the low position occupied by marine art both in the academic hierarchy and in the discipline of art history?"[9] Part of the reason, I suspect, is that we have tended to judge eighteenth-century marine paintings through a post-romantic lens, expecting of them the kinds of visual and emotive experience offered by, for example, J. M. W. Turner's radical reimaginings of the sea. *Spreading Canvas* aims to recapture what eighteenth-century viewers expected and understood from marine paintings.

While these works have been under-examined by art historians, they have been addressed in surveys, dictionaries, and monographic studies of artists. Although these contain indispensable research, they tend to cater to collectors and enthusiasts, and thus to treat the works in either connoisseurial or highly technical terms.[10] At the extreme of dismissiveness, Denys Brook-Hart's guide for potential buyers, *British 19th-Century Marine Painting* (1974) regards eighteenth-century British marine paint-ing as "a formalized tradition inherited from the Dutch" and breathlessly anticipates "the genius, incredible range and vast output" of Turner as the progenitor of British marine art.[11] As Brook-Hart's characterization suggests, much of the twentieth-century literature on marine painting tended to view eighteenth-century British marine painters as stylistic imitators of the Dutch seventeenth-century tradition, in particular the Willem van de Veldes, father and son, who settled in London in 1672–73. Likewise, the superabundant literature on J. M. W. Turner fairly positions him as respondent to that tradition, but without acknowledging his British contemporaries and, to some degree, competitors.[12] As the field of art history shifted at the end of the twentieth century to allow a broader consideration of visual culture and related stud-ies in imperialism and circum-oceanic histories, a new generation of scholars (many of them contributors to this book) has been reassessing the tradition that emerged between the Van de Veldes and Turner. The artists discussed here may have produced work in other genres, including landscape and portraits, but were invariably referred

to as "marine painters" by contemporary commentators such as Horace Walpole, Edward Edwards, Joseph Farington, and the reviewers of Royal Academy exhibitions. Similarly, sea pieces are listed separately from other categories of painting in sales catalogues of the period.

Spreading Canvas takes as its prelude the arrival in England of the Van de Veldes, who had sailed with the Dutch fleet to make drawings and then paintings of the sea battles of the first and second Anglo-Dutch wars.[13] Given a studio at the Queen's House in Greenwich and paid for the "taking and making of Draughts of Sea Fights," they began producing works for British royal and naval patrons. In the early eighteenth century, the numerous works of the Van de Velde studio, particularly its hundreds of drawings, were collected and used as models by British artists. In his essay in this volume, Richard Johns examines precisely how and why the Van de Velde model served the first generations of British marine painters, moving beyond stylistic and technical comparisons to a consideration of the ideological resonances and broader cultural significance of copying.

By the late 1730s a distinctive category of artists were identified or identified themselves as marine painters. Many were involved in a thriving metropolitan network that included William Hogarth and was centered first at Old Slaughter's Coffee House and then at the nearby St. Martin's Lane Academy, which Hogarth founded in 1735.[14] The foremost native artist of the time, Hogarth was embarked upon the twin projects of promoting British art and articulating a view of Britain that has been described as "mercantile yet anti-imperial, enlightened yet laced with English chauvinism."[15] He facilitated the redesign of Jonathan Tyers's Vauxhall Gardens by a cadre of St. Martin's Lane artists, including the decoration of its supperboxes by Francis Hayman and Hubert François Gravelot, one of the first public displays of British painting.[16] Peter Monamy contributed four paintings for the supperboxes that inflected a space traditionally devoted to pleasure with political, national, and imperial concerns.[17] More importantly, Hogarth orchestrated the decoration of the Court of Director's Room and other public spaces at the Foundling Hospital, the institution founded by Captain Thomas Coram to shelter abandoned children, with works donated by native British artists including Hogarth himself, Hayman, Joseph Highmore, Richard Wilson, and Thomas Gainsborough.[18] Monamy and Scott were among the artists who contributed works in the 1740s and were in return elected governors of the hospital. In 1754 a third marine painter, Charles Brooking, presented a large work still in the hospital's collection (fig. 5). Another project to emerge from the St. Martin's Lane set was John Pine's influential publication illustrating the tapestries of the Spanish Armada then hanging in the House of Lords (cats. 36–38). Published in 1739, it offered depictions of the defeat of the Armada in 1588 that doubtless resonated with Vernon's victory; the Armada episode would serve as a touchstone into the nineteenth century. With its combination of historical account, Pine's glorious engravings of the tapestries, and a chart for each tapestry showing the location of the action, *The Tapestry Hangings of the House of Lords* served as a model for the ways in which such events could be recounted, represented, and understood. Vernon's capture of Puerto Bello and the developing War

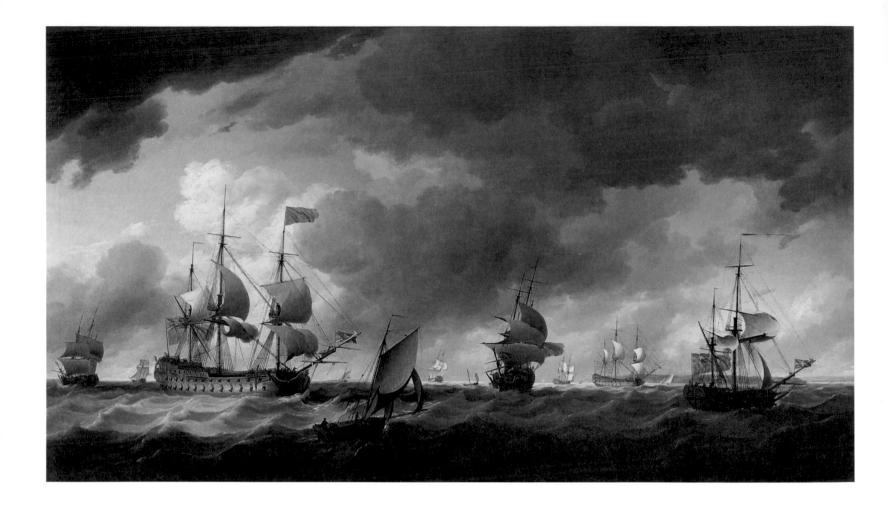

FIG. 5. Charles Brooking, *A Flagship before the Wind under Easy Sail*, 1754, oil on canvas, 70 x 123 in. (177.8 x 312.4 cm). Trustees of the Foundling Museum, London (cat. 40)

of the Austrian Succession, then, coincided with the emergence in the 1740s of new arenas for the representation of British maritime endeavors.

Another contemporary, the Swiss-born artist and writer Jean André Rouquet, included in his book *The Present State of the Arts in England*, first published in English in 1755, a frequently quoted account of the motivations for commissioning and producing paintings of naval engagements: "It is become almost the fashion for a sea officer, to employ a painter to draw the picture of the ship which he commanded in an engagement, and where he came off with glory; this is a flattering monument, for which he pays with pleasure. The hero scrupulously directs the artist in every thing that relates to the situation of his vessel, as well in regard to those with whom, as to those against whom he fought."[19] Rouquet, Hogarth's friend and spokesman, was almost certainly referring to Scott and Brooking. Marine painters' surviving annotated sketches and letters bear evidence of the requirement that artists' depictions be as proximate as possible to the facts of naval engagements. They reveal the degree to which officer patrons worked with the artist to ensure that the details of events—the number of ships involved, the direction of the wind, the damage sustained to masts, spars, rigging, and sails at a given point in the action—were accurately depicted in finished paintings. By including examples of the sketches, plans, and textual accounts that

underlay the finished works, *Spreading Canvas* reveals the processes through which marine painters constructed depictions of highly complex events that had taken place at removes of space and time. My own essay uses the drawings and correspondence of a later artist, Nicholas Pocock, to reconstruct the ways in which commissions were shaped by, on the one hand, the eyewitnessing of events and the authority of the artist in recording the appearance of ships and landscapes, and, on the other, the desire for "harmonious composition" and the legible depiction of heroic action.

The suite of paintings that Samuel Scott made for the family of Admiral George Anson, Lord Anson, at Shugborough, and its display there as described in a letter from Elizabeth, Lady Anson, to her sister-in-law, form a focal point of the exhibition. Along with other instances of commissioning and display, in which women frequently played a role, these works by Scott are discussed in Catherine Roach's essay. A focus on marine painting in such settings complicates postcolonial studies that see empire as solely land-based and encourages consideration of how empires were implemented and maintained — physically and ideologically — on the oceans. This focus might be seen to respond in a new way to Kathleen Wilson's critique of "traditional" histories of eighteenth-century Britain's expansion. Wilson suggested that an emphasis on "'the great events': battles won and lost, military and naval strategies that succeeded in wrenching some colonies from European rivals and indigenous peoples alike" is "of limited usefulness to those who wish to know the meaning and significance of empire at home. How was empire, its acquisition, maintenance, and costs, represented, consumed and understood in England by those for whom it existed as much in ideology and imagination as in policy?"[20] Postcolonial studies of empire have diversified since Wilson's essay was published, in 1995. But as Roach's essay demonstrates, eighteenth-century British marine paintings, precisely those that depict in detail the "battles won and lost," are a vital part of the way that empire was imagined. They have of course been used extensively as illustrations in the kinds of history cited by Wilson, where they tend to be treated as reportage instead of the skillfully manipulated artistic constructions that *Spreading Canvas* reveals them to be. Insofar as war was repeatedly and exhaustively represented in eighteenth-century art, then, rather than discarding it as a topic, I propose that it has not yet been sufficiently discussed.

Indeed, as Douglas Fordham has argued, war served not only as a subject for representation by eighteenth-century artists but also as a catalyst through which "institutionalized state violence paradoxically brought about the formation of a modern art world defined by its autonomy."[21] The synchrony of the end of the Seven Years' War in 1763 and the beginning of public art exhibitions in London — in particular the Society for the Encouragement of Arts, Manufactures and Commerce (Society of Arts) in 1760, the Society of Artists of Great Britain in 1761, and the Royal Academy of Arts in 1768 — was not coincidental. However, if, as Fordham suggests, exhibitions of contemporary art aimed "to secure Britain's greatly expanded imperial responsibilities to a firmer moral foundation through the promotion of 'those politer Arts' that made cultural superiority transparently evident," then marine paintings, which laid bare that "institutional violence," had an uneasy role to play. *Spreading Canvas* thus

considers how marine paintings were received in and adapted to the emergence of exhibition culture, and particularly the founding of the Royal Academy. It was there that marine paintings, particularly those representations of engagements and battles that were privately commissioned, became publicly visible and subject to responses in the press; and it is through those responses that we are able to gauge the interest in the genre and a tension between the function of marine paintings for those who commissioned them and their part in the national narratives played out on the walls of the Academy.

At issue are two related concerns: the degree to which marine paintings, with their mandate to satisfy nautical accuracy, were able to fulfill their potential role in the public sphere, and the extent to which their marginal position in current art-historical thinking stems from their exclusion from aesthetic categories of the late eighteenth and early nineteenth centuries. Because these strains were rooted in the artistic discourse that emerged in part through metropolitan institutions, *Spreading Canvas* of necessity focuses on painting in London rather than the rich traditions that flourished in other maritime centers, such as Bristol, Liverpool, Hull, and colonial Boston. Geoff Quilley's essay in this volume further parses the maritime-metropolitan nexus by addressing the ambiguous position of the maritime as manifested in representations of and at Greenwich. The presence of marine paintings at the Royal Academy, the official center of the metropolitan art world, refigures the annual exhibition as a site of convergent artistic and maritime concerns, situated as it was in the same buildings as the Navy Office from 1780. There, depictions of individual conflicts served as part of a larger national narrative that also included imperial landscapes and portraits of imperial subjects.[22]

The ambiguous status of marine painting in the eighteenth century was reflected in that of the painters themselves. A key figure in this regard is Dominic Serres, a founding member of the Royal Academy, who was poised between the realms of nautical expertise and gentlemanly engagement with art. Serres was born in France in 1722 and received a classical education at the English Benedictine college in Auch, but ran away to sea rather than join the priesthood.[23] As a merchant captain, he was captured by the English and brought as a prisoner to London, where he established himself as a marine painter.[24] He exhibited at the Society of Artists of Great Britain in 1765, allying himself with the artists who would eventually found the Royal Academy. But it must have been his social status as well as his artistic abilities that suited him to the position of Royal Academician: Edwards states of Serres's appointment as Royal Academy librarian in 1792 that "he was better qualified than some others who have enjoyed it, for he was a tolerable Latin scholar, spoke the Italian language perfectly, understood the Spanish, and possessed something of the Portuguese; add to this, that few foreigners were better masters of the English language."[25] Portraits of Serres, such as Philippe Jean's miniature of 1788, register the complexity of artistic self-representation and of Serres's position as the sole marine painter within the academy (fig. 6). Dressed in a singularly unworkmanlike manner, Serres is shown in an upholstered chair before an easel bearing a painting of a naval engagement, a stern

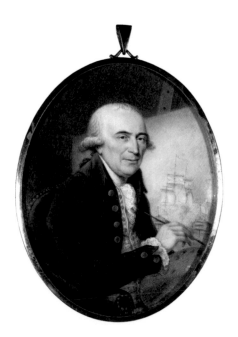

FIG. 6. Philippe Jean, *Dominic Serres*, 1788, watercolor and bodycolor on ivory, 4¼ x 3¼ in. (10.8 x 8.3 cm). National Portrait Gallery, London

view of two ships firing broadsides at each other. Jean has painted the tip of Serres's brush poised above the palette so that it meets with the edge of the portrait, thus evading representation of industry while giving rise to the fanciful notion that Serres is painting his own portrait as well as the painting on the easel. In short, there is nothing of the sailor here, nor of the artist's proximity to the nautical engines he is depicting, but rather a self-demarcated position within the realm of gentlemanly occupation.

Like Serres, the marine painters who would eventually exhibit at the Royal Academy had naval or dockyard origins. John Cleveley was born in Southwark and worked in the Royal Dockyard at Deptford. E. H. H. Archibald makes the interesting case that Cleveley may have learned to paint as an indirect result of a scandal over the cost of carved decorations on the *Royal Sovereign* in 1701, after which the Admiralty decreed that "only the head and stern galleries of ships could have carved decorations, while the rest of the decorations must be in paint." Archibald continues, "thus many woodcarvers were paid off in the Royal Dockyards and decorative painters taken on to paint the trophies of arms, classical figures, chariots, etc., which adorned the sides of most ships from head to stern at the level of the upper-deck gunwales and above." Archibald suggests that Cleveley could have learned to paint from the dockyard painters and "refined his work to easel painting."[26] Cleveley's sons John Cleveley the Younger and Robert, both exhibiting marine painters, had brief careers at Deptford, as shipwright and caulker respectively. The diarist and Royal Academician Joseph Farington wrote of Robert Cleveley that he "was bred a caulker but not liking the business quitted it. . . . When [he] was a caulker He was laughed at for working in Gloves." It is tempting to assume that he was protecting his hands so that he could paint.[27] Both brothers went to sea: John traveled as a draftsman on Sir Joseph Banks's Royal Society expedition to Iceland in 1772 and exhibited resulting drawings at the Royal Academy in 1773; Robert, having become a clerk to Captain George Vandeput, served on the *Asia* in America and the West Indies. Their brother James also served at sea, and made indirect artistic contributions; he was ship's carpenter on the *Resolution* during Captain James Cook's third voyage of discovery, and brought back sketches from which John made finished drawings that were engraved.[28] Other marine painters, such as Thomas Luny and Francis Swaine, had naval careers (the latter was a messenger for the Navy). Nicholas Pocock, the most prolific exhibitor of all, sailed the Atlantic and Mediterranean as a merchant captain before beginning to exhibit at the Royal Academy in 1782 (fig. 7).

Although not a marine painter himself, Farington was an enormously influential figure at the Royal Academy, particularly during the presidency of Benjamin West. He also had extensive nautical as well as artistic connections: his second cousin by marriage was Rear-Admiral Alan Gardner, who commanded the *Queen* at the first fleet engagement between Britain and France in the French Revolutionary Wars, the Battle of the Glorious First of June, in 1794, and four of Farington's brothers went to sea in the service of the East India Company. Having received a commission from the Board of the Admiralty to paint topographical views of the Royal Dockyards, he depicted Chatham and Deptford; the others were subcontracted to Nicholas Pocock.[29]

Several artists achieved recognition in the form of royal appointments, although these were largely honorific. Serres was appointed marine painter to George III in 1780, to be replaced at his death by his son, John Thomas Serres, who as marine draftsman to the Admiralty had the substantial task of sailing the coasts of Britain, France, and Spain to make topographical drawings of coastlines, many of which were published.[30] Robert Cleveley also held royal appointments as draftsman to the Duke of Clarence and marine painter to the Prince Regent.[31] While no marine painters other than Serres became Royal Academicians, several nominated themselves as candidates for election as Associates, positions that became vacant only when full Royal Academicians died.[32] They all failed, but the competition was formidable: the four vacant positions between 1776 and 1788 were won by John Singleton Copley, George Stubbs, Farington, and Henry Fuseli. Perhaps because of his royal appointments, Robert Cleveley's associations with the Royal Academy were close enough that he was invited to its annual dinner in 1798. Farington records a discussion of Cleveley's candidacy for Associate with the landscape painter Paul Sandby: "He thought [Martin Archer] Shee and [J. M. W.] Turner the proper men to be Associates to which I agreed. — Cleveley He supposed would have no chance."[33] This hitherto unconsidered evidence demonstrates that, while not competitive with the most accomplished practitioners, marine painters did consider themselves to be part of the central body of artists working in London.

The reception of marine paintings when they were displayed, particularly at the Royal Academy, repeated the insistence on accuracy that characterized their commissioning, to the extent that "accuracy" and "correctness" became automatic corollaries to the subject matter of marine painting. For example, on a painting by Serres exhibited in 1775: "There is a boldness in the several situations of Mr. Serres' ships, and an accuracy in describing the minutest parts of the rigging, etc. which leave him unequalled in this line of painting. His seas are likewise finely agitated and natural."[34] And on Robert Cleveley's picture of a ship being towed into Portsmouth harbor: "The present specimen is a very accurate representation of such an event; the sky and water are clearly managed, and the figures touched with great taste"; "an excellent piece of nautical accuracy and spirit."[35] Similarly, on a view of Chatham Yard by Thomas Mitchell: "A neat well-finished picture: the ship-pieces of this artist are deservedly held in high estimation by real judges, being executed with great accuracy, truth, and judgment."[36]

While these comments are more explicit than most in addressing the appearance of the paintings, they are representative of the press response to marine paintings

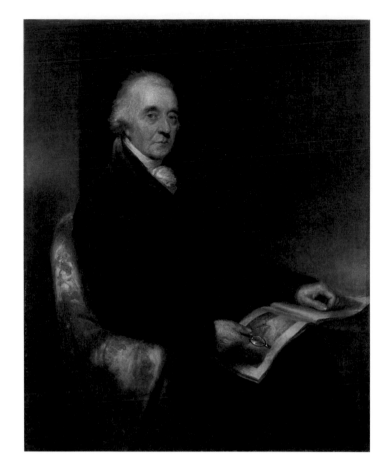

FIG. 7. Isaac Pocock, *Nicholas Pocock*, 1810, oil on canvas, 49 x 39¼ in. (124.4 x 99.7 cm). Bristol Museums, Galleries & Archives

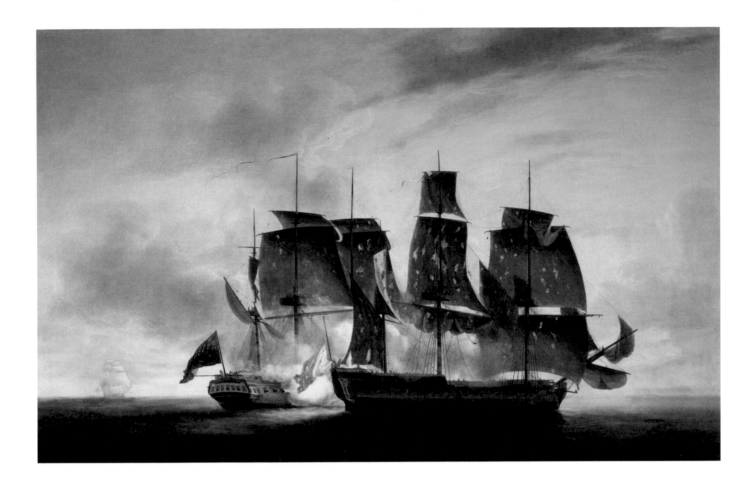

FIG. 8. Robert Dodd, *L'Amazone of 36 Guns, 301 Men, after an Hour and a Quarter's Engagement, Striking to His Majesty's Frigate* Santa Margarita *of 36 Guns, 255 Men, Elliott Salter Commander, on the Evening of the 29th July, 1782*, ca. 1783, oil on canvas, 30½ x 48 in. (77.5 x 122 cm). National Maritime Museum, Greenwich, London, Presented by Eric Miller through The Art Fund (cat. 92)

in terms of their preoccupations and omissions, in particular their emphasis on elements (water, smoke, sky) other than their putative subject, the ships. A review of Robert Dodd's paintings of *L'Amazone* and the *Santa Margarita*, exhibited in 1784, exemplifies the obliqueness of the language used to address the depiction of shipping: "The hulls, mast and rigging of the ships are delineated with architectural proportion, the hulls are bright and clear, equal to Backhuysen, the water possesses great transparency, and the distant sky good keeping" (fig. 8).[37] Water, in many reviews, is variously described as "agitated and natural," "finely animated," "quite in motion," and, especially, as "transparent." In fact, the ability of marine painters to render the transparency of water is a preoccupation of the critics of marine paintings throughout the period, as if the desired transparency of the setting in which the shipping is depicted can compensate for the opacity or illegibility of the shipping itself. The use of the word "accuracy" as it pertains to marine paintings seems to refer to a specificity in the depiction of masts, spars, rigging, the set of sails in response to weather conditions, and so on. Paradoxically, these repeated assertions of accuracy come to stand as a cipher, contradicting that very particularity to which they are supposed to refer; an acknowledgment of accuracy in the popular press may have operated to mask a *lack* of engagement with the particulars of shipping while bespeaking an authority suggested by the picture itself.

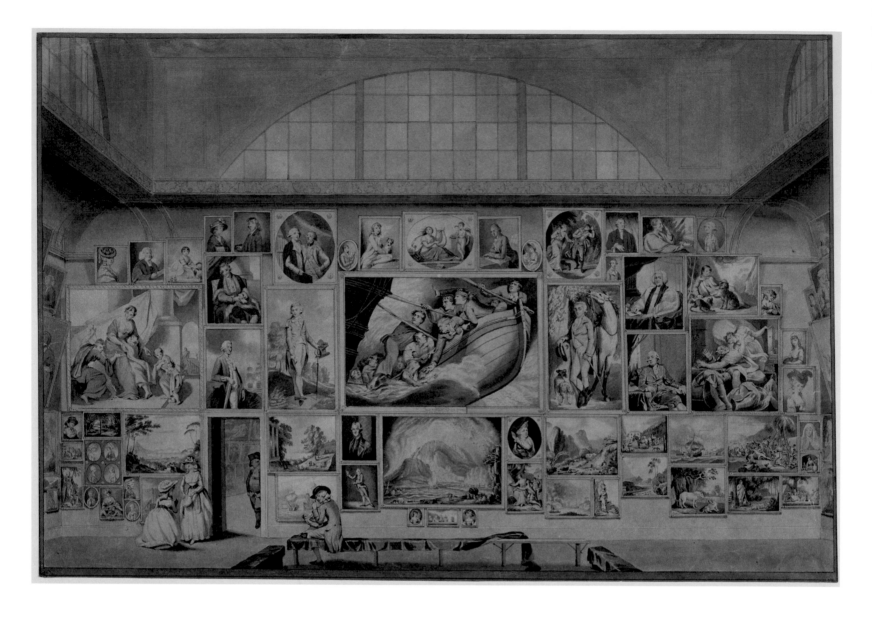

Such authority, however, sat at odds with the aesthetic imperatives of the Royal Academy as they were laid out in Joshua Reynolds's *Discourses*, delivered annually as formal lectures between 1769 and 1790, which place history painting at the apex of a hierarchy of genres. In the third Discourse, which centers on the assertion that "all the arts receive their perfection from an ideal beauty, superior to what is to be found in individual nature," Reynolds argues that, to attain greatness, an artist "instead of endeavouring to amuse mankind with the minute neatness of his imitations . . . must endeavour to improve them by the grandness of his ideas." Such ideas can be truly expressed only in history painting, which depends on the human figure and therefore on the study of works of classical sculpture: "A hand thus exercised, and a mind thus instructed, will bring the art to a higher degree of excellence than, perhaps, it has hitherto attained in this country." The "Sea-Views of Vandervelde" are relegated to the category of those artists whose "genius has been employed on low and confined

FIG. 9. Edward Francis Burney, *West Wall, The Great Room, Somerset House*, 1784, pen and ink, wash, and watercolor, 13⅛ x 19⅜ in. (33.5 x 49.2 cm). British Museum, London (cat. 91)

subjects."[38] Reynolds does not comment on contemporary marine painting as a genre. It is one in which, after all, people appear in miniature, as signifiers either of labor, working the machine that was the eighteenth-century sailing ship, or of malfunction, as bodies falling in battle. In other words, marine paintings operate at the scale of the ship, not the human figure, to relay their narratives.

The transcription of heroic signifiers from the human to the inanimate required the viewer's ability to pick up complex visual cues as well as a familiarity with the events depicted. Of course, visitors to the Royal Academy were aided by the paintings' titles as printed in the catalogues, which invariably provided detailed identification of ships, firepower, manpower, and command, as well as a sense of the events unfolding on canvas. The full title of the aforementioned painting by Robert Dodd, for example, appears in the catalogue for 1784 as "L'Amazonne of 36 guns, 301 men, after an hour and a quarters engagement, striking to his Majesty's frigate Santa Margaritta of 36 guns, 255 men, Elliot Salter commander, on the evening of the 29th July, 1782." In E. F. Burney's drawing of this work on display at the Royal Academy, viewers indeed appear to be using the catalogue to decipher the painting, which appears to the left of the doorway (fig. 9). The complexity of narrative and detail involved in an "accurate" representation is surely what led many reviewers to assume a divided audience for marine paintings: "The nautical parts of Mr. Serres pictures, are pronounced by professional men to be minutely faithful. The parts that are cognisoble by every spectator, and their effect, are evidently inferior to nothing of Scott, or Van de Velde."[39]

Spreading Canvas concludes with marine painters' responses to the artistic revolutions of the 1790s, in which early modern ways of depicting and knowing became eclipsed by new modes of representation and exhibition, once again at a moment of international conflagration. These new modes included the panorama, the single-work exhibition, and, in particular, the experiments of J. M. W. Turner, who was responding to his British contemporaries as well as his Dutch predecessors. In her essay in this volume, Christine Riding examines cultural interest in the theme of storm and shipwreck over the period addressed in the exhibition, culminating in Turner's sustained explorations.

Rather than treating marine paintings as documents of naval achievement or as evidence of the development of a British style out of Dutch influences, *Spreading Canvas* aims to address these works as the ideologically laden products of relations among painters, patrons, and publics, focusing on key moments of intersection between developments in the artistic and naval spheres. In the nineteenth century the public role of marine painting would shift under a different set of aesthetic imperatives and ways of imagining the nation and its emerging empire. But eighteenth-century marine painting was not a minor genre appealing to nautical specialists. Rather, it was a practice at the center of a newly formalized art establishment, a genre comprehensible and of interest to the public at large, and a narrative vehicle through which Britons told themselves about heroic action and national virtue.

1. Cyril Hughes Hartman, *The Angry Admiral: The Later Career of Edward Vernon, Admiral of the White* (London: Heinemann, 1953), 16–35. The War of Jenkins's Ear, which would merge into the War of the Austrian Succession, takes its name from a Spanish customs officer's punishment of a British merchant captain for exceeding the limit of one British ship each year that was allowed to trade with Spanish-American colonies; the officer sliced off Robert Jenkins's ear and suggested it be sent to George II.

2. See Kathleen Wilson, *The Sense of the People: Politics, Culture, and Imperialism in England, 1715–1785* (Cambridge: Cambridge Univ. Press, 1998), 140–51.

3. While Hogarth's series is set in the contested borough of Oxfordshire, tradition has it that a Porto Bello inn located in St. Martin's Lane had a sign painted by Peter Monamy, the marine painter. Ronald Paulson, *Hogarth*, 3 vols. (New Brunswick, NJ: Rutgers Univ. Press, 1992), 3:159.

4. Richard Kingzett, "A Catalogue of the Works of Samuel Scott," *Walpole Society* 48 (1980–82): 25.

5. Stephen Deuchar, *Concise Catalogue of Oil Paintings in the National Maritime Museum* (Woodbridge, UK: Antique Collectors' Club, 1988), 14.

6. *London Magazine*, March 13, 1740.

7. See Eleanor Hughes, "Guns in the Gardens: Peter Monamy's Supperbox Paintings for Vauxhall," in *The Pleasure Garden, from Vauxhall to Coney Island*, ed. Jonathan Conlin (Philadelphia: Univ. of Pennsylvania Press, 2013), 78–99.

8. A notable exception is David H. Solkin, *Art in Britain, 1660–1815* (New Haven and London: Yale Univ. Press, in association with Paul Mellon Centre for Studies in British Art, 2015).

9. Geoff Quilley, "Missing the Boat: The Place of the Maritime in the History of British Visual Culture," *Visual Culture in Britain* 1, no. 2 (2000): 81.

10. See, for example, David Cordingly, *Marine Painting in England, 1700–1900* (London: Studio Vista, 1974); William Gaunt, *Marine Painting: An Historical Survey* (London: Secker & Warburg, 1975); E. H. H. Archibald, *Dictionary of Sea Painters* (Woodbridge, UK: Antique Collectors' Club, 1980); James Taylor, *Marine Painting: Images of Sail, Sea and Shore* (London: Studio Editions, 1995). The monographic studies include Richard Kingzett, "Catalogue of the Works of Samuel Scott," 1–134; Charles Harrison-Wallace, "Peter Monamy," *Société Jersiase, Annual Bulletin* 23, no. 1 (1981): 97–113; David Cordingly, *Nicholas Pocock, 1740–1821* (London: Conway Maritime Press, 1986); Frank B. Cockett, *Early Sea Painters, 1660–1730* (Woodbridge, UK: Antique Collectors' Club, 1995); Olivier Meslay, "Dominic Serres, peintre de marine du roi George III d'Angleterre," *Société archéologique et historique du Gers* (3e trimestre 1997): 288–321; David Joel, *Charles Brooking, 1723–1759, and the 18th Century British Marine Painters* (Woodbridge, UK: Antique Collectors' Club, 2000); F. B. Cockett, *Peter Monamy, 1681–1749, and His Circle* (Woodbridge, UK: Antique Collectors' Club, 2000); Alan Russett, *Dominic Serres, War Artist to the Navy, 1719–1793* (Woodbridge, UK: Antique Collectors' Club, 2001).

11. Denys Brook-Hart, *British 19th-Century Marine Painting* (Woodbridge, UK: Antique Collectors' Club, 1974), 2.

12. A notable exception is Christine Riding and Richard John, eds., *Turner and the Sea* (London: Thames & Hudson, 2013).

13. For more on the Van de Veldes' transition, see Richard Johns's essay in this volume.

14. See Paulson, *Hogarth*, 2:64.

15. Douglas Fordham, *British Art and the Seven Years' War: Allegiance and Autonomy* (Philadelphia: Univ. of Pennsylvania Press, 2010), 25.

16. Of the extensive literature on Vauxhall, see David H. Solkin, *Painting for Money: The Visual Arts and the Public Sphere in Eighteenth-Century England* (New Haven and London: Published for the Paul Mellon Centre for Studies in British Art by Yale Univ. Press, 1992), 106–56; David Coke and Alan Borg, *Vauxhall Gardens: A History* (New Haven and London: Published for the Paul Mellon Centre for Studies in British Art by Yale Univ. Press, 2011), 96–120.

17. See Hughes, "Guns in the Gardens," 98.

18. Solkin, *Painting for Money*, 157–74; Fordham, *British Art and the Seven Years' War*, 26–30.

19. Jean André Rouquet, *The Present State of the*

Arts in England, trans. from French (1755; facs. repr. London: Cornmarket Press, 1970), 60–61.

20. Wilson, *The Sense of the People*, 137–38.

21. Fordham, *British Art and the Seven Years' War*, 24.

22. See Eleanor Hughes, "Ships of the 'Line': Marine Paintings at the Royal Academy Exhibition of 1784," in *Art and the British Empire*, ed. Tim Barringer, Geoff Quilley, and Douglas Fordham (Manchester: Manchester Univ. Press, 2007), 139–52.

23. Archibald notes that Serres was brought up in his father's "country mansion" and that his uncle was Archbishop of Rheims. Archibald, *Dictionary of Sea Painters*, 196.

24. Olivier Meslay, "Dominique Serres," 289. My thanks to Brian Allen for bringing this article to my attention.

25. Edward Edwards, *Anecdotes of Painters Who Have Resided or Been Born in England, with Critical Remarks on Their Productions* (London: Leigh and Sotheby, 1808), 215.

26. Archibald, *Dictionary of Sea Painters*, 97.

27. Joseph Farington, *The Diary of Joseph Farington*, ed. Kenneth Garlick and Angus Macintyre, (New Haven and London: Published for the Paul Mellon Centre for Studies in British Art by Yale Univ. Press, 1978 onward; original ed., 1922–28), 2:308.

28. Archibald, *Dictionary of Sea Painters*, 97–98.

29. Farington, *Diary*, 1:xv–xxvi.

30. Le Sieur Bougard, *The Little Sea Torch: or, True Guide for Coasting Pilots*, trans. J. T. Serres (London: J. Debrett, 1801).

31. Archibald, *Dictionary of Sea Painters*, 98.

32. *Royal Academy General Assembly Minutes*, vols. 1 and 2.

33. Farington, *Diary*, 3:1067.

34. *London Evening-Post*, May 6–9, 1775.

35. Source unknown, May 1, 1781, *Royal Academy Critiques*, vol. 1, following 145 ; *Diary: or, Woodfall's Register*, May 3, 1781, 3.

36. *Morning Post and Daily Advertiser*, May 6, 1786.

37. *Morning Herald and Daily Advertiser*, April 28, 1784, 2.

38. Sir Joshua Reynolds, *Discourses on Art*, ed. Robert R. Wark (New Haven and London: Published for the Paul Mellon Centre for Studies in British Art by Yale Univ. Press, 1997; original ed., 1769–91), 42, 50, 51–52.

39. *Morning Chronicle and London Advertiser*, May 11, 1784.

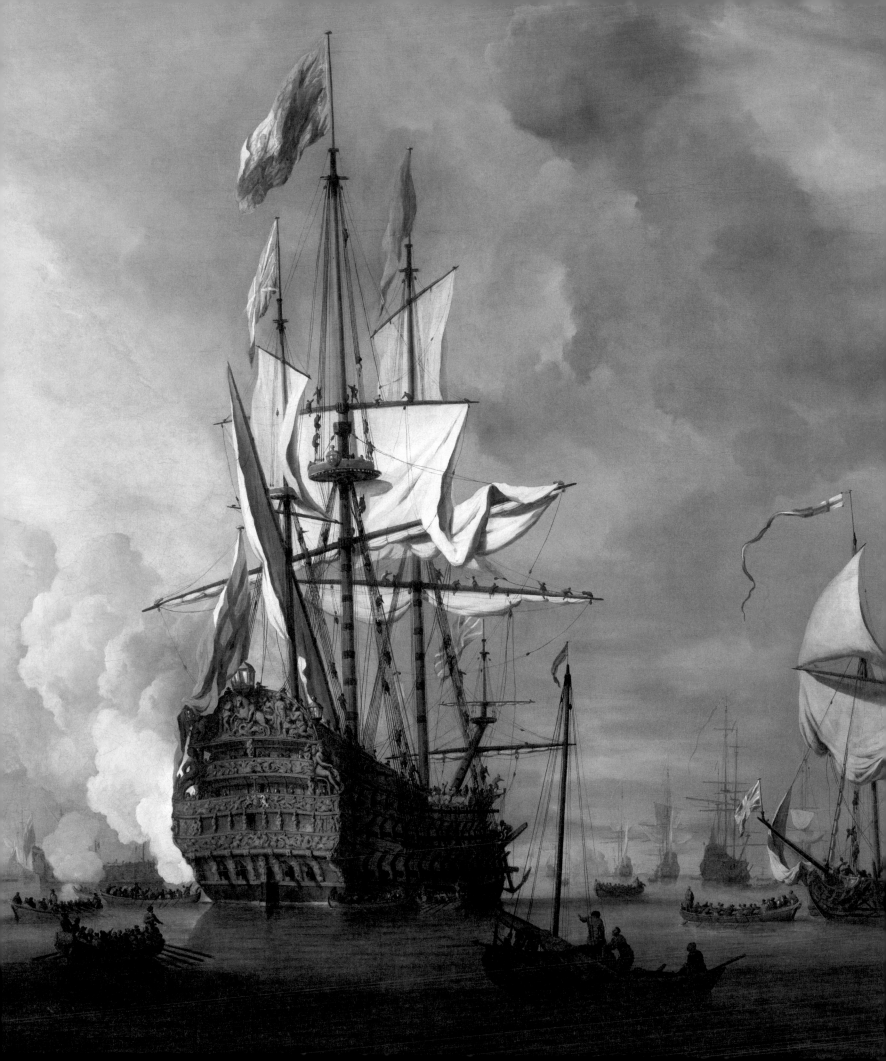

After Van de Velde

RICHARD JOHNS

T HE NAME WILLEM VAN DE VELDE signals both an end and a beginning in the history of early modern European art. On the one hand, it marks the culmination of an illustrious tradition of marine painting that had developed as a distinctive genre in the Netherlands during the late sixteenth and early seventeenth centuries, in tandem with the emergence of the United Provinces as a dominant maritime and imperial power. On the other hand, the arrival in London of both Willem van de Veldes, father and son, in the winter of 1672–73, marks a turning point for a pictorial tradition that would continue to flourish in England for another hundred years and more.[1]

The Van de Veldes were not the first foreign artists to bring a visual culture of ships and the sea to England. Almost a century earlier, in the 1590s, Hendrick Cornelisz. Vroom had been commissioned by Charles Howard, later Earl of Nottingham, to produce a series of tapestry designs that would chronicle the recent defeat of the Spanish Armada.[2] Woven in Brussels, the Armada tapestries were acquired for the Royal Collection by James I and moved to the Palace of Westminster by Oliver Cromwell in 1650, two years before the first Anglo-Dutch War. Displayed for nearly two centuries in the House of Lords before they were destroyed by the great fire of 1834, the tapestries are now known through a series of eighteenth-century prints (see cats. 36–38). Jan Porcellis, a pupil of Vroom whose work helped to establish marine painting as a distinctive genre in the Low Countries, lived for a time in England, where his patrons included Henry, Prince of Wales.[3] And Isaac Sailmaker, a contemporary of Willem van de Velde the Younger, worked consistently in England from his arrival as a young man in the 1650s until his death in 1721. A portrait of the fighting ship *Britannia* seen simultaneously in two positions exemplifies Sailmaker's meticulous approach to his subject (fig. 10).

Other marine painters also made the journey by sea, via Hellevoetsluis and Harwich. Jan van Beecq, an Amsterdam marine painter, spent the best part of a decade in England before moving on to greater success in Paris, where he became the leading marine painter at the Académie française. Adriaen van Diest, representing the

Willem van de Velde the Younger,
The English Ship Royal Sovereign
with a Royal Yacht in a Light Air
(detail, fig. 13)

17

FIG. 10. Isaac Sailmaker, Britannia *in Two Positions*, ca. 1690, oil on canvas, 37 5/8 x 57 1/4 in. (95.5 x 145.5 cm). National Maritime Museum, Greenwich, London, Caird Collection

third generation of a family of marine painters from the Hague, moved to England in his youth and became a prolific painter of land, coast, and sea.[4] The cosmopolitan culture and art market of Restoration London also attracted Lorenzo Castro, a Flemish painter of Portuguese origin with a specialty in Mediterranean port scenes and historical battles.[5]

Though each of these highly mobile artists operated broadly within the same emerging Netherlandish tradition of seascape painting, even the briefest overview of their surviving work reveals a varied and distinctive culture of marine painting in England by the end of the seventeenth century. However, none of these painters had anything like the impact that the Van de Velde studio was to have on contemporary taste or on the subsequent history of British art. By the mid-1700s, one foreign observer surveying the state of the arts in England wrote that "marine painting in Vandervelt's taste, is a branch of the art in which one need not be afraid to affirm that the English excel."[6] The author, a Swiss painter of enamel portrait miniatures named Jean André Rouquet, went on to suggest that the pleasure English patrons took from marine painting was consistent with their perception of England as a modern maritime nation, bound up with contemporary notions of politeness, heroism, and naval custom. His observation, offered to French- and English-speaking audiences as part of a broader assessment of the visual arts in his adopted country, is often cited as a

benchmark of the increasingly specialized appeal of marine painting. The question is why a genre of painting that quickly developed a distinctive identity in England continued to be described most effectively by reference to a Dutch artist who had by then been dead for nearly fifty years.

The critical history of marine painting has until recently privileged detail and pictorial accuracy as markers of authenticity when addressing questions of attribution and aesthetic value. This attention goes further even than most other accounts of seventeenth-century Dutch realism, as encountered in, say, portraiture or still life. Characterized by the precise observation of weather and rigging — of mizzens and mains, brailed or mastheaded, of foreyards and fo'c'sles — the conventional lexicon of marine painting records a level of technical detail that can seem eccentric to the landlubber art historian.[7] While such language displays an elegant logic, its effect has been to designate maritime art as a singular genre, unmoored from the mainstream of British art in ways that Rouquet seems to anticipate, but which neither the Van de Veldes nor their immediate followers are likely to have recognized. Such an emphasis on the particular and the verifiable inevitably draws attention away from the symbolic potential of marine painting.[8] To help bring the genre closer to the center of British art of the period, it is important to consider its conventions in relation to those of other kinds of painting, including portraiture, and alongside different visual media, such as print. One way to do this is to examine how the name and reputation of the Van de Velde studio was recast for an English audience: by the artists themselves following their arrival in England in the early 1670s and by a new generation of painters and printmakers.

"VANDERVELT'S TASTE"

At the time of their departure for England, the Van de Veldes enjoyed an unrivaled reputation in the Netherlands. Lodewijk van der Helst's portrait of Willem the Younger, painted around 1670, when the sitter was in his late thirties, presents a compelling image of individual artistic success while subtly acknowledging the collaborative nature of the Van de Veldes' family enterprise (fig. 11). The sitter holds and gestures toward an unfurled drawing of the kind for which Van de Velde the Elder was known; more specifically, he points to his father's signature on a wooden spar floating in the water. Behind the drawing is a partial view of a large seascape, painted in the manner for which the younger artist was better known. Not much of the painting is visible — only a Dutch flag flying from the mainmast of a large ship — but this fragment and its juxtaposition with the drawing are sufficient to indicate how closely the combined reputation of the Van de Velde studio was aligned with the military and commercial fortunes of the Dutch Republic.

The artists journeyed across the North Sea in the context of war and economic crisis, as the United Provinces came under damaging attack by the joint forces of France and England, and following a declaration by Charles II in the spring of 1672 encouraging Dutch citizens to desert the troubled republic with the promise of the

English king's protection.[9] Still, the timing of their move was extraordinary. In May Willem the Elder watched and sketched from a Dutch-protected sailboat as his country-men launched a surprise attack on the Anglo-French fleet during the Battle of Solebay. Within a year, he was working by royal appointment from rooms in the Queen's House in Greenwich, using the same drawings as the basis for a series of cartoons for six large tapestries chronicling the battle from an English perspective. Royal patronage fur-nished the two artists with an income and status sufficient to persuade them to make London their permanent home despite the prospect of lucrative employment at several other courts across Europe.[10] Once in England, the Van de Veldes became part of a cosmopolitan circle of Continen-tal artists that included the famed Dutch portrait specialist Peter Lely and the Italian decorative history painter Anto-nio Verrio. Together, these well-traveled artists reshaped the visual culture of the restored English court, at Windsor Castle and Whitehall Palace, and around the country in the great houses of leading courtiers.[11]

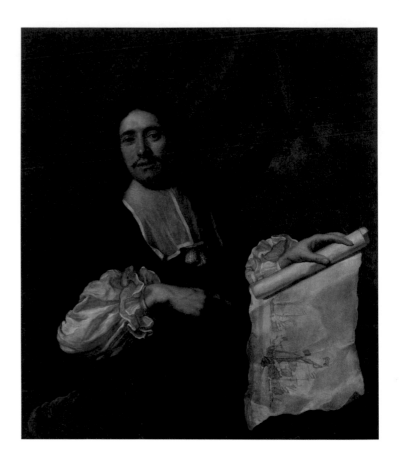

While part of this elite circle of artists, the Van de Veldes established a thriving commercial studio in Greenwich, which before long included Willem the Younger's English-born son, Cornelis van de Velde, who continued the family business for several years after his father's death in 1707.[12] A sample of picture sales held in London between 1689 and 1692—years in which public art auctions became a regular feature of cultural and economic life in the capital, and which coincided with the final years of Willem the Elder's life—suggests that, within a lively market for pictures of all kinds, there was a substantial audience for maritime subjects, and for Van de Veldes in particu-lar.[13] The abbreviated form of most sale catalogues permits only tentative conclusions about the number and type of paintings sold: with the exception of a few annotated examples, they give no indication of which paintings actually changed hands, or how often the same artwork featured in more than one sale. Moreover, it is highly probable that in most sales a significant number of the works listed were wrongly identified, whether deliberately or not, and many others were sold unattributed. Nevertheless, it is noteworthy that upward of two hundred sea pieces offered for sale in the years around 1690 were said to have originated in the Van de Veldes' studio—substantially more than came from any other named painter.[14] The frequency with which paintings described as "a sea piece of Vanderveld" (or variation thereof) were offered for sale during the period tells an important story about the artists' role in the emergence of a public for marine painting that reached far beyond the immediate interests of the court or a dedicated but relatively narrow constituency of naval officers. It seems that no serious collection of paintings was complete without a good "piece of Vanderveld"

FIG. 11. Lodewijk van der Helst, *Willem van de Velde the Younger*, ca. 1660–72, oil on canvas, 40½ x 35⅞ in. (103 x 91 cm). Rijks-museum, Amsterdam

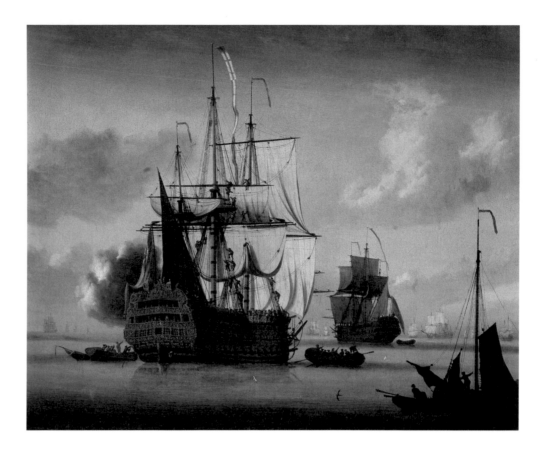

or two. And, as we will see, the Van de Velde studio responded quickly to the evolving tastes of this expanding art-buying public by producing variations of their own compositions, in a range of shapes and sizes, to meet a growing demand for marine painting across different levels of the market.

More fragmentary evidence relating to art sales in subsequent years suggests that demand for the Van de Veldes' work remained buoyant well into the eighteenth century. To give just one example, of ten marine paintings included in the posthumous sale of the collection of the English decorative history painter James Thornhill in 1735, five were identified as by "Vanderveld," their value ranging from £1 11s 6d for a pair of small sea pieces to £17 for a single canvas.[15]

The conspicuous success of the Van de Veldes shaped the work of a new generation of artists during the opening decades of the eighteenth century. They included the English composer and painter Robert Woodcock, best remembered for his woodwind concertos.[16] There were also L. D. Man, probably a Dutchman, who produced several portraits of Royal Navy ships and other vessels during the first quarter of the eighteenth century (fig. 12); Thomas Leemans, who was a painter of calm harbor scenes in the manner of Willem the Younger and about whom little else is known; and the even more elusive H. Vale and R. Vale.[17] These names are representative of a larger body of artists euphemistically described by modern saleroom specialists as "circle of" or "follower of." Too easily dismissed as poor imitations of a once-great model, their work lies

for the most part hidden deep in museum storerooms or fetches relatively low prices at occasional specialist sales, in both cases kept apart from the mainstream. In today's art market, a painting that can be firmly identified with the "hand" of Willem the Younger is likely to be valued one hundred or more times greater than a comparable work of uncertain authorship—a magnitude that is only partly explained by perceived differences in quality.

Collectively, these "followers" have been well served by the publications of the Antique Collectors' Club, but they are virtually unknown to a wider audience, and basic questions of attribution and chronology remain.[18] While there is a good deal more to learn about the lives and achievements of these lesser-known painters, a history of art that foregrounds individual biographies, or that seeks to distinguish the oeuvre of one maker definitively from another, offers a limited model for understanding the sea pieces these painters produced in such numbers. To take "Vandervelt's taste" as an indicator of the salient aesthetic preferences of early eighteenth-century audiences is not only to acknowledge the growing influence of an impersonal and open market on the art of marine painting but also to foreground the creative potential and art-historical significance of emulation, imitation, and repetition.

THE ROYAL SOVEREIGN

Few works of art have had a more visibly profound impact on the history of painting in Britain than Willem the Younger's monumental stern quarter view of a Royal Navy fighting ship, now known by the modern title *The English Ship* Royal Sovereign *with a Royal Yacht in a Light Air* (fig. 13). The large canvas, completed in 1703, is itself a variation of a well-rehearsed type of calm harbor scene that had helped to secure the young marine painter's international reputation in the 1660s. More immediately, its composition closely resembles that of another sea piece by the artist—a portrait of the Royal Navy flagship *Britannia*, first painted in the 1690s as a pendant to a storm scene for Admiral Edward Russell, commander of the Anglo-Dutch fleet at Barfleur and La Hogue.[19] The painting of the *Royal Sovereign* is first recorded in the collection of Thomas Walker, a wealthy picture collector and member of the influential society for artists and connoisseurs the Virtuosi of St. Luke. It was one of a dozen paintings from the Van de Velde studio in Walker's collection at the time of his death in 1748.[20]

The Van de Velde studio made alternative versions of the painting in a range of sizes and formats. Production continued even after the death of Willem the Younger, until eventually fifteen or more variations of the *Royal Sovereign* were in circulation.[21] Besides these official studio productions, the stately calm exemplified by the original painting was further codified in the process of imitation and adaptation by a new generation of marine painters. The composition formed the basis of paintings by artists including Robert Woodcock, who taught himself to paint in oils by repeatedly copying works by Van de Velde, one canvas after another. Thomas Leemans and L. D. Man also produced variations on the theme.[22] In the early 1720s, Thomas Baston's *View of Her Majesty's Ship* Royal Sovereign combined elements of Willem the Younger's design

FIG. 13. Willem van de Velde the Younger, *The English Ship* Royal Sovereign *with a Royal Yacht in a Light Air*, 1703, oil on canvas, 71 x 57 in. (180.3 x 144.7 cm). National Maritime Museum, Greenwich, London, Caird Collection

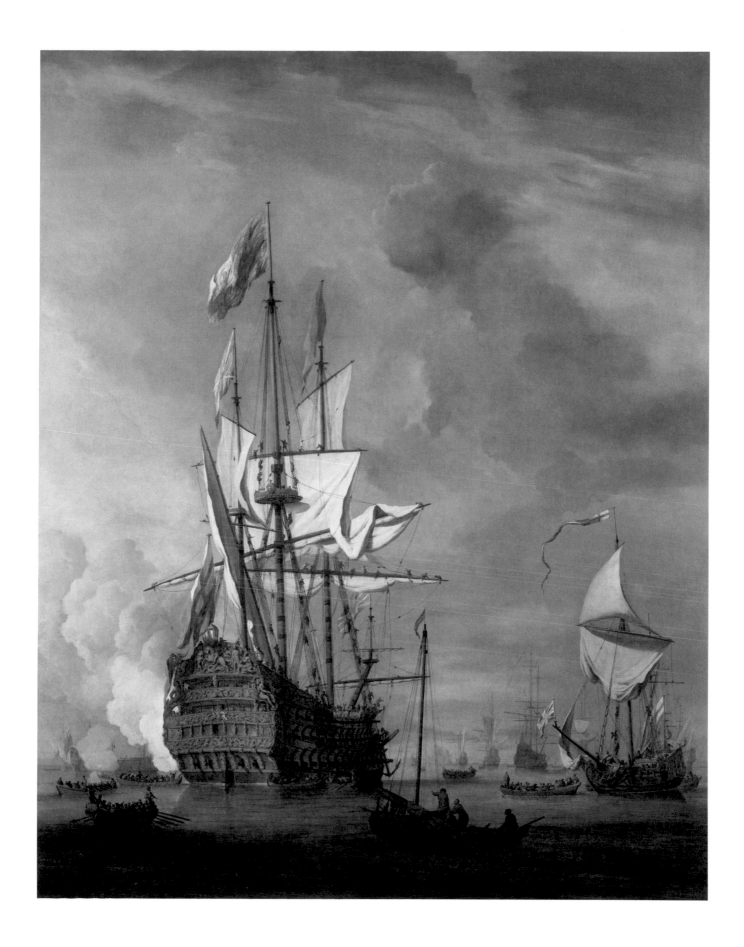

with a monochrome technique reminiscent of the *penschilderingen*, or pen paintings, pioneered by Willem the Elder (fig. 14). In the process of being engraved by Claude Dubosc in the 1720s, Baston's image was reversed, and thus came to resemble its distinguished model even more closely.

Van de Velde's *Royal Sovereign* also inspired a succession of harbor scenes by later artists, including Peter Monamy and Charles Brooking, whose reputations have fared better than those of Woodcock, Baston, and others. In the 1730s the stern quarter view exemplified by Van de Velde's design was a recurring theme of Samuel Scott's early marine subjects, and three decades later, in 1765, Francis Swaine (who had married Monamy's daughter) was awarded a premium by the Society of Arts for a painting of a royal disembarkation featuring a saluting flagship closely modeled on Van de Velde's earlier composition (fig. 15). These examples and countless others reveal the wide appeal, adaptability, and subtle stylistic variety of marine painting in England during the early decades of the eighteenth century. But more particularly, for viewers at the time and since, they embody the far-reaching appeal and distillation of "Vandervelt's taste." Closer examination reveals why Van de Velde's *Royal Sovereign* became such a compelling model for so many.

At the time of its launch, in July 1701, the *Royal Sovereign* was without rival as the most powerful and prestigious fighting ship in the Royal Navy.[23] Armed with 100 guns and richly adorned inside and out, it boasted more firepower and gold decoration than any other vessel afloat. Its elaborate giltwood stern, laden with heraldic motifs and other allegorical and maritime symbols, was matched by the painted ceiling of the ship's great cabin, where Neptune received the dominion of the seas, accompanied by the personified figures of Justice, Peace, and Prosperity.[24] In Van de Velde's painting the great warship is encircled by smaller vessels, the most prominent of which is a royal yacht approaching from the right of the picture. On either side of the *Royal Sovereign*, a line of ships reaches across a calm sea toward the low, hazy horizon. At least four-fifths of the picture is given over to sky and clouds, against which the ship's sails and flags are sharply defined, as if illuminated by a midday sun. There are no landmarks or other indicators of place, but the presence of half a dozen or so barges and a single fishing boat, nearest to the viewer, indicates that we are not far from dry land. In any case, all attention is directed toward the towering warship.

The painting was begun in the light of England's entry into the War of the Spanish Succession in 1702 and likely commemorates a royal visit to the fleet at Spithead,

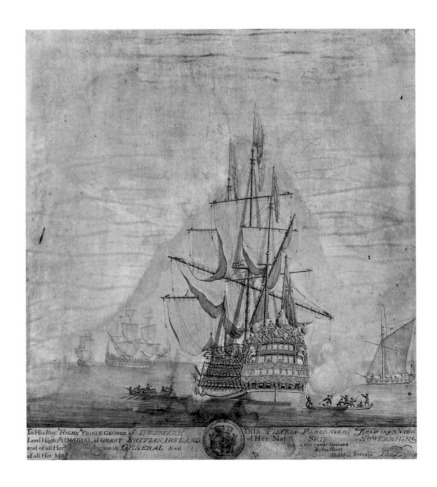

FIG. 14. Thomas Baston, *A View of Her Majesty's Ship* Royal Sovereign, ca. 1721, pencil, pen, and wash on parchment, 13 x 11¾ in. (33 x 29.8 cm). Private collection

off the south coast of England, in June of that year, when the newly appointed Lord High Admiral, Prince George of Denmark, dined on board the *Royal Sovereign* with the Duke of Ormonde and Admiral George Rooke; the prince's presence is signaled by the Royal Standard flying above the mainmast.[25] The ship's heavily carved and gilded stern is thrown into relief by a great billowing cloud of smoke from a salute fired to indicate that all is in good order and returned by the guns of at least two other vessels in the distance. Meanwhile, the ship's enormous firepower is displayed through open gun ports along three decks. Easily overlooked at first glance are the many figures, including the ship's disciplined crew: besides those in the surrounding vessels, the *Royal Sovereign* is alive with sailors dwarfed by the ship's architecture as they attend to the rigging.

Among the many hundreds of drawings that survive from the Van de Veldes' studio are several of the *Royal Sovereign*, made around the time of the ship's launch at Woolwich. Some of these drawings were subsequently worked up with a pen to emphasize areas of particular interest, or — these are preparatory sketches in more than one sense — to pick out the ship's industrious crew as it readies the vessel for the high seas (fig. 16). Their economy of detail attests to a lifetime spent in close proximity to ships and the sea. It also explains why works on paper from the Van de Velde studio were highly valued by later artists. Samuel Scott may have owned as many as five

FIG. 16. Willem van de Velde the Elder, *Portrait of the* Royal Sovereign, 1701, graphite with pen and ink on paper, 16⅞ x 22⅝ in. (42.7 x 57.6 cm). National Maritime Museum, Greenwich, London

hundred such drawings, and later painters, from Dominic Serres and Nicholas Pocock to J. M. W. Turner, collected them in large numbers, drawing on them (sometimes literally; see cat. 5) in their own explorations of the genre.[26]

The crew of the *Royal Sovereign* was singled out for attention in other ways by the naval chaplain Philip Stubs, who delivered a sermon to officers and tars aboard the ship a few weeks after its launch. Alluding to the classical metaphor of the ship of state, Stubs told the newly convened crew that God was their true pilot and insisted that the future safety of the vessel — in the face of tempest, enemy action, and disease — would depend on the moral virtue and religious obedience of all those on board. Published soon after as *God's Dominion over the Seas, and the Seaman's Duty*, Stubs's call for lower-deck reform quickly reached several editions and was even translated for the education of French prisoners of war.[27]

Before long, the *Royal Sovereign* had become a symbol of early success in the war, as Rooke's flagship at the Battle of Vigo Bay (1702). That was the first and only time the ship faced enemy fire, but the imposing structure remained afloat and in view for several decades, a conspicuous symbol of Britain's maritime aspirations and a potent show of strength in an escalating arms race between Europe's competing imperial powers. Van de Velde's painting can thus be understood both as a depiction of the ship's actual strength and as an extension of its allegorical firepower. Its visual symbolism includes the casual tilt of the yards and the drape of the sails; the ceremonial trinity of flags awakened by the "light air" appended to the painting's modern title; the great plume of gun smoke; and the disciplined sail drill of the crew that heaves and hauls the vessel into life. Posed for optimum effect, Van de Velde's *Royal Sovereign*

offered a forceful image of the fiscal-military state—an idyllic prospect of maritime order and prosperity under a Protestant monarch.

The powerful associations of Van de Velde's composition for an eighteenth-century audience is revealed further by Peter Monamy's decision to mark his promotion to the upper ranks, or livery, of London's Painter-Stainers' Company in 1726 by painting a variation of the *Royal Sovereign* for the company's hall, making it larger even than Van de Velde's canvas, though somewhat looser in style.[28] Monamy's career had begun with the Painter-Stainers in the 1690s, through an apprenticeship to William Clark, a former master of the company, and he was "made free," marking a formal end to his apprenticeship, in March 1704.[29] The ancient customs and artisanal outlook of the company had little significant bearing on Monamy's subsequent artistic practice, but there were social and political advantages to joining the livery and ascending the hierarchy of one of the City of London's ancient guilds. There was also good reason for marking the occasion with a patriotic and visually commanding gift for the company's headquarters, which, before the reopening of Vauxhall Gardens in the 1730s and the establishment of the picture rooms of the Foundling Hospital in the 1740s (both of which offered opportune spaces for the promotion of patriotic marine painting), provided one of the most prestigious locations for the display of contemporary art in London.[30] The company's influence over the painting trade was waning by the 1720s, but it maintained an impressive presence in the capital. Since being rebuilt after the Great Fire of 1666, the company's hall had become home to a rich array of paintings—many of which were presented by "stranger painters" who, like Van Beecq and Van Diest, had forged an association with the company after traveling to London from the Low Countries during the 1670s and 1680s.[31] An inventory completed a few years before Monamy's promotion in 1726 indicates that, within a generation, the walls of the hall had been filled with all manner of paintings, including portraits, historical subjects, landscapes, and still lifes. There were marine paintings too, including a storm at sea painted and given by Sailmaker, as well as an earlier storm scene by Monamy himself.[32]

Monamy's decision to commemorate his promotion with a painting so closely reminiscent of Van de Velde's earlier canvas suggests that by the mid-1720s the stern quarter view of the *Royal Sovereign* signified much more than the mechanistic repetition of a marketable image. The prominence of such a large sea piece on the crowded walls of the company's hall ensured that marine painting in "Vandervelt's taste" would become more powerfully aligned than ever with the cultural and political identity of the City of London as a branch of painting that was at once patriotic and artistically ambitious. Significantly, as one of the largest paintings in the company's possession, Monamy's *Royal Sovereign* was equal in size and format to a series of royal portraits by the likes of Godfrey Kneller and Jacob Huysmans, and including a full-length portrait of Queen Anne painted and given by Michael Dahl. The resulting arrangement enacted a more fundamental artistic dialogue initiated by Van de Velde's original design. At almost six feet high, Van de Velde's canvas owes more to the history and conventions of portraiture than to marine painting. As such, it invites a comparison of a different sort with the work and legacy of an earlier artist from the Low Countries, Anthony van

Dyck, whose portraits had a formative and far-reaching impact on the history of British art. Van Dyck's observation and pictorial assimilation of the court of Charles I during the 1630s is exemplified by his flamboyant double portrait of Lords John and Bernard Stuart, painted a few years before the outbreak of civil war, in which both brothers were killed fighting for the king (fig. 17). Besides their young age and seemingly limitless resources, the identity and biographical details of the Stuart brothers are less important here than the way their portrait molds the material excesses of the Caroline court into a symbolic code of youthful brilliance and self-assurance that defined grand manner portraiture in British art for more than a century.

The point of such a comparison is partly historical: it concerns two equally mobile and versatile artists whose influence on the arts in England extended far beyond the courtly environment in which it initially took hold and whose careers exemplify a pervasive narrative of Netherlandish influence over painting in early modern England. In a more fundamental sense, both artists explore a shared visual grammar of power and control: a hierarchical interaction between bodies, conveyed with a scrupulous hold over the pitch and turn of armature and the corresponding folds of fabric. Whether the body is that of a full-blooded young courtier or a fully manned ship of the line, each painter conveys an ideologically charged balance of action and repose, confidence and self-control, refinement and latent aggression that appeared inevitable and incontestable, and thus eminently repeatable. In other words, we come closer to understanding the enduring power of Van de Velde's painting for successive generations of marine painters by recognizing his *Royal Sovereign* as the archetypal "swagger portrait" of English naval power.

FIG. 17. Anthony van Dyck, *Lord John Stuart and His Brother, Lord Bernard Stuart*, ca. 1638, oil on canvas, 93¼ x 57½ in. (237.5 x 146.1 cm). National Gallery, London

"PRINTS OF SHIPPING"

Five years after Peter Monamy's gift to the Painter-Stainers' Company, in 1731, the printmaker John Faber published a mezzotint likeness of the English marine painter after a portrait by the little-known artist Thomas Stubly (fig. 18).[33] Monamy's fashionable appearance and polite address to the viewer — conventional signs of eighteenth-century gentility — are distinguished in Faber's print by the accompanying inscription: *Navium et Prospectum marionorum Pictor: Vandeveldo Soli Secundus* ("Painter of Ships and Marine Prospects: Second Only to Van de Velde"). This ambitious claim for artistic

FIG. 18. John Faber the Younger after Thomas Stubly, *Petrus Monamy, Navium et Prospectum marionorum Pictor: Vandeveldo Soli Secundus*, 1731, mezzotint, 15 x 10 3/8 in. (38 x 26.4 cm). National Maritime Museum, Greenwich, London (cat. 18)

association extends into the picture, as we are invited to join Monamy in casting a connoisseurial eye over a small painting of a ship foundering on a rocky coast—a type of storm scene painted regularly by the artist, and one that had also been popular among English patrons of the Van de Velde studio. With a successful practice in Westminster, a growing circle of eminent patrons, and strong links to London's painting trade, Monamy had a good claim to be regarded as the social and artistic successor to the eminent Dutch painter. But with no visible evidence of the artist's own labor (no brush or palette in sight), the print's combination of word and image raises a question of attribution. Is Monamy showing us a picture of his own making, or is he boldly gesturing toward a painting by the Dutch master against whose example he wished his own work to be measured? The uncertainty is surely deliberate, and unusual insofar as it encourages a kind of connoisseurship that purposefully blurs the distinction between the two artists. Significantly, Monamy's assertion was made within the public and commercial realm of eighteenth-century London's flourishing print culture, where "Vandervelt's taste" was transformed and commodified in new ways.

Aside from a small number of early ship portraits by Willem the Elder, no works from the Van de Velde studio appear to have been translated into print until several years after the death of Willem the Younger.[34] The apparent absence of contemporary prints is especially striking given that the mechanics and formal effects of printmaking were integral to the artists' practice in other ways. Willem the Elder's international renown rested on his monochromatic *penschilderingen*, which purposefully and exquisitely imitate the fine crosshatched lines created by an engraver's burin or etcher's needle (fig. 19). Both artists also made extensive use of offset drawing—in effect a form of monotype, used to produce a reverse duplicate of a graphite drawing—and they often turned to the work of contemporary printmakers for their own compositions. Wenceslaus Hollar was a prominent source. Returning to England from Tangier in 1669, he was aboard the *Mary Rose* when the convoy it was accompanying came under attack from a squadron of North African corsairs. His pictorial account of the ensuing battle, during which the pirates were repelled, featured the following year in John Ogilby's *Africa*, alongside a detailed account of the action (fig. 20). The same etching later provided the basis for one of a series of sea fights that the Van de Veldes painted for the Duke of York, shortly after their arrival in England.[35]

Hollar produced numerous maritime subjects during his long career. With characteristic brilliance, a series of Dutch warships and merchant vessels he published in 1647 as *Navium Variae Figurae et Formae* exploits the creative possibilities of copper, ink, and paper by combining innovative compositional techniques with a miniaturist's eye for detail to create a series of dynamic etchings that stood apart from the formal conventions of contemporary seascape painting (fig. 21).[36] Other artists and printmakers also benefitted from a growing demand for timely prints relating to maritime affairs. Following Hollar's example, Isaac Sailmaker assured viewers that his prospect of the Battle of Barfleur, engraved by Michael Vandergucht as *A True Draught of the Great Victory at Sea*, had been made under "the Special Direction of several on Board dureing the Action" (fig. 22). The artist's claim for authenticity is underscored by a

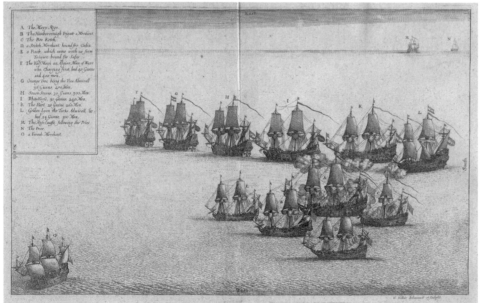

FIG. 19. Willem van de Velde the Elder, *Seascape with Dutch Men-of-War Including the* Drenthe *and the* Prince Frederick-Henry, ink on prepared panel, 27⅝ x 35⅜ in. (70 x 90 cm). Rijksmuseum, Amsterdam

FIG. 20. Wenceslaus Hollar, *Captain Kempthorn's Engagement in the* Mary Rose, *with Seven Algier Men-of-War*, etching, in John Ogilby, *Africa*, 1670. Yale Center for British Art, Paul Mellon Collection

FIG. 21. Wenceslaus Hollar, *Naues Mercatoriae Hollandicae per Indias Occidentales*, 1647, etching, 5⅝ x 9⅛ in. (14.2 x 23.1 cm). British Museum, London

FIG. 22. Michael Vandergucht after Isaac Sailmaker, *A True Draught of the Great Victory at Sea Gained by the English and Dutch over ye French May ye 19th 1692*, ca. 1692, engraving with etching, 13 x 17¾ in. (33 x 45 cm). British Museum, London

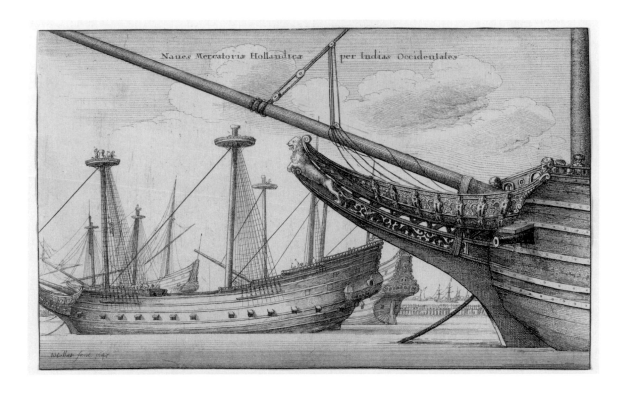

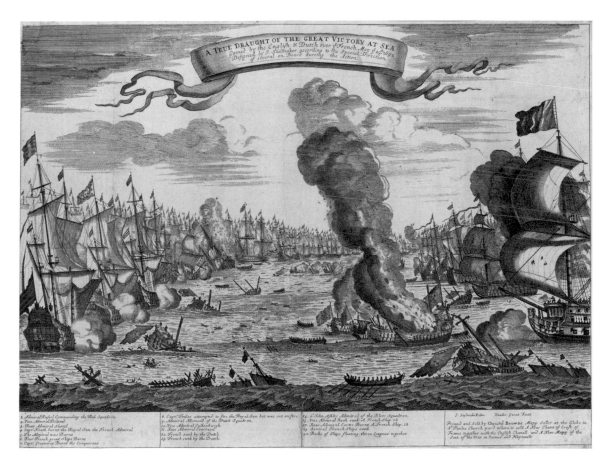

key identifying the admirals and vessels involved in the fight, while elsewhere on the page an advertisement for other prints sold by the publisher—"A New Chart of Coast of France" and a map of the concurrent land war on the Continent—provides a clear indication of the patriotic context in which such images found meaning, as viewers were invited to chart the progress of England's military exploits abroad.[37]

Given the range of opportunities to participate in and profit from a burgeoning market for maritime pictures, the Van de Veldes' abstention from contemporary print culture can be understood as another example of the close control the father-and-son studio maintained over every aspect of their artistic identity. Prints after Van de Velde began to appear regularly in London shops only as the studio finally ceased production around the time of Cornelis van de Velde's death, in 1714.[38] But the commercial potential of the artists' legacy was explored most fully in the 1720s by Elisha Kirkall, one of the eighteenth century's most enterprising printmakers and a key figure for the subsequent course of maritime art in Britain. Kirkall is best remembered for producing an early pirated version of William Hogarth's *A Harlot's Progress* (one of several unsanctioned copies that prompted Hogarth's support for the Engraving Copyright Act of 1735), but his influence on early eighteenth-century print culture was already visible.[39] As a member of the Rose and Crown Club and a regular at Godfrey Kneller's art academy on Great Queen Street, Kirkall was well connected to the London art world.[40] He also understood better than most how to profit from the capital's vibrant print market by combining established high-status subjects with an experimental and consumer-oriented approach to the business of printmaking.

Kirkall's practice during the 1720s and 1730s exemplifies the diverse image market in which the Van de Veldes' posthumous reputation continued to evolve, where a broadening interest in the visuality of Britain's maritime-industrial complex developed alongside an increasingly sophisticated discourse of fine art that depended on the continuous reinterpretation of a discrete canon of European painters. In 1722 Kirkall began accepting subscriptions for a set of twelve prints in "Chiaro Oscuro," copied from original drawings by "the best Italian Masters" in the possession of notable collectors, including the Duke of Devonshire and the renowned physician and connoisseur Richard Mead. The project stood apart from rival publications of the time, not only by promising subscribers privileged access to the cabinets of some of England's leading virtuosi, but also by its use of a previously unseen tinted metal-cut process.[41] Combining relief printing, etching, and mezzotint, the visual effects of Kirkall's novel technique recalled the highly prized chiaroscuro woodcuts of sixteenth-century Italian and German printmakers. Later experiments in color printing included a new rendition of Raphael's celebrated tapestry cartoons,

FIG. 23. Elisha Kirkall after Raphael, *The Miraculous Draught of Fishes*, 1720–30, mezzotint, 10 x 15⅛ in. (25.5 x 38.5 cm). British Museum, London

offered in a striking choice of green, red, yellow, or "any other Tint desired" (fig. 23), which capitalized on the critical and commercial success of other recent copies after Raphael's designs by Nicolas Dorigny and Simon Gribelin.[42]

Following the success of his "Chiaro Oscuro" prints and claiming the encouragement of "many Gentlemen, Painters, and Lovers of Art," Kirkall embarked on an equally ambitious project to publish a series of sixteen large mezzotints after original paintings by "that celebrated Master William Vanderveld"—to be printed, irresistibly, with sea-green ink. The terms of the subscription were the same as for the "Italian Masters" series: one guinea from subscribers up front, another payable on publication (fig. 24). Notices for the scheme began to appear toward the end of 1725 (repeat advertising was one of Kirkall's favored tactics), and by May of the following year the first eight images were ready for collection from the printmaker's Fleet Street premises.[43] The aspirational price may have put the prints beyond the reach of most, but by exploiting the distinctive tonal possibilities of mezzotint (with the added frisson of color) to animate an explosive battle scene or storm-filled sky, or to evoke the suffused light of a morning calm, Kirkall's series ensured that the range and reputation of the Van de Velde studio would become more widely recognized than ever before (figs. 25–26; cat. 13). According to George Vertue, a great chronicler of the early eighteenth-century art scene, and a friend and professional rival of Kirkall, the project was a resounding success, making an astonishing £1000 for the printmaker.[44]

The sixteen "Prints of Shipping" were not Kirkall's only maritime venture. Before embarking on the project he had been one of several engravers employed by Thomas Bowles for a prestigious portfolio of twenty-two "Capital Ships of His Majesty's Royal Navy" and other sea pieces after designs by Thomas Baston (which included Dubosc's version of Baston's *Royal Sovereign*, engraved with an allegorical border and a table giving the ship's dimensions).[45] Kirkall's contribution included a portrait of the first rate *Britannia* and a crowded harbor scene dedicated to the beleaguered directors of the South Sea Company, *A Representation of the Fishery of Great Britain, in Its Three Different Branches vizt. Cod, Herring, and Whale* (fig. 27). Several years later, in 1736, he returned to the theme of maritime industry with a set of twelve smaller prints after designs by Sieuwert van der Meulen, which followed the course of an Arctic whaling fleet "from the first discovering [the whales] to the wounding, killing, and cutting them up."[46] Priced at only six shillings and with no subscription required, these later images of maritime industry and violence were aimed at a different level of the market from the more exclusive Van de Velde portfolio.

Within this diverse and potentially lucrative environment, Kirkall's "Prints of Shipping" found meaning somewhere between the high artistic principles gestured at by his own interpretation of Raphael's *Miraculous Draught of Fishes* (an image of far greater significance for the history of marine painting in Britain than may at first appear) and the more explicitly commercial priorities of his contemporary depictions of the killing and rendering of whales. Crucially, by opening what Kirkall described in his publicity as the "Closets of the Curious" and bringing the full range of Van de Velde's practice into view, the sixteen prints also claimed to represent a paradigm of good taste alongside which the storms, calms, and sea fights of future generations of painters would be judged.[47]

A decade later, in January 1737, Kirkall published another large mezzotint purporting to represent a recent storm at sea, in which George II was feared to have drowned on his way back from a visit to Hanover. The print was copied from an earlier painting by Peter Monamy—a variation of the kind of tempestuous scene that featured in Stubly's and Faber's portraits of the artist—but an opportunistic change of title and a sharply placed advertisement (published on the same day as reports of the king's safe return) reframed Monamy's design as an exclusive and timely representation of an event of great national importance.[48] Around the same time, Kirkall began a series of

FIG. 25. Elisha Kirkall after Willem van de Velde the Younger, Plate 5 from "Prints of Shipping," 1725, mezzotint, 17⅜ x 12⅛ in. (44.1 x 30.8 cm). Yale Center for British Art, Paul Mellon Collection (cat. 14)

FIG. 26. Elisha Kirkall after Willem van de Velde the Younger, Plate 15 from "Prints of Shipping," 1727, mezzotint, 13⅛ x 15⅞ in. (33.3 x 40.2 cm). British Museum, London

FIG. 27. Elisha Kirkall after Thomas Baston, *A Representation of the Fishery of Great Britain, in Its Three Different Branches vizt. Cod, Herring, and Whale*, ca. 1721, etching, 13½ x 18½ in. (34.3 x 47 cm). MIT Museum, Cambridge, MA

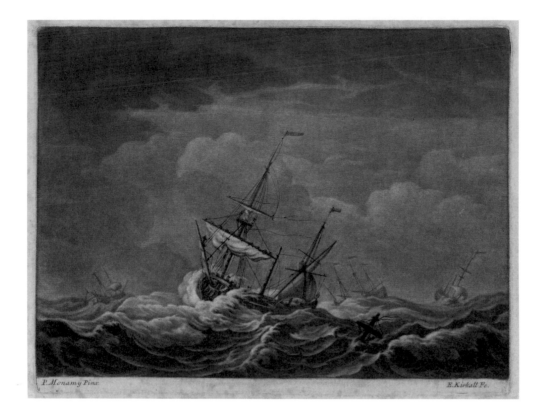

FIG. 28. Elisha Kirkall after Peter Monamy, *Ships Foundering in High Seas*, ca. 1730, mezzotint, 7¾ x 10 in. (19.6 x 25.6 cm). British Museum, London

smaller mezzotints after paintings by Monamy (fig. 28). Selected to demonstrate the breadth of the painter's practice, and printed in the same sea-green hue, they clearly invited a sustained comparison with the earlier "Prints of Shipping" and a reassertion of the painter's status as *Vandeveldo Soli Secundus*. It was here, within the capitalistic spaces of London's print culture, where technical innovation and a sharp division of artistic labor posed further challenges to traditional notions of individual authorship, that the Van de Velde legacy permeated still deeper into the artistic imagination of eighteenth-century Britain. In the longer term, Kirkall's response to the creative and commercial possibilities of "Vandervelt's taste" proved influential in unexpected ways and may even have inspired one of the greatest of all maritime artistic careers. More than a century after Kirkall's sixteen "Prints of Shipping" were published, J. M. W. Turner is said to have caught sight of an old mezzotint. It was, he reminisced, the image that "made me a painter." The artist's biographer went on to explain: "It was a green mezzotinto, a Vandervelde — an upright; a single large vessel running before the wind, and bearing up bravely against the waves."⁴⁹

1. Jenny Gaschke, ed., *Turmoil and Tranquillity: The Sea through the Eyes of Dutch and Flemish Masters, 1550–1700*, exh. cat. (London: National Maritime Museum, 2008); and Roger Quarm, "British Marine Painting and the Continent, 1600–1850," *Mariner's Mirror* 97, no. 1 (Feb. 2011): 180–92, esp. 182–84. This essay is indebted to the friendship and expertise of Jenny Gaschke, Roger Quarm, and Pieter van der Merwe, all former colleagues at the National Maritime Museum, Greenwich.

2. Margarita Russell, *Visions of the Sea: Hendrick C. Vroom and the Origins of Dutch Marine Painting* (Leiden: E. J. Brill, 1993), esp. 116–40.

3. See Quarm, "British Marine Painting," 182–83; and Edward Town, "A Biographical Dictionary of London Painters, 1547–1625," *Walpole Society* 76 (2014): 157.

4. [Bainbrigg Buckeridge], "An Essay towards an English School of Painters," appended to Roger de Piles, *The Art of Painting, and the Lives of the Painters* (London: Printed for J. Nutt . . ., 1706), 468–69; Frank B. Cockett, *Early Sea Painters, 1660–1730: The Group Who Worked in England under the Shadow of the Van de Veldes* (Woodbridge, UK: Antique Collectors' Club, 1995); Gary Schwartz, "J. van Beecq, Amsterdam Marine Painter, 'The Only One Here [in France] Who Excels in This Genre,'" in *Les échanges artistiques entre les anciens Pay-Bas et la France, 1482–1814*, ed. Gaëtane Maës and Jan Blanc (Turnhout, Belgium: Brepols, 2010), 15–32.

5. Cockett, *Early Sea Painters*, 98–107.

6. Jean André Rouquet, *The Present State of the Arts in England*, trans. from French (1755; facs. repr. London: Cornmarket Press, 1970), 60–61.

7. Such an approach is exemplified by Michael S. Robinson's catalogue raisonné, *Van de Velde: A Catalogue of the Paintings in the National Maritime Museum Made by the Elder and the Younger Willem Van de Velde*, 2 vols. (Greenwich: National Maritime Museum, 1990). See esp. "Accuracy and Seamanship," 2:unpaginated end matter.

8. Issues surrounding the modern historiographical status of marine painting were first raised and explored in detail by Geoff Quilley in "Missing the Boat: The Place of the Maritime in the History of British Visual Culture," *Visual Culture in Britain* 1, no. 2 (2000): 79–92.

9. Recent research indicates that the Van de Veldes may have had personal and professional interests in England for some time. Two painters who were brothers, Peter van de Velde and Paul van de Velde, are recorded as working in London around 1600. See Town, "A Biographical Dictionary of London Painters," 181–82. See also Remmelt Daalder, "Van de Velde & Zoon, zeeschilders: Het bedrijf van Willem van de Velde de Oude en Willem van de Velde de Jonge, 1640–1707" (PhD diss., Univ. of Amsterdam, 2013).

10. Quarm, "British Marine Painting," 184.

11. See, for example, Richard Johns, "Antonio Verrio and the Triumph of Painting at the Restoration Court," in *Court, Country, City: British Art and Architecture, 1660–1735*, ed. Mark Hallett, Nigel Llewellyn, and Martin Myrone (New Haven and London: Yale Center for British Art and the Paul Mellon Centre for Studies in British Art in association with Yale Univ. Press, 2016), 153–76.

12. On the corporate identity of the Van de Velde studio, see Daalder, "Vande Velde & Zoon." See also Roger Quarm, "The Willem van de Veldes: Dutch Marine Art in England," in Gaschke, *Turmoil and Tranquillity*, 55–64.

13. Modern studies of the art market in early modern London reveal a wide-ranging appetite for pictures, many of which were supplied by foreign painters resident in the capital. See, for example, David Ormrod, "Cultural Production and Import Substitution: The Fine and Decorative Arts in London, 1660–1730," in *Urban Achievement in Early Modern Europe: Golden Ages in Antwerp, Amsterdam and London*, ed. Patrick O'Brien (Cambridge: Cambridge Univ. Press, 2001), 210–30; and Carol Gibson-Wood's study of probate inventories, "Picture Consumption in London at the End of the Seventeenth Century," *Art Bulletin* 84, no. 3 (Sept. 2002): 491–500.

14. This estimate is based on sale catalogues for the period that have been transcribed and made digitally available via "The Art World in Britain, 1660 to 1735": artworld.york.ac.uk. Details of sales between 1689 and 1692 are particularly well preserved thanks to a collection of 132 catalogues compiled at the time by Narcissus Luttrell and now in the British Library.

15. "Sir James Thornhill's Collection," *Burlington Magazine* 82, no. 483 (June 1943): 133–37. Thornhill's sale also included two marine paintings by Robert Woodcock, which sold for £4 1s and £10. The prices obtained and the names of a handful of buyers are noted in an eighteenth-century manuscript copy of the sale catalogue bound as "Sale catalogues of the principal collections of pictures . . . sold by auction in England within the years 1711–1759," 1:12. National Art Library, London, MSL/1938/867.

16. George Vertue, "The Note-books of George Vertue II," *Walpole Society* 22 (1933–34): 23; David Lasocki and Helen Neate, "The Life and Works of Robert Woodcock, 1690–1728," *American Recorder* 29, no. 3 (Aug. 1988): 92–104.

17. See Cockett, *Early Sea Painters*.

18. Cockett, *Early Sea Painters*; and Frank B. Cockett, *Peter Monamy (1681–1749) and His Circle* (Woodbridge, UK: Antique Collectors' Club, 2000).

19. Robinson, *Van de Velde Paintings*, 2:620–24, 1074–75. The portrait of *Britannia* was also produced in several versions, including a large canvas now in the collection of the National Gallery of Ireland, Dublin, NGI.276.

20. Robinson, *Van de Velde Paintings*, 2:624–27.

21. Robinson, *Van de Velde Paintings*, 2:627–36.

22. Cockett, *Early Sea Painters;* Lasocki and Neate, "The Life and Works of Robert Woodcock," 92–104; Vertue, "Note-books II," 23.

23. The launch of the ship was commemorated at the time in a portrait of the shipwright Fisher Harding by Jonathan Richardson the Elder (National Maritime Museum, Greenwich, BHC2743).

24. The painted wooden ceiling, attributed to Thomas Highmore, survives on the staircase of the Commissioner's House at the Historic Royal Dockyard, Chatham.

25. Robinson, *Van de Velde Paintings*, 2:624–27.

26. See Richard Kingzett, "A Catalogue of the Works of Samuel Scott," *Walpole Society* 48 (1982): 1–134, esp. 108–29. See also M. S. Robinson, *Van de Velde Drawings: A Catalogue of Drawings in the National Maritime Museum Made by the Elder and Younger Willem van de Velde*, 2 vols. (Cambridge: Cambridge Univ. Press, 1958 and 1974); and Quarm, "British Marine Painting," 187.

27. *God's Dominion over the Seas, and the Seaman's Duty, Consider'd, in a Sermon Preached at Long-Reach August the 10th 1701, On Board His Majesty's Capital Ship The Royal Sovereign* (London: Printed for Henry Mortlock . . . and Richard Mount . . ., Stationer to the Navy, 1701). The sermon was in a fifth edition by 1706. Stubs's other published work includes *The Religious Seaman* (1696).

28. Monamy's painting was described in the company's minutes at the time as "a valuable seapiece of his own painting." See William Alexander Devereux Englefield, *The History of the Painter-Stainers' Company of London*, 2nd ed. (London: Chapman and Dodd, 1936), 169.

29. Guildhall Library, London, MS 5667/2 part 1, 364 (March 1, 1703/4). See also Cockett, *Peter Monamy*, 11–26.

30. Eleanor Hughes, "Guns in the Gardens: Peter Monamy's Paintings for Vauxhall," in *The Pleasure Garden, from Vauxhall to Coney Island*, ed. Jonathan Conlin (Philadelphia: Univ. of Pennsylvania Press, 2013), 78–99; Richard Johns, "Framing Robert Aggas: The Painter-Stainers' Company and the 'English School of Painters,'" *Art History* 31, no. 3 (June 2008): 322–41.

31. See Johns, "Framing Robert Aggas," 322–41. For Van Beecq, see Schwartz, "J. van Beecq."

32. Guildhall Library, MS 11505, Terrier of the Painter-Stainers' Company (1713–23). Among the paintings recorded in the terrier of 1723 is "A sea storm in a carved Guilt Frame painted and given by Peter Monamy."

33. Stubly's painting is illustrated in Cockett, *Peter Monamy*, 19.

34. See, for example, Rijksmuseum, Amsterdam, RP-P-OB-76.957.

35. Robinson, *Van de Velde Paintings*, 1:158–160.

36. George Vertue recorded forty prints of maritime subjects by Hollar, including the twelve images of *Navium Variae Figurae et Formae*, in *A Description of the Works of the Ingenious Delineator and Engraver Wenceslaus Hollar*, 2nd ed. (London: William Bathoe, 1759), 47–49. See also Richard Pennington, *A Descriptive Catalogue of the Etched Work of Wenceslaus Hollar, 1607–77* (Cambridge: Cambridge Univ. Press, 1982), cats. 1244–1287A; and *The New Hollstein*

German Engravings, Etchings and Woodcuts, 1400-1700: Wenceslaus Hollar, comp. Simon Turner, ed. Giulia Bartrum (Ouderkerk aan den IJssel Netherlands: Sound & Vision Publishers in cooperation with the British Museum, 2009).

37. Despite the promise, Sailmaker's design represents a vastly distorted view of the action by showing a sea littered with sinking French ships. Although both sides suffered heavy damage, no ships were sunk during the battle.

38. A small untitled print of two English warships, etched by H. Terasson in 1713 and published by Edward Cooper, is a rare early example, although its claim to be after Van de Velde is open to question. See British Museum, London, 1861,1109.386.

39. Faramerz Dabhoiwala, "The Appropriation of Hogarth's Progresses," *Huntingdon Library Quarterly* 75, no. 4 (Winter 2012): 577-595; Mark Hallett, *The Spectacle of Difference: Graphic Satire in the Age of Hogarth* (New Haven and London: Published for the Paul Mellon Centre for Studies in British Art by Yale Univ. Press, 1999), chap. 3.

40. Ilaria Bignamini, "George Vertue, Art Historian, and Art Institutions in London, 1689–1768," *Walpole Society* 54 (1988): 1–148.

41. Examples of Kirkall's subscription tickets are in the British Museum. The publication of the completed set was first announced in the *Weekly Packet* two years later, on September 12, 1724.

42. *London Evening Post*, May 1–4, 1731. Although Kirkall continued to use the phrase "Chiaro Oscuro" to describe his work, it did not always signal a repeat of his metal-cut technique. Jonathan Richardson, *An Essay on the Theory of Painting* (London: Printed by W. Bowyer, for John Churchill . . . , 1715); Jonathan Richardson, *Two Discourses: I. An Essay on the Art of Criticism, As It Relates to Painting . . . II. An Argument in Behalf of the Science of a Connoisseur, Etc.* (London: Printed for W. Churchill . . . , 1719). See also Carol Gibson-Wood, *Jonathan Richardson: Art Theorist of the English Enlightenment* (New Haven and London: Published for the Paul Mellon Centre for Studies in British Art by Yale Univ. Press, 2000). Dorigny copies were published in 1719; Gribelin, in 1720.

43. See, for example, the *London Journal*, November 20, 1725; *Mist's Weekly Journal*, November 27, 1725; and the *Daily Journal*, May 11, 1726.

44. George Vertue, "The Note-books of George Vertue III," *Walpole Society* 22 (1933–34), 113.

45. The imminent publication of the series was announced at the beginning of 1726. *Daily Post*, Feb. 4, 1726. A selection of plates from the series was reissued in the 1760s by Carington Bowles as *Ten Prints of the Royal Navy and Fishery of Great Britain*.

46. *Daily Post*, March 12, 1736. Although Kirkall's whaling prints are hard to find (but see, for example, Grosvenor Prints, *Catalogue 54* (2015), no. 149; stock 37512), Van der Meulen's whaling designs proved popular throughout the eighteenth century and were reproduced in various formats. See Stuart M. Frank, *Delftware: Dutch and Flemish Faience in the Kendall Whaling Museum, with a Catalogue of Related Works by Sieuwart van der Meulen and Adolf van der Laan* (Sharon, MA: Kendall Whaling Museum, 1993).

47. See, for example, the *London Journal*, Nov. 20, 1725.

48. *London Evening Post* 1430 (Jan. 13–15, 1737). There is a poor impression of the print in the British Museum, London. Monamy's original painting is now at Tate (T00807).

49. Walter Thornbury, *The Life of J. M. W. Turner, R. A.*, 2 vols. (London: Hurst and Blackett, 1862), 1:18.

Placing the Sea in Eighteenth-Century British Art

GEOFF QUILLEY

THE ARRIVAL OF THE DUTCH PAINTERS Willem Van de Velde, father and son, in England in 1672-73 and the opening of the National Gallery of Naval Art at Greenwich Hospital in 1824 serve as the chronological parameters of this book and the exhibition it accompanies. The first event marks what came to be regarded in the eighteenth and nineteenth centuries as the inception of a recognizably British tradition of maritime art and the second its culmination in a public exhibition space devoted to national maritime history. While the subject matter of marine painting had a global reach, encompassing sites of British colonial and imperial interest and the seas between, its eighteenth-century story begins and concludes at Greenwich, where the Van de Veldes were provided a studio at the Queen's House, and where the Naval Gallery was installed in the hospital's Painted Hall.

In terms of British culture and history, Greenwich might also be understood as the preeminent maritime center, *the* place of the sea, at least from 1692, when it became the home of the Royal Hospital for Seamen at Greenwich. Until that point, it was the site of Greenwich Palace, with its frontage on the Thames, and one of the principal residences of the Tudor and Stuart monarchies. Following the Restoration in 1660, Charles II began rebuilding the palace, adding the Royal Observatory as a means for improving navigation through astronomical observation. The observatory supplemented the Palladian magnificence of Inigo Jones's early seventeenth-century Queen's House. When, during rebuilding, the royal palace was repurposed, on Queen Mary's instructions, as a hospital for wounded and disabled sailors of the Royal Navy, it was therefore already a site associated with navigation and the visual representation of the sea. The renovation was undertaken by Britain's leading architect, Sir Christopher Wren, designer of the nation's spiritual center, St. Paul's Cathedral, which the palace domes clearly emulate. In the early decades of the eighteenth century the palace-turned-hospital was embellished with Sir James Thornhill's extravagant decorative scheme for the Painted Hall, which constituted a monumental pictorial statement on the inexorable rise of the maritime nation, founded on ideas of Protestant liberty and constitutional monarchy under the Hanoverian succession. By the beginning of the

Philippe-Jacques de Loutherbourg, *The Evening Coach, London in the Distance* (detail, fig. 36)

41

nineteenth century, the complex of buildings presented, in the words of the writer and engraver Samuel Ireland, "a splendor of scenery scarcely to be equalled in this country" and was the focal point of national maritime activity.[1] In thinking about the place of the sea in eighteenth-century Britain, therefore, Greenwich is an obvious place to start.

However, once we begin to consider how the place of the sea is represented at Greenwich, we encounter ambiguities about the significance of the sea in British culture and particularly its visual representation. One of the most important paintings made specifically for Greenwich was Benjamin West's *St. Paul Shaking the Viper from His Hand after the Shipwreck*. Commissioned for the hospital chapel, which was dedicated to St. Peter and St. Paul, it illuminates the range of issues at play (fig. 29). The imagery points to a fracture within maritime culture, whereby it was at one level visibly celebrated as a source of nationalistic sentiment but at others displaced, elided, or denied.

St. Paul is not commonly identified as a maritime saint, but West's altarpiece, showing an episode following the shipwreck of the apostle on the island of Malta, would appear to suggest otherwise. Conventionally, as the patron saint of London and the eponymous saint of its cathedral, St. Paul was more readily understood in Britain as the figurehead of the Anglican Church through his dissemination of true religion enabled by extraordinary powers of oratory. Neither is the Anglo-American West regarded as a marine painter, though his artistic career was fundamentally rooted in transatlantic experience, which may have informed his work in ways not hitherto considered. It is echoed in the subject of the altarpiece: the voyage as transformative and revelatory, as well as a testament of faith.

The altarpiece, the largest painting by West prior to the last decade of his life, was installed at Greenwich in 1789.[2] It was the centerpiece of a larger pictorial scheme that constituted the final phase of the rebuilding of the chapel following a disastrous fire of January 1779. It shows the moment when, after the saint and other travelers on the shipwrecked vessel had reached land safely, a deadly viper came out of a newly lit fire and fastened upon Paul's hand, only to be shaken off as his faith rendered him impervious to the venom.

This is a shrewd and ingenious choice of subject. It clearly suited West's aspirations as a history painter better than the scene of the shipwreck itself, since it allowed him to demonstrate his skill in the disposition of large figural groupings in the manner of Renaissance or Baroque artists such as Raphael or Poussin; it also alludes to the most significant artistic treatment of the life of St. Paul, Raphael's cartoons in the Royal Collection. More importantly, in depicting not calamity but rescue *from* it, the painting provided an apt metaphor for the recent history of the chapel itself: destroyed by fire and then reconstructed. The Reverend John Cooke used the same moment of the narrative for his sermon marking the opening of the new chapel before his audience of Greenwich pensioners, the retired sailors that constituted the hospital's community. Cooke concluded the sermon by linking the fire that ruined the chapel with the fire in the narrative of the painting, urging the pensioners to abandon the dissolute life

FIG. 29. Benjamin West, *St. Paul Shaking the Viper from His Hand after the Shipwreck*, 1786, oil on canvas. Royal Naval College, Greenwich, Chapel of St. Peter and St. Paul

of the sailor and look toward the afterlife. If they could copy the Apostle's example in the "steadiness of [their] faith, . . . though our bodies be subject to decay and death . . . yet, like this building, which we once saw desolated and destroyed by fire, we shall be raised again with fresh beauty, 'the living Temples of the living God.'"[3] With its maritime and devotional allusions, the altarpiece suited its naval community and appealed as well to a wider, national constituency.

Because it treats the sea elliptically, however, the altarpiece is at once instructive and problematic for thinking about the place of the maritime in eighteenth-century British culture. The sea as the subject is both there, understood in the prior narrative by which St. Paul ended up on the shores of Malta, and elided—placed, as it were, beyond the frame. The painting answers the immediate requirement of the chapel's dedication to the saint and picks up on the maritime associations of Greenwich but more readily focuses on the recent history of the chapel itself, in its parallel near-destruction and survival. The composition centers on the illuminated full-length figure of St. Paul, surrounded by a crowd of soldiers, sailors, and islanders, with the Roman centurion whom he had converted en route standing beside him, ranged against a backdrop of colossal rocks and cliffs. The coastal location is registered only through the inclusion of the sea as the setting of the shipwreck, visible through a gap in the rocks at bottom left. A preparatory drawing makes the coastal location much more prominent, with the hull of the ship clearly visible (fig. 30); the marginalization of the sea was, therefore, a deliberate choice for the final composition, no doubt in view of the chapel as the setting for the altarpiece.

Most conspicuously, West redirects the viewer's gaze away from the maritime world of Greenwich by explicitly referencing the most celebrated immediate artistic precedent for the iconography of the shipwreck of St. Paul: the monumental treatment of the subject by Sir James Thornhill as part of his decorative scheme for the cupola of St. Paul's (fig. 31). West's composition is clearly a quotation of Thornhill's, most notably in the figure of the saint himself, and thus invites the viewer to place the Greenwich altarpiece within the larger orbit of London's cathedral. As Richard Johns has pointed out, that cathedral is itself a "monument to . . . recovery from the Great Fire," and emphasizes further the significance of St. Paul as the "embodiment of the

FIG. 30. Benjamin West, *St. Paul Shaking the Viper from His Hand after the Shipwreck*, ca. 1786, pen and ink, wash, and watercolor on paper, 19 ⅜ x 13 ½ in. (49.2 x 34.1 cm). Museum of Fine Arts Boston, Gift in memory of John Hubbard Sturgis by his daughters, Miss Frances C. Sturgis, Miss Mabel R. Sturgis, Mrs. William Haynes-Smith (Alice Maud Sturgis), and Miss Evelyn R. Sturgis

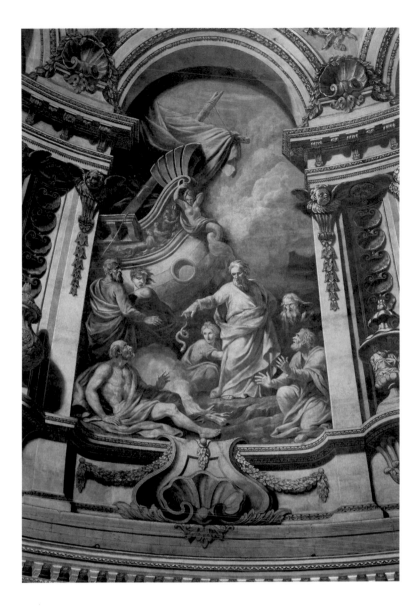

modern Anglican Church" and the larger civic, political, and national context that the cathedral symbolized.[4]

In thus referring Greenwich away from the sea toward the capital and its cathedral, West was subtly adapting iconography in landscape painting dating from the second half of the seventeenth century, which gave the view toward London from Greenwich, and particularly the impressive panorama of the city from One Tree Hill in Greenwich Park. This subject, frequently revisited from the 1670s to the 1820s, shows the significance of Greenwich subsumed under the larger royal or civic meanings of London in the distance. Typical in this period is Jan Griffier's depiction of about 1690, showing Greenwich Palace under redevelopment (just prior to its becoming the hospital), with the dome of a rebuilt St. Paul's in the distance (also still under construction), and taking in the Royal Observatory at the left edge (fig. 32). The prospect offered is a vision of the stability, prosperity, and modern reconstruction of the state under the restored Stuart monarchy.[5] At the end of that period, Turner's *View of London from Greenwich* of 1825 provides a complex, partly satirical essay on the interlinked histories of Greenwich and London, and early nineteenth-century proposals for the city's development as what has been called "a scenographic and fittingly imperial capital": the smog-covered dome of St. Paul's in the center distance echoes the domes of Greenwich Hospital at bottom right (fig. 33). The view this time does not encompass the Royal Observatory but is taken from its vantage point, acknowledging a genealogy of such views going back to the Restoration, including Turner's own earlier large-scale treatment of the subject in *London from Greenwich Park* (1809).[6] Peter Tillemans's depiction from the early eighteenth century makes explicit the identification of the single dome of the hospital still under construction with that of St. Paul's, juxtaposing them in the center of the scene and making them almost exactly the same size on the canvas (fig. 34). Once again, the observatory is included to the left. The same viewpoint is taken in John Feary's conversation piece of 1779, but with an additional element alluding to the larger maritime context, the red-coated gentleman pointing toward the spreading oak of One Tree Hill (fig. 35). His gesture, through reference to David Garrick's popular song "Hearts of Oak," a celebration

FIG. 32. Jan Griffier the Elder, *London and the River Thames from One Tree Hill, Greenwich Park*, ca. 1690, oil on canvas, 34 x 51 in. (86.5 x 129.5 cm). National Maritime Museum, Greenwich, London

FIG. 33. J. M. W. Turner, *View of London from Greenwich*, 1825, watercolor and gouache over graphite on paper, 8⅜ x 11 in. (21.3 x 28 cm). The Metropolitan Museum of Art, New York, Bequest of Alexandrine Sinsheimer, 1958

FIG. 34. Peter Tillemans, *London from Greenwich Park*, ca. 1730–34, oil on canvas, 22½ x 46⅛ in. (57 x 117 cm). Bank of England Museum, London

FIG. 35. John Feary, *One Tree Hill, Greenwich, with London in the Distance*, 1779, oil on canvas, 27½ x 48 in. (69.9 x 121.9 cm). Yale Center for British Art, Paul Mellon Collection

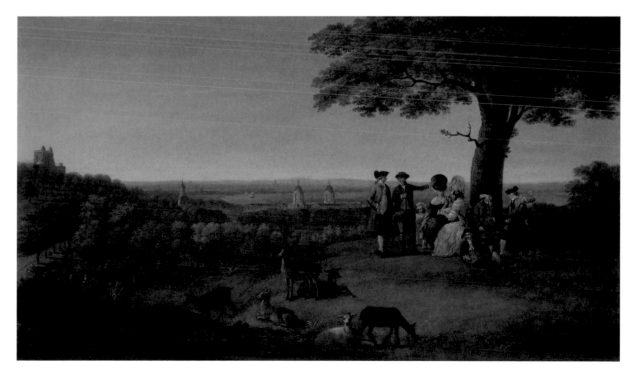

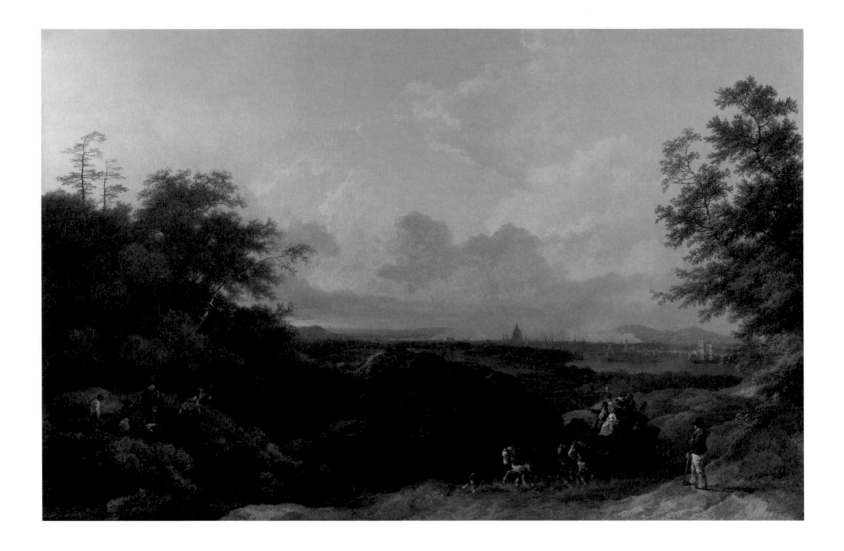

of ships and tars written during the Seven Years' War (1756–1763), thus foregrounds the same symbolic duality of navy and monarchy encapsulated in the parallel domes of Greenwich and St. Paul, placed once again in the exact center of the composition.[7] The prominence of the deer in the foreground is a reminder of the earlier history of Greenwich as a royal palace and hunting park. Produced at a moment of crisis in an imperial war against revolutionary America, Feary's work, with its inclusion of the oak in the conventional prospect from One Tree Hill, had unmistakably nationalistic associations. In Philippe-Jacques de Loutherbourg's lyrical and radiant adaptation of the view, *The Evening Coach*, the vantage point appears to be similar, with the view across the river to St. Paul's (fig. 36). But here Greenwich has been erased entirely, and its maritime significance is represented only in the solitary, enigmatic figure of the tar at the side of the road watching the coach as it passes. He, however, may also be a nationalistic reference, given the date of the painting (1805), since the coach is heading out of London toward the south coast, in the direction of Portsmouth, where Nelson's flagship *Victory* was moored after returning from his defeat of the French and Spanish fleets at the Battle of Trafalgar (see cat. 129).[8]

FIG. 36. Philippe-Jacques de Loutherbourg, *The Evening Coach, London in the Distance*, 1805, oil on canvas, 29½ x 46 in. (74.9 x 116.8 cm). Yale Center for British Art, Paul Mellon Collection

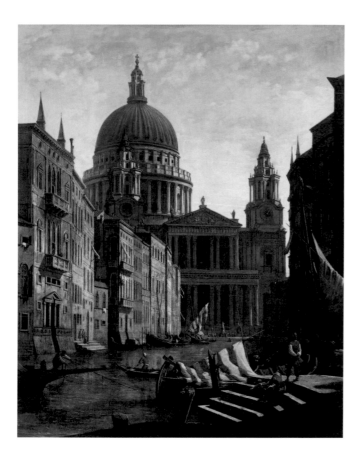

The strategy West used in his altarpiece, of diversion from Greenwich through referral back to the national center of St. Paul's, thus underlies the visual representation of Greenwich more generally: the maritime is acknowledged at a symbolic or an associative level, but is displaced or elided in its material configurations. An extreme expression of this ambiguity regarding the place of the maritime in Britain's national life is William Marlow's *Capriccio: St. Paul's and a Venetian Canal* of the 1790s, in which the street of Ludgate Hill leading up to the main façade of the cathedral is replaced by a Venetian canal (fig. 37). The painting has received little detailed critical attention, no doubt because of uncertainty about whether it is meant to be taken as serious or satirical, as admonitory or celebratory of Britain's maritime and imperial ambitions.[9] Its shock value derives from the relocation of St. Paul's to a maritime environment, which proves to be much more problematic than the conventionally elliptical association of St. Paul's with Greenwich.

The difficulties attendant on associating the maritime too directly with St. Paul had been implicit from the reopening of the chapel. In a sermon to the pensioners in October of that year, a month after the Reverend Cooke's, Charles Peter Layard admonished the veteran sailors for not being as dutiful, deferential, and grateful for their situation as they might be, in deprecating "the respect you owe to those under whose protection and government, and instruction, you are placed." Instead of performing the "few and easy" duties of their final days in preparation "for the kingdom of God," he said, the pensioners were indulging "those excesses too often fallen into by sea-faring men": drunkenness, cursing, and blaspheming. Invoking the imagery of West's altarpiece before them, Layard attempted a final appeal for reform:

> You have been conducted hither by God's providence, as St. Paul was once, to a place of refuge and rest from the stormy tempest. Cast off every sin, which, like the viper, may try to fasten upon you; and endeavour so to purify your whole lives and conversations, by the aid of the divine grace, that God, through Christ Jesus, may bring you, at the last, into that haven of peace, where ye would be.[10]

Rather than being complementary, therefore, as implied in the panoramic views of London from One Tree Hill, Greenwich and St. Paul could be antithetical. This disjunction is more evident in another set of sermons, James Stanier Clarke's *Naval Sermons, Preached on Board His Majesty's Ship the Impetueux, in the Western Squadron,*

during Its Services off Brest: To Which Is Added a Thanksgiving Sermon for Naval Victories. The *Impetueux*, upon which Clarke had served as chaplain, was one of the ships involved in the 1797 naval mutiny at Spithead, a rebellion across the navy's working population that was unforeseen by the British establishment and thoroughly destabilizing to it. When the rebellion spread to the fleet at Sheerness, at the mouth of the Thames, it constituted a national disaster of potentially cataclysmic proportions.[11] The lower-deck sailors across the entire fleet refused to sail, in protest at their pay and conditions, and at Sheerness attempted to blockade the Thames, thus exposing the country to potential invasion and revealing both a politicization of the lower-deck tar and, more worrying, the capacity for Britain's "hearts of oak" to turn against the country they served. Clarke's sermons, then, published in 1798, were directed not just at sailors' characteristic "excesses," but at their potential for disloyalty.

Like Cooke and Layard, Clarke reverts to the exemplary narrative of St. Paul to remind the sailors of their duty, with direct allusion to the mutiny and its national significance. His guiding text is Acts 27:31—"Except these abide in the ship, ye cannot be saved." St. Paul, through his powers of oratory, persuades the crew of the foundering ship that they must all remain on board, or else they will be lost, and that performance of their duty is therefore their only means of preservation. Clarke interprets:

> Submission unto our Governors, unto them who are in authority over us, is a doctrine, which the apostle St. Paul, whose conduct you have so much reason to admire, continually inculcates. . . .
>
> You are all immediately the servants of your King and Country: the just performance of your duties, will consequently have a considerable and lasting effect, on the happiness of the community at large. If this important and noble service, should ever appear ungrateful; if a too warm and active imagination should eagerly grasp at some advantage, which promises attainment, in a situation different from that, where you are at present placed; still have the resolution to abide in the ship! The prospect, which seems so flattering, may be only a snare, to seduce you from Duty. Arise! pursue again with zeal the commands of your Superiors, and the dream will cease.[12]

For Clarke in the immediate crisis of the mutinies, the deferential relation of Greenwich to St. Paul's is transformed into an antagonism in which the apostle stands as the necessary figure of command over an unruly maritime populace. Such a problematic image of St. Paul as both national icon and maritime saint indicates the delicate and difficult territory that West's altarpiece for the chapel had to negotiate.

Other than the site of Greenwich Hospital itself and perhaps John Bacon's sculptural monument to George III in the inner court of Somerset House (home of the Navy Office), which was a paean to maritime empire under the command of the king, there was no clearly defined civic or public space, monument, or ceremony that formally articulated the place of the sea in the life of the nation. There was nothing, for instance, like Venice's annual ceremony of the *Sposalizio del Mare*, in which the doge

cast a ring into the water of the lagoon, "marrying" the city-state to the sea surrounding it. The lack of any similar culture in Britain formed a gap that the many proposals at the turn of the nineteenth century for a pillar or other monument to British naval victories were designed to fill. They culminated, via a tortuous process, in Nelson's column, eventually erected in Trafalgar Square in 1843, almost four decades after the battle it commemorates.[13] Even the Armada tapestries in the House of Lords, destroyed in the 1834 fire, necessarily addressed a severely circumscribed, patrician idea of the public, defined along purely aristocratic lines.

Nevertheless, the absence of any civic or ritual space marking Britain's maritime disposition was offset by the almost ubiquitous and unavoidable imagery of the sea in displays public and private, fixed and ephemeral, all across London. The Foundling Hospital and Vauxhall Gardens were two of the most prominent and prestigious public spaces for viewing contemporary art prior to the establishment of exhibiting societies and the Royal Academy of Arts (1768). The hospital showed paintings by the leading marine artist Peter Monamy as well as Charles Brooking's *A Flagship before the Wind under Easy Sail*, which was donated in 1754 (cat. 40); and following British naval victories in the Seven Years' War, Vauxhall displayed Francis Hayman's *Triumph of Britannia* (now known only through the print by Simon Ravenet, fig. 38). Hayman's large-scale

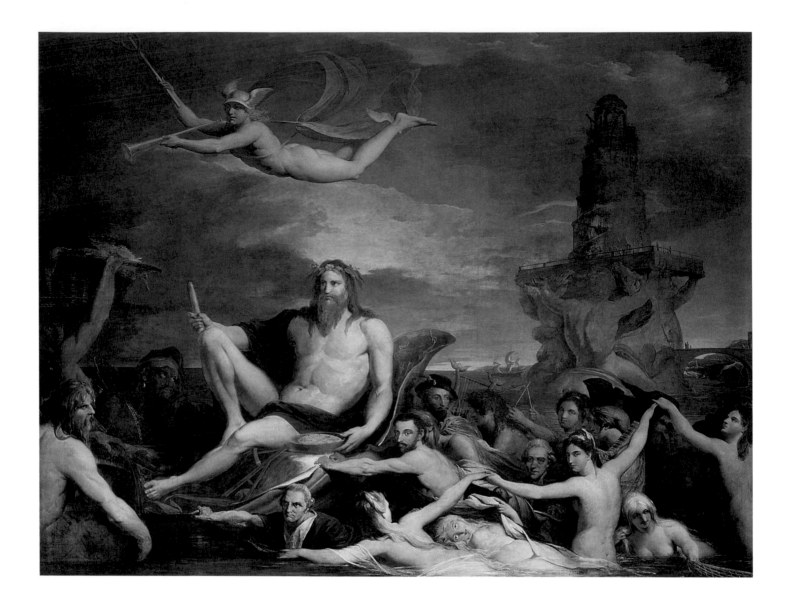

painting was based in part on a transparency designed by Andrea Casali for the 1748 fireworks in Vauxhall Gardens to celebrate the end of the War of the Austrian Succession, and the same design informed James Barry's extravagant mural for the Society of Arts, Manufactures, and Commerce, *Commerce, or the Triumph of the Thames*, completed between 1777 and 1801 (fig. 39).[14] Nautical transparencies were a regular feature of the festivals and ceremonies taking place on the streets of the capital: in 1789, to celebrate George III's recovery from illness, transparencies of maritime subjects were displayed in theaters as well. Lord Heathfield, hero of the Siege of Gibraltar (1779–83) put on a display of "illuminations" at Turnham Green, including "six large transparencies," of which the center one, according to a newspaper report, was "16 feet by 12, representing Britannia surrounded by Commerce, Plenty, and the Arts, intermixed with groups of dancing children and music: on the right hand of Britannia is a ship at anchor or safe in port, and painted on the stern The George and Charlotte."[15]

FIG. 39. James Barry, *Commerce, or the Triumph of the Thames*, 1777–1801, oil on canvas, 141¾ x 182 in. (360 x 462 cm). Royal Society of Arts, London

Reenactments of naval battles, similarly ephemeral, were a regular feature on the London stage during Britain's involvement in the French Revolutionary and Napoleonic Wars (1793–1815), paralleling a growth at that time in the number of monuments to fallen naval heroes in St. Paul's and Westminster Abbey. At the annual exhibitions at the Society of Artists of Great Britain and the Royal Academy from the 1760s, marine painting was often on display.[16] And maritime motifs recurred in public decoration, such as the façade of East India House on Leadenhall Street, where the East India Company announced its public image at first through the representation of a ship at sea and, later, when the company's London headquarters was rebuilt in the 1730s, with an elaborate pediment showing its global commercial presence. At Somerset House, the home of both the Navy Office and the Royal Academy from 1780, sculptural heads represented "Ocean" and eight of England's navigable rivers.[17] Private spaces filled with maritime imagery are demonstrated, for instance, by Johan Zoffany's *Sir Lawrence Dundas with His Grandson* (see fig. 100, p. 151), showing the collector in a room exhibiting his marine paintings; or the Earl of Abercorn's town house on Dean Street, Soho, where the walls were decorated in the 1740s with a grandiose scheme of murals on themes of travel and shipping.[18]

To some extent, maritime culture was taken for granted as a staple of national life. Sir J. G. Dalyell commented in the preface to his 1812 compilation *Shipwrecks and Disasters at Sea* that "in a country such as Britain, where every individual is either immediately or remotely concerned with the fortune of the sea, the casualties attendant on the mariner must be viewed with peculiar interest," adding that "perhaps not less than 5000 natives of these islands yearly perish at sea." He was working from the reasonable premise that virtually everyone in the country had some material or emotional interest in the sea (and consequently in the subject of his book).[19]

This was an interest that transcended ideological difference. Some seven decades earlier, the Tory politician Lord Bolingbroke outlined the national importance of commerce and therefore of the maritime, as a universal value: "By trade and commerce we grow a rich and powerful nation. . . . As trade and commerce enrich, so they fortify, our country. The sea is our barrier, ships are our fortresses, and the mariners, that trade and commerce alone can furnish, are the garrisons to defend them."[20] Bolingbroke even went so far as to claim that "like other amphibious animals we must come occasionally on shore: but the water is more properly our element."[21]

The idea that the British were "amphibious animals" is indicative of the degree to which a positive conception of the nation as maritime dependent had become a core understanding of national identity during the eighteenth century. It was not the case, therefore, that the subject of the maritime was marginal to eighteenth-century visual culture. Instead, marine paintings at annual exhibitions, through their organization on the walls, provided an appeal to a sense of a national and imperial collectivity based on the sea, that notionally at least bypassed class or cultural distinctions in promoting a sense of patriotic affiliation. This was especially the case against a backdrop of continual warfare fought on an increasingly global scale, as commercial and maritime conflicts.[22] By the end of the first such global war, the Seven Years' War, it was widely

accepted, particularly through the writings of so-called Scottish Enlightenment philosophers such as David Hume, Adam Smith, and Henry Home, Lord Kames, that commerce was the foundation of civil society and the wellspring of national prosperity, and furthermore that commerce was virtually synonymous with navigation. When John Entick wrote in 1757, "By Navigation the whole World is connected, and the most distant Parts of it correspond with each other," he was voicing an idea that had largely lost any contentiousness it may have held earlier in the century due to commerce's association with the debilitating effects of luxury upon established social hierarchies. The change had occurred through the expansion of a mercantile "middling" class whose power lay in the accumulation of private wealth rather than political representation and influence in the public interest. For Entick, navigation was the key to the nation's survival:

> Navigation may be considered, as the Channel through which all our Commerce circulates. And from hence we must perceive of how great Importance it is, that it should be free and undisturbed: That whatever clogs or obstructs it, must be an universal Detriment; and that whatever promotes Navigation must be allowed to promote the general Interest of the Nation: For thereon depends our Trade; and upon our Trade depends the Value of our Houses, Lands and Produce.[23]

If, in the theoretical realm of social philosophy and history, commerce had largely lost its negative connotations, in the material practices of the maritime world it had not. Underlying the displacement of the maritime in eighteenth-century culture was an aversion to contemplation of the amoral otherness associated with the sea and the communities that lived by it. The potential of traders to be transformed into monsters of venality, excess, and corruption was everywhere evident, from the rapacity of the East India Company in appropriating the wealth of Bengal from the 1760s, to the pursuit of profit at any human cost that underlay the trade in enslaved Africans across the Atlantic throughout the century. Such aspects of maritime practice are almost entirely absent from eighteenth-century maritime painting, and are all the more conspicuous for being so. In addition, the labor force on which shipping and commerce ultimately relied—the common sailor—had the reputation of being, as Clarke's *Naval Sermons* indicated, notoriously unruly, uncivilized, potentially threatening, and—figuratively, if not literally—foreign to the nation on whose behalf he worked. It is perhaps not surprising, therefore, that there is hardly any eighteenth-century visual representation of maritime labor, though smugglers and pirates, as well as sailors ashore, appear in satirical prints. Notably, the eighteenth-century maritime image that was perhaps the most influential—a print of a cross-section showing stowage on the slave ship *Brooks*, utilized to considerable political effect by the abolitionist movement—achieved its impact through the brilliant exposure of precisely this cultural blindness (fig. 40).[24]

In *The Novel and the Sea*, Margaret Cohen offers an account of eighteenth-century representations of maritime labor in prose that can be seen to parallel developments

FIG. 40. Printed for James Phillips, *Description of a Slave Ship*, 1789, woodcut and letterpress, 24¾ x 19¾ in. (63 x 50 cm). Beinecke Rare Book & Manuscript Library, Yale University

DESCRIPTION OF A SLAVE SHIP.

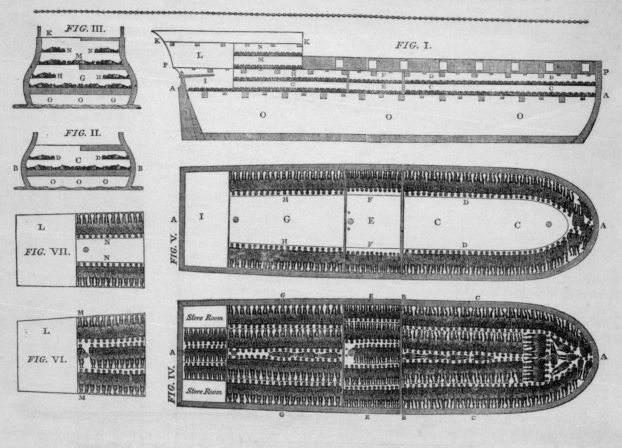

DIMENSIONS OF THE SHIP.

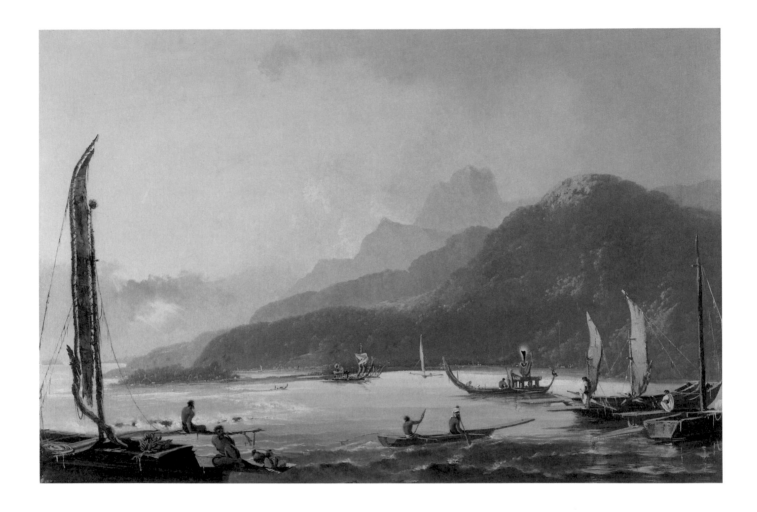

FIG. 41. William Hodges, *A View of Matavai Bay in the Island of Otaheite*, 1776, oil on canvas, 36 x 54 in. (91.4 x 137.2 cm). Yale Center for British Art, Paul Mellon Collection

in visual art. In the first half of the century a narrative form that she terms "the maritime picaresque" predominated, typified by the novels of Daniel Defoe and Tobias Smollett, in which the "craft" of maritime life and work was key. The maritime novel effectively disappeared from the middle of the century until the 1820s; during the expansion of Pacific exploration it was replaced by the hugely popular genre of nonfiction travel writing: "accounts of the pioneering voyages of Anson, Bougainville, Cook, and La Pérouse captivated international audiences."[25] The heroic resourcefulness of a fictional hero such as Robinson Crusoe was transposed onto the actual figure of an explorer such as James Cook, thus collapsing the distinction between the fictive and the documented voyage. A similar pattern is observable in visual culture, with a shift between the late seventeenth or early eighteenth-century depiction of the maritime and that of the later eighteenth century. Representations of the sea in the grand, courtly set pieces of the Van de Veldes emphasize the monumentality of the vessels, but upon close viewing also reveal a teeming crew of tiny figures busy in the rigging and on deck managing and working the ship through the oceans. In the 1760s and 1770s this practice gave way to the innovation of taking artists on board as part of the professional team of naturalists to make records of the expedition's findings. So the works of William Hodges or John Webber, the draftsmen appointed to Cook's second

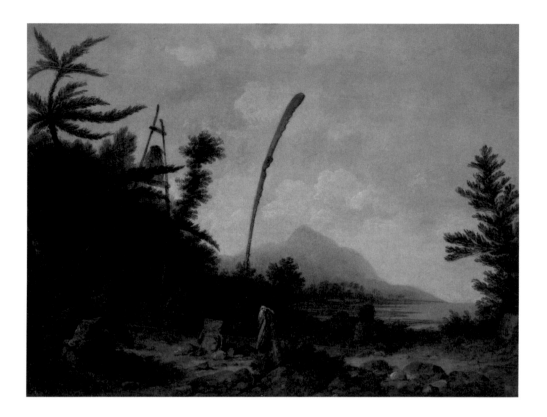

and third voyages, respectively, document key people, places, and phenomena encountered on the expeditions and add poetic or philosophical interpretative accounts of them, in line with the written ethnographic, botanical, geological, or other records by the naturalists on board (figs. 41–42). Toward the end of the century such imagery, which not only blurs the distinction between the documentary and the imaginative, but also places an equivalent value on the visual and the verbal record, was increasingly emphasized as a reliable source of information about maritime travel. Yet it does not show explicitly either the artists' own craft in making such records or the craft of the sailors on whom they relied to get them from place to place.

With the rise of the nonfiction narrative, Cohen observes a literary tendency toward the "sublimation of the sea": a move away from the "craft" of the sea and the figure of the mariner to an increasing view of the sea itself as an unmediated source of the sublime, which finds its logical conclusion in Immanuel Kant's commentary on the subject: "To call the ocean sublime we must regard it as poets do, merely by what strikes the eye."[26] The sublimity of the ocean, therefore, is vested entirely in the faculty of sight, as a fact that neither has nor needs any explanation. Such a construction of the sea as a manifestation of the sublime, Cohen writes, necessitates the elision of the people living and working on it, the sailors and mariners, in "a shift from the depiction of the ocean known in the intimacy of human practice to the ocean as 'space itself,'" a term she borrows from the travel writer and novelist Jonathan Raban.[27] For Cohen, the visual counterpart to Kant's observations about the sublimity of the ocean is the work of J. M. W. Turner, particularly paintings such as *The Shipwreck* (1805) and

Snow Storm—Steam-Boat off a Harbour's Mouth (1842), in which the pigment on the canvas becomes a ferment like the sea itself, and the artist "details the waves with a textured, highly visible brushstroke. . . . With such a transformation, these waves start to call attention not only to the materiality of painterly technique, but also to the power of Turner's vision and execution."[28] If we go further into the nineteenth century, to late Victorian visions such as John Brett's *Britannia's Realm* (1880), we find the sublimity of the ocean as "space itself" tied to a concept of British national and imperial identity: like the sea, simply a visible fact, needing no qualification or explanation (fig. 43).

For James Stanier Clarke, addressing his motley crew of discontented, politicized, lower-deck tars in the 1790s, the sublimity of the sea was a spur to religious devotion and obedience: by virtue of his profession, the sailor was provided the ideal opportunity for piety, through contemplation of oceanic space: "when you are dwelling on that ocean, which forms the most stupendous object in creation."[29]

Although the demand of the Kantian sublime to view the ocean "as poets do" hardly correlates with the pragmatic world of physical labor and sheer survival inhabited by the lower-deck sailor, Clarke pursues the apparently inescapable logic of the argument: "Who can observe this abyss of waters, rolling in the greatness of its strength, without experiencing the sublimest sentiments of devotion?"[30] It is in this context of the sublimity of the sea as "space itself"—that is, elsewhere, not here—that Clarke

FIG. 43. John Brett, *Britannia's Realm*, 1880, oil on canvas, 41½ x 83½ in. (105.4 x 212.1 cm). Tate

goes on to propose to the sailors in his pastoral care the heroic example of St. Paul as the paradigm of unquestioning obedience and trust in God. And it was a similarly troublesome community of naval veterans in Greenwich Hospital, commonly associated with what today might be called antisocial behavior, that West's altarpiece was designed to address. In view of the irreconcilable contradictions surrounding the "place" of the sea in eighteenth-century culture, the choice of St. Paul shaking off the viper following his salvation from shipwreck as the subject for the painting is a remarkably deft way of acknowledging the dissonant cultural values of the sea and its problematic connotations. But at the same time it avoids any direct engagement with the sea's "otherness" by referring St. Paul elsewhere, first to the Maltese coast where the scene is set, and second to St. Paul's Cathedral and Thornhill's pictorial precedent, in which the apostle is reclaimed as a saint for a "polite and commercial" nation.[31] Through such agile visual maneuvering, West both places and displaces the sea as a subject for history painting but, in so doing, "sublimates" the labor of the sea personified by the pensioners in a manner parallel to the sublimation of the sea in the eighteenth-century novel.

Until recently, maritime visual imagery was consigned by art historians to a specialist, marginal, and barely noticed category of "marine painting," held to have little, if any, impact on the key figures and issues in eighteenth-century art in general, the study of which has been dominated by the terrestrial genres of portraiture and landscape. Recent critical recognition of art history's interconnectedness with imperial and colonial history has broadened the range of visual cultural inquiry and provided scope for imagery related to the sea to signify in more nuanced ways. To a considerable extent the field has been influenced by the growth in Atlantic studies, black history, the history of slavery, and subaltern studies, exemplified by the work of Stuart Hall, Paul Gilroy, and many others, and their combined impact on the wider fields of anthropology, historical geography, colonial and postcolonial history and literary studies, and economic and social history.[32] Even so, the study of art and empire still tends to be land- rather than maritime-based.[33] And works such as West's Greenwich altarpiece, despite its importance both to the nation and to the artist's career, receive little attention within general histories of eighteenth-century British art.[34] No doubt this has something to do with the work's physical location in Greenwich rather than a central London museum or gallery, and the impact of "place" in that sense too — collection and exhibition — upon the shaping of art history. It is certainly the case that the "place" of the sea is just as problematic for modern art history as it was within eighteenth-century British culture. The sea is referred elsewhere, ultimately, through the discourse of the sublime, to "space itself," everywhere and nowhere.

1. Samuel Ireland, *Picturesque Views on the River Thames*, 2 vols. (London: T. Egerton, 1801–02), 2:241.

2. Helmut von Erffa and Allen Staley, *The Paintings of Benjamin West* (New Haven: Yale Univ. Press, 1986), 384–86, cat. 397.

3. John Cooke, *A Sermon, Preached at the Opening of the Chapel of the Royal Hospital for Seamen at Greenwich, before the Directors, Officers, and Pensioners of the Said Hospital, on Sunday the 20th Day of September, 1789* (Greenwich, 1789), 17–18. The allusion is to 2 Corinthians 2:16, "ye are the temple of the living God."

4. Richard Johns, "'An Air of Grandeur and Modesty': James Thornhill's Painting in the Dome of St. Paul's Cathedral," *Eighteenth-Century Studies* 42, no. 4 (Summer 2009), 501–27 (quotes 501, 522). There are other parallels between West's and Thornhill's pictorial schemes, notably the use of grisaille (which West used elsewhere in the chapel decoration) and the shared reference to Raphael's cartoons in the Royal Collection.

5. Another example is Jan Vorsterman, *Greenwich and London from One Tree Hill* (ca. 1680), oil on canvas: National Maritime Museum, Greenwich, London, Greenwich Hospital Collection, BHC1808. See Richard Johns, "A Maritime View of Charles II's England," National Maritime Museum: http://collections.rmg.co.uk/usercollections/7d7ded6fb50d6031e2884961a205c98d.html (accessed May 26, 2015).

6. John Bonehill and Stephen Daniels, "Projecting London: Turner and Greenwich," *Oxford Art Journal* 35, no. 2 (2012): 171–94 (quote, 173).

7. "Heart of oak are our ships, jolly tars are our men" was the song's refrain. On the centrality of English oak in shipbuilding, see cats. 68–73.

8. For a discussion of the painting in detail, see Geoff Quilley, "Art History and Double Consciousness: Visual Culture and Eighteenth-Century Maritime Britain," *Eighteenth-Century Studies* 48, no. 1 (2014): 21–35.

9. The current Tate website entry sees it as a "fantasy of the ultimate imperial city": http://www.tate.org.uk/art/artworks/marlow-capriccio-st-pauls-and-a-venetian-canal-no6213 (accessed May 26, 2015). In contrast, Michael Liversidge associated the picture with the fall of Venice to France in 1797, seeing it as a melancholy meditation on imperial decline with particular relevance for maritime Britain: Michael Liversidge and Jane Farrington, eds., *Canaletto & England*, exh. cat. (London: Merrell Holberton, in association with Birmingham Museums & Art Gallery, 1993), 146–47.

10. Charles Peter Layard, *A Sermon, Preached in the Chapel of the Royal Hospital for Seamen, at Greenwich, on Sunday, October 18, 1789* (London: J. F. and C. Rivington, 1789), 17–18, 19–20.

11. James Dugan, *The Great Mutiny* (London: Deutsch, 1966), 89, 94.

12. James Stanier Clarke, *Naval Sermons, Preached on Board His Majesty's Ship the Impetueux, in the Western Squadron, during Its Services off Brest: To Which Is Added a Thanksgiving Sermon for Naval Victories: Preached at Park-Street Chapel, Grosvenor-Square, Dec. 19. M, DCC, XCVII* (London: T. Paybe, B. White, 1798), 140, 145–47. For a discussion of Clarke's sermons and the mutinies in greater detail, see Geoff Quilley, *Empire to Nation: Art, History, and the Visualization of Maritime Britain 1768–1829* (New Haven and London: Published for the Paul Mellon Centre for Studies in British Art by Yale Univ. Press, 2011), 184–87.

13. On the naval pillar and subsequent monuments to naval heroes, see Alison Yarrington, *The Commemoration of the Hero, 1800–1864: Monuments to the British Victors of the Napoleonic Wars* (London: Garland, 1988); and Alison Yarrington, "Popular and Imaginary Pantheons in Early Nineteenth-Century England," in *Pantheons: Transformations of a Monumental Idea*, ed. Richard Wrigley and Matthew Craske (Aldershot, UK: Ashgate, 2004), 107–22.

14. For details of Casali's design of *The Return of Neptune*, the print of which was copied as an oil painting by the teenage John Singleton Copley in Boston, see Albert Teneyck Gardner, "A Copley Primitive," *Metropolitan Museum of Art Bulletin*, New Series 20, no. 8 (1962): 257–63.

15. *London Chronicle*, April 23, 1789 (repeated in the *Whitehall Evening Post*, April 25). See Quilley, *Empire to Nation*, 97–99.

16. Eleanor Hughes, "Ships of the 'Line': Marine Paintings at the Royal Academy Exhibition of 1784, in *Art and the British Empire*, ed. Tim Barringer, Geoff Quilley, and Douglas Fordham

(Manchester: Manchester Univ. Press, 2007), 139–52.

17. Hughes, "Ships of the 'Line,'" 143.

18. For Zoffany, see Martin Postle, ed., *Johan Zoffany RA: Society Observed*, exh. cat. (New Haven: Yale Center for British Art; London: Royal Academy of Arts, in association with Yale Univ. Press, 2011), 251–52, cat. 71; for Dean Street, see Edward Croft-Murray, *Decorative Painting in England, 1537–1837*, 2 vols. (London: Country Life, 1970), 2:201.

19. [Sir J. G. Dalyell], *Shipwrecks and Disasters at Sea; or the Historical Narratives of the Most Noted Calamities and Providential Deliverances Which Have Resulted from Maritime Enterprise* (Edinburgh: A. Constable & Co., 1812), xi–xii.

20. Henry St. John, Viscount Lord Bolingbroke, "The Idea of a Patriot King," in *The Works of Lord Bolingbroke, in Four Volumes* (1844; facs. repr. London: F. Cass, 1967), 2:414.

21. Quoted in Paul Kennedy, *The Rise and Fall of British Naval Mastery* (London: Allen Lane, 1976), 4.

22. Hughes, "Ships of the 'Line,'" 151.

23. John Entick, *A New Naval History: Or, Compleat View of the British Marine* (London: Printed for R. Manby, 1757), i.

24. For a fuller discussion, see Geoff Quilley, "Art History and Double Consciousness." (The ship's name is misspelled on some plans as *Brookes*.)

25. Margaret Cohen, *The Novel and the Sea* (Princeton: Princeton Univ. Press, 2010), 8–9, 99–105. George Anson completed a circumnavigation of the globe between 1740 and 1744, undertaken during the War of the Austrian Succession (see cats. 49–50). The French admiral and explorer Louis-Antoine de Bougainville completed a circumnavigation in 1766–69, and besides Cook was the most influential figure in opening up the Pacific, and particularly Tahiti, to European interests. Jean-François de Galaup, comte de La Pérouse, was appointed by Louis XVI in 1785 to lead a French expedition through the Pacific, following up on Cook's and Bougainville's voyages; having amassed copious documentation, forwarded to Paris en route, the expedition vanished in the South Pacific in 1789.

26. Cohen, *The Novel and the Sea*, 116, citing Immanuel Kant, *Critique of Judgment*, trans. J. H. Bernard (New York: Hafner Publishing Co., 1951), 111.

27. Cohen, *The Novel and the Sea*, 117. "Space itself" is from Jonathan Raban, introduction, *The Oxford Book of the Sea*, ed. Jonathan Raban (Oxford: Oxford Univ. Press, 1993), 8.

28. Cohen, *The Novel and the Sea*, 128–29.

29. Clarke, *Naval Sermons*, 27.

30. Clarke, *Naval Sermons*, 30.

31. From the title of Paul Langford's history of eighteenth-century England, *A Polite and Commercial People: England 1727–1783* (Oxford: Clarendon Press, 1989).

32. For a useful overview of postcolonial studies, see David Lambert, Luciana Martins, and Miles Ogborn, "Currents, Visions and Voyages: Historical Geographies of the Sea," *Journal of Historical Geography* 32 (2006): 479–93.

33. See John E. Crowley, *Imperial Landscapes: Britain's Global Visual Culture, 1745–1820* (New Haven and London: Published for the Paul Mellon Centre for Studies in British Art by Yale Univ. Press, 2011), an excellent expansion of the innovations in British landscape studies of the 1980s and 1990s across an imperial framework.

34. For example, Von Erffa and Staley, *The Paintings of Benjamin West*, 385.

Nicholas Pocock: Accuracy and Agency

ELEANOR HUGHES

I N 1764 THE EMINENT PHYSICIAN Dr. William Hunter received from a surgeon colleague in Bristol a specimen of a pharyngeal pouch—a hernia of the pharynx, in this instance fatal—accompanied by four drawings and a written account of the case. The drawings, now in the collection of the Hunterian Museum, in Glasgow, are signed "N. Pocock" (fig. 44). Nicholas Pocock, then aged twenty-three, would go on to have interdependent careers as a merchant sea captain and a practicing artist, first in his native Bristol and later in London, where he would become the most prolific exhibitor of marine paintings at the Royal Academy and a founding member of the Society of Painters in Water Colours. Although their accuracy can be confirmed through comparison with the actual specimen, also in the Hunterian collections, Pocock's drawings lack the panache and facility of the red-chalk drawings by Jan van Rymsdyk that Hunter commissioned to accompany the published account of the case (fig. 45).[1] Nonetheless, as some of the earliest known works by Pocock, the previously unpublished drawings sent to Hunter in 1764 are remarkable for the evidence they bear of a draftsman's ability, already known locally, to delineate with accuracy, a defining characteristic of the production and reception of marine painting at the time, but one that compromised the reception of the genre and the reputation of its practitioners in subsequent historiography. These apparently unique examples of Pocock trying his hand at medical illustration, and the opportunity to compare them with the identical subject represented by a professional artist steeped in Continental tradition, reveal what was at stake for marine painting in ways that an early-career portrait or landscape by Pocock might not.

Pocock's career provides a case study of the tensions between truth, accuracy, and pictorial convention that characterized marine painting, challenging the assumption that, until Romantic artists refocused on the sea itself, the purpose of marine painting was essentially reportage.[2] Pocock's drawings for Hunter are among the last of his works to demonstrate an uncompromising reach for factual correctness. For the rest of his career, his work was characterized by a deliberate balancing of the pictorial and the factual that, while acknowledged in other genres (the idealized portrait, or

Nicholas Pocock, *The River Avon, with Passing Vessels* (detail, fig. 52)

the alteration of landscape in the creation of a picturesque view, for example), is relatively unexamined with regard to marine painting. And yet the unique characteristics of its practice, in particular the involvement and expertise of the naval officers who commissioned views of naval engagements, meant that this balance was unusually pressured. Naval commanders wished to see reflected in paintings the visual acuity on which their actions (and by extension the fortunes of the nation) depended: the ability to identify the nationality, firepower, and sailing ability of other ships, for example. Likewise, the outcome of an engagement depended on a multitude of factors, including change in wind direction, damage inflicted on or by the enemy, and human error, much of which had to be visually registered, processed, and acted upon. As we shall see, the necessary accuracy of these visual signifiers did not preclude altering the position of ships for the sake of composition, or indeed to heighten the narrative.

In surveys of marine painting, naval histories, and David Cordingly's foundational monographs, Pocock is consistently acknowledged to be among the more interesting (if not the most "talented") of the eighteenth-century marine painters. This view is based in part on the extant evidence of his working practice, in the form of letters and sketches, and in part on two received notions about the "authenticity" of his productions. The first notion is that he was unschooled in art but taught himself to draw by illustrating his logbooks while serving as a merchant sea captain; the second, that his renderings of the first major sea battle between Britain and France in the French Revolutionary Wars, the "Glorious First of June," in 1794, were eyewitness accounts, and that he was thus the first artist to be present at a major British naval engagement since Willem van de Velde made sketches during the Anglo-Dutch Wars.[3] Both of those notions are worth reexamining, not only to set straight the biographical record, but also to reveal the degree to which, by emphasizing Pocock's status as an eyewitness,

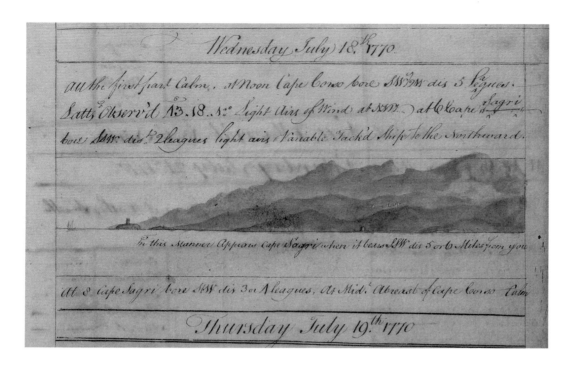

FIG. 46. Nicholas Pocock, *Logbook of the Betsey, Kept on a Voyage from Bristol to the Mediterranean* (detail), 1770. National Maritime Museum, Greenwich, London (cat. 99)

FIG. 47. Nicholas Pocock, *Logbook of the Lloyd, Kept on a Voyage from Bristol to South Carolina* (detail), 1767. National Maritime Museum, Greenwich, London (cat. 97)

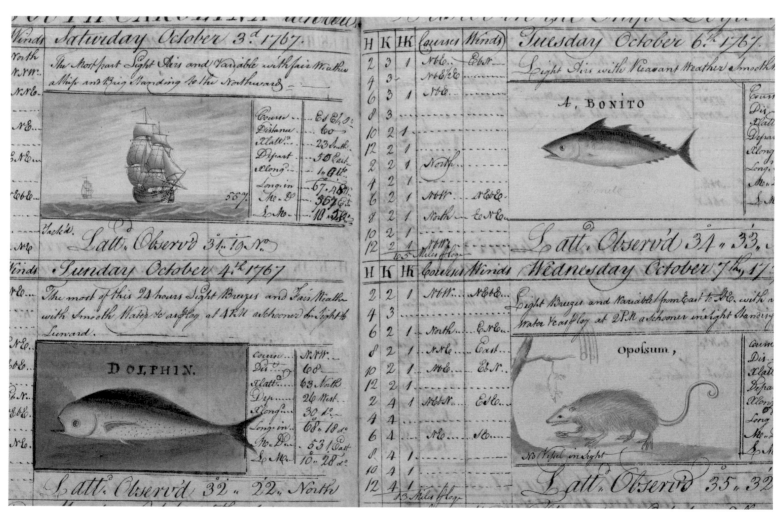

they have implicitly minimized his artistic agency. That tendency can be redressed through a reconsideration of the visual and textual evidence of his life and careers.

Born in Bristol in 1740, Nicholas Pocock was apprenticed at the age of seventeen to his father, a mariner. Two years after his drawings were sent to William Hunter, Pocock was serving as captain of the *Lloyd*, on which he made six trading voyages from Bristol to Charleston, South Carolina, for his employer, Richard Champion, between 1766 and 1769. Champion, a Quaker and member of a prominent Bristol family with extensive mercantile and maritime interests, had joined the Society of Merchant Venturers of Bristol by the age of twenty-four and, with the help of family connections in Charleston, established a business in trade with South Carolina.[4] The slave trade had brought Bristol its wealth and, although on the decline in that city, was still a vital part of its economy. If not directly engaged in that trade, Champion was one of those who, according to a contemporary inquiry on the involvement of Bristol Quakers, "in the course of business furnish[ed] goods to merchants in that trade."[5] His father, Joseph, had been one of the managers of the Company of Merchants Trading to Africa, and, as a prominent Whig, Richard was a close ally of Thomas Farr, a slave trader.[6]

Advertisements in the *South Carolina Gazette* reporting the goods "imported in the Ship Lloyd, Captain Pococke" reveal the cargo to have been typical for the period, comprising British manufactures and re-exports from the Mediterranean and Far East, while Pocock's log records the raw commodities brought back from North America, including rice, skins, and hemp.[7] The rising tensions between Britain and the colonies reflected in the correspondence between Champion and his Charleston relatives may have prompted Champion to diversify and to entrust new ventures to Pocock on the basis of his experience with the Carolina trade; in 1770 Pocock made one eventful voyage to the Mediterranean in the *Betsey*, and then, between 1771 and 1776, two voyages to the Caribbean in the *Lloyd* and four in the *Minerva*. Pocock's younger brothers William and Isaac, who had served under him on the *Lloyd*, took over as captains on the South Carolina route; during the American Revolution Champion wrote to his contacts in the colonies begging indulgence for them if they should be captured by American privateers.[8]

On his voyages Pocock kept detailed logbooks for his employer that provided an account of the ship's progress by recording its speed, heading, and wind direction, taken every two hours, and daily notes on the conditions of the weather and the ship.

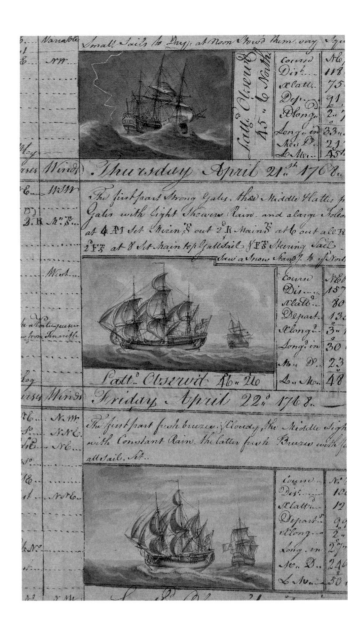

FIG. 48. Nicholas Pocock, *Logbook of the* Lloyd, *Kept on a Voyage from Bristol to South Carolina* (detail), 1768. National Maritime Museum, Greenwich, London (cat. 98)

FIG. 49. Elisha Kirkall after Willem van de Velde the Younger, Plate 4 from "Prints of Shipping," 1727, mezzotint, 13 x 15¾ in. (33 x 40 cm). British Museum, London

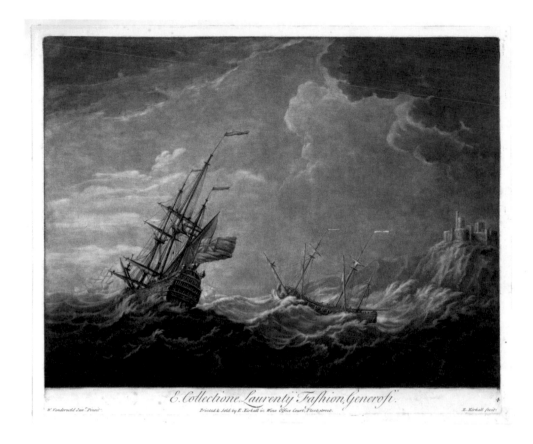

In each day's entry he left space for an illustration, in which he made drawings, often of the ship, but also coastal profiles (a vital assistance to navigation, and part of the training of naval officers) and native fauna (figs. 46–47). With varying degrees of dismissiveness Cordingly and others have characterized these drawings as "delightful" additions and acknowledged them as Pocock's training ground for delineating his observations. Cordingly notes that "although these are meticulously carried out, they are more valuable as evidence of the artist's regard for recording facts than as works of art."[9] The drawings of coastlines, flying fish, squid, and possum, framed in a grid of notations, are on a continuum with the medical illustrations sent to Hunter. Collectively, they constitute an example of what Sam Smiles has described as a phenomenon of the later eighteenth century, "a fertile zone where the demands of rational knowledge and the business of representation came together, all predicated on the notion that accurate notation of visual observation was the mark of truth."[10]

The drawings of the ship, however, inhabit a different point in the nexus between scientific and visual culture that the logbooks can be seen to occupy. Although as master of the ship Pocock was intimately familiar with every inch of the vessel, he could not have observed it from the distance implied in order to draw it as shown, particularly under some of the more extreme weather conditions; neither, of course, could he have done so for the drawings made on terra firma (fig. 48). These drawings are abstractions: the results, if made at sea, of an imaginative projection either outward from the vessel, looking back on it, or, if made on land, of the vessel at a previous

moment. While these have been dismissed as "largely imaginative," they nonetheless are very much informed by artistic tradition, most particularly seventeenth-century Dutch depictions of ships in storms, which Pocock may have known through prints such as those made by Elisha Kirkall after Willem van de Velde the Younger (fig. 49).[11]

The logbooks appear to have been made for Richard Champion, who may have played a larger part than previously acknowledged in Pocock's transition from sea captain to professional artist. Champion's sister wrote that Pocock "was much caressed by my brother, and valued by us all. In the intervals when he was not at sea, he spent much time at my brother's, and never seemed happier than when there."[12] Indeed, Pocock's letters to Champion, written during his voyages to the Caribbean in the 1770s, reveal an intensely felt friendship. Acknowledged to have been written at Champion's behest as "a copy of my thoughts and feelings, as they occur," these letters are clearly personal and kept separate from the business correspondence that would have accompanied them.[13] The earliest, written from Dominica, is typical in its characterization of his relationship with Champion: "You saw my thoughts and remov'd the Uneasiness I have felt that a difference of situation in life shou'd prevent Social Souls from Enjoying that Freedom & Friendship without which we cannot be said to live."[14] On one occasion Pocock observes how his current profession hinders the pursuit of art:

> I have not yet touched the Picture since I left. . . . It wants but little and I shall have it ready by the time I see you. I promised myself and other some drawing [but] cannot find time to execute unless I neglect more material concerns. I have not peeped into A Box [of colors] or sat down to draw with any degree of Composure since I arrived here [for] fear of accidents continually haunts and disturbs the little genius I might have had for drawing.[15]

The letters repeatedly acknowledge Pocock's unhappiness with the separation forced by his trade: "If ever I had a wish to reap any of fortune's favours, it was that I might be enabled to Change a manner of Life, that so often tortured me with absence from those I love," and "I cannot be Happy from Home. I have Michanically reconciled myself to the Necessity of doing my Duty as it is call'd in the World."[16] In a letter of March 1773 he describes to Champion a dream born of their separation, a dream so unsettling that he could not "shake of the impression" that "I seem'd like one who had no soul!" He cites Tobias Smollett, who "says it is a fault or Disorder in some and calls extreme sensibility a Morbid excess of sensation."[17] Even if they do not directly express artistic ambition, the letters to Champion show a sensibility clearly oppressed by the isolation of seafaring: "To express as well as I can the Genuine feelings of my heart to one who has a right to all I think is my greatest pleasure."[18]

While some of the reasons for Pocock's retirement from seafaring after 1776 to become a professional artist may be surmised from his letters to Champion, changes in Champion's own fortunes perhaps helped to force the shift. Champion is best known for his activities as a porcelain manufacturer and for his political influence and affiliations. A moderate Whig, he was instrumental in supporting the election of Edmund

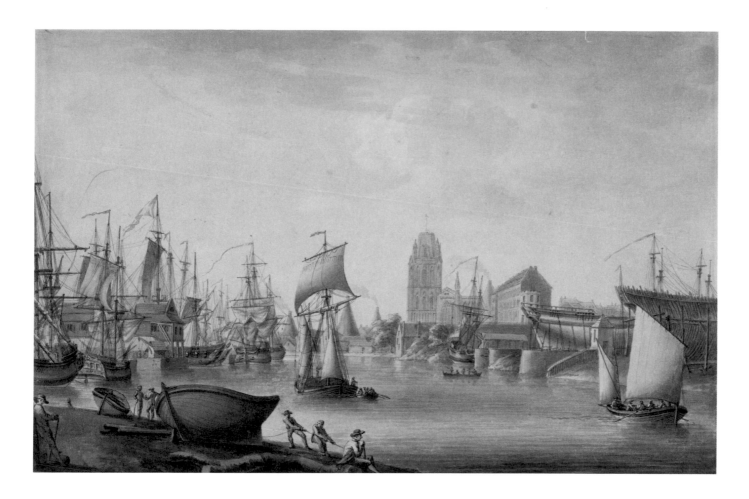

FIG. 50. Nicholas Pocock, *Bristol*, ca. 1780, gray wash and pen and ink on paper, 9¾ x 14⅞ in. (24.8 x 37.8 cm). Yale Center for British Art, Paul Mellon Collection

Burke as Member of Parliament for Bristol in 1774. During the decade-long friendship that ensued, Champion's contacts were Burke's chief source of information on events and feelings in the American colonies, conveyed partly via the brothers Pocock. Also in 1774, Champion was assigned the patent secured by the chemist William Cookworthy for the production of hard-paste porcelain and became manager of the factory producing what came to be known as Bristol porcelain. When he attempted to extend the patent the following year, Champion entered into a ruinous rivalry with Josiah Wedgwood and other Staffordshire potters. The decline in the American trade due to the revolution and the costs of his legal wrangling with Wedgwood meant that by 1776 Champion was in serious financial difficulties that surely spelled the end of Pocock's employment; it was the year of Pocock's final trading voyage to the Caribbean. Two years later, the porcelain factory was placed under financial administration, and Champion was expelled from the Society of Friends. In 1784, after the disastrous end of his friendship with Burke and a failed attempt to secure an appointment as consul-general in North America, Champion and his family emigrated to South Carolina.[19]

While there is little evidence of Pocock's activities in the years immediately following his final voyage, by the late 1770s he had established a practice in portraits of ships for Bristol shipowners and views of Bristol itself (fig. 50). These minutely detailed and graphic drawings are executed primarily in pen and ink and gray wash,

FIG. 51. Coplestone Warre Bampfylde, *The Humble Rock*, undated, watercolor and graphite on paper, 7¼ x 10½ in. (18.4 x 26.7 cm). Yale Center for British Art, Paul Mellon Collection

resembling engravings in both format and execution. During the same period, however, he also sought artistic instruction, as revealed in a previously unpublished letter from Mary Hartley, daughter of the philosopher David Hartley, to her longtime correspondent William Gilpin, the theorist of the picturesque:

> I have been extremely entertained with the drawings of an artist at Bristol, who is a very great genius, & whose representations of rocks & sea are amazingly beautiful. He has a very fine idea of light & shade, in many of his drawings; his evening skys are warm & glowing, his clouds light & flighing, the waves foaming, & almost transparent; it is astonishing to me how the surf of the sea can be so well expressed in meer drawings; his ships are quite in motion, & their forms so correct, that even seamen find nothing to criticize. Indeed he has been a sailor himself. His name is Pocock, & he has been Captain of a merchant vessel the chief part of his life. He seems to me not to be less than fifty, & I understand that it is but very five years that he has been a painter. I rather think not above 5 or 6; but of this I am not sure. a gentleman of my acquaintance that was at the hot-wells, brought him over to spend a day with me, & I was much pleased with him. his manner is extremely modest, & he does not seem to be at all conscious of his own genius. he seeks every where, with the greatest eagerness for improvement, from every artist & every picture that he sees; but he finds it most, I think, in the study of nature, which he is constantly copying. He says Mr. Bampfylde was [his] tutor, for he knew nothing at all of drawing till he got acquainted with him. I am told that his pictures are very good; but I have only seen his drawings. they are done in

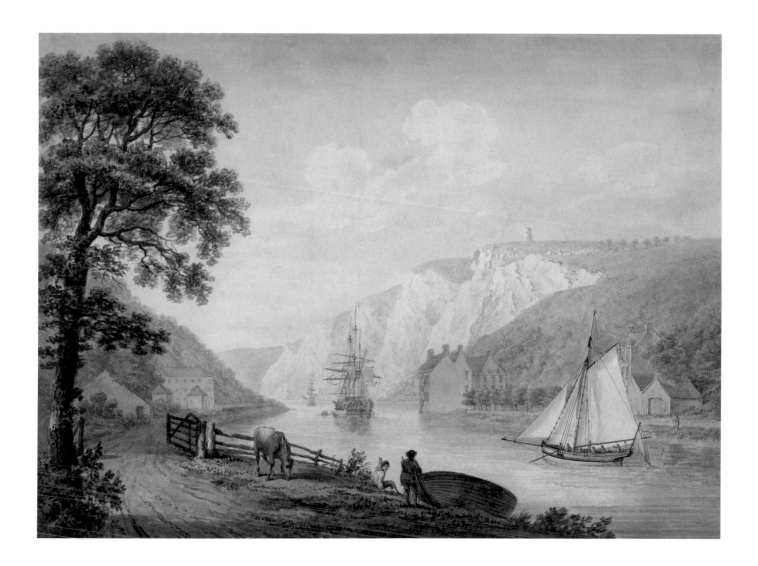

FIG. 52. Nicholas Pocock, *The River Avon, with Passing Vessels*, 1785, watercolor and pen and black ink over graphite, 16⅜ x 22⅛ in. (41.6 x 56.2 cm). Yale Center for British Art, Paul Mellon Collection (cat. 101)

a very masterly & spirited manner, & with the utmost rapidity. He was so obliging as to make a little sketch before me, to show me what his manner of proceeding was; & I was astonished to see how very rapid he was.[20]

The "Mr. Bampfylde" referred to can be identified as Coplestone Warre Bampfylde, a gentleman artist and garden designer.[21] In a later letter Hartley records, "Pocock says he rec'd his first instructions in landscape from Mr. Bampfylde; however, the scholar now excells the master; as may well be supposed, from his constant practice, in having made it his profession."[22] Bampfylde's technique in watercolor, with its loose brushwork, and in particular his knowledge of composition (fig. 51), can be readily seen as an influence on the numerous views of Bristol in watercolor and oils that Pocock began producing in the early 1780s (fig. 52), including a series that he published in aquatint between 1782 and 1789. Pocock may have been prompted to expand his training by the response he received from Sir Joshua Reynolds on submitting a painting for the Royal Academy exhibition in 1780:

Dear Sir, Your picture came too late for the exhibition. It is much beyond what I expected from a first essay in oil colours: all the parts separately are extremely well painted; but there wants a harmony in the whole together; there is no union between the clouds, the sea, and the sails. Though the sea appears sometimes as green as you have painted it, yet it is a choice very unfavourable to the art; it seems to me absolutely necessary in order to produce harmony, and that the picture should appear to be painted, as the phrase is, from one palette, that those three great objects of ship-painting should be very much of the same colour as was the practice of Vandevelde, and he seems to be driven to this conduct by necessity. Whatever colour predominates in a picture, that colour must be introduced in other parts; but no green colour, such as you have given to the sea, can make a part of a sky. I believe the truth is, that however the sea may appear green, when you are looking down on it, and it is very near—at such a distance as your ships are supposed to be, it assumes the colour of the sky.[23]

Reynolds, unsurprisingly, acknowledges observation ("though the sea sometimes appears green") but ultimately grants priority to pictorial unity, citing Van de Velde as the authority, and finally bending—in a rather patronizing manner, considering the experience of his correspondent—the "truth" of visual observation to his preferred artistic practice. Limited as it is to the role of color, which, unless serving to identify flags and signals, does not appear to enter into the concerns of naval patrons, Reynolds's advice was evidently amenable to Pocock, who from 1782 began exhibiting at the Royal Academy.

While Bampfylde's instruction clearly taught him much about landscape, Pocock also gained exposure to paintings and drawings by Van de Velde, the former evidenced by copies and sketches "in imitation," and the latter by the shift in his technique for sketching ships.[24] Moving away from the careful delineation of parts that characterized his Bristol practice, he adopted the Younger's fluid line and a kind of Morse code of dots and dashes that serve to represent the intersections of masts and spars more than the elements themselves (fig. 53). The style corresponds to what Mary Hartley described as his "very masterly & spirited manner" executed "with the utmost rapidity."

In 1789 Pocock and his family made the vital move from Bristol to London, settling on Great George Street, Westminster, only a few minutes' walk from Whitehall and the Admiralty. The relocation brought him what has been described as "an extensive acquaintance with admirals and commanders of the Navy," who would provide him with the commissions for the paintings of battles and individual actions that he exhibited at the Royal Academy between 1782 and 1815 and for a range of other projects.[25] In 1791, for example, he collaborated with Edward Dayes on a commission to work up into finished watercolors a series of sketches made on the scientific expedition to Iceland led by John Thomas Stanley, Lord Stanley of Alderley; he also prepared a set of the same views for Thomas Pennant, the natural historian, for his unpublished volume on the northern regions of the globe.[26] In 1804, aged sixty-three

and regarded as "an artist of position, deservedly in high esteem," Pocock became a founding member of the Society of Painters in Water Colours, where he would exhibit a total of 183 pictures over the next fifteen years.[27] These were divided between maritime subjects and landscapes, the latter particularly views in north and south Wales; like other artists of his generation, impeded by war from travel to the Continent in search of picturesque and sublime landscape subjects, Pocock made at least two tours in Wales.[28] At least two hundred of his subjects were engraved and published during his lifetime, including illustrations for two editions of William Falconer's poem *The Shipwreck* (1804 and 1811) and for James Stanier Clarke and John MacArthur's *The Life of Admiral Lord Nelson, K. B., from His Lordship's Manuscripts*, published in 1809.

Pocock's naval patrons often employed him in the manner described by Jean André Rouquet in *The Present State of the Arts in England*, "scrupulously direct[ing] the artist in every thing that relates to the situation of his vessel, as well in regard to those against whom he fought."[29] The accuracy of factual detail demanded by the naval "hero," in Rouquet's term, is borne out in Pocock's drawings and letters, which serve as the physical remnants of a complex interaction between patron and artist. One stage of the process is demonstrated in a letter to Pocock from Sir Richard Strachan, a celebrated frigate captain and a regular patron:

> Sir Richard Strachan's compliment to Mr Pocock and informs him he just remembers that the French Admiral's mizen topmast should be shot away at the time the picture is meant to represent. The French admiral is that ship engaged by Namur—the ship with main topsail aback, & main yard carried away. The French adml should have his ensign hanging as if fallen over the stem, and the flag and mizzen topmast hanging after. NB the Courageux stern should be like a frigate.[30]

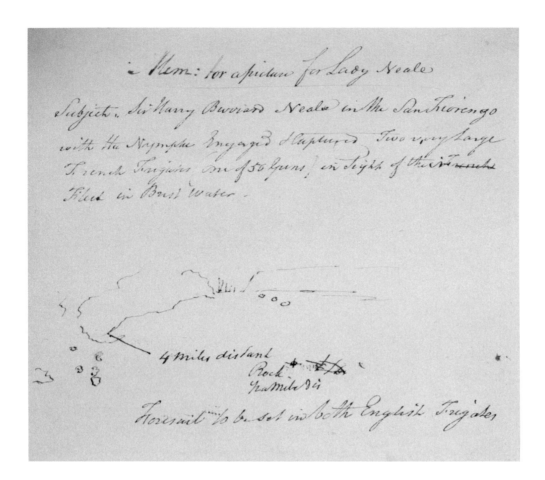

FIG. 54. Nicholas Pocock, Memorandum for *Capture of the Résistance and Constance, French Frigates, close in with Brest, March 9th, 1797, by His Majesty's Frigates* San Fiorenzo, *Captain Sir H. B. Neale, Bart. and the* Nymphe, *Captain Cook*, 1797, graphite on paper, mount 7½ × 7¼ in. (19.3 × 18.3 cm). National Maritime Museum, Greenwich, London (cat. 103)

Many of Pocock's commissions were for depictions not of large-scale naval battles but of more limited engagements waged by frigates, which were smaller and nimbler than the great ships of the line, and part of a fluid wartime strategy. They operated solo, in pairs, or in small squadrons, performing a range of duties including escorting convoys and conducting patrols. Their commanders, the frigate captains, had the potential for acquiring sensational riches as their legal share of the proceeds from the sale of their captures, known as prize money, and Pocock's regular patrons were among the most lauded frigate captains of the Napoleonic Wars. Between 1793 and 1798, for example, Sir Richard Strachan received prize money totaling £6,477, some of which must have funded the paintings he commissioned from Pocock celebrating the actions in which he took the prizes.[31]

In 1797 Pocock received a commission "for Lady Neale" to depict a daring action of March 9 that year in which Sir Harry Burrard Neale captured two French frigates in full view of the French fleet anchored at Brest, as recorded in an initial diagram that gives the relative positions of ships to shore (fig. 54). Grace Elizabeth Neale was an artist in her own right, and on their marriage in 1795 she and Sir Harry moved to Walhampton, where they were neighbors and intimates of William Gilpin; it is tempting to suppose that Mary Hartley's endorsements of Pocock may have prompted Gilpin to recommend him to the Neales.[32] Pocock evidently sent Neale an initial

sketch and requested further information, perhaps in the form of a letter describing the action; letters of this kind were regularly published in newspapers and journals. Neale responded:

> I have no letter concerning any particulars on the Engagement off Brest: The ships in Brest Harbour should be more distinct, & five sail should have their topsail hoisted ready to come out (which was the case)[.] Mr Pocock may place the ships as they are in the sketch, or as they were during the action, the two English engaging the Resistance, which perhaps would look better; either would be correct as when the Resistance struck, the Nymph directly engaged the Constance; and from Point St. Matthews to Brest signals were flying to give information to the Port Admiral at Brest[. T]hat little spot in the sketch near the ships is intended for the Parquet Rock from which they were half a mile.[33]

Neale's concern for both narrative clarity and a picture "which perhaps would look better" was shared by Pocock, who produced two compositions. One shows a cluster of three ships on the left, which are the British ships *San Fiorenzo* and *Nymphe* on either side of the French frigate *Résistance*; the other French frigate, the *Constance*, is seen a little distance to the right (fig. 55). As was his frequent practice, Pocock included a plan showing the point of view of the drawing, with lines ruled to the bow and stern of each ship so that the plan corresponds to the angle of view of each ship in the drawing. The other drawing has the ships engaged in pairs, the *San Fiorenzo* dueling with the *Résistance* and the *Nymphe* close to the *Constance*, and an inscription: "Mr. P thinks this better as to disposition of the ships being more extended" (fig. 56). Indeed, save for a slight change in the position of the *San Fiorenzo*, its composition is identical to that of the painting that Pocock exhibited at the Royal Academy in 1798 under the title "Capture of the Resistance and Constance, French frigates, close in with Brest, March 9th 1797, by His Majesty's frigates St Fiorenzo, Captain Sir H B Neale, Bart. and the Nymph, Captain Cook" (fig. 57).

As requested by Neale, the topsails of the French ships in the harbor are just visible—the ships' proximity emphasizing the daring nature of the action while staying within the bounds of fact—as are the signals flying on the hilltop. Sailors are balanced on the lifelines of the *San Fiorenzo*, taking in its topsails, slowing the ship's forward movement as the French ship *Résistance* surrenders. The damage to the *Résistance* is revealed in precise detail; its lines dangle over the side, its hull is splintered in places, there are large holes in its sails, and sailors are visible taking in the French colors. Pocock adds his own persuasive touches as well: the hull of the *San Fiorenzo* lit up by the ship's own cannon fire, the splashes of waves hitting the ships, and the subtle variations of color between the pink of the clouds and the blue-gray of the smoke.

The convincing "accuracy" of the painting, however, belies the fictiveness of its composition. Pocock has chosen to depict neither the configuration of ships during the action nor the pairs as they appeared at its close. As Neale's letter clearly indicates, both ships engaged the *Résistance* until it surrendered, at which point the *Nymphe*

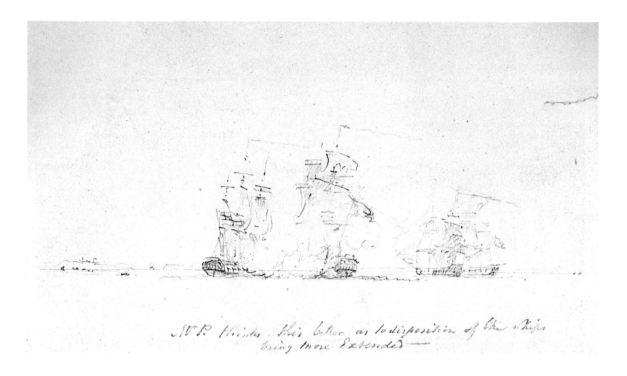

FIG. 55. Nicholas Pocock, Design for *Capture of the* Résistance *and* Constance, *French Frigates, Close in with Brest, March 9th, 1797, by His Majesty's Frigates* San Fiorenzo, *Captain Sir H. B. Neale, Bart. and the* Nymphe, *Captain Cook*, 1797, graphite on paper, mount 5⅞ x 9⅝ in. (15 x 24.6 cm). National Maritime Museum, Greenwich, London (cat. 104)

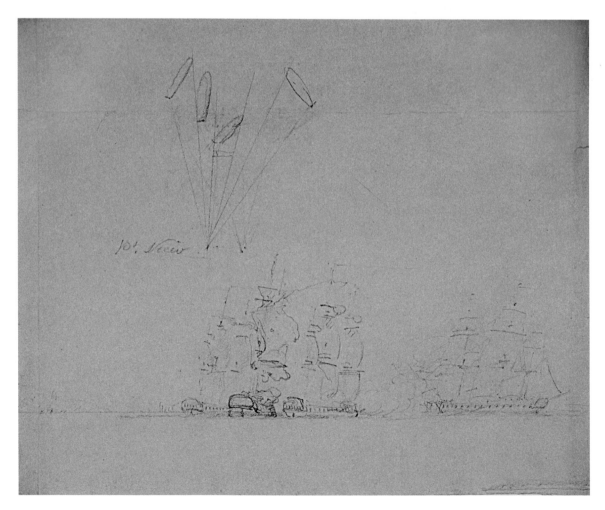

FIG. 56. Nicholas Pocock, Design for *Capture of the* Résistance *and* Constance, *French Frigates, Close in with Brest, March 9th, 1797, by His Majesty's Frigates* San Fiorenzo, *Captain Sir H. B. Neale, Bart. and the* Nymphe, *Captain Cook*, 1797, graphite on paper, mount 9⅝ x 12¼ in. (24.6 x 31 cm). National Maritime Museum, Greenwich, London (cat. 105)

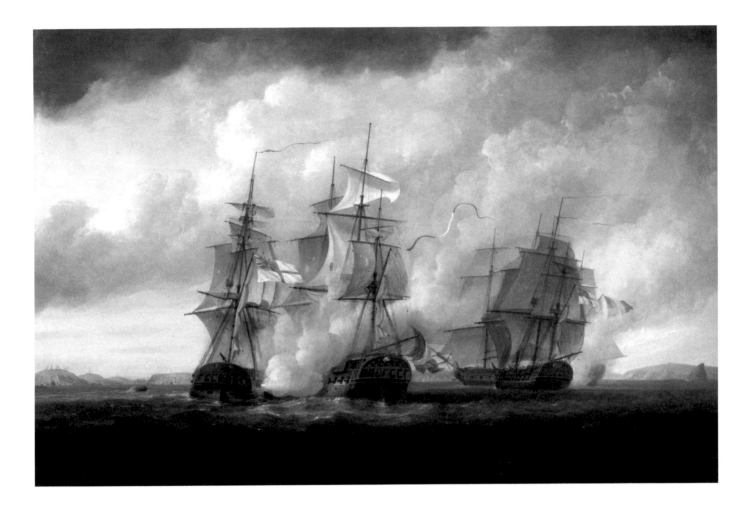

FIG. 57. Nicholas Pocock, *Capture of the* Résistance *and* Constance, *French Frigates, Close in with Brest, March 9th, 1797, by His Majesty's Frigates* San Fiorenzo, *Captain Sir H. B. Neale, Bart. and the* Nymphe, *Captain Cook*, 1798, oil on canvas, 30 x 44 in. (76.2 x 111.8 cm). National Maritime Museum, Greenwich, London, Macpherson Collection (cat. 106)

engaged the *Constance*. The final painting presents a composite moment, a compression in which the entire narrative is mapped onto the painting, from left to right: the *San Fiorenzo* fires on the *Résistance*, which surrenders; the *Nymphe* pulls away to engage the *Constance*. The painting, then, mediates between the demands of compositional propriety and the accuracy of detail that would enable an officer to recount the story of the event.

The very persuasiveness of such an image, however, has caused later viewers to underestimate the artistic agency brought to bear in its creation, particularly when the possibility arises that the artist may have been present at the event depicted. The conflation of accuracy with eyewitnessing, based on the notion that he was present at the Glorious First of June, in 1794, underlies the perception of Pocock's later career. The assumption of his presence took hold in the 1930s, when the National Maritime Museum acquired a notebook from a descendant of the artist.[34] Titled "Operations of the Grand Fleet under the Command of Lord Howe from 28th of May to the Total Defeat of the French Fleet on the 1st June 1794," it contains four schematic drawings of the positions of the English and French fleets at various times during the engagement, an annotated newspaper clipping identifying the ships of the lines of battle (fig. 58), and three separate eyewitness accounts. The authors of two of these are cited:

For the MORNING HERALD.
A Sketch of the Manœuvre on the Morning of the 1st of June, preparatory to the Engagement on that Day.

Scale of one Mile or 8 Cables

Wind

Stand to the Westward. Larbord Tack
Stand to Eastward. Starbord
that is. Caesar Leeds on Larbord
Thunderer. on the Starbord

British Line (left)

Caesar
Bellerophon
Leviathan
Russell
Marlborough
R. Sovereign
Retribution
Impregnable
Tremendous
Barfleur
Invincible
Culloden
Gibraltar
Q. Charlotte
Brunswick
Valiant
Orion
Queen
Ramillies
Alfred
Montague
R. George
Majestic
Glory
Thunderer

French Line (right)

L'America
Le Revolutionaire
Le Gasparin
L'Indomptable
Le Terrible
L'Impetueux
L'Eole
Le Trajan
Le Tourville
Le Pelletier
Le Tyrannicide
Le Juste
Le Jacobin
L'Achille
Le Montagne
Le Vengeur
Le Northumberland
L'Entreprenante
Le Neptune
Le Jemappe
Le Convention
Le Republicain
Le Scipion
Le Montagnard
Le Jane Patriot
Le Temeraire
Le Patriot

Published as the Act directs, June 16. 1794.

ILLUSTRATIVE REMARKS.

JUNE 1.

The enemy had fallen a good deal to leeward in the night, and could only be seen at day-light from the mast-heads of the English fleet, bearing North.

At 18 minutes past four, A. M. Lord Howe, observing that the ships a-head, and in the van had fore-reached upon the centre, made the signal to close to the centre; at half past four he made the signal to close to the van.

At ten minutes past five, altered the course together to N. W. and at 48 minutes past six altered the course together to North, per signal. At 54 minutes past six, the signal for the van squadron to close the centre. At 20 minutes past seven, the Admiral made the signal for the fleet to come to the wind together on the larbord tack, and form the line; the French fleet being then in a compact line of battle to leeward, drawn up in good order, and very close to each other, their centre bearing N. by W. distant between five and six miles, Wind S. by W. At 48 minutes past seven, the Admiral made the signal that he meant to pass through the enemy's line and engage them to leeward, and made the signal for the van to close to the centre. At 46 minutes past eight he made the signal for each ship to prepare to engage the ship in the enemy's line opposed to her. At 56 minutes past eight, to execute the preceding signal; immediately on

which, every ship in the line put up her helm, and steered large, increasing and shortening sail occasionally to preserve a perfect line a-breast, that every ship might commence the action as nearly together as possible. At 52 minutes past nine the Admiral made the signal to engage close; and 49 minutes past nine for the fleet to make more sail; at this time the enemy had began their fire nearly from van to rear, which the English fleet did not return for near 10 minutes, running still nearer to them, when the whole of the British ships opened a tremendous fire upon the enemy, and continued in close fight till half past 12; partial firing was kept up till two o'clock; but the great business was atchieved in little more than two hours, when the French Admiral, in Le Montagne, led his shattered fleet away to leeward, and favoured what disabled ships were in his reach, leaving the British fleet complext masters of the sea, though in a very unmanageable condition; the Admiral then made the signal to form the line a-head and a-stern. Lord Howe certainly went to leeward of the French line, and would have been close alongside the Montagne, had not his fore and main top masts gone over the side. The Brunswick, and Defence also passed through, with other ships that could not be so well noticed, for the prodigious smoke. His Lordship's reason for wishing to get the lee-gage of the enemy was a judicious manoeuvre, though it did not generally succeed, the enemy in most parts of their

line keeping so very close together; the sea was high on the morning of the action, and prevented the ships firing their lower deck guns to the greatest advantage.

The above is a very correct sketch of the two fleets in coming into action; more cannot be done. It must easily be conceived, that after the first 20 minutes, a very imperfect line was observed on either side, till soon became disorder, and irregular fighting.

Soon after the smoke cleared away, between two and three o'clock P. M. the following English ships appeared, in the following disabled state, viz.

QUEEN CHARLOTTE, without her top masts.
ROYAL SOVEREIGN, fore and main top gallant masts gone.
ROYAL GEORGE, fore mast and two top masts ditto.
QUEEN, main mast and mizen top mast ditto.
INVINCIBLE, much damaged in all her masts.
ORION, main top mast gone.
GLORY, fore top mast gone, and fore yard gone.
MARLBOROUGH, all her lower masts gone by the board.
DEFENCE, ditto. ditto.
BARFLEUR, fore mast, fore yard sprung, and two top mast, wounded.

FRENCH SHIPS taken, and now in our possession.			
Le Sans Pareil	80	L'Achille	74
L'Impetueux	80	Le Northumberland	74
L'America	74	Le Juste	80
Taken and sunk after—Le Vengeur.			
Retaken again—Le Jacobin.			

FLAG OFFICERS OF BRITISH DIVISIONS.

Flag Ships;	Flags, and where hoisted.
	REAR-ADMIRAL PASLEY.
BELLEROPHON,	White at the Mizen.
	ADMIRAL GRAVES.
ROYAL SOVEREIGN,	Blue at the Main.
	REAR-ADMIRAL CALDWALL.
IMPREGNABLE,	White at the Fore.
	REAR-ADMIRAL BOWYER.
BARFLEUR,	Red at the Fore*.
	ADMIRAL EARL HOWE.
QUEEN CHARLOTTE,	Union at the Main.
	REAR-ADMIRAL GARDNER.
QUEEN,	Blue at the Fore.
	VICE-ADMIRAL Sir ALEXANDER HOOD.
ROYAL GEORGE,	Red at the Main.
proper Flag,	Red at the Mizen,
ditto ditto,	Blue at the Mizen, but altered by way of distinction.

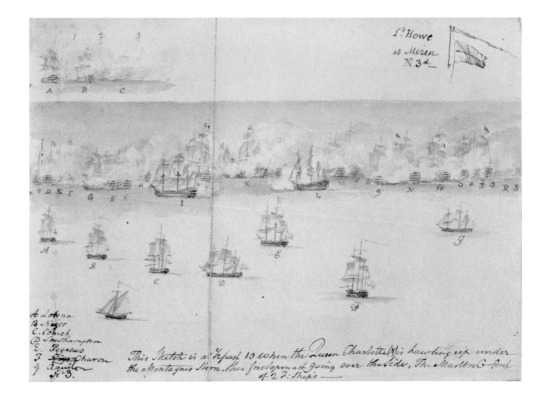

"A Report of the Proceedings of His Majesty's Ship Orion Jno Thos Duckworth Esq. Commander & his Observations during the Actions," and "Copy of a letter from Mr Bevan a Lieutenant of the Brunswick." The third account is titled simply "Notes taken on board His Majesty's Ship Pegasus from May 28. to June 1st 1794" and cites no author. The handwriting having been verified as Pocock's, along with the sketches and watercolors that he is supposed to have made at the scene, the notebook has come to be seen as proof of his eyewitnessing the battle as the unofficial guest of an officer on board the *Pegasus*, an assumption that has carried considerable weight in assessments of his career.[35]

The immediate evidence is compelling yet problematic, and depends on connoisseurial judgments of the persuasiveness of the various visual depictions. The four sketches in the notebooks showing the two fleets in aerial perspective at different times during the engagement (for example, fig. 59) are uncharacteristic of Pocock. When marking the positions of ships in his sketches, he tended to demarcate the ships diagrammatically, as seen in the sketches for the Neale commission, sometimes with lines drawn diagonally across the hulls to denote the set of the sails. Moreover, the ships in these sketches are far more awkwardly drawn than was Pocock's manner by this period, which was characterized by a facility and fluidity of line. The notebooks thus leave some doubt that Pocock was present at the First of June. Independent of the notebooks there exist a number of drawings by Pocock of the battle, sketched in graphite and subsequently washed in watercolor (fig. 60). For Cordingly, these sketches of the battle "have every appearance of having been done on the spot; they combine hastily applied brushwork with careful observation of significant detail."[36] They are

FIG. 60. Nicholas Pocock, *The Battle of the First of June: Brunswick and Le Vengeur*, 1794, watercolor with graphite, mount 5½ x 8 in. (14 x 20.1 cm). National Maritime Museum, Greenwich, London (cat. 117)

colored, which is unusual in Pocock's sketches (as opposed to his finished watercolor drawings). Without color, however, they would look much like Pocock's other sketches, containing an equivalent degree of "significant detail," depicting battles for which there have been no claims that he was present. Their color, in this case, may be part of what makes them appear more "authentic," and their persuasiveness may have more to do with Pocock's skill than with his presence at the battle.

There is a wider field of evidence for doubt about his eyewitnessing, however, that enters into the competitive strategies deployed by artists—and particularly by publishers of the reproductive prints made after their works—not only when their pictures went on display but nearly from the moment the events were publicly communicated. The Glorious First of June stimulated intense artistic rivalry, waged as much in print as in the exhibiting rooms and galleries of the metropolis.[37] The arrival at Portsmouth of the British fleet with the six French ships it had captured was immediately followed by announcements in the press of artists traveling there to secure the best information for their forthcoming productions. For example, the *Morning Chronicle* reported, concerning the marine painter Robert Cleveley:

On the arrival of Lord Howe's Fleet, Mr R. Cleveley immediately went to Portsmouth, for the express purpose of taking Portraits of the different ships of the British fleet, and of the six captured Line of Battle ships, and has collected from the best authority a plan of the two fleets, at the different points of time in which he is to represent them, and every other information requisite for the elucidation of so extensive a subject.[38]

Once the pictures were finished and exhibited, puff pieces in newspapers invoked the authority of information received from naval officers in the action to bolster the authenticity of the works. Similarly, the *Naval Chronicle*, a monthly publication of all things nautical—including biographical memoirs of naval heroes, disquisitions on shipbuilding, essays on marine zoology, recipes for preventing scurvy, marine poetry, and schemes for rescuing sailors from shipwrecks—rigorously cited the sources both of its pictures and of the information on which the pictures were based. Its editors signaled their aim for accuracy from the publication's inception; in a "notice" to the first volume, they announced that "our leading principle will be to adhere strictly unto truth; to render justice unto naval merit, present and departed, both when it has met with success, and also, which is of the greatest importance, when it has had to struggle with unfavorable events."[39] In the first year of its publication, the *Naval Chronicle* was embellished with illustrations of battles and views of foreign harbors, all by Pocock, including four on the subject of the battle of the Glorious First of June. Pocock's view of an action led by Lord Bridport off Port L'Orient, printed "to give the public a clear view of the situation of the British fleet," carries with it the note that "the English ships in this, as well as in succeeding designs, being taken from real sketches, may be considered as correct portraits."[40] Significant here is the difference between "sketch" and "design"; the latter seems to refer to composition, the former to eyewitness renderings. Similarly, a chart of the Bay of Aboukir, site of the Battle of the Nile in 1798, is taken by Pocock "from a drawing by a French officer in Admiral de Bruey's fleet," and an officer of Nelson's has "placed ships in His Majesty's squadron to the best of his judgment."[41]

The captions and explanations of the plates illustrating the Glorious First of June make no mention of what would have been the ultimate eyewitness authority, an artist who was actually present at the battle. The first plate shows the *Queen Charlotte*, Howe's flagship, having broken the French line of battle. The caption explains that the view "is supposed to be taken from the eastward, in order to show the extent of the enemy's line, which is on the larboard tack."[42] The wording—"is *supposed* to be taken"—suggests that this is an invented view, albeit one based on fact. This plate evidently caused confusion among some readers, as noted in a later issue:

> The plate in our first number, which described Lord Howe's manner of passing the French line on the 29th of May, has not in general been clearly understood, by persons unaquainted with the sea, though much commended by our naval friends. It gives a correct and faithful representation, and we believe the only one extant, of that gallant manoeuvre, not drawn from the imagination, but faithfully and correctly copied from the sketches and minutes of officers in the action. The Queen Charlotte, and Bellerophon, are exact portraits.[43]

This caption bears out the notion that Pocock was among those artists who traveled to Portsmouth and compiled his information on the battle secondhand, "from the sketches and minutes of the officers in the action." The "exact portraits" conform to the sketches that he made of the British ships and damaged French prizes, as does the

FIG. 61. Robert Pollard after Nicholas Pocock, *View of the Prizes Taken on the 1st of June by E. Howe at Anchor at Spithead*, engraving and aquatint on paper, in *Naval Chronicle*, 1799, vol. 1, p. 155. Yale Center for British Art, Paul Mellon Collection (cat. 119)

third of his First of June pictures in the *Naval Chronicle*, a view of the "Prizes taken by Lord Howe, from the French, on the 1st of June 1794, at anchor at Spithead, under jury masts, in the exact state they arrived, from the *original sketch* by Mr. Pocock. . . . Ships are all correct portraits" (fig. 61).[44] In other words, while the *Naval Chronicle* captions accompanying Pocock's illustrations of the First of June insist upon his having been at Portsmouth to make accurate depictions of the ships as they appeared on their return, none mention his having been present at the battle, indeed insisting instead on his having received information from officers who were in the action. An unsigned memorandum in the archives of the National Maritime Museum, dated 1846, provides additional confirmation of the circumstances surrounding the production of Pocock's most striking painting of the battle, exhibited at the Royal Academy in 1796 as "His Majesty's ship the Brunswick engaging the Vengeur on the 4th [*sic*] of June" (fig. 62). The "Mr. Pocock" cited here as the source of information must be Nicholas Pocock's son John Innes Pocock, who would have been nine years old at the time of the battle:[45]

The large painting of the Brunswick, Vengeur and Achille, in the 1st of June Action[,] Mr Pocock's information[:] The late Mr N. Pocock who painted this Picture got his information on the subject from Lord Howe, who, with Lord Nelson, Lord Gardner and others used to make slight sketches, of their different Actions, & bring them to Mr Pocock and stand over him, while he sketched them, frm their discription. And then from those sketches made the Pictures — Mr Pocock of Lincoln's Row says that his father went to Portsmouth to see the ships and their prizes soon after Lord Howe's Victory while the Royal Family where there. . . . The portrait of the Brunswick and Achille are from life, and that of the Vengeur which foundered is from discription collected from Eye witnesses of the battle then at Portsmouth, and that the representation of the Combat is as nearly truth as possible and Mr Pocock adds that this Picture is one of the best if not the best his Father ever painted.[46]

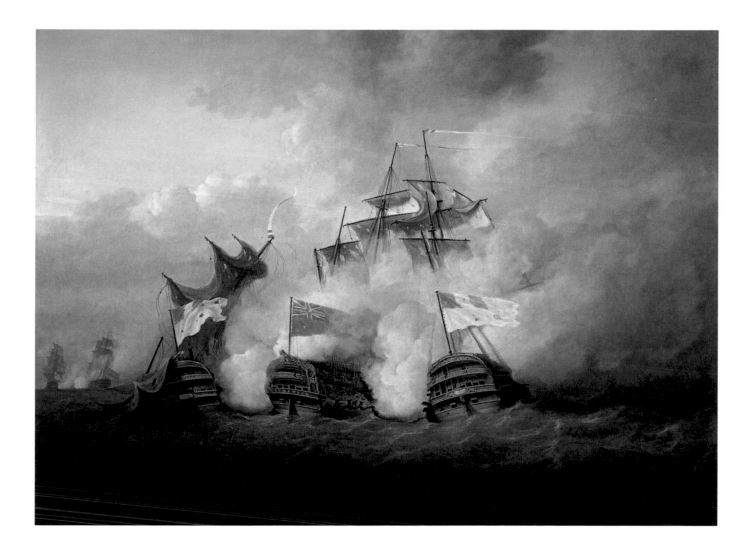

FIG. 62. Nicholas Pocock, *His Majesty's Ship the* Brunswick *Engaging the* Vengeur *on the First of June*, 1795, oil on canvas, 54⅛ x 74¾ in. (137.5 x 190 cm). National Maritime Museum, Greenwich, London, Caird Collection (cat. 115)

Nicholas Pocock's name is not listed in the ship's muster of the *Pegasus*.[47] Neither is his presence at the battle mentioned in any contemporary source — including his own obituary and those of his son Isaac, a renowned playwright and painter in his own right — nor in the accounts of Pocock's career in Samuel Redgrave's *Dictionary of Artists of the English School* (1878), and John Lewis Roget's *History of the "Old Water-Color" Society* (1891).[48] Indeed, no mention is made prior to the acquisition of the notebook by the nascent Maritime Museum in the early 1930s. If Pocock had been present at the First of June, it seems likely that he and his publishers would have taken the chance to capitalize on his eyewitnessing, or indeed to produce more images; apart from the engravings for the *Naval Chronicle*, Pocock produced only a handful of pictures of the battle.[49]

What is at stake in the question of Pocock's presence is illustrated by David Cordingly's response to another of his paintings, *The* Defence *at the Battle of the First of June* (fig. 63). Calling it "one of the most authentic depictions of a sea battle ever painted," Cordingly credits this as being the only picture Pocock made of the battle that has "sparkle and atmosphere." He continues:

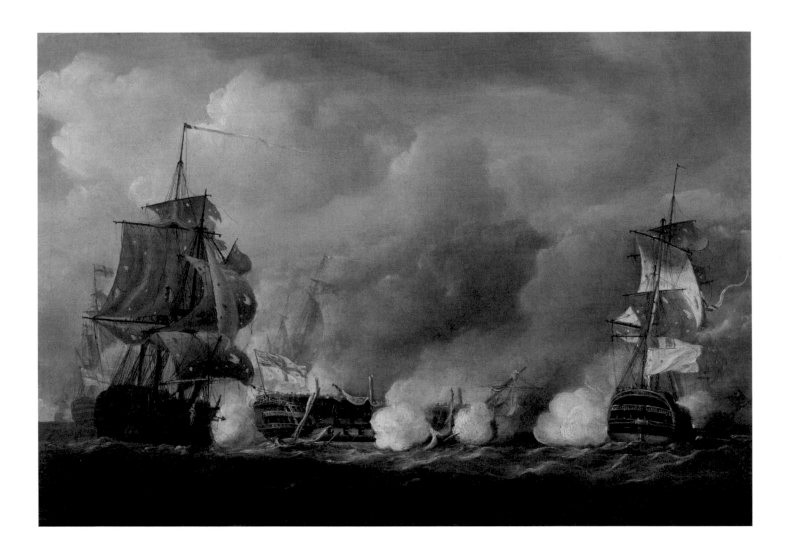

It is totally lacking the bravura and the drama of [Philippe-Jacques de] Loutherbourg's famous painting, *The Glorious First of June*, but it has a dead-pan realism and a mastery of brilliantly observed detail which brings that distant battle to life. We enjoy Loutherbourg's great canvas as a magnificent piece of theatre, but we turn to Pocock to find out what it was really like to be present among the ships on that June day nearly two hundred years ago.[50]

Implicit in Cordingly's comment is the assumption that the authenticity of Pocock's depiction derives from his actually having been an eyewitness at the battle, thus excluding the possibility of imaginative projection and artistic judgment that we have seen Pocock deploy, starting in his logbooks and continuing in his marine paintings. Equally telling is the assumption that the purpose of marine painting was for the viewer "to find out what it was really like to be present among the ships." Paintings made by marine painters for naval patrons served specific purposes, commemorative but also narrative; once they were shown at public exhibitions, the divergence in criteria between accuracy and effect became evident, even if a single artist could satisfy

FIG. 63. Nicholas Pocock, *The* Defence *at the Battle of the First of June*, 1811, oil on canvas, 14 x 20 in. (35.5 x 50.8 cm). National Maritime Museum, Greenwich, London, Greenwich Hospital Collection

FIG. 64. J. M. W. Turner,
Fishermen at Sea, 1796, oil on
canvas, 36 x 48⅛ in. (91.4 x
122.2 cm). Tate

both, as noted in one newspaper review: "The nautical parts of Mr. Serres pictures, are pronounced by professional men to be minutely faithful. The parts that are cognisoble by every spectator, and their effect, are evidently inferior to nothing of Scott, or Van de Velde."[51] At the same time, calls had been made for precisely the kind of pictures that would "plunge the spectator at once in the heat of the battle," and in the mid-1790s the proprietors of the newly opened panorama in Leicester Square, which offered 360-degree landscapes, were claiming that "observers may suppose themselves on the open sea."[52] The Royal Academy exhibition at which Pocock showed *His Majesty's Ship the* Brunswick *Engaging the* Vengeur *on the First of June* also saw J. M. W. Turner's debut in oils, *Fishermen at Sea*, two pictures not so very disparate in the mood and tone of their response to contemporary events (fig. 64).[53] However, Turner's subsequent experimental seascapes would offer a radical reinvention of marine painting, experiential and imaginative. While these were subject to criticism in his day, his achievement as it is now recognized has tended to color expectations of eighteenth-century marine paintings in retrospect, so that they are found wanting in comparison. Viewed on their own terms, as through the lens of Pocock's practice, these works become much more than reportage, the accurate delineation, as it were, of specimens: they are at once the evidence of a highly inventive artistic practice, a series of relations between painters and patrons, and the pictorial aspect of the complex ways in which the nation told its stories of triumph and disaster.

1. "A Case of obstructed Deglutition, from a pre-
 ternatural Dilatation of, and Bag formed in the
 Pharynx; in a Letter from Mr. Ludlow, Surgeon,
 at Bristol, to Dr. Hunter. Read Aug. 27, 1764,"
 Medical Observations and Inquiries 3 (1769):
 85–101.
2. On material versus sublime views of the sea,
 see Geoff Quilley's and Christine Riding's essays
 in this volume.
3. See E. H. H. Archibald, *Introduction to Marine
 Painting* (London: Arts Council of Great Britain,
 1965), n.p., and Archibald, *Dictionary of Sea
 Painters* (Woodbridge, UK: Antique Collec-
 tors' Club, 1980), 157–58. David Cordingly has
 written most prolifically on Pocock; see *Marine
 Painting in England, 1700–1900* (London:
 Studio Vista, 1974), 87–89; *Nicholas Pocock,
 1741–1821: A Selection of His Marine Works
 from the Collections of the National Maritime
 Museum*, exh. cat. (Greenwich, UK: National
 Maritime Museum, 1975), 1–6; *Painters of the
 Sea: A Survey of Dutch and English Marine
 Paintings from British Collections*, exh. cat.
 (London: Lund Humphries [for] the Royal
 Pavillion, Art Gallery and Museums, Brighton,
 1979), 57: *Nicholas Pocock, 1741–1821* (London:
 Conway Maritime Press, 1986), 9–11.
4. See Karin M. Walton, "Richard Champion
 (1743–91)," in *Oxford Dictionary of National
 Biography*, Oxford Univ. Press, 2004: http://
 dx.doi.org/10.1093/ref:odnb/5094 (accessed
 Sept. 17, 2015); Walter E. Minchinto n, "Nicho-
 las Pocock and the Carolina Trade," *South
 Carolina Magazine* 65, no. 2 (April 1964): 87–91;
 Cordingly, *Nicholas Pocock* (1986), 16.
5. Quoted in Madge Dresser, *Slavery Obscured:
 The Social History of the Slave Trade in Bristol*
 (Bristol: Redcliffe, 2007), 132. See also cats. 97–
 100 in this volume; Kenneth Morgan, *Bristol and
 the Atlantic Trade in the Eighteenth Century*
 (Cambridge: Cambridge Univ. Press, 1993).
6. Dresser, *Slavery Obscured*, 131–32.
7. Walter E. Minchinton, "Richard Champion,
 Nicholas Pocock, and the Carolina Trade:
 A Note," *South Carolina Magazine* 70, no. 2
 (April 1969): 99–100.
8. Cordingly, *Nicholas Pocock* (1986), 33–34.
9. Cordingly, *Nicholas Pocock* (1975), 4.
10. Sam Smiles, *Eye Witness: Artists and Visual
 Documentation in Britain, 1770–1830* (Burling-
 ton, VT: Ashgate, 2000), 41.
11. Cordingly, *Nicholas Pocock* (1975), 3. See also
 Richard Johns's essay in this volume.
12. Hugh Owen, *Two Centuries of Ceramic Art in
 Bristol, Being a History of the Manufacture of
 "The True Porcelain" by Richard Champion*
 (London: Bell and Daldy, 1873), 49.
13. Nicholas Pocock to Richard Champion, Jan. 6,
 1773. *The Letterbooks of Richard Champion,
 1760–1775, in the Bristol Record Office and the
 New York Public Library*, ed. Deborah M. Olsen
 and Walter E. Minchinton, British Records Relat-
 ing to America in Microform (East Ardsley, UK:
 Microform Academic Publishers, 1986), 333.
14. Pocock to Champion, Dominica, Feb. 25, 1771.
 Letterbooks, 171.
15. Pocock to Champion, Dominica, June 12, 1774.
 Letterbooks, n.p.
16. Pocock to Champion, Dominica, March 9, 1772,
 Letterbooks, 285, and April 1774, n.p.
17. Pocock to Champion, March 7, 1773. *Letter-
 books*, n.p.
18. Pocock to Champion, Dominica, March 5, 1775.
 Letterbooks, 296.
19. Walton, "Richard Champion"; Walter E.
 Minchinton, introduction, *Letterbooks*, 8.
20. Mary Hartley to William Gilpin, December 29,
 1788. Bodleian Library, Univ. of Oxford, MS.
 English Misc. D 572.
21. See Philip White, *A Gentleman of Fine Taste:
 The Watercolours of Coplestone Warre
 Bampfylde (1720–1791)* (London: Christie's,
 1995); Philip White, "Coplestone Warre
 Bampfylde (1720–1791)," in *Oxford Diction-
 ary of National Biography*, Oxford Univ. Press,
 2004: http://dx.doi.org/10.1093/ref:odnb/1261
 (accessed April 7, 2006).
22. Hartley to Gilpin, Feb. 14, 1789. Bodleian
 Library, University of Oxford, MS. English Misc. D
 572, cited in Alan Russett, *Dominic Serres R. A.
 1719–1793: War Artist to the Navy* (Woodbridge,
 UK: Antique Collectors' Club, 2001), 188.
23. James Northcote, *Life of Sir Joshua Reynolds*,
 2 vols. (London: Cornmarket Press, 1971),
 2:89–91.
24. Cordingly, *Nicholas Pocock* (1986), 43.
25. John Lewis Roget, *A History of the "Old
 Water-Colour" Society, Now the Royal Society*

of Painters in Water Colours, 2 vols. (London: Longmans, Green and Co., 1891), 1:144.

26. Cordingly, *Nicholas Pocock* (1986), 47–52.

27. Roget, *History*, 1:143.

28. See Cordingly, *Nicholas Pocock* (1986), 57–59.

29. Jean André Rouquet, *The Present State of the Arts in England*, trans. from French (1755; facs. repr. London: Cornmarket Press, 1970), 60–61.

30. Strachan to Pocock, between 1805 and 1812. National Maritime Museum (NMM), AGC/24/4 (cf. PAD 8807). This action took place in 1805: the *Formidable* was the French Admiral Dumanoir's flagship.

31. See Tom Wareham, *Star Captains: Frigate Command in the Napoleonic Wars* (Annapolis, MD: Naval Institute Press, 2001), 45.

32. Carl Paul Barber, *William Gilpin: His Drawings, Teaching, and Theory of the Picturesque* (Oxford: Clarendon Press, 1963), 168.

33. Harry Burrard Neale to Pocock, 1797. NMM, Box 0279. The sketch to which Neale refers does not seem to be any of the ones at the NMM.

34. NMM, Caird Library, MS. JOD/a.

35. Lord Howe was Richard Howe, first Earl Howe.

36. Cordingly, *Nicholas Pocock* (1986), 70.

37. See Eleanor Hughes, "Sanguinary Engagements: Exhibiting the Naval Battles of the French Revolutionary and Napoleonic Wars," in *Exhibiting the Empire: Cultures of Display and the British Empire*, ed. John McAleer and John McKenzie, Studies in Imperialism (Manchester: Manchester Univ. Press, 2015).

38. *Morning Chronicle*, July 14, 1794.

39. Preface, *Naval Chronicle* 1 (London: Bunney and Gold, 1799), n.p.

40. *Naval Chronicle* 1 (1799): 300, pl. 7. Bridport was Alexander Hood, first Viscount Bridport.

41. *Naval Chronicle* 1 (1799): 521.

42. *Naval Chronicle* 1 (1799): 24, pl. 1.

43. *Naval Chronicle* 1 (1799): 154.

44. *Naval Chronicle* 1 (1799): 154, pl. 4. One of Pocock's pictures of the battle, showing Earl Howe on the *Queen Charlotte*, breaking the line, is captioned, "from an original design by Mr Pocock." *Naval Chronicle* 1 (1799): 220, pl. 5.

45. Of Pocock's nine children, his other six sons were deceased by 1845. The date of John Innes's death is unknown (see family tree in Cordingly, *Nicholas Pocock* [1986], 8).

46. NMM, AGCI24/4.

47. The National Archives (TNA), ADM 36/11535.

48. Pocock's son Isaac began his career as an artist, apprenticed first to George Romney and then to Sir William Beechey, and won a prize for best original history painting at the British Institution for Promoting the Fine Arts in the United Kingdom, a private society, in 1807; see fig. 7, p. 10. He gained fame, however, as a playwright. *Gentleman's Magazine* 158 (Dec. 1835): 657–58.

49. Two further paintings were exhibited at the Royal Academy: *The Subdivision of the Van Squadron of the British Fleet on the 1st of June 1794*, in 1797, and another showing an earlier stage of the engagement, *Appearance of H M Ship Bellerophon, Rear Admiral Paisley, Captain W Hope, As Seen Passing through the French Line, May 29th 1794*, in 1798.

50. Cordingly, *Nicholas Pocock* (1986), 75.

51. *Morning Chronicle and London Advertiser*, May 11, 1784.

52. *Whitehall Evening-Post*, May 22–24, 1787, 4.

53. See Eleanor Hughes, "The Battle of the Pictures," in *Turner and the Sea*, ed. Christine Riding and Richard Johns (London: Thames and Hudson, 2013), 52–54.

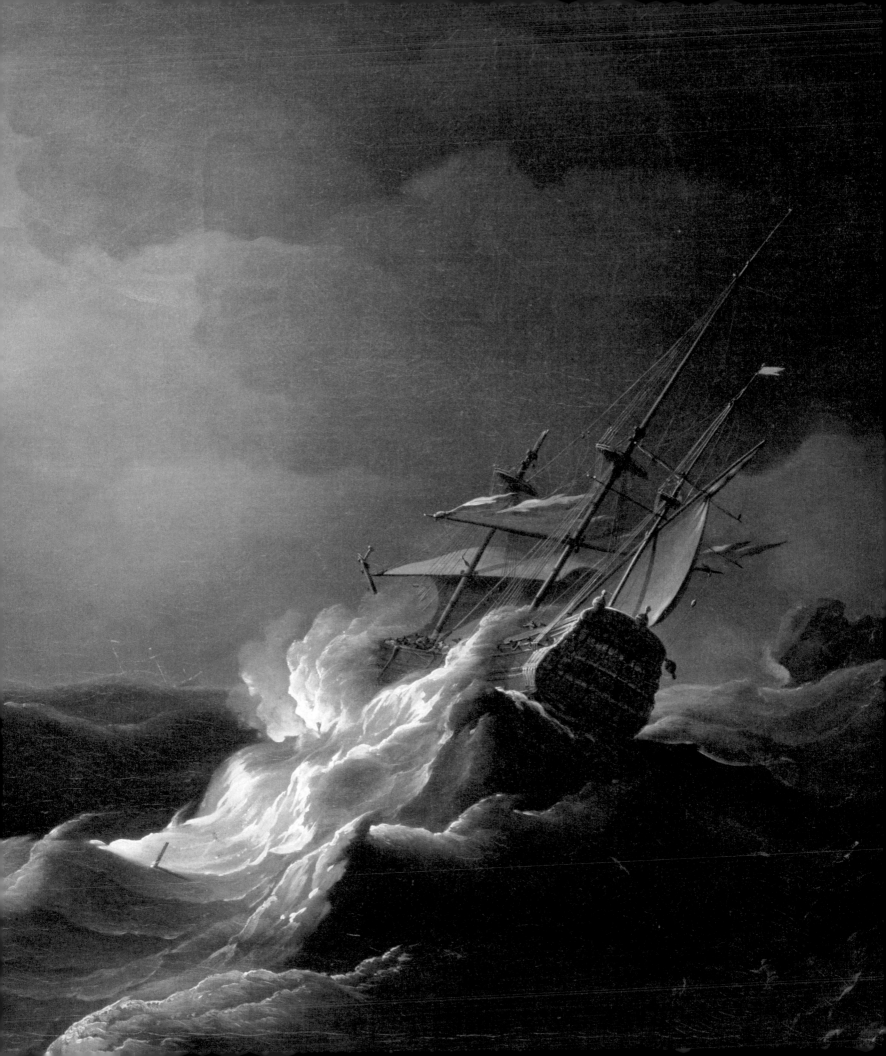

Shipwreck and Storm in British Art

CHRISTINE RIDING

J AMES GILLRAY'S CARICATURE entitled *End of the Irish Invasion:-or-the Destruction of the French Armada*, published on January 20, 1797, depicts the failed attempt by a French squadron to invade Britain during the French Revolutionary Wars (1792–1802). Playing upon long-established conventions of shipwreck imagery, Gillray shows three French warships overwhelmed by towering waves that churn and break in a violent storm. In fact, the whole composition has erupted, paralleling the confusion and distress of the human figures depicted (fig. 65).

At once a celebration of French naval failure and a critique of domestic politics, the print lampoons Whig politicians, who had repeatedly dismissed any idea of an invasion. In the shipwreck trope of terrified sailors and passengers, figures in the foreground are identifiable Whigs, and their leader, Charles James Fox, is represented at the center of the image as the dismayed figurehead of the warship *Le Révolutionnaire*.[1] The Tory prime minister, William Pitt, and other members of the British government can be seen hovering above as the four winds, blasting the enemy.

Gillray's image derived its impact at the time through an implied reference to the Armada of Catholic Spain, which was destroyed in 1588 by storms and English fire-ships when it attempted to invade England and depose the Protestant Queen Elizabeth I. Such historical references remind us that storm and shipwreck not only marked turning points in the fortune of nation states but were also the daily reality of many Britons as citizens of an island nation and maritime power. There was widespread fascination with the risks and challenges of seafaring, as is demonstrated by the popularity of voyage narratives, of which some two thousand were published in Britain during the eighteenth century.[2] Anders Sparrman, the Swedish naturalist on Captain James Cook's second Pacific voyage (1762–65), noted in his *Voyage to the Cape of Good Hope* (1785) that accounts of sea travel had always been avidly read, "but perhaps, in no age so well as in the present" and "more especially in this island, not only by the learned and polite, but also by the rude and illiterate."[3] Shipwreck narratives became a distinct subgenre of voyage literature in the second half of the eighteenth century, and after 1800 multivolume anthologies made their appearance. Among them were Archibald

Peter Monamy, *Ships in Distress in a Storm* (detail, fig. 67)

J.^G.^ inv.^ & f. End of the Irish Invasion;__ or __ The Destruction of the French Armada. Pub.^ Jan.^ 20.^ 1797. by H.Humphrey.
New Bond Street.

Duncan's *The Mariner's Chronicle, Being a Collection of the Most Interesting Narratives of Shipwrecks, Fires, Famines, and Other Calamities Incident to a Life of Maritime Enterprise* (six volumes, 1804-08), John Stanier Clarke's *Naufragia, or, Historical Memoirs of Shipwrecks and the Providential Deliverance of Vessels* (two volumes, 1805-06), and John Graham Dalyell's *Shipwrecks and Disasters at Sea* (three volumes, 1812).[4]

While British artists undoubtedly drew upon such literature for drama and details that would imbue their representations with greater authenticity, they were also engaging with and building upon a pictorial tradition. In art and visual culture, shipwreck imagery had emerged as an independent theme — that is, distinct from biblical and classical narratives — in late sixteenth-century Italy and the Netherlands, and by the 1750s had become a significant subgenre of British and Continental marine art.[5] As Lawrence Goedde has observed, the eighteenth century also saw a significant expansion in the variety of situations and subjects in storm scenes — depicted, increasingly, not by landscape and marine painters, but by artists better known for portraiture and history painting.[6] The primary catalyst for this expansion, certainly in British art, was the public exhibition, particularly from the 1760s, with the creation of the Society of

Artists and the Royal Academy of Arts. The exhibition's effect was intensified by an expanding print culture and, by the end of the century, developments in theater and in entertainments such as the panorama. In 1781 the first performance of Philippe-Jacques de Loutherbourg's *Eidophusikon*, an animated stage set that produced "Moving Pictures, representing Phenomena of Nature" and has been seen as a precursor to cinema, featured a "Storm at Sea and Shipwreck." And in 1820 a production at London's Royal Coburg Theatre included "an Immense Ship 40 feet long! Fully manned, Struck by a Thunderbolt & Sunk, completely from the View of the Audience."[7]

A defining feature of the vast majority of eighteenth-century shipwreck images, whether they dealt with real or imagined events, was their focus not on human error but on the ravages of nature. A later trend in Western art—particularly nineteenth-century British art and most notably the work of J. M. W. Turner—was to show the aftermath of maritime disaster, such as a drifting hulk or wreckage in now tranquil waters. But most eighteenth-century works represent a pictorial "still" at a high-point of the storm, emphasizing the impact of elemental violence on ships and on humans struggling to survive. Although depictions of known wrecks became highly popular, these works of art often do not relate to actual events, even if the vessel types and locations represented are recognizable. Such images cannot be understood, therefore, as reportage or, as is often assumed about Dutch and Flemish marine art, highly accomplished exercises in the "neutral recording of phenomena analogous to scientific observation."[8] Rather, such representations acted as pictorial prompts for philosophical contemplation, moral instruction, or ideas concerning national identity and character. In this sense, the themes of shipwreck and of seafaring more generally could never distance themselves entirely from biblical and classical subjects, whether translated into history, portrait, or marine formats. As Geoff Quilley notes in his essay in this volume, the eighteenth-century representations of the shipwreck of St. Paul, by Sir James Thornhill in the dome of St. Paul's Cathedral (1716–19) and by Benjamin West in the chapel of Greenwich Hospital (1787–89), are an indication of how shipwreck continued to be deployed in a religious context. Moreover, the choice of shipwreck for these specific locations, a cathedral and the chapel of a charitable institution, underlines distinctions made at the time between appropriate Protestant imagery and that perceived as Catholic, the former tending toward representations of exemplary behavior and the latter toward visceral scenes of martyrdom.[9]

The wider resonance of shipwreck within a native Protestant tradition is indicated by Daniel Defoe's *Robinson Crusoe* (1719), a novel that rivaled John Bunyan's *The Pilgrim's Progress* (1678) in popularity throughout the eighteenth century.[10] *Robinson Crusoe* can, like its predecessor, be understood as a Christian allegory, given Defoe's emphasis on the Christian notions of Providence, penitence, and redemption. While Crusoe's "Providential" delivery from a shipwreck and subsequent experiences as a castaway are the best-remembered part of the story, shipwreck as a narrative device is used throughout the novel to elicit plot shifts and to place further challenges and opportunities before the protagonist. For example, it is while investigating the aftermath of a shipwreck that Crusoe discovers cannibals on the island and saves one

of their intended victims, whom he names "Friday." *Robinson Crusoe* can accommodate a number of different interpretations, not least as a comment on Britain's then burgeoning imperial ambitions and the associated themes of cultural imperialism and relativism, in which shipwreck serves as a cautionary element or as an opportunity to promote British values; a case in point is Crusoe's adoption of Friday as his servant and his teaching him English and elementary Christian concepts. A related and time-honored analogy in eighteenth-century discourse is that between the captain steering a ship and the statesman guiding his nation, discussed by Plato in *The Republic* (Book 6); by extension, the wrecked ship is a powerful political and social metaphor, as seen in Gillray's caricature.[11]

Of interest in this context is not only why artists in Britain responded to specific shipwrecks, but also how they composed shipwreck images. As Richard Johns has claimed, the most celebrated exponent of marine painting in Britain, throughout the eighteenth century and beyond, was Willem van de Velde the Younger, who "introduced into British art a Netherlandish tradition . . . that would, in every sense, become naturalized."[12] Like battle scenes, ship portraits, and seascapes in general, shipwreck representations would also draw extensively and self-consciously on the authority of Van de Velde, who created such compelling and commercially desirable works as *A Mediterranean Brigantine Drifting onto a Rocky Coast in a Storm* (fig. 66). Typical examples of his influence in this line can be found in the works of his early British follower Peter Monamy, such as *A Shipwreck* (The Wilson, Cheltenham) and *Ships in Distress in a Storm* (fig. 67). And at the turn of the nineteenth century, the relationship between British and Dutch marine painting was dramatically reaffirmed by Turner's *Dutch Boats in a Gale* (a watercolor copy is shown here), which was commissioned by Francis Egerton, third Duke of Bridgewater, as a pendant to a painting in his collection by Van de Velde, *A Rising Gale* (figs. 68–69).[13]

When Joshua Reynolds gave advice to the marine painter Nicholas Pocock in 1780, he pointed to the work of both Van de Velde the Younger and Claude-Joseph Vernet, and in so doing highlighted two key strands in British shipwreck imagery.[14] In Rome in 1749–50, Reynolds had met and befriended Vernet, widely acknowledged to be the most important French landscape and marine painter of his day. During the 1740s Vernet had worked for numerous influential Italian patrons, as well as many "Grand Tourists" (usually British) with whom his art became closely associated. Vernet's originality and thus desirability came from his ability to blend contemporary Italian art practice — as represented by the Dutch-born Gaspar van Wittel (Vanvitelli), Giovanni Paolo Panini, and other artists of the *veduta*, or vista — with admired art-historical traditions. In demonstrating his agility with an extraordinary

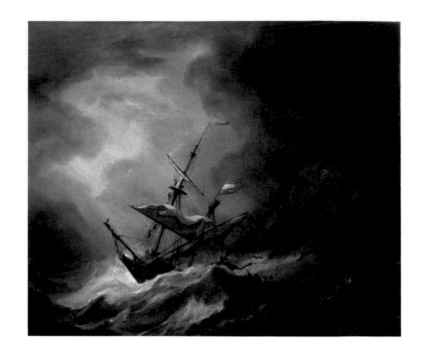

FIG. 66. Willem van de Velde the Younger, *A Mediterranean Brigantine Drifting onto a Rocky Coast in a Storm*, ca. 1700, oil on canvas, 25 x 30 in. (63.5 x 76.2 cm). National Maritime Museum, Greenwich, London, Palmer Collection

FIG. 67. Peter Monamy, *Ships in Distress in a Storm*, ca. 1720–30, oil on canvas, 30 x 41⅞ in. (76.5 x 106.4 cm). Tate

FIG. 68. Matthew Shepperson after J. M. W. Turner, *Dutch Boats in a Gale: Fishermen Endeavouring to Put Their Fish on Board* ("The Bridgewater Sea-Piece"), 1811–21, watercolor, 10½ x 14 in. (26.6 x 35.8 cm). British Museum

FIG. 69. Willem van de Velde the Younger, *A Rising Gale*, 1671–72, oil on canvas, 52 x 75½ in. (132.2 x 191.9 cm). Toledo Museum of Art

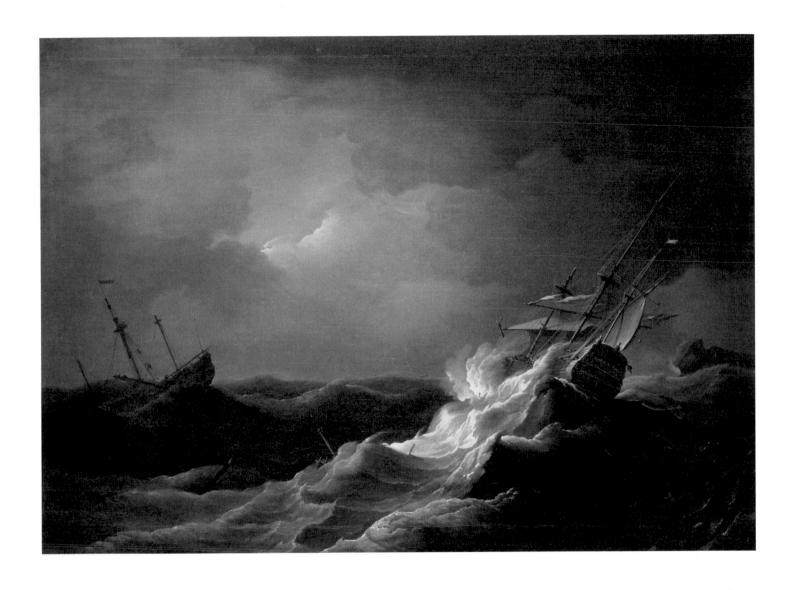

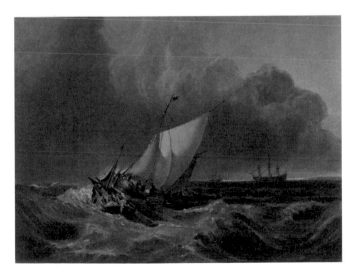

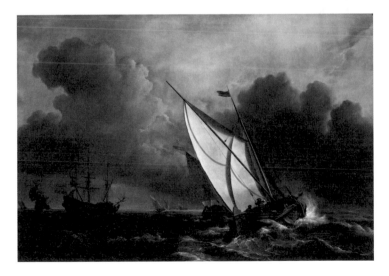

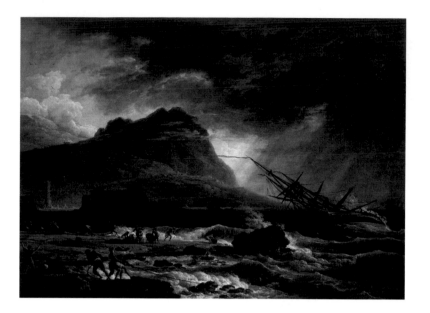

range of climatic effects, Vernet evoked comparison with Van de Velde and the Dutch tradition, then defined by its direct observation and faithful representation of the natural world, and with Italian and French classicist painters of the seventeenth century, whose works his wealthy clients in Rome were busily buying. Vernet's ship-wreck scenes, in British collections at least, play their part in a principal goal of the Grand Tour: through an encounter with ancient, Renaissance, and modern Rome, to acquire the necessary life experiences, erudition, and "polish" of a cultured gentle-man. As David Solkin has observed, echoing other scholars, "no credential was more tangible than the works of art which the young 'milords' were encouraged to acquire while abroad."[15] The Grand Tourist Benjamin Lethieullier, for instance, while visit-ing Rome commissioned Vernet's *Four Times of Day* series (1751, Uppark House, West Sussex), along with an identical set subsequently acquired by his brother-in-law Sir Matthew Fetherstonaugh. The paintings are *Morning: A Port in Mist, Midday: A Ship off Shore Foundering* (fig. 70), *Evening: A Harbour Scene with Boats,* and *Night: A Rocky Inlet with Fisherfolk Setting Their Nets* (fig. 71).

As these commissions suggest, Vernet's patrons often acquired "storm and ship-wreck" subjects within pairs or larger groups of paintings. Although pairings of "calms" and "storms" from the seventeenth or eighteenth century have rarely survived in col-lections today, there is evidence that pairs and sequences were common.[16] The effect of shipwreck scenes would be made more striking through juxtaposition, as in the series of prints produced after Monamy in the 1740s (figs. 72–73). Beyond landscape and sea-scape genres, the "four times of day" format that Vernet utilized so deftly was employed as a sequence of *tableaux de mode* — scenes reflecting the pastimes of the fashionable urban elite. Examples include Nicolas Lancret's *Les heures du jour* (1739-40; National Gallery, London) and William Hogarth's more satirical *Four Times of Day* (1736; private collection and Upton House, Warwickshire).[17] Shipwreck imagery thus became a more widely marketable commodity, beyond a niche subject for those interested in maritime

FIG. 70. Claude-Joseph Vernet, *Midday: A Ship off Shore Foundering,* 1751, oil on canvas, 39 × 53 in. (99 × 134.5 cm). National Trust, Uppark, West Sussex

FIG. 71. Claude-Joseph Vernet, *Night: A Rocky Inlet with Fisherfolk Setting Their Nets,* 1751, oil on canvas, 39 × 53 in. (99 × 134.5 cm). National Trust, Uppark, West Sussex

FIG. 72. Pierre-Charles Canot after Peter Monamy, *Morning, or Sun Rising*, 1745, engraving, 10⅝ x 15 in. (27 x 37.9 cm). Yale Center for British Art, Paul Mellon Collection (cat. 32)

FIG. 73. Pierre-Charles Canot after Peter Monamy, *Shipwrack*, 1745, engraving, 10⅝ x 15⅛ in. (26.9 x 38.2 cm). Yale Center for British Art, Paul Mellon Collection (cat. 35)

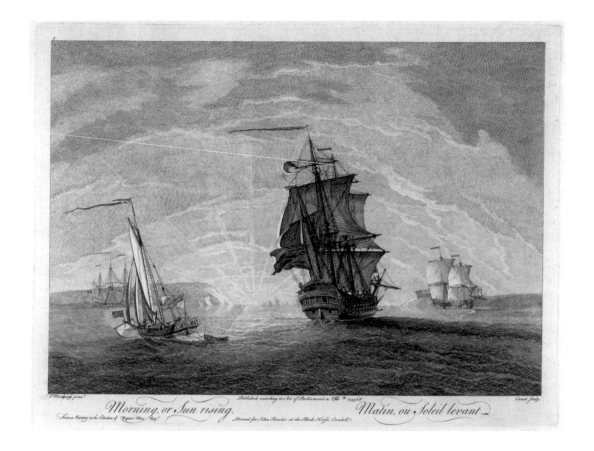

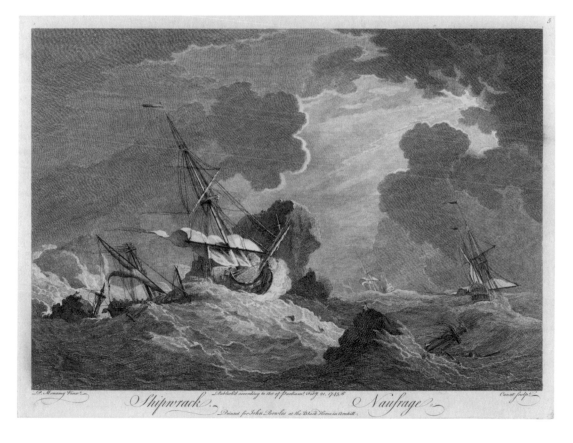

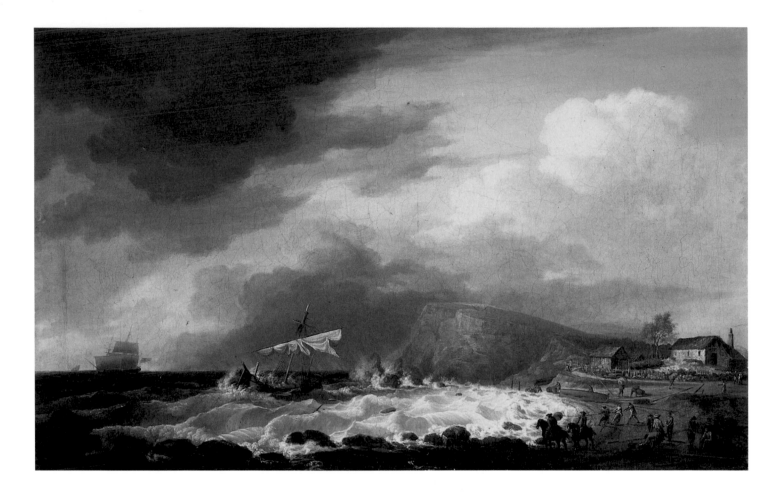

FIG. 74. Dominic Serres, *Shipwreck off a Coast with Survivors and Rescuers on a Beach: Freshwater Bay, Isle of Wight*, 1760, oil on canvas, 25 x 40¼ in. (63.5 x 102.3 cm). Private collection

matters; it was absorbed into elite cultural practice, in which pictorial variety and artistic inventiveness were at least as important as conveying the subjective experience of storm at sea and human distress. Such imagery continued to feature in series in the early nineteenth century as a result of the growing market for deluxe topographical prints, such as *Picturesque Views on the Southern Coast of England* (1814-26), by multiple artists, and Turner's *Picturesque Views in England and Wales* (1825-38).[18]

Vernet's cosmopolitan approach proved attractive to a number of contemporary artists who were similarly attempting to secure the patronage of Europe's social elite. These included his fellow Frenchmen Dominic Serres and Loutherbourg, both of whom were important figures in British art in the second half of the eighteenth century. In fact, Serres's and Loutherbourg's success in Paris and London beginning in the 1760s was to a large extent based on their ability to assimilate the formal language of Vernet's coastal and port scenes. Their works were characterized by expansive skies and detailed shorelines that incorporated human figures and dramatic incidents, as seen in Serres's *Shipwreck off a Coast with Survivors and Rescuers on a Beach: Freshwater Bay, Isle of Wight* (fig. 74). In reviews of the Paris Salons of 1765 and 1767, the author and critic Denis Diderot continually compared the work of Loutherbourg with that of his elder, Vernet, whom Diderot greatly admired. He observed that a storm scene shown in 1767 included numerous vignettes "taken" and "borrowed" from Vernet, such as "a drowned

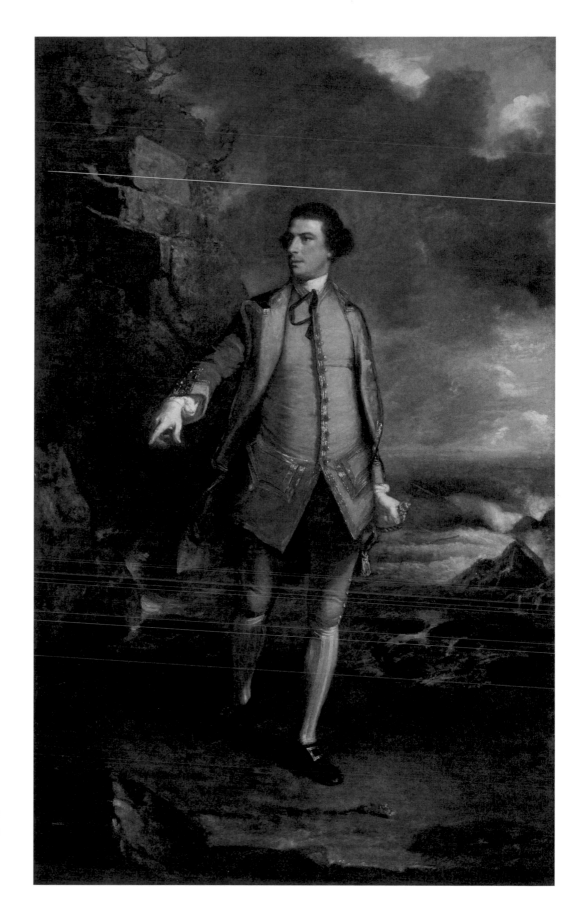

child lying on the shore and its distraught mother" and "a husband holding his nude, dying wife," and concluded that the work overall was "painted after reminiscences after several other works, plagiarism." Furthermore, putting a premium on an artist's direct experience of the natural world—a quality he consistently highlighted in Vernet—Diderot advised: "Monsieur de Loutherbourg, go look at the sea; you've visited stables, that's clear, but you've never seen a storm at sea."[19]

That Vernet's sophisticated mode of picture making was eminently transferrable across artistic genres is clearly demonstrated by Reynolds's *Captain the Honourable Augustus Keppel* (fig. 75). This dramatic, full-length portrait succeeded in launching Reynolds's career in the 1750s, in part due to his choice of sitter—an aristocrat and celebrated naval hero— and the manner in which he was portrayed, as a fearless man of action. For those on the Grand Tour, the Italian artist Pompeo Batoni was to portraiture what Vernet was to landscape and marine art, and in *Keppel*, Reynolds might be said to have assimilated the practices of both. Keppel's pose is based on a seventeenth-century statue of the Greek god Apollo, itself a reference to the Apollo Belvedere, the revered classical sculpture that is emblematic of the art and architecture that Batoni incorporated into his portraits of Grand Tourists. Keppel is seen striding across a barren, rocky shoreline, as dramatically conceived as any storm scene by Vernet or, indeed, Van de Velde. According to the artist James Northcote, Reynolds's biographer, an incident of 1747 informed the narrative of this painting: Keppel's ship, *Maidstone*, in pursuit of French privateers, was wrecked off the coast of Brittany. The portrait thus neatly underlines the intimate connection between national rivalry, conflict, and maritime disaster while demonstrating how such dramatic themes, as Mark Hallett has recently noted, could be visually exploited using the conventions of European marine painting.[20]

The effect underlines Reynolds's awareness of the viewer standing before this large-scale portrait, a consideration that is particularly pertinent since the work was displayed for many years in the relative intimacy of his studio. There, visitors would have encountered the illusion of a life-sized figure of Keppel walking purposefully toward them out of the storm.[21] The extent to which Reynolds was breaking new ground in his fusion of two highly successful but seemingly distinct strands of contemporary art becomes apparent when the Keppel portrait is compared with that of Commodore Augustus Hervey (1768-69; Ickworth House, Bury St. Edmunds) by Thomas Gainsborough. There the subject is shown as the epitome of the officer-gentleman, standing with legs crossed, leaning on a ship's anchor and surrounded by the usual accoutrements of naval portraiture.[22]

Artists of the past with whom Vernet, Reynolds, Loutherbourg, and others engaged—particularly Claude Lorrain, Nicolas Poussin, and Salvator Rosa—not only were exemplars of a "classical" ideal but were also associated with specific qualities: Claude with beauty, Poussin with the intellectual, and Rosa with the sublime.[23] Perhaps inevitably, the aesthetic opposition assigned to Claude and Rosa during the eighteenth century, through images of luminous calm and savage storm, respectively, draws us closer to a discussion of shipwreck in the context of the sublime, and thus

alternative cultural parameters within which such images were experienced and appreciated as the eighteenth century progressed. The equation between shipwreck and the sublime had been made well before the Romantic period (from about 1780 to 1830), when British shipwreck imagery was arguably at its most pervasive, and when the term "sublime" was widely understood as shorthand for certain visual and textual effects. The first known treatise on the subject, *On the Sublime*, by the anonymous Greek author of the first century CE known as Longinus, was brought to prominence in France, Britain, and elsewhere through successive translations, by Nicholas Boileau-Despréaux in 1674 and William Smith in 1739, among others. *On the Sublime* informed two of the most influential treatises of the eighteenth century, Edmund Burke's *A Philosophical Enquiry into the Origin of Our Ideas of the Sublime and Beautiful* (1757) and Immanuel Kant's *The Critique of Judgment* (1790).

These critical and theoretical discussions of the sublime give a prominent and consistent role to the sea. Although Longinus concentrated on the effect of the written and spoken word, he illustrated his point by alluding to the ocean's majesty of scale: "Hence it is almost an instinct that we follow in giving our admiration, not to small streams, though they be pellucid and useful, but to the Nile and Danube, or Rhine, and far more to the Ocean."[24] And in his oft-quoted summation of the sublime, Burke, too, was drawn to the sea as an exemplar, its watery vastness evoking the terror that was key:

> No passion so effectually robs the mind of all its powers of acting and reasoning as fear. For fear being an apprehension of pain and death, it operates in a manner that resembles actual pain. Whatever therefore is terrible, with regard to sight, is sublime too, whether this cause of terror, be endured with greatness of dimensions or not. . . . And to things of great dimension, if we annex an adventitious idea of terror, they become without comparison greater. A level plain of a vast land, is certainly no mean idea; the prospect of such a plain may be as extensive as a prospect of the ocean; but can it ever fill the mind with any thing so great as the ocean itself? This is owing to several causes, but it is owing to none more than this, that the ocean is an object of no small terror. Indeed terror is in all cases whatsoever, either openly or latently the ruling principle of the sublime.[25]

Terror is the ruling principle, but, as Burke notes earlier in the essay, imagining "pain and danger" and the need for self-preservation "without being actually in such circumstances" results in a kind of "delight."[26] This may explain why the subject of shipwreck was so regularly adopted by artists planning works for public consumption.[27] It may also explain why these artists tended to engage with "storm at sea" more than with its aftermath. While Burke was skeptical, if not dismissive, of the "imitative arts" in the production of an authentic sublime effect, he nonetheless gave some pointers in the *Philosophical Enquiry* as to how this could be attempted, through the imitation of core properties (as he saw them) of the sublime:

But painting, when we have allowed for the pleasure of imitation, can only affect simply by the images it presents; and even in painting a judicious *obscurity* in some things contributes to the effect of the picture; because images in painting are exactly similar to those in nature; and in nature *dark, confused, uncertain images have a greater power on the fancy to form the grander passions than those which are more clear and determinate.*[28]

In this context, Van de Velde's *A Mediterranean Brigantine Drifting onto a Rocky Coast in a Storm* is as successful a pictorial exposition of the Burkean sublime as Turner's monumental *The Shipwreck*, painted over a century later (fig. 76).

For many eighteenth-century commentators, the sublime was premised on the contemplation of powerful scenes or objects, primarily but not exclusively natural phenomena, that aroused feelings of awe and terror. Writing several decades before Burke, Joseph Addison, in his essay "On the Pleasures of the Imagination" (1712), lists the examples of "high rocks and precipices," "a wide expanse of water," and "huge heaps of mountains," and states: "Our imagination loves to be filled with an object, or to grasp at anything that is too big for its capacity. We are flung into a pleasing astonishment at such unbounded views, and feel a delightful stillness and amazement in the soul at the apprehension of them."[29] The viewer is sufficiently caught up to feel overwhelmed, but from a position of safety. The pleasure in the process is one that Samuel Johnson described, in the context of sublime language, as a transition from "sudden astonishment" to "rational admiration," when the mind relaxes in relief, precipitating what Addison had previously called "agreeable horror" and Burke, "delightful terror."[30]

Descriptions of the sublime have varied, and, as Jonathan Lamb wrote in the mid-1990s, some art historians use the term inappropriately. "Despite the frequent assertion to the contrary" by specialists in eighteenth-century landscape, he noted, "there is no sublime environment, no phenomenon in nature that can claim an intrinsic part in these intensities, or pretend to be a cause or end of them."[31] The "crisis," he asserts, is in the viewer rather than in nature. Lamb illustrates his point by quoting from Kant's *Critique of Judgment*: "Thus the broad ocean agitated by storms cannot be called sublime. . . . All we can say is that the object lends itself to presentation of a sublimity discoverable in the mind. For the sublime, in the strict sense of the word, cannot be contained in any sensuous form."[32]

The challenge for a painter in "manufacturing" such an experience, then, is to transport viewers out of their own time and space and *into* the composition. Seascape compositions tend to dramatize the disparity in scale, and thus power, between human figures and the natural world. Shipwreck scenes by Van de Velde and Vernet offer the kind of dramatic effects and devices that have come to be expected of "sublime" seascapes, such as sharp contrasts in light and dark, battering winds, turbulent seas, buffeted ships, and, in the case of Vernet, struggling human beings. However, in Vernet's compositions the proximity of the rocky coastline suggests that dry land might offer respite from the drama—a place of safety that is absent in Van de Velde's

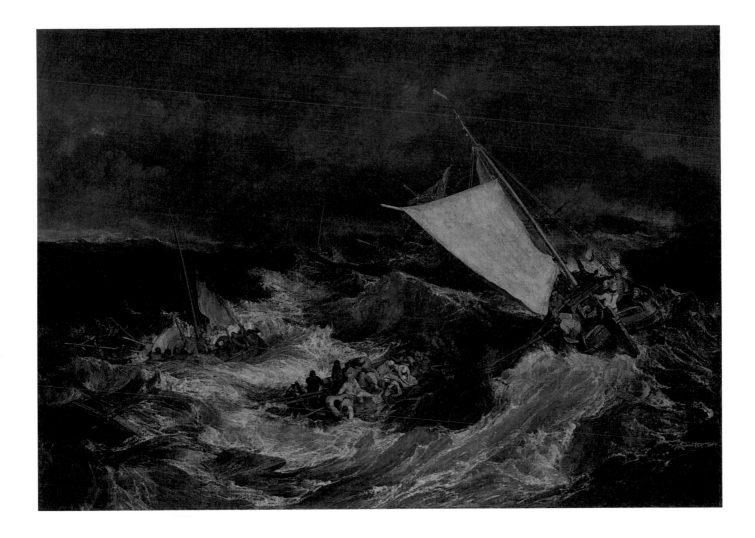

FIG. 76. J. M. W. Turner, *The Shipwreck*, 1805, oil on canvas, 67⅛ x 95⅛ in. (170.5 x 241.6 cm). Tate

composition. This absence of refuge is a device that Turner was to exploit to an even greater dramatic effect in the early nineteenth century.

In pursuing the experiential possibilities of storm at sea and shipwreck, some artists took into account not only the scale and composition of the image but also its optimum position within a display, achieving an eighteenth-century approximation of what we might call a virtual or immersive experience. In 1784 James Northcote exhibited *The Wreck of the* Centaur at the Royal Academy. Although the painting is now lost, its scale (8 by 12 feet) and composition are known through an engraving by Thomas Gaugain, published in the same year (fig. 77). The painting's prominent hanging position, some eight feet off the floor in the Great Room at Somerset House, is recorded in a watercolor by Edward Frances Burney (fig. 78). The ominous presence of the ship, just visible in the top left corner, and the steep, upward tilt of the boat as viewed from below were surely calculated to exaggerate the sensation of being in the line of impact. Northcote was not a marine painter, and his choice of a shipwreck subject was clearly opportunistic: *The Wreck of the* Centaur was his first modern history painting and, as he later noted, "the grandest and most original thing I ever did."[33] In short, Northcote

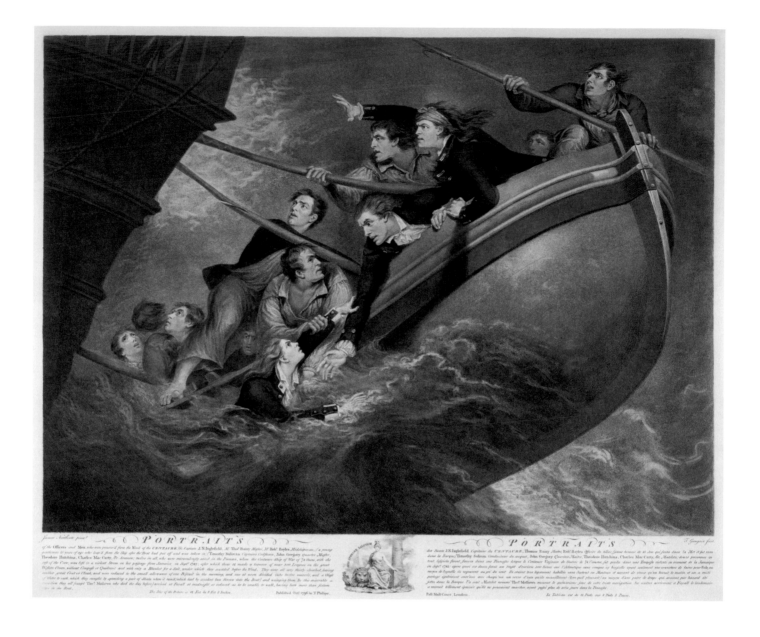

knew that visitors to the exhibition would be drawn to his work because of its physical dominance within the display, its unusual composition, and its topicality, factors that together characterize a strategy that had become more pronounced in British art with the advent of public contemporary art exhibitions, and above all the annual exhibition at the Royal Academy.

The *Centaur*, a 74-gun ship of the line, had been crossing the Atlantic in 1782, escorting prizes back to Britain from Jamaica, when it was wrecked in a hurricane near Newfoundland Banks. Some six hundred men were lost, but the captain, John Nicholson Inglefield, and eleven of the crew escaped (the moment shown in North-cote's painting). The survivors subsisted at sea for a further sixteen days, successfully navigating their way to an island in the Azores. A court martial—normal procedure after the loss of a navy ship—acquitted Captain Inglefield, and he became a national

FIG. 77. Thomas Gaugain after James Northcote, *Portraits of the Officers and Men Who Were Preserv'd from the Wreck of the Centaur*, 1784, engraving, 22 3/8 x 27 1/8 in. (56.8 x 69 cm). National Maritime Museum, Greenwich, London

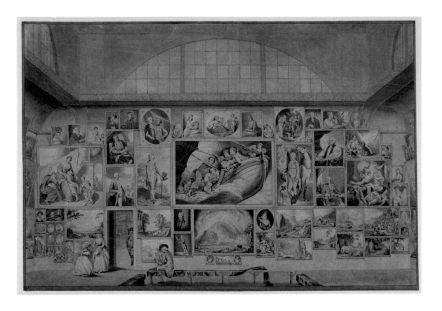

celebrity. In Northcote's composition, the inclusion of portraits of the survivors capitalized on the topicality of the event and even formed part of the marketing campaign for the engraved version.

The critical and popular success of both the painting and the print helped launch the artist's career as a history painter, which began in earnest in 1786, the year he was elected associate member of the Royal Academy.[34] Other contemporary history subjects that achieved notice at the time ranged from national events melded with personal sacrifice, exemplified by Benjamin West's *Death of General Wolfe* (National Gallery of Canada, Ottawa), exhibited at the academy in 1771, to more local, biographical moments, made heroic via a grandeur of scale and composition, as in John Singleton Copley's *Watson and the Shark* (National Gallery of Art, Washington), exhibited at the academy in 1778. Albeit not a scene of shipwreck, Copley's sensational image of maritime misadventure provided more than a hint for Northcote in his creation of *Wreck of the* Centaur. It may even have encouraged him in the choice of subject for his next modern history painting, *The Death of Prince Leopold of Brunswick* (1785/1807; Hunterian Museum, Glasgow), in which the prince's drowning is represented in the manner of a biblical deluge.

Northcote's *Wreck of the* Centaur appears to have been the only significant pictorial response to that event. Another sea disaster was more widely depicted: the wreck of the *Halsewell* off the Dorset coast in January 1786, only a few days after embarking on a voyage from Gravesend to Madras (Cennai), became the subject of paintings by Northcote, Robert Smirke, Thomas Stothard, and Robert Dodd. All of their works were engraved; Dodd made the engraving after his own painting (fig. 79).[35] An additional measure of the market for such disaster scenes is suggested by Gillray's focus on shipwreck at this time, when he was attempting to establish himself as an engraver of serious subjects. He engraved a number of Northcote's paintings, including that of the *Halsewell*, published in June of 1787, and among his own compositions is *The Nancy Packet* (October 1784), which represents a shipwreck that occurred off the Scilly Isles. Finally, Loutherbourg adapted his generic scene of shipwreck for the *Eidophusikon* to resemble more closely the details of the *Halsewell* event.[36]

Given the commonplace nature of shipwreck, the fascination with the *Halsewell*, as Geoff Quilley has observed, was undoubtedly due to the location of the disaster on the English coast, its scale (only around 70 survived out of some 240 passengers and crew), and the pathos surrounding the fate of the captain, Richard Pierce, his two eldest daughters, and two nieces, all of whom perished.[37] Of the artists who depicted the event, Dodd, the marine painter, focused on the moment when the *Halsewell* had been driven onto the shore, across a cave in the cliffs; he was employing the pictorial

Painted & Engraved by R. Dodd

conventions associated with coastal shipwreck scenes popularized by Vernet, Serres, and Loutherbourg. The other artistic responses all focus on the distress of those left on board, and in particular the last moments of Pierce, his daughters, and the other female passengers he had refused to leave behind, and thus are more in keeping with the conventions of modern history painting.

The courage, selflessness, and loyalty reportedly displayed by Captain Pierce remind us how important the behavior of those in command was in the retelling of shipwreck stories, whether in visual or literary form. The wreck of the French naval ship *Medusa* off the coast of Senegal in July 1816 and that of the British ship *Alceste* off the east coast of Sumatra in February 1817 were sometimes paired by British publishers because of the contrasts in seamanship, leadership, and discipline that they appeared to represent (the French purportedly lacking in all departments). To British commentators, at least, this was thought to reveal differences in character between the two nations.[38] Such observations also featured in British reviews of Théodore Géricault's painting *The Raft of the* Medusa when it was exhibited at the Egyptian Hall, Piccadilly, London, in 1820.[39] There was, of course, ample evidence

FIG. 79. Robert Dodd, *The Loss of the* Halsewell, ca. 1786, aquatint and etching, 16 3/8 x 21 7/8 in. (41.5 x 55.5 cm). National Maritime Museum, Greenwich, London

FIG. 80. Thomas Luny, *The Wreck of the East Indiaman* Dutton *in Plymouth Sands*, 1821, oil on canvas, 30⅜ x 44⅛ in. (77 x 112 cm). National Maritime Museum, Greenwich, London

of bad discipline and poor decision-making also on British ships, leading to the kind of disputes and soul-searching that marked the loss of the *Medusa*; the mutiny on the *Bounty* in April 1789 was the best-known example at the time. But this made instances of exemplary behavior during moments of crisis even more crucial, especially in promoting Britain's moral authority as a maritime and imperial power. Sometimes officers were commendable even when not at sea, as in the wreck of the East Indiaman *Dutton*, which was bound for the West Indies with troops on board when it was driven ashore near Plymouth during a gale on January 26, 1796. Captain Sir Edward Pellew, later first Viscount Exmouth, who was stationed at nearby Falmouth, happened to be in Plymouth at the time of the wreck. He swam out to the stricken vessel with a line that allowed breeches buoys (rope-based rescue devices) to be rigged. As a result of his and others' actions, all but four of the six hundred people on board, including women and children, were saved. Thomas Luny's *The Wreck of the East Indiaman* Dutton *in Plymouth Sands* shows a crowd on the beach pulling the rescue line taut as figures move along it from ship to shore (fig. 80). The figure in a blue uniform visible on board probably represents Pellew. In fact, Luny's painting

was based on a print after a drawing by Nicholas Pocock, which was published shortly after the event in 1796. Luny painted seven versions of the subject, one of which was acquired by Pellew himself, and his son, Captain the Honorable Fleetwood Pellew, owned the version now at the National Maritime Museum in Greenwich. Luny's paintings, therefore, which served as keepsakes marking the heroic actions of a family member, also exemplify how shipwreck images, especially those associated with noteworthy events and people, were repeated and recycled. Like Reynolds's portrait of Keppel, they could both enhance the reputations of naval officers and participate in a broader visual culture surrounding the Royal Navy that underscored the rights of social and naval rank.

The expectation among contemporaries, subsequent audiences, and, more recently, art historians, that British shipwreck scenes represent an actual event is highlighted by the reception of a number of works by Turner. Maritime disaster was arguably the single most consistent theme across the artist's career, and the titles that he gave his works could, by turns, be vague or highly specific. Thus, his watercolor of about 1818, now known as *The Loss of the East Indiaman* (Cecil Higgins Gallery, Bedford), may well refer back to the wreck of the *Halsewell*, as claimed by a number of art historians.[40] *The Shipwreck* (1805) and *The Wreck of a Transport Ship* (about 1810; Fundação Calouste Gulbenkian, Lisbon) have been said to represent, respectively, the wreck of the *Earl of Abergavenny* (in 1805) and that of HMS *Minotaur* (in 1810), despite a lack of evidence from Turner himself.[41] In each case, the proximity of the event to the date of the work — although the painting in question was probably completed before the event occurred — seems to have been enough to make the link. In any case, both shipwrecks had contemporary resonance that would have been useful for the artist in drawing attention to the work.

HMS *Minotaur* was a 74-gun British ship of the line that had fought in three major fleet actions of the Napoleonic War — the battles of the Nile (1798), Trafalgar (1805), and Copenhagen (1807). It was wrecked on the Texel, an island in North Holland, on December 22, 1810, with heavy loss of life. All survivors were taken to France as prisoners of war. The *Abergavenny* was an East Indiaman bound for Bengal and China that sank off Dorset in February 1805 with the loss of 260 lives. It remains one of the worst disasters in British waters, and, whether or not it influenced Turner's choice of subject, the recent news of such a terrible maritime event cannot have failed to resonate with the painting's early audience.[42] Indeed, the *Abergavenny* disaster spawned a number of popular publications, including *An Authentic Narrative of the Loss of the* Earl of Abergavenny, by William Dalmeida (1805), which rapidly ran through several editions.[43] This wreck was even more noteworthy because the captain of the *Abergavenny* was John Wordsworth, brother of the poet. William Wordsworth's direct response to his brother's death was to write a number of poems in his memory, including "Elegiac Stanzas Suggested by a Picture of Peele Castle in a Storm," composed in April 1806. The picture referred to in the poem's title, of a ship foundering in a violent sea, was by the connoisseur and amateur artist Sir George Beaumont, who was a friend and patron of both Wordsworth and Samuel Taylor Coleridge.[44]

Perhaps the most compelling literary relationship with Turner's *Shipwreck* was the highly successful edition, published in 1804, of William Falconer's celebrated poem *The Shipwreck* (1762). This included a biographical memoir of the author by James Stanier Clarke, then a naval chaplain, and illustrations engraved after watercolors by Pocock.[45] Turner already knew and admired Falconer's poem, and possibly had a copy in his possession as early as 1795, in Robert Anderson's *The Works of British Poets*.[46] From humble beginnings, William Falconer had become a professional sailor, serving as a merchant seaman and briefly as a naval midshipman. Eventually he became a naval purser, managing money and supplies on board, with time to concentrate on his writing, which included an important nautical dictionary first published in 1769. He is assumed to have died in January 1770—a poetic twist of fate—when the East Indiaman *Aurora* disappeared, presumably wrecked, in the Mozambique Channel, Madagascar. Much of *The Shipwreck* is autobiographical, including an account of Falconer's escape from drowning in 1749, off Sunion (Cape Colonna), Greece, when he was second mate of a merchantman wrecked there. Falconer underscored the accuracy and thus authenticity of his narrative by including copious notes explaining weather conditions and other technical matters. This attention to detail was reinforced in the 1811 edition of the poem, for which Pocock provided not only the illustrations, but also their detailed technical captions.[47]

Falconer's poem recounts the final voyage of the merchant ship *Britannia*, elevating the national and moral significance of this contemporary subject with multiple references to such classical literature as Virgil's *Aeneid*, which was often read as the foundation epic of ancient Rome and was influenced by Homer's *Iliad* and *Odyssey*. In Falconer's poem, the *Britannia* is wrecked on the coast of Greece, the site of a once great civilization, thus reinforcing the implication in the ship's name that the British Empire, too, would eventually fall. Anderson's biographical sketch not only compared Falconer to Virgil but also noted that although the "situation of a *sailor* may be thought unfavorable to the *poet*, . . . none but a sailor could give so didactic an account, and so accurate a description of the voyage and catastrophe related in his performance; and none but a genuine poet could have embellished both with equal harmony of numbers and strength of imagery.[48] Among the passages that were admired by many is the moment of the ship's sinking:

> Again she plunges! hark! a second shock
> Tears her strong bottom on the marble rock!
> Down on the vale of Death, with dismal cries,
> The fated victims shuddering roll their eyes,
> In wild despair; while yet another stroke,
> With deep convulsion, rends the solid oak.[49]

Falconer's life and work as poet-sailor suggested a powerful identity that could be seen to parallel the experiences and ambitions of marine painters. That his poem was a touchstone for the reception of seascape paintings is underlined by the reviewer for

FIG. 81. Nicholas Pocock, *The Wreck* from Falconer's *The Shipwreck*, 1810, watercolor with graphite and pen and ink, heightened with white, on board, 10 x 15⅝ in. (25.3 x 39.7 cm). National Maritime Museum, Greenwich, London. Royal Naval Museum Greenwich Collection

the *Times*, writing in 1797 in response to one of Turner's earliest exhibited works, *Fishermen Coming Ashore at Sun Set, Previous to a Gale* (location unknown). The painting, the critic judged, represented "the sickly appearance of the setting sun at sea, preparatory to a storm, as it is described in Falconer's poem."[50] As Turner knew well, there were a number of British and French marine artists in the eighteenth and nineteenth centuries — Dominic Serres, Pocock, and later, Clarkson Stanfield — who were, or had been, naval officers or professional sailors. Indeed, as discussed in Eleanor Hughes's essay in this volume, Pocock's oeuvre has tended to be viewed in light of his experience as a merchant sea captain. But his participation in various illustrated editions of Falconer's poem may well have been an attempt to align himself as the poet-sailor's counterpart in visual art. In 1810 Pocock exhibited all the drawings for the 1811 edition of *The Shipwreck* at the Society of Painters in Water Colours, of which he had been a founding member six years earlier. While drawings such as *The Wreck* (fig. 81) have much in common with his early logbook illustrations of the ship in stormy conditions, the earlier illustrations themselves were not the result of firsthand observation alone, but were informed by much-admired traditions of shipwreck imagery. By the end of the eighteenth century, "shipwreck and misadventure" had become integral to the mythology of the marine artist, the belief that it was seafaring experience that gave

the artist authority as interpreter of the natural world and mediator between that world and the spectator. This distinction linked seventeenth-century Dutch and Flemish marine painters (who were often described in biographies as seeking out storms to inform their art) not only to later European artists such as Vernet, Serres, Pocock, and Turner, but also to literature, through the likes of Lord Byron and Percy Bysshe Shelley as well as Defoe and Falconer.

Bold and dramatic, Turner's *The Shipwreck* of 1805 can be seen to encapsulate both the aims and ambitions of past and contemporary marine painters and the popularity and marketability of shipwreck subjects current in Britain at the time. Sketches for the composition can be found in Turner's so-called "Calais Pier" sketchbook and two "Shipwreck" sketchbooks (Tate), some of which draw directly from the artist's experience of a rough passage to France in 1802, and others that possibly resulted from the observation of actual wrecks.[51] The composition also formed part of a broader artistic project associated with the sea that showcased Turner's painterly agility across a myriad of weather conditions and times of day in the manner of Van de Velde and Vernet. *The Shipwreck* could be paired with Turner's *Sun Rising through Vapour*, painted in 1807, which shows fishermen cleaning and selling fish on shore: the danger of shipwreck contrasted with the safety and comfort of calm, hazy conditions. The depiction of the disaster was the first of Turner's paintings to be engraved—by Charles Turner, in mezzotint, published in January 1807, with an impressive list of subscribers that included members of the aristocracy, landed gentry, collectors, connoisseurs, and artists. The prospectus for the engraving made clear that the painting could be viewed in the artist's picture gallery on Harley Street, London.[52] Displayed in the relative intimacy of a domestic gallery, with the swell of the sea at eye level, a work of such large scale (5½ by 7⅞ feet) must have struck visitors all the more forcibly.

That Turner was positioning himself as the most exciting and ambitious of all marine painters is suggested by the sequence of three extraordinary paintings of comparable size, theme, and complexity that were painted within seven years: *The Shipwreck* and *The Wreck of a Transport Ship* had been preceded by *Calais Pier* (1803; National Gallery, London). Together they form a kind of triptych that commemorates the heroism of native seafarers. Widening the association, one might also posit a connection between *The Shipwreck* and Turner's *The Battle of Trafalgar, as Seen from the Mizen Starboard Shrouds of the* Victory (1806–08; Tate), which is the same size. The engraver John Landseer described the latter in 1808 as "new in its kind . . . a *British epic picture*."[53] Since individual sacrifice within an event of panoramic grandeur is the subject of both works, they seem equally to fulfill the role of national epic for maritime Britain.

1. Richard Godfrey, *James Gillray: The Art of Caricature*, exh. cat. (London: Tate Publishing, 2001), 116.

2. Philip Edwards, *The Story of the Voyage: Sea Narratives in Eighteenth-Century England* (Cambridge: Cambridge Univ. Press, 1994), 2.

3. Quoted in Edwards, *Story of the Voyage*, 1.

4. Carl Thompson, *Romantic-Era Shipwreck Narratives: An Anthology* (Nottingham: Trent Editions, 2007), 2.

5. Lawrence Otto Goedde, *Tempest and Shipwreck in Dutch and Flemish Art: Convention, Rhetoric, and Interpretation* (University Park: Pennsylvania State Univ. Press, 1989), 110.

6. Lawrence Otto Goedde, "Elemental Strife and Sublime Transcendence: Tempest and Disaster in Western Painting," in *Tempests and Romantic Visionaries: Images of Storms in European and American Art*, ed. George S. Hardy, exh. cat. (Oklahoma City: Oklahoma City Museum of Art, 2006), 29–33.

7. Royal Coburg Theatre playbill, Thursday, April 6, 1820. British Library. Quoted in Christine Riding, "The Raft of the Medusa in Britain: Audience and Context," in *Constable to Delacroix: British Art and the French Romantics*, ed. Patrick Noon, exh. cat. (London: Tate Publishing, 2003), 69.

8. Goedde, *Tempest and Shipwreck*, 111.

9. The story of the Good Samaritan, for instance, was a popular subject in Britain for altarpieces because of its focus on ideas of Christian charity and love of fellow man. See Jacqueline Riding, "'The Mere Relation of the Suffering of Others': Joseph Highmore, History Painting and the Foundling Hospital," *Art History: Journal of the Association of Art Historians* (June 2012): 527–32.

10. Maximillian E. Novak, *Daniel Defoe: Master of Fictions* (Oxford: Oxford Univ. Press, 2001), 57.

11. On shipwreck as metaphor, see Hans Blumenberg, *Shipwreck with Spectator: Paradigm of a Metaphor for Existence*, trans. Steven Rendall (Cambridge, MA: MIT Press, 1997), 9–11.

12. Richard Johns, "Charted Waters," in *Turner and the Sea*, ed. Christine Riding and Richard Johns (London: Thames & Hudson, 2013), 26.

13. Johns, "Charted Waters," 34.

14. On Reynolds's advice to Pocock, see Eleanor Hughes's essay in this volume.

15. David Solkin, *Richard Wilson: The Landscape of Reaction*, exh. cat. (London: Tate Publishing, 1982), 39.

16. Goedde, "Elemental Strife and Sublime Transcendence," 29–33.

17. Mark Hallett and Christine Riding, *Hogarth*, exh. cat. (London: Tate Publishing, 2006), 119–21, 149.

18. Christine Riding, "M for Marine," in *Turner and the Sea*, 63–67.

19. Denis Diderot, *Diderot on Art: The Salon of 1767*, ed. and trans. John Goodman, 2 vols. (New Haven: Yale Univ. Press, 1995), 2:238–39.

20. Mark Hallett, *Reynolds: Portraiture in Action* (New Haven and London: Published for the Paul Mellon Centre for Studies in British Art by Yale Univ. Press, 2014), 102.

21. David Mannings and Martin Postle, *Sir Joshua Reynolds: A Complete Catalogue of His Paintings*, 2 vols. (New Haven and London: Published for the Paul Mellon Centre for Studies in British Art by Yale Univ. Press, 2000), 1:287–88, 2:pl. 10, fig. 70.

22. Martin Postle, ed., *Joshua Reynolds: The Creation of Celebrity*, exh. cat. (London: Tate Publishing, 2005), 92.

23. Christine Riding, "Shipwreck in French and British Visual Art, 1700–1842," in *Shipwreck in Art and Literature: Images and Interpretations from Antiquity to the Present Day*, ed. Carl Thompson (New York: Routledge, 2013), 118–19; see also Andrew Wilton and Tim Barringer, *American Sublime: Landscape Painting in the United States, 1820–1880*, exh. cat. (London: Tate Publishing, 2002), 11–14.

24. [Cassius] Longinus, *Longinus on the Sublime*, trans. Thomas Stebbing (Oxford: T. & G. Shrimpton, 1867), 136.

25. Edmund Burke, *Philosophical Enquiry into the Origin of Our Ideas of the Sublime and Beautiful, and Other Pre-Revolutionary Writings*, ed. David Womersley, rev. ed. (London: Penguin Books, 1998), 101–02.

26. Burke, *Philosophical Enquiry*, 97.

27. Thompson, *Romantic-Era Shipwreck Narratives*, 15.

28. Burke, *Philosophical Enquiry*, 106. Emphasis added.

29. [Joseph Addison,] "On the Pleasures of the Imagination," *Spectator* 412 (1712): 134.

30. Samuel Johnson, *The Lives of the Most Eminent*

English Poets, with Critical Observations on Their Works, 4 vols. (London: Printed for C. Bathurst, 1781), 1:31; [Addison,] *"Pleasures,"* 134; Burke, *Philosophical Enquiry*, 97.

31. Jonathan Lamb, *The Rhetoric of Suffering: Reading the Book of Job in the Eighteenth Century* (Oxford: Clarendon Press, 1995), 10.

32. Lamb, *Rhetoric of Suffering*, 10–11.

33. Martin Postle, "James Northcote (1746–1831)," in Oxford Dictionary of National Biography, Oxford Univ. Press, 2004: http://dx.doi:10.1093/ref:odnb/20326 (accessed Feb. 28, 2016).

34. Northcote's painting was exhibited at the Royal Academy as "Portraits painted from life, representing Capt. Englefield, with eleven of his crew, saving themselves in the pinnace, from the wreck of the Centaur, of 74 guns, last Sepr. 1782." For a comprehensive discussion of Northcote's *Wreck of the* Centaur, see Geoff Quilley, *Empire to Nation: Art, History and the Visualization of Maritime Britain, 1768–1829* (New Haven and London: Published for the Paul Mellon Centre for Studies in British Art by Yale Univ. Press, 2011), 113–24. See also Mark Ledbury, *James Northcote, History Painting, and the Fables* (New Haven: Yale Center for British Art, 2014).

35. Smirke's painting was engraved by Robert Pollard (published 1786; Dodd's engraving was published the month after the *Halsewell* wreck. The engraving of Stothard's small oil painting, *The Wreck of the* Halsewell, *East Indiaman*, 1786 (National Maritime Museum, Greenwich, ZBA4537) was executed in early 1786 for the engraver and publisher Edmund Scott.

36. Carl Thompson, "Shipwreck and the Forging of the Commercial Nation: The 1786 Wreck of the *Halsewell*," in Thompson, *Shipwreck in Art and Literature*, 96.

37. Quilley, *Empire to Nation*, 148.

38. Riding, "Raft of the Medusa in Britain," 69–71; see also Christine Riding, "Staging the Raft of the Medusa," *Visual Culture in Britain* 5 (2004): 17–19, 26.

39. Riding, "Raft of the Medusa in Britain," 71–73.

40. See Riding and Johns, *Turner and the Sea*, 187.

41. Martin Butlin and Evelyn Joll, *The Paintings of J. M. W. Turner*, 2 vols. (New Haven and London: Published for the Paul Mellon Centre for Studies in British Art and the Tate Gallery by Yale Univ. Press, 1977), 1:36, 116–17.

42. Thompson, *Romantic-Era Shipwreck Narratives*, 146; see also Alethea Hayter, *The Wreck of the Abergavenny* (London: Macmillan, 2002).

43. Thompson, *Romantic-Era Shipwreck Narratives*, 146.

44. Riding and Johns, *Turner and the Sea*, 13–14. The Beaumont painting, dated 1805, is now in the collection of the Wordsworth Trust, Grasmere.

45. The original drawings by Pocock for the 1804 edition are in the British Museum, London.

46. Bernard Falk, *Turner the Painter: His Hidden Life, a Frank and Revealing Biography* (London: Hutchinson & Co. 1938), 255.

47. Nine of Pocock's ten original watercolors for the 1811 edition are in the National Maritime Museum, Greenwich, PAF5913–21.

48. Robert Anderson, *The Works of the British Poets*, 13 vols. (London: Printed for John & Arthur Arch . . . and for Bell & Bradfute and J. Mundell & Co. Edinburgh, 1795), 10:573.

49. Anderson, *Works of the British Poets*, 573; Falconer, *The Shipwreck* 3:640–45.

50. Cited in Butlin and Joll, *Paintings of J. M. W. Turner*, 1:2.

51. *Calais Pier* sketchbook (Tate, D04902–D05072; Turner Bequest LXXXI), *Shipwreck (1)* sketchbook (Tate, D05376–D05427; D40694–D40696; Turner Bequest LXXXVII), and *Shipwreck (2)* sketchbook (Tate, D05428–D05445; D40697–D40700; Turner Bequest LXXXVIII).

52. Butlin and Joll, *Paintings of J. M. W. Turner*, 1:6.

53. John Landseer, *Review of Publications of Art* 1 (pamphlet, London, 1808), 83–84. Emphasis in the original.

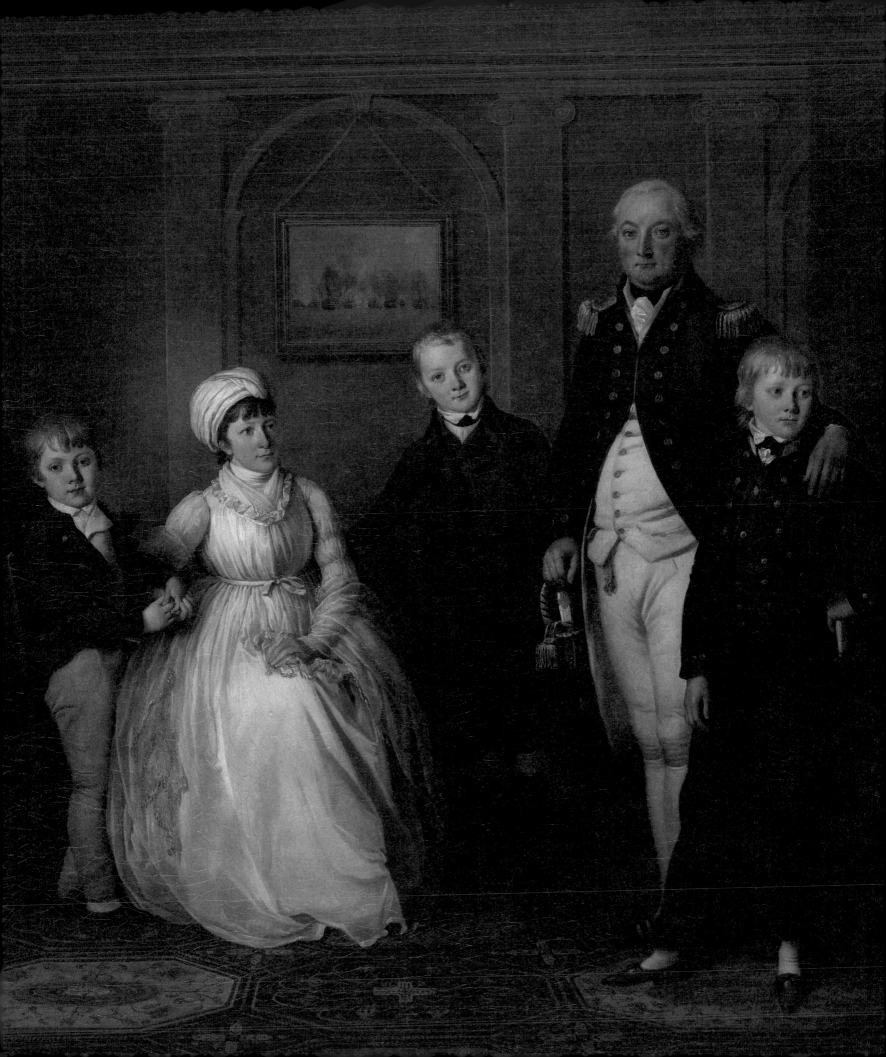

"My Hero": Women and the Domestic Display of Marine Paintings

CATHERINE ROACH

KATHERINE GRINDALL, HER HUSBAND, Captain Richard Grindall, and their sons pose before a marine painting of a naval engagement, the line of their bodies echoing the line of ships (fig. 82).[1] This late eighteenth-century group portrait depicts naval service as a family project: Mrs. Grindall has produced and reared sons who will fight in battles like the one pictured above her. Home and conflict are shown to be intimately connected, but this portrait is also a tender fiction, suggesting that the consequences of naval clashes can be contained within a gilded frame. Displayed in the family home, the portrait would also have conveyed a sense of cohesion in the face of absence. The group depicted would soon be dispersed, and some would die while in naval service: the youngest, Edmund, shown here with both hands clasped around his mother's, died while a midshipman in 1811; his older brother Festing, standing beneath his father's arm, survived the Battle of Trafalgar as a midshipman on the *Victory*, only to die a year after his younger brother.[2] In its insistence on unity, this painting anticipates potential loss and celebrates a shared commitment to service. Through the acquisition and display of portraits, relics, and marine paintings, women like Mrs. Grindall asserted their connection to male family members who were frequently away at sea. Such displays promoted officers' reputations and visualized women's claims on the men they frequently referred to, without irony, as "my hero."

In the Grindall family portrait, the picture-within-the-picture functions as a sign of service; it may also depict a specific battle in which Grindall fought.[3] But this depiction of a solitary picture does not reflect typical eighteenth-century display practice. Some officers' families who invested in images did so lavishly, developing richly layered interiors that celebrated success and suppressed any hint of failure. As Britain emerged as a global imperial power in the eighteenth century, a culture of commemoration flourished, encompassing everything from costly church monuments to ceramics and prints that the common sailor could afford.[4] For the officer class, the home

Richard Livesay, *Captain Richard Grindall (1750–1820) and His Family* (detail, fig. 82)

113

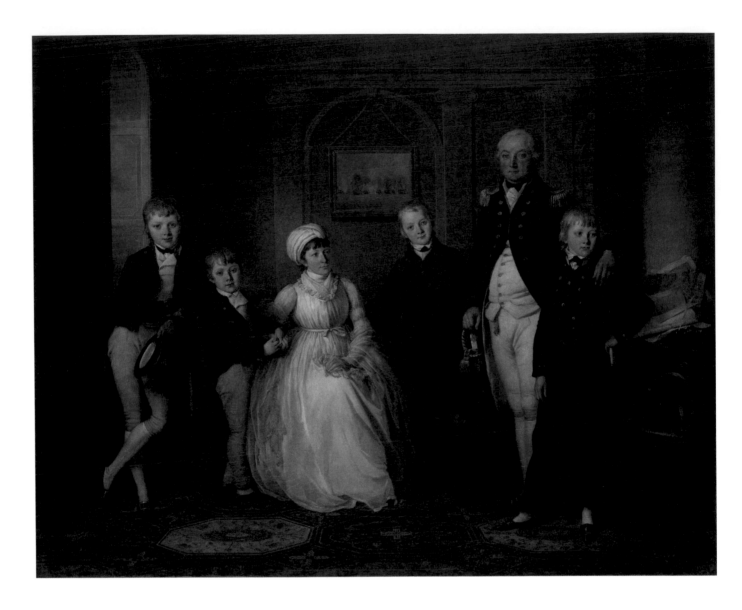

FIG. 82. Richard Livesay, *Captain Richard Grindall (1750–1820) and His Family*, ca. 1800, oil on canvas, 40 x 50⅝ in. (101.7 x 128.7 cm), National Maritime Museum, Greenwich, London

served as a venue in which to signify status, accomplishments, and political position, especially for families to whom service had brought rapid material and social advancement.[5] At these sites, an aesthetic of abundance and repetition prevailed. Pendants and series showed different moments of single battles or depicted whole careers. In addition, a notable battle or personage was sometimes represented many times over within a room, through many different media: printed in ink on paper, etched into a silver service, woven into a linen tablecloth, and painted in oils.[6]

Women were by no means the only authors of such displays; male relatives, especially fathers and older brothers, often played a role.[7] But in affluent families of this period, while a husband might be in charge of major purchases, decoration was usually a wife's prerogative.[8] Moreover, officers' frequent absences increased many women's authority, giving them full sway in the arrangement and even choice of a domicile.[9] In an age when naval officers could become overnight celebrities, with their likenesses circulated on everything from bowls to jewelry, domestic displays asserted the special

claims of the family. After Captain Edward Boscawen helped defeat French forces at the Battle of Finisterre in 1747, his wife Frances saluted him as "my hero—for that is your justest appellation."[10] A meaningfully possessive term, "my hero" could be used to stress women's ties to men lauded as national figures. So, too, could the commissioning and presentation of images. For example, Mrs. Boscawen gave an engraved portrait of her husband in a frame of her own design to the Corporation of Truro, which her husband represented in Parliament. She did not ask her husband to review the design before it was sent, instead telling him: "I wish you could see the frame I have got made (from a design of my own). . . . It is the finest carving I ever saw, of heaps of trophies joined together by cables."[11] Her gift simultaneously promoted his public reputation and her wifely devotion, literally framing his image to her own taste.

In addition to visualizing a wife's claims on her husband, images and their display could visualize claims among officers. Boscawen had secured his election to represent Truro in part by providing places in his crews for local sons, an illustration of the importance of naval patronage in this era.[12] Mrs. Boscawen commemorated such ties between officers in a domestic display that she designed. Late in 1747 she wrote to her husband about redecorating a room in their London home, reporting progress on paint and furnishings. She also noted her intent to display a portrait of his fellow officer, Thomas Henry Grenville, who was killed at Finisterre: "I spoke to Miss Grenville about putting up her brother's picture, which she very obligingly said was the greatest compliment you could pay her and it would give her great satisfaction to see such a mark of your regard for him." Mrs. Boscawen was simultaneously decorating a room and designing a memorial. She did so with full authority to choose among artists: "my outward room only waits for that sad dog [Allan] Ramsay to paint your sister Lucy. . . . I think Ramsay is more like to hit her face for being used to it, else [Thomas] Hudson should do it."[13] As this example suggests, domestic displays served multiple functions, including that of exhibiting ties of family, friendship, or patronage. Aside from creating a sense of connection with the absent, they could justify elevations in rank and fortune won at sea, occlude less successful actions, and assert the family's contribution to national and imperial pursuits.

Such displays were at once domestic and public.[14] Lawrence Klein has argued that eighteenth-century use of language reveals that "the distinction between the private and the public did not correspond to the distinction between home and not-home. . . . People at home, both men and women, were not necessarily in private."[15] This observation applies especially to the spaces—dining rooms, parlors, and galleries—discussed here, which will be described as domestic rather than private. At country houses the audience included not only the family and their guests, but also tourists, usually shown about the house by a servant.

Often, women in naval families deployed images of events they would not have experienced first hand, such as the boarding of enemy ships or the sacking of cities. Communications between husbands and wives from this period often stress this gendered difference in experience. For example, after his defeat of the US frigate *Chesapeake* during the War of 1812, Captain Philip Broke wrote to his wife, telling her he

had secured drawings of the engagement, "which I shall take care of to shew my Loo tho' she does not love such pictures of fire and terror, but they represent one of the happiest moments of my life — as affording me the privilege of retiring with honor to my beloved Loo's arms."[16] Noting that his wife did not enjoy images of battle, he asked that she nonetheless view them as proof of his right to her regard.

Yet there were many women who not only appreciated "pictures of fire and terror," but also were well equipped to understand the highly specific visual information they conveyed. The correspondence of Elizabeth, Lady Anson, wife of Admiral George Anson, reveals that she was passionately interested in tactics and well aware of the consequences of prevailing winds on fleet movements. At times she even ventured to critique the Admiralty's deployment of forces.[17] Women from naval families were sometimes consulted as sources of oral history: an artist painting the Battle of Cape St. Vincent long after the event was advised to contact the wife of one of the officers present.[18] Moreover, a husband's naval career was viewed by some as a shared project, in which a wife's social activities could play an important part.[19] In March of 1747, Mrs. Boscawen opined to her husband that the Admiralty should have given him some sort of promotion: "They will not ask me which is most proper, but in their conscience surely they must allow that one was extremely so. You will wrest it from them sooner or later, and then we shall be the less obliged to them."[20] Her shift into the first person plural is telling: he will do the wresting, but she will share the obligation — and, by extension, the honor.

At public exhibitions of the eighteenth and early nineteenth centuries, visitors read displays collectively, generating narrative links among the works on the walls.[21] Naval families of this period created interiors that could be interpreted in a similar fashion. The first example considered below, that of the Anson family, exemplifies the aesthetic of abundance and repetition prevalent in mid-eighteenth-century domestic displays; the second, that of the Duncans, shows how naval families coopted the new modes of visualizing naval achievement that developed in the wake of the French Revolution; the third, that of Lady Hamilton, mistress of Admiral Lord Nelson, represents both the apotheosis and the limits of female-designed displays in the opening years of the nineteenth century. Many of the personal relics Lady Hamilton displayed went on to become exhibits at the nation's first public museum of maritime achievement, the National Gallery of Naval Art (usually called the Naval Gallery), opened at Greenwich in 1824. There, a pioneering curator, Edward Hawke Locker, adapted the eighteenth-century aesthetic of abundance and repetition to the purposes of a new kind of display venue, the public museum.

The arrangement of works created by the family of Admiral Lord Anson at Shugborough, in Staffordshire, is one of the best-documented naval displays of the eighteenth century. A younger son, Anson made his fortune in a voyage around the world. In 1740, at the start of the War of the Austrian Succession, he led an expedition westward around Cape Horn to the Pacific coast of South America, where his charge was to incite rebellion in Spain's colonies and intercept their trading ships.[22] But the trip was harrowing, beset by storms, shipwreck, and disease. Reaching the Pacific with

a much diminished force, Anson was unable to carry out many of the objectives set out in his orders. After a fruitless attempt to catch a Spanish galleon laden with trade goods, he continued westward across the Pacific, where further hardships awaited. In June 1743 he finally succeeded in capturing the *Nuestra Señora de Cavadonga*, often referred to at the time as the Acapulco galleon. Packed with spoils, Anson's flagship completed its circumnavigation of the globe, returning to England in 1744. This voyage and the capture of the galleon were hailed as a major success of the war, and it took thirty-two wagons to haul the loot paraded through London. But the journey had been achieved at great cost. Anson set out with eight ships and some 1,900 men; he returned to England with only one ship, carrying fewer than two hundred of the original crew.[23]

Upon his return, Anson was elected to Parliament and appointed to the Admiralty, but he was not without detractors. Amid the celebrations of his circumnavigation, some questioned whether the achievement had been worth the loss of so many lives.[24] In addition, officers from ships Anson had ordered abandoned during the journey brought lawsuits claiming full shares of the prize money awarded by the Admiralty. Anson was obliged to testify, and his veracity was brought into question.[25] He countered these critiques with a narrative he commissioned, *A Voyage round the World, in the Years MDCCXL, I, II, III, IV*. First published in 1748, it went into numerous editions and was accompanied by forty-two plates, many based on drawings by Lieutenant Peircy Brett, which the text claimed set a new standard for accuracy.[26]

The Anson family seat, Shugborough, provided a domestic counterpart to the admiral's self-promoting publication. Indeed, the decorative program at Shugborough drew on the same visual source material as the book. Although the home belonged to George's older brother Thomas, George's prize money helped fund its renovation in the 1740s.[27] Its transformation was a collective family project, one in which the women of the family played an important role.[28] Beginning in 1745, Thomas expanded the house and installed garden monuments in the classical and Chinese styles.[29] In 1747 George cemented his reputation by leading a fleet to success at the Battle of Finisterre and was created Baron Anson of Soberton. In the following year he married Elizabeth Yorke, the daughter of his political ally Lord Hardwicke. Before they purchased their own country house in 1752, the couple treated Shugborough as their country residence and were closely involved in its decoration. This included displays relating to George's naval achievements; for example, Thomas sought relics of his brother's conquest that could be used to impress visitors: "I beg leave to borrow the general's flag of the Acapulco," he wrote to his brother, adding, "It may be deposited here safely, to be return'd when call'd for, & I may in the meantime contrive to make an occasional Display of it."[30] As this letter indicates, Thomas had an interest in promoting his brother's reputation, one that could only have increased when his brother was raised to the peerage. After 1747 George outranked his elder brother, overturning the regular workings of primogeniture. But the displays at Shugborough claimed the newly minted Admiral Lord Anson's status for his brother and for the family as a whole.

Evidence about the historical arrangement of pictures is usually scarce, but Shugborough is an exception, thanks to a letter written in 1750 by Lady Anson to her brother Philip's wife, Jemima Yorke, Marchioness Grey. The letter indicates that the new decorative arrangements in the large entrance hall had been suggested by Lady Grey. Richard Kingzett previously published part of this letter and connected many of the paintings mentioned with known works by Samuel Scott (fig. 83).[31] But Kingzett's edited version omits much information: the presence of two landscape paintings, the use of ornamental stucco and gilding, and the existence of an earlier display of engravings. This passage of the letter is reproduced here in full for the first time:

> The Hall [is] partly finished with the Sea-pieces, & Stucco, but not finished; & the Prints removed into the <u>Gallery</u>, which is now a very spacious Room, by the management of the Recess made for the model of a Man of War: These and some new openings without doors, and a great Scheme scarcely sketched out, have furnished us with Conversation & Admiration since we came; and when we praise the Hall we pay all due acknowledgements to your Ladyship for the idea of fitting up as it is now in the way of being, wch. really makes it look much larger as well as better: the Action off Cape Finisterre is already up, & looks finely; the two Islands are over two of the Doors, (I hope Mr. Wray will not be in the way when you receive this Letter, for I cannot flatter Mr. Pond upon those performances;— indeed we all agree that they look, only a little bigger, but otherwise, exactly like two of the Prints not very pleasingly colored, with the black Ink coming thro'.) the burning of Payta is to be over the Chimney, the actions between the Centurion & the Galleon, & the Lyon & Elizabeth of each side of the Door into the room you dined in, & two other actions of Captains of my Lords in the War over the other Doors; so that the whole will be a kind of History, and with Gilding and Ornaments of Stucco will be vastly pretty.[32]

As the phrase "a kind of History" suggests, this new display was intended not only to please the eye, but also to inform the viewer about Anson's career.

The full text of Lady Anson's letter reveals that the installation in the hall was intimately connected with Anson's publication, *Voyage round the World*. In addition to battle paintings by Samuel Scott, the hall contained depictions of "the two Islands" by a "Mr. Pond."[33] The artist in question is surely Arthur Pond, who was commissioned by George Anson to oversee the production of the plates for *Voyage*.[34] Pond and the Yorke family had a mutual friend in the antiquarian Daniel Wray—the "Mr. Wray" who Lady Anson hoped would not be informed of her poor opinion of Pond's work.[35] Lady Anson's complaint that Pond's paintings were "only a little bigger, but otherwise, exactly like two of the Prints not very pleasingly colored," makes it clear that these paintings, like several of Scott's, were closely related to plates from *Voyage*, which had previously hung in the hall before being "removed into the <u>Gallery</u>."[36] Reversing the usual order of production, the oil paintings were produced after the engravings were

FIG. 83. Samuel Scott, *The Capture of the* Nuestra Señora de Cavadonga *by the* Centurion, *20 June 1743*, ca. 1743, oil on canvas, 40½ x 59½ in. (102.9 x 151.1 cm). National Maritime Museum, Greenwich, London, Caird Collection (cat. 55)

FIG. 84. James Mason, *A View of Cape Espiritu Santo*, from Richard Walter, *A Voyage round the World*, 1748, engraving, 8½ x 19½ in. (22 x 49.5 cm). Beinecke Rare Book & Manuscript Library, Yale University

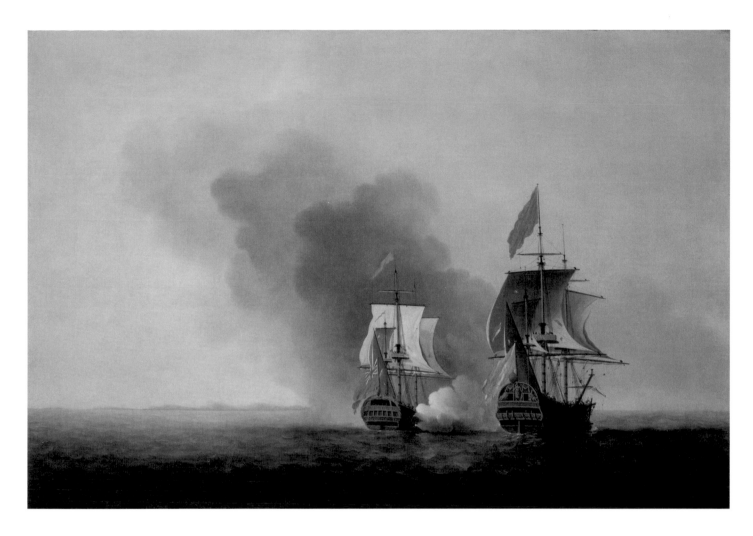

Plate XI.

A view of CAPE ESPIRITU SANTO, on SAMAL, one of the Phillipine Islands, in the latitude of 12:40 N? Bearing WSW distant 6 leagues. In the position here represented his Majestys Ship the CENTURION engag'd and took the Spanish Galeon call'd NOSTRA SEIGNIORA DE CABADONGA, from ACAPULCO bound to MANILA.

printed; both oils and prints were based on drawings made by Peircy Brett, ostensibly during the mission (fig. 84). Visitors familiar with *Voyage*, an extraordinarily popular book, would have entered the hall and found a color version of a visual narrative that they had already encountered in print, augmented by paintings of Anson's subsequent triumphs at sea, including his victory at Finisterre (see cat. 53). They would have encountered these same compositions again when viewing the prints in the gallery.

Redundancy does not seem to have been a concern; rather, multiple representations offered the visual pleasures of comparison and the narrative pleasures of conversation. In the entrance hall, surrounded by gilding and stucco, the paintings represented multiple single-ship actions, a major fleet engagement, the burning of a city, and the islands where Anson's expedition had found refuge, thus alternating between sea and land, conflict and calm. Just as Mrs. Boscawen's display had done several years earlier, the installation in the Ansons' hall invoked ties between officers. Two paintings hung above doors represented what Lady Anson called "two other actions of Captains of my Lords in the War."[37] In addition, on either side of a doorway hung two single-ship actions: first, the capture of the Spanish galleon; and second, the clash in 1745 between the *Lion*, commanded by Peircy Brett, and the *Elizabeth*, which was escorting Charles Edward Stuart, the Jacobite claimant to the throne, to Scotland. This pairing thus invoked two different campaigns against two different foes, led by two different officers. Together, these images encompassed not only Anson's own actions, but also those of the men whom he had trained. Alongside these scenes hung Scott's vivid depiction of *The Burning of Payta* (fig. 85). It was hung above a fireplace, perhaps because it was thematically appropriate, contrasting an uncontrolled

blaze with the contained warmth of a domestic hearth.[38] This dramatic depiction of a city in flames gave no indication that the city in question was of little strategic value; the diminished state of Anson's forces when he reached the Pacific had prevented him from attacking more substantial South American targets.[39] In its plenitude, the display conveyed the impression of a complete narrative while glossing over less flattering details.

Pond's images of islands also turned attention away from the difficulties of the voyage. Although these paintings have yet to be located, Lady Anson's account indicates that they very closely followed engravings from the book, likely *A View of the Commodore's Tent at the Island of Juan Fernandes* and *A View of the Watering Place at Tenian* (figs. 86–87). The first site (Juan Fernández, off the Chilean coast) was the

meeting place for Anson's forces after their brutal passage around Cape Horn, and the second, the island (Tinian) where they were later stranded in the Pacific, east of the Philippines. These pastoral compositions depict the islands as if they were already cultivated English colonies rather than temporary refuges for an expedition in desperate condition. They provide no hint of the miserable state of the scurvy-ridden men described in *Voyage*, some of them so weak that they lay on the beach waiting to be carried to shelter.[40] Instead, these images follow other passages of the text, which praise the beauty of the islands: Tinian, the text claims, does not appear "uncultivated," but "has much more the air of a magnificent plantation." Similarly, it points out the "elegance of the situation" that Anson "made choice of for his own residence" on Juan Fernández.[41] There is no land, this text implies, that cannot be turned into an English country estate.[42] Visitors to the Anson home would have been able to shift their gaze from Pond's idealized landscapes of distant islands to Shugborough's grounds, which Anson's prize money had shaped to meet the same aesthetic standards.

Such visual messages would have been reinforced through a crucial but ephemeral aspect of this display: the conversations it occasioned. These discussions very likely included the women who had been closely involved in its creation, Lady Anson and Lady Grey. Lady Anson certainly viewed discussion of battles as appropriate entertainment for visitors. During the Seven Years' War, days after the victory of British allied forces at the Battle of Minden, she wrote to Lady Grey, inviting her to visit their country house: "Do, dear Madam, let me have the pleasure of seeing you at Moor-Park; my Cook indeed is sick, but you shall have the Entertainment of a Nice Plan of the Battle . . . whc. will explain the whole affair delightfully to you."[43] Reviewing battles, apparently, was a type of entertainment that might compensate for the lack of other types of hospitality, such as elaborate cuisine. But this entertainment also had a serious goal: vindicating the reputation of the commanding officer, Prince Ferdinand of Brunswick. Lady Anson claimed that the accounts of the battle she had gathered would allow her guest to "see how every thing was considered, tho' some say P. Ferdinand was <u>surprized</u>." One suspects that Lady Anson was no less fervent when discussing her own husband's career at Shugborough. As she noted, the installation of paintings in that house's hall constituted "a kind of History." It was a history that was visually communicated, subject to verbal extrapolation, and deeply partisan.

Domestic displays like the Ansons' became increasingly common as Britain's imperial ambitions grew over the course of the eighteenth century. The scale of the wars against the French between 1793, when Britain became involved, and 1815 created many opportunities for the advancement of naval officers, whose families adapted the existing tradition of domestic displays. One such family was that of Admiral Adam Duncan, who achieved a decisive victory over France's Dutch allies at the Battle of Camperdown in 1797, for which he was created Viscount Duncan. The first major battle after the mutinies of British sailors at Spithead and Nore, Camperdown helped restore confidence in the navy and made Duncan a national hero.[44] His family's collecting practices show how domestic displays responded to the newer, more spectacular modes of visualizing naval victory that developed in the wake of the French Revolution.

FIG. 88. John Singleton Copley, *Victory of Lord Duncan*, 1799, oil on canvas, 108 x 145 in. (275 x 368.5 cm). National Galleries of Scotland

When commissioning artworks, Duncan seems to have preferred portraits, leaving it to his relatives to supply images of battle for the family's homes. His aunt, Lady Mary Duncan, took an active interest in his career, even going so far as to harangue their relative, Henry Dundas, Secretary of State for War, about Duncan's reward for Camperdown: "The whole nation thinks the least you can do is to give him an earldom. Please to recollect what a chicken-hearted way all the nation was in, low spirited by the war, murmuring at taxes (tho' necessary), grumbling and dissatisfied in every county. Now comes my hero, the first that attempted to quash the rebellious seamen. . . . He flies after the Dutch; completely beats them, though they resisted like brave men."[45] Many artists capitalized on public interest in Camperdown, including John Singleton Copley, who in 1799 staged a one-work exhibition of a monumental canvas, *Victory of Lord Duncan* (fig. 88).[46] The reviewer for the *Morning Chronicle* deemed it "a successful

attempt to treat naval victory in a new and agreeable manner."[47] This new manner, first developed by artists in response to the victory on June 1, 1794 (the "Glorious First of June"), against the French Revolutionary navy, provided a closer view of the protagonists.[48] In 1801 Lady Duncan purchased a framed engraving of Copley's image.[49] A year later, she arranged to buy the painting itself as a gift for her nephew. As the Ansons had done, Lady Duncan acquired the print before adding a painting of the same composition to the family collection. According to the artist's wife, Lady Duncan "said it was a very fine picture; that it ought to be in and remain in Lord Duncan's family, and she did not wish to have it placed in any public situation."[50] Lady Duncan's wish to keep the painting from a public situation may seem perverse, given that it had been designed expressly for exhibition and indeed shown to a paying audience. But her purchase had powerful symbolic value, reclaiming the image for the family and for the home. Duncan's victory at Camperdown had put his image into wide circulation. His likeness appeared in prints and paintings and on mugs and tokens (fig. 89).[51] Lady Duncan's purchase of Copley's painting put the image of the man she called "my hero" firmly back in the family's control.

Yet, as was usually the case with domestic displays, the acquisition of Copley's painting did not mean that it was seen only by the family. Duncan chose to display his aunt's gift in his townhouse in Edinburgh, where it became the locus of a new ritual: every year on the anniversary of Camperdown, the house would be opened to visitors, who came to see the painting and to mark the memory of the battle.[52] His wife continued the tradition after his death. The family's private ownership of the image—and by extension, of Duncan's reputation—was thus ratified by annual public witness. In other words, some publicity was necessary to make meaningful the possession of the picture in private hands.

At the same time that Copley's *Victory of Lord Duncan* was installed in an Edinburgh townhouse, Emma, Lady Hamilton, was designing a home for another renowned officer, Admiral Lord Nelson, at Merton Place in Surrey. The daughter of a blacksmith, Lady Hamilton had worked as an artist's model before marrying the diplomat Sir William Hamilton, and was famous for her performance of "attitudes" emulating classical sculpture. After she fell in love with Horatio Nelson, she lived with her husband and the admiral in an unconventional but congenial trio. Unlike the other women discussed here, Lady Hamilton was not the legal partner of a naval officer.[53] During Nelson's lifetime, though the trio lived at Merton, it was not legally or socially recognized as her house, and responses to it were inevitably colored by that fact. Nonetheless, Merton and its decor deserve to be considered as part of the tradition of domestic display spaces designed by women of naval families. At Merton, Lady Hamilton embraced existing elite modes of visual self-promotion, especially the aesthetic of abundance and repetition.

The house was selected by Lady Hamilton, purchased by Nelson sight unseen in 1801, and expanded and furnished under her direction. As in earlier displays, including the Ansons', she integrated portraits, battle images, and relics with other elements of home decor. But in this case, the display was condemned by some as overdone. Visiting in 1802, Gilbert Elliot, first Earl of Minto, wrote:

FIG. 89. Peter Kempson, Peter Wyon, and Thomas Wyon, *Dundee Penny Token Commemorating Admiral of the Fleet Adam Duncan (1731–1804) and the Battle of Camperdown*, 1797, 1798, copper, 1¼ in. (3.2 cm) diam. National Maritime Museum, Greenwich, London

FIG. 90. Thomas Baxter, *Lady Hamilton as Britannia, with a Bust of Nelson*, from "Book of Drawings by Thomas Baxter of Lady Hamilton, Merton, etc., Originally Belonging to Lady Hamilton." National Maritime Museum, Greenwich, London, Archive

Not only the rooms, but the whole house, staircase and all, are covered with nothing but pictures of her and him, of all sizes and sorts, and representations of his naval actions, coats of arms, pieces of plate in his honour, the flagstaff of 'L'Orient', &c.—an excess of vanity which counteracts its own purpose. If it was Lady H's house there might be a pretence for it; to make his own a mere looking-glass to view himself all day is bad taste.[54]

Without further primary evidence, it is impossible to judge whether the decor at Merton was as excessive as this report suggests. If creating a domestic interior that repeatedly visualized the accomplishments of an officer was indeed in bad taste, then many eighteenth-century naval families had been guilty of it. Perhaps the number of objects at Merton was extreme even by the standards of the day. But it also seems clear that Minto's distaste was as much for Lady Hamilton's social origins and her irregular relationship with Nelson as for the actual decor of the home. In any case, Minto was deeply mistaken about whom the display at Merton was for—while it may have served as a "looking-glass" for Nelson, it also reflected the interests of its author, Lady Hamilton. Merton provided her with a connection to Nelson when he was away at sea, with a sense of legitimacy as Nelson's consort, and with a lavish visual context in which to perform that role for visitors to the house.

Some sense of the interior's appearance can be gleaned from a narrative by the Danish author A. A. Feldborg, who visited Merton in the summer of 1805. His account indicates how domestic ensembles could be activated through conversation. Feldborg claimed that he received a personalized tour from Nelson, who drew his attention to items he perceived would be of special interest: "Lord Nelson paused on the stair-case, the walls of which were adorned with prints of his Lordship's battles, and other naval engagements; he pointed out to me the battle of Copenhagen."[55] In this description, conversation makes the abundant display so disliked by Minto both comprehensible and of personal significance. Feldborg also reported that at Merton one encountered Nelson's image before one saw the man himself: "Entering the house, I proceeded through a lobby, which, among a variety of paintings, and other pieces of art, contained an excellent marble bust of the illustrious Admiral. . . . I was then ushered into a magnificent apartment where Lady Hamilton sat at the window; I first scarcely observed his Lordship, he having placed himself immediately at the entrance on the right."[56]

Whether strictly accurate or not, this passage speaks to a deeper truth about Merton: adorned with images of Nelson, it was a stage set for Lady Hamilton to

present herself, artfully arranged in a window or otherwise. In this context it might at first be difficult to notice the actual Nelson, even when he was in residence. An album of drawings attributed to the china painter Thomas Baxter suggests that Lady Hamilton continued to perform her attitudes at Merton, now with the help of Nelson's nieces.[57] One of these drawings shows her as Britannia, embracing a bust that is likely the one mentioned by Feldborg (fig. 90). Although Lady Hamilton's attitudes were unique, naval families' country houses had long served as the platform for self-presentation, where women could not only converse about the decor with guests and pore over battle plans, but also engage in amateur theatricals. After Nelson's death at Trafalgar in 1805, Lady Hamilton fell deeper into debt and was eventually forced to sell most of her possessions.[58] Many of her personal relics entered public collections. Like other domestic displays from this period, Merton provided the material of memory that would be redeployed in the public museums of the nineteenth century.

The domestic spaces discussed so far had a limited audience of family members, guests, and, in some cases, country house tourists. In the early nineteenth century, newly founded museums addressed a wider, ostensibly national, audience. Geoff Quilley has recently shown that around 1800 a new kind of display emerged, "a systematic and taxonomic visual classification of national maritime history," fueled in part by developing, contested concepts of nationhood.[59] These new taxonomies were often constructed from works originally commissioned for domestic contexts. Moreover, their arrangement was influenced by domestic practices. The carryover of such practices is most often discussed in terms of art museums, such as London's National Gallery, which was opened to the public largely unchanged from its original configuration as a connoisseur's townhouse.[60] But domestic practices also influenced the nation's earliest museum of naval history, the Naval Gallery (fig. 91). Opened to the public in 1824, this installation transformed the Painted Hall of Greenwich Hospital, a royally funded home for elderly or disabled seamen, into a visual history of the British navy: a collective statement about national glory, constructed through images of individual achievements, many of which had been originally intended for the home.[61] The Naval Gallery showed images of officers and their actions alongside relics, including captured standards and Nelson's uniforms, just as the Spanish galleon's flag had been shown at Shugborough and parts of the mast of *L'Orient*, from the Battle of the Nile, at Merton.

The Naval Gallery was both a public monument and a family project: first proposed by the hospital's lieutenant governor, William Locker, in the 1790s, it was brought to fruition in the 1820s by his son, the hospital's secretary, Edward Hawke Locker. Along with a large gift from George IV, private donations formed the heart of the collections. Family reputation was at stake, even as it had been in the creation of the country house collections from which works were extracted. "When I go into the country," wrote one potential donor, "I will have my family pictures examined and select from them my rever'd grandfather who I feel will not be the least distinguished character in your brilliant collection of British Heroes."[62] Similarly, Admiral Duncan's son retained Copley's grand battle painting, but donated a portrait of his father and

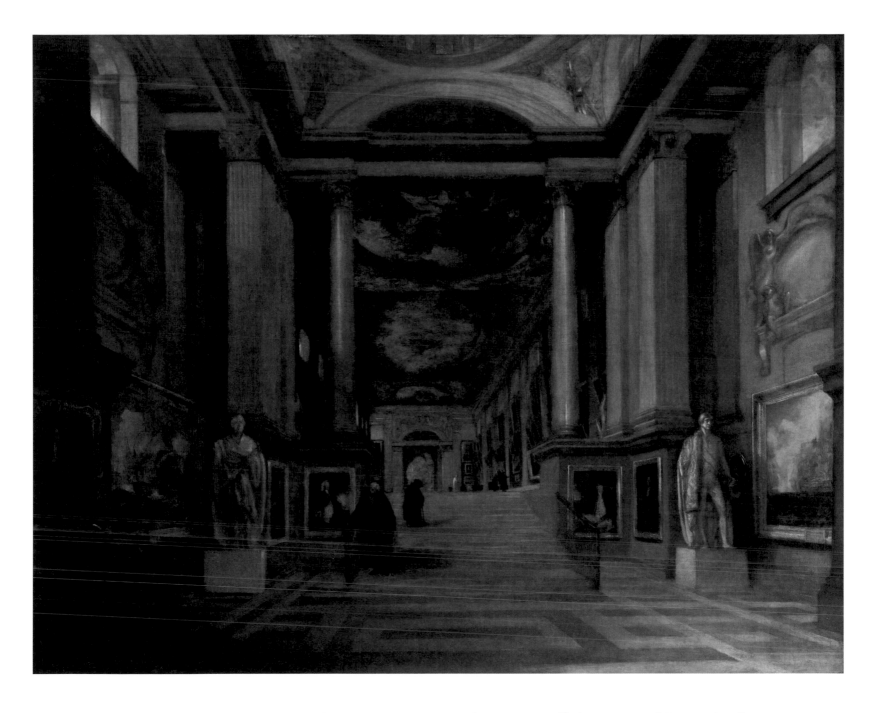

FIG. 91. John Scarlett Davis,
*The Interior of the Painted Hall,
Greenwich Hospital*, 1830, oil on
canvas, 44⅜ x 56½ in. (112.7 x
143.6 cm). The Walters Art
Museum (cat. 140)

protested when it was not hung in the main space.[63] The creation of the Naval Gallery
thus gave a new public outlet to family commemoration.

E. H. Locker believed that works of historical interest should be removed from
"the obscurity of private apartments."[64] At the same time, however, his curation of the
Naval Gallery was informed by the arrangements of such apartments. Locker's own
residence was lavishly furnished with artworks commemorating his father's naval
career.[65] Battle scenes hung alongside portraits celebrating patronage relationships
between Locker family members and some of the most illustrious admirals of the day.
In the Naval Gallery, Locker employed the same aesthetic of abundance seen in his

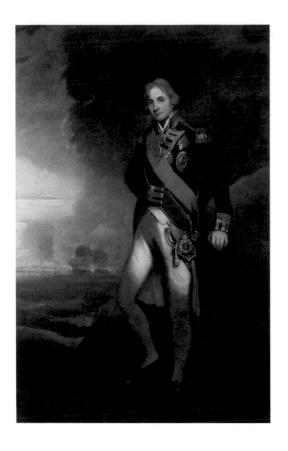

own home and in those of his eighteenth-century predecessors. Visitors to Shugborough in the 1750s could see in one room images depicting several phases of Anson's career. Visitors to Locker's apartments in the 1830s could see portraits of Nelson before and after his loss of an arm, hung on adjoining walls.[66] Similarly, on the north wall of the Naval Gallery, Captain James Cook simultaneously pointed confidently to his nautical charts and was struck down in Hawaii; Nelson stood tall as the victor of Copenhagen and lay dying below decks on the *Victory* (figs. 92-93).[67] Not all of these paintings had been crafted for a domestic context: the images of death in service to the nation were designed for wider circulation through exhibitions and reproductions. Yet the manner in which Locker arranged these paintings closely resembled domestic displays, including his own. Chronology provided the overall logic of the Naval Gallery hang, but, as in homes of the period, an abundance of imagery also created more complex temporal effects, looping and layering time.

The Naval Gallery also pioneered new display practices, one of which had major consequences for the reception of marine paintings of naval engagements. With the advent of the public gallery, many families broke up sets that had originally been commissioned as pendants or series.[68] Locker himself split a pair of paintings he had inherited from his father, donating Dominic Serres's Experiment *Taking the* Télémaque, *1757* to the gallery (fig. 94), while keeping for his home its pendant of the same title, now in a private collection. Dispersing sets hindered their use in the detailed recounting of battles, which was central to their original function.[69] But the multiplicity of

FIG. 92. Matthew Shepperson after John Hoppner, *Rear Admiral Sir Horatio Nelson, 1st Viscount Nelson*, 1823–24, oil on canvas, 94 x 58 in. (239 x 147.5 cm). National Maritime Museum, Greenwich, London, Greenwich Hospital Collection

FIG. 93. Arthur Devis, *The Death of Nelson*, 1807, oil on canvas, 77 x 103 in. (195.6 x 261.6 cm). National Maritime Museum, Greenwich, London, Greenwich Hospital Collection

FIG. 94. Dominic Serres, Experiment *Taking the* Télémaque, 1757, 1769, oil on canvas, 26 x 37 in. (66.1 x 94 cm). National Maritime Museum, Greenwich, London, Greenwich Hospital Collection (cat. 113)

images common in the eighteenth century now provided an opportunity to maximize a family's exposure, pursuing glory simultaneously in the museum and in the home.

A final, crucial difference between eighteenth-century domestic displays and the nineteenth-century museum was the role of women. At the Naval Gallery, women could participate as donors and as viewers, but not as authors of the display.[70] This attitude is reflected in a painting that shows a slightly later incarnation of the Naval Gallery, Andrew Morton's *United Service* of 1845 (fig. 95). Morton presents an idealized depiction of working-class veterans, Chelsea and Greenwich pensioners, who discuss a representation of the Battle of the Nile. In contrast, the women in the picture are mostly preoccupied with a baby. Only one girl has chosen to join the group of pensioners and to listen to the story as she looks at the painting. Her presence among

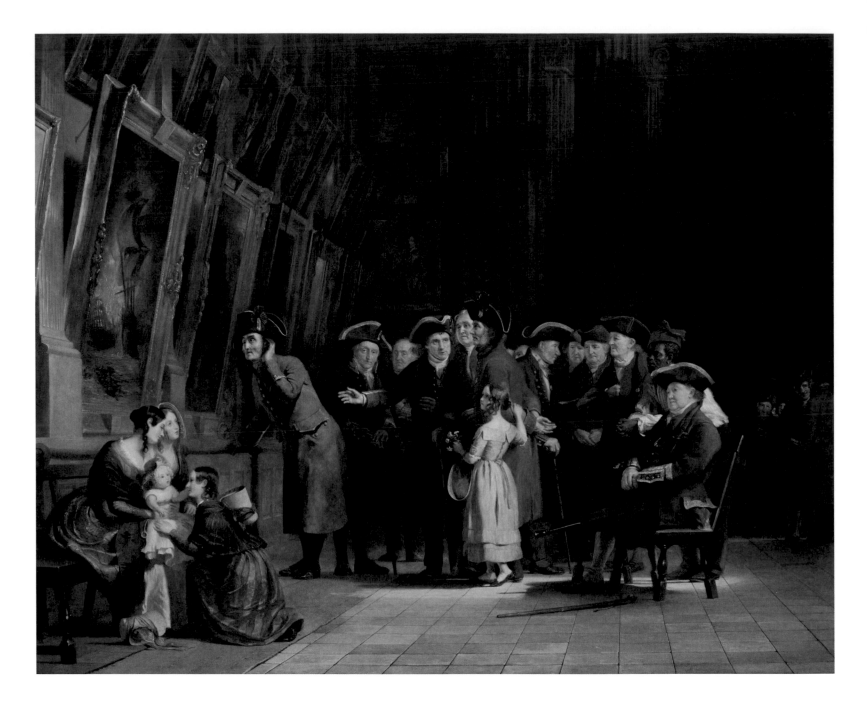

the veterans creates an artificial family, masking the harsh reality that pensioners' relatives were not allowed to live at the hospital.[71] As a lone female among men, this figure recalls that of Katherine Grindall in the painting with which this essay began. But unlike Mrs. Grindall and the other eighteenth-century women discussed here, this girl cannot choose to rearrange the display in which she is pictured. Despite the development of new styles and the dispersal of commissioned sets, eighteenth-century marine paintings of naval engagements constituted a vital element of the new, public museum. But in the transition from home to gallery, the dynamic tradition of the deployment of marine paintings by naval family members of both sexes was lost.

FIG. 95. Andrew Morton, *The United Service*, 1845, oil on canvas, 46 x 58 in. (116.8 x 147.3 cm). National Maritime Museum, Greenwich, London

1. Research for this essay was made possible by a Caird Short-Term Research Fellowship at the National Maritime Museum and a Virginia Commonwealth University School of the Arts Dean's Research Reassignment.

2. Based on their apparent ages, I have tentatively identified the boys as, from left to right: Richard Henry Festing Grindall, (1784–?); Edmund Grindall (1791–1811); Rivers Francis Grindall (1786–1832); and Festing Horatio Grindall (1787–1812). Many thanks to John Robson, Map Librarian, University of Waikato, New Zealand, for generously sharing his research on the Grindall family.

3. In June 1795 Grindall had distinguished himself by being the first to engage the French at Bridport's Action (also known as the Battle of Groix). T. A. Heathcote, *Nelson's Trafalgar Captains and Their Battles* (Barnsley: Pen & Sword Maritime, 2005), 75.

4. Matthew Craske, "Making National Heroes? A Survey of the Social and Political Functions and Meanings of Major British Funeral Monuments to Naval and Military Figures, 1730–1770," in *Conflicting Visions: War and Visual Culture in Britain and France, c. 1700–1830*, ed. John Bonehill and Geoff Quilley (Aldershot, UK: Ashgate, 2005), 41–59; Rina Prentice, *A Celebration of the Sea: The Decorative Arts Collections of the National Maritime Museum* (London: Her Majesty's Stationery Office, 1994).

5. For a related example, see Joan Coutu, "Setting the Empire in Stone: Commemorating Wolfe in the Gardens at Stowe," in *The Culture of the Seven Years' War: Empire, Identity, and the Arts in the Eighteenth-Century Atlantic World*, ed. Frans De Bruyn and Shaun Regan (Toronto: Univ. of Toronto Press, 2014), 274.

6. See, for example, Prentice, *Celebration*, 36–37.

7. See, for example, the Parker family: Alan Russet, *Dominic Serres R.A., 1719–1793: War Artist to the Navy* (Woodbridge, UK: Antique Collectors' Club, 2001), 106–11; Oliver Garnett, *Melford Hall, Suffolk* (London: National Trust, 2005), 34.

8. Amanda Vickery, *The Gentleman's Daughter: Women's Lives in Georgian England* (London: Folio Society, 2006), 23.

9. Margarette Lincoln, *Naval Wives and Mistresses*, 1st ed. (Greenwich: National Maritime Museum, 2007), 101.

10. Cecil Aspinall-Oglander, *Admiral's Wife: Being the Life and Letters of the Hon. Mrs. Edward Boscawen from 1719 to 1761* (London: Longmans, 1940), 43.

11. Aspinall-Oglander, *Admiral's Wife*, 72.

12. Romney Sedgwick, *The House of Commons, 1715–1754*, 2 vols. (London: Her Majesty's Stationery Office, 1970), 1:475.

13. Aspinall-Oglander, *Admiral's Wife*, 65; see also Lincoln, *Naval Wives*, 53.

14. On recent approaches to gender in the eighteenth century that complicate the public/private binary, see Kathleen Wilson, *The Island Race: Englishness, Empire and Gender in the Eighteenth Century* (London: Routledge, 2003), 92.

15. Lawrence Eliot Klein, "Gender and the Public/Private Distinction in the Eighteenth Century: Some Questions about Evidence and Analytic Procedure," *Eighteenth-Century Studies* 29, no. 1 (1995): 105.

16. Quoted in Ann V. Gunn, "The Rival Frigates: Commemorating the Battle of the Shannon and the Chesapeake," *British Art Journal* 7, no. 2 (2006): 103.

17. Lady Elizabeth Anson to Thomas Anson, Aug. 23 [1757]. Staffordshire Record Office, Records of the Anson Family of Shugborough, Earls of Lichfield, D615/P(S)/1/3/28A.

18. Edward Hawke Locker to George Jones, July 12, 1828. The National Archives Public Record Office (hereafter TNA PRO), Greenwich Hospital, Naval Gallery, Correspondence of Edward Hawke Locker, 30/26/27, 168.

19. Lincoln, *Naval Wives*, 52.

20. Aspinall-Oglander, *Admiral's Wife*, 36.

21. Mark Hallett, "Reading the Walls: Pictorial Dialogue at the British Royal Academy," *Eighteenth-Century Studies* 37, no. 4 (Summer 2004): 581–604; Eleanor Hughes, "Ships of the 'Line': The Royal Academy Exhibition of 1784," in *Art and the British Empire*, ed. Tim Barringer, Geoff Quilley, and Douglas Fordham (Manchester: Manchester Univ. Press, 2006), 139–52.

22. This account of the voyage is based on Glyn Williams, *The Prize of All the Oceans: The*

Triumph and Tragedy of Anson's Voyage Round the World (London: Harper Collins, 1999).

23. Accounts vary as to precisely how many from the original expedition returned with Anson; N. A. M. Rodger puts the number at 145. "George Anson, Baron Anson (1697–1762)," in *Oxford Dictionary of National Biography*, Oxford Univ. Press, 2004: http://dx.doi:10.1093/ref:odnb/574 (accessed Nov. 3, 2014). Some crewmembers made it back separately. Glyn Williams estimates that around 500 of the original 1,900-man force survived, roughly a 75 percent mortality rate. Williams, *Prize*, 202.

24. Williams, *Prize*, 208.

25. Williams, *Prize*, 215.

26. See Sarah Monks, "Our Man in Havana: Representation and Reputation in Lieutenant Philip Orsbridge's *Britannia's Triumph* (1765)," in Bonehill and Quilley, *Conflicting Visions*, 95–98.

27. John Martin Robinson, *Shugborough* (London: National Trust, 1989), 7.

28. See, for example, Thomas's request for Lady Anson's assistance with the completion of the Chinese House. Thomas Anson to George Anson [n.d.]. British Library (hereafter BL), Original, Private, and Official Correspondence of Lord Anson, Add MS 15955, f. 85.

29. Kerry Bristol, "The Society of Dilettanti, James 'Athenian' Stuart and the Anson Family," *Apollo* 152, no. 461 (July 2000): 46–54.

30. Thomas Anson to George Anson, July 30 [no year]. BL, Add MS 15955, f. 55.

31. Richard Kingzett, "A Catalogue of the Works of Samuel Scott," *Walpole Society* 48 (1980–82): 130.

32. Although Kingzett identifies the letter's location as the Staffordshire Record Office, it is held by the Bedfordshire Archives. Elizabeth, Lady Anson, to Jemima Yorke, Marchioness Grey, Aug. 20 [1750]. Bedfordshire and Luton Archives and Records Service (hereafter BRS), L30/9/3/24, Correspondence to Jemima, née Campbell (1722–1797), Marchioness Grey and Baroness Lucas.

33. On the battle paintings, see Kingzett, "Catalogue of Works of Samuel Scott," 130–33.

34. Louise Lippincott, *Selling Art in Georgian London: The Rise of Arthur Pond* (New Haven and London: Published for the Paul Mellon Centre for Studies in British Art by Yale Univ. Press, 1983), 154–56.

35. E. I. Carlyle, "Daniel Wray (1701–1783)," rev. J. A. Marchand, in *Oxford Dictionary of National Biography*, Oxford Univ. Press, 2004: http://dx.doi:10.1093/ref:odnb/30016 (accessed Nov. 6, 2014).

36. Kingzett, "Catalogue of Works of Samuel Scott," 130–33.

37. One of the paintings may have been Scott's Nottingham *and* Mars, depicting the capture of a French ship in 1746 by Captain Philip de Saumarez, who had served on the circumnavigation; the other has yet to be identified. Kingzett, "Catalogue of Works of Samuel Scott," 33, 132.

38. For the practice of hanging marines over the hearth, see Eleanor Hughes, "Vessels of Empire: Eighteenth-Century Marine Paintings" (PhD diss., Univ. of California, Berkeley, 2001), 82.

39. Williams, *Prize*, 113.

40. *A Voyage round the World, in the Years MDCCXL, I, II, III, IV. By George Anson, Esq . . .* , compiled and published by Richard Walter, 5th edition (London: John and Paul Knapton, 1749), 113.

41. *Voyage*, 306, 118–19.

42. As Tim Barringer has shown, pictorial conventions could be used to "deny the differences between a tropical and a European landscape." Barringer, "Picturesque Prospects and the Labor of the Enslaved," in *Art and Emancipation in Jamaica: Isaac Mendes Belisario and His Worlds*, ed. Tim Barringer, Gillian Forrester, and Barbaro Martinez-Ruiz, exh. cat. (New Haven: Yale Center for British Art in association with Yale Univ. Press, 2007), 41.

43. For this and the following quotation, see Lady Elizabeth Anson to Jemima Yorke, Marchioness Grey, Aug. 9 [1759]. BRS, L30/9/3/105.

44. Janice Murray, *Glorious Victory: Admiral Duncan and the Battle of Camperdown* (Dundee: Dundee City Council, 1997), 22.

45. Quoted in Murray, *Glorious Victory*, 41.

46. Emily Ballew Neff and William L. Pressly, *John Singleton Copley in England* (London: Merrell Publishers, 1995), 35.

47. Quoted in Nicholas Tracy, *Britannia's Palette: The Arts of Naval Victory* (Montreal: McGill-Queen's Univ. Press, 2007), 120.

48. Eleanor Hughes, "Sanguinary Engagements: Exhibiting the Naval Battles of the French Revolutionary and Napoleonic Wars," in *Exhibiting the Empire: Cultures of Display and the British Empire*, ed. John McAleer and John M. Mackenzie (Manchester: Manchester Univ. Press, 2015), 90–110.

49. Lincoln, *Naval Wives*, 18.

50. Martha Babcock Amory, *The Domestic and Artistic Life of John Singleton Copley, R. A.* (Boston: Houghton, Mifflin, 1882), 95.

51. Murray, *Glorious Victory*, 53, 59.

52. John Kay, *A Series of Original Portraits and Caricature Etchings*, 2 vols. (Edinburgh: Adam and Charles Black, 1877), 1:363. See also Murray, *Glorious Victory*, 67–69.

53. See Kathleen Wilson, "Nelson's Women: Female Masculinity and Body Politics in the French and Napoleonic Wars," *European History Quarterly* 37, no. 4 (2007): 562–81.

54. Gilbert Elliot, *Life and Letters of Sir Gilbert Elliot, First Earl of Minto, from 1751 to 1806*, ed. Emma Elliot, Countess of Minto, 3 vols. (London: Longmans, Green, 1874), 3:242.

55. A. A. Feldborg, writing as J. A. Anderson, *A Dane's Excursions in Britain*, 2 vols. (London: Matthews and Leigh, 1809), 1:23.

56. Feldborg, *Dane's Excursions*, 1:17–18.

57. "Book of drawings by Thomas Baxter of Lady Hamilton, Merton, etc., originally belonging to Lady Hamilton," National Maritime Museum, WAL/49.

58. Kate Williams, *England's Mistress: The Infamous Life of Emma Hamilton* (London: Hutchinson, 2006), 337.

59. Geoff Quilley, *Empire to Nation: Art, History, and the Visualization of Maritime Britain, 1768–1829* (New Haven and London: Published for the Paul Mellon Centre for Studies in British Art by Yale Univ. Press, 2011), 203.

60. See, for example, Holger Hoock, "Reforming Culture: National Art Institutions in the Age of Reform," in *Rethinking the Age of Reform*, ed. Arthur Burns and Joanna Innes (Cambridge: Cambridge Univ. Press, 2003), 261.

61. Pieter van der Merwe, "'A Proud Monument of the Glory of England': The Greenwich Hospital Collection," in *Art for the Nation: The Oil Paintings Collection of the National Maritime Museum*, ed. Geoff Quilley (London: National Maritime Museum, 2006), 19–38.

62. Edward Hawke, third Baron Hawke, to E. H. Locker, Dec. 13, 1823. TNA PRO, 30/26/27, 77. Cicely Robinson has recently reconstructed the Naval Gallery hang and discovered important archival sources. Robinson, "Edward Hawke Locker and the Foundation of the National Gallery of Naval Art (c. 1795–1845)," 2 vols. (PhD diss., Univ. of York, 2014).

63. Van der Merwe, "A Proud Monument," 27.

64. E. H. Locker, "Memorandum," Sept. 20, 1823. TNA PRO 30/26/27, 19. See also Robinson, "Edward Hawke Locker," 1:58.

65. Catherine Roach, "Domestic Display and Imperial Identity: A Visual Record of the Art Collections of Edward Hawke Locker," *Huntington Library Quarterly* 75, no. 3 (Autumn 2012): 411–28.

66. Roach, "Domestic Display," 415.

67. Robinson, "Edward Hawke Locker," 2:58–60.

68. Examples include Admiral James Gambier's donation of one of Nicholas Pocock's pendants of the Battle of St. Kitts (Robinson, "Edward Hawke Locker," 1:85–86) and Shute Barrington's successful request for the return of one painting each from the three sets depicting his brother Samuel's actions by Dominic Serres (Van der Merwe, "A Proud Monument," 33). In addition, a protégé of Sir Edward Hughes arranged for the transfer of all but one of a series of seven Serres paintings to the town hall at Ipswich (Van der Merwe, "A Proud Monument," 33; Russett, *Dominic Serres*, 170).

69. Hughes, "Vessels of Empire," 4.

70. For the numerous female donors to the gallery, see *Descriptive Catalogue of the Portraits of Naval Commanders, Representations of Naval Actions, Relics, &c., Exhibited in the Painted Hall of Greenwich Hospital, and the Royal Naval Museum, Greenwich* (London: Eyre and Spottiswode, 1922).

71. "Holiday Walks, no. 2. Greenwich," *Penny Magazine of the Society for the Diffusion of Useful Knowledge*, June 9, 1832, 98.

"Taking and Making
of Draughts of Sea Fights"

THE VAN DE VELDES IN ENGLAND

I N T H E W I N T E R of 1672–73 the Dutch artists Willem van de Velde, father and son, left Holland—which was under threat from France by land and England by sea, and in the grip of an economic depression—to settle in London. During the first and second Anglo-Dutch wars the Van de Veldes had worked under contract for the Dutch state; the Elder observed and sketched the movements and battles of the Dutch navy from a galliot under orders to go wherever he needed it in order to make drawings, of which he made thousands. It is unclear whether the Van de Veldes' move was motivated by personal considerations or by a proclamation from Charles II in 1672 inviting Dutch people to settle in England. In either case, both the king and his brother James, Duke of York, recognized the value of their presence. In addition to their salaries, the Van de Veldes were granted studio rooms at the Queen's House, in Greenwich, where they proceeded to make drawings and paintings of the battles of the third Anglo-Dutch war, royal visits to the fleet, ship launches, and more general marine subjects for the court, wealthy merchants, and naval patrons.

The prolific output of the Van de Velde studio would serve as the model for a nascent British school of marine painting. British painters copied and adapted the compositions of Willem the Younger, learning from his technique in evoking atmosphere. They also collected drawings by both artists, which served as exemplars of accurate draftsmanship.

1

FIG. 96 Jan Vorsterman, *Windsor Castle*, ca. 1690,
oil on canvas, 29¼ x 63⅝ in. (74.2 x 161.5 cm).
National Maritime Museum, Greenwich, London,
Greenwich Hospital Collection

1

Jan Vorsterman (ca. 1643–after 1685)

**Greenwich, with a View of London
in the Distance**

ca. 1680
Oil on canvas
29½ x 57½ in. (74.9 x 146.1 cm)
Yale Center for British Art, Paul Mellon Collection,
B1976.7.112

PROVENANCE: Capt. E. Butler-Charteris, Cahir
Park, Co. Tipperary; Christie's, May 3, 1940,
bt by Leggatt Bros, from whom bt by Paul Mellon,
June 1962

EXHIBITIONS: VMFA/RA/YUAG 1963–65 (VMFA
only: 3); Penn State 1982 (6); Bruce 1999–2000

LITERATURE: Marianne Smith et al., *The Art of
Time*, exh. cat. (Greenwich, CT: Bruce Museum of
Arts and Science, 1999)

THIS COMPOSITION and a painting of Windsor Castle were probably conceived as pendants, linking the two royal Thames-side sites to the east and west of London. At least three versions of each work are known. Vorsterman's views of Windsor show it as an imposing royal fortress and country retreat (fig. 96).[1] By contrast, the artist represents Greenwich in a state of change: the site of the long-established Greenwich Royal Park and a fashionable resort, it has a new classical-style palace in progress for King Charles II (albeit later repurposed as the Royal Hospital for Seamen) and, dominating the park, his Royal Observatory, England's pioneering new center for "the finding out of the longitude of places for perfecting navigation and astronomy."[2] In the broader landscape here, Greenwich is also shown as a key point on the highway of maritime commerce, naval power, and royal prestige, linking London to the North Sea and the wider world. The westering sun, breaking through clouds above the distant city, dramatically highlights a scene confidently combining old and new under the restored monarchy.

The canvas shows a carriage arrival or departure at the park entrance of Inigo Jones's Queen's House, where in about 1673 the Willem van de Veldes were given studio rooms on the ground floor. To the right, behind the ruined towers flanking Henry VIII's tilt yard (jousting ground), stands the unfinished shell of Charles II's King's House on the site of the former Tudor Palace of Greenwich, the chapel and service buildings of which still lie on the riverfront at far right. On the hill to the left is Charles II's observatory (completed in 1676), with the fine houses of Crooms Hill on the west side of the park running down toward the medieval church of St. Alfege (destroyed in 1710). Beyond its tower, where the river curves around the Isle of Dogs, lies the Royal Dockyard at Deptford, with Royal Navy ships "in ordinary" (reserve) lying off it. Other naval vessels, including a number of royal yachts, also throng the river off the old palace site — repurposed from 1694 as the Royal Hospital (also referred to as Greenwich Hospital, and now the Old Royal Naval College). The first English royal yacht, the *Mary*, was presented to Charles II by the Dutch at his restoration in 1660, rapidly prompting him and his brother

James, Duke of York, to order home-designed examples from the Royal Dockyards at Deptford and Woolwich, for both racing and royal transport. Thereafter Deptford remained the principal yacht-building and maintenance yard, and Greenwich Hospital the normal London embarkation and disembarkation point for royal and other official use until steam replaced sail in the early nineteenth century. — PVDM

1. The version at the National Maritime Museum (BHC1808) has its same-size Windsor pendant, illustrated here; another version is in the collection of the Guildhall, London (acc. no. 1769).
2. Derek Howse, *Greenwich Time and the Longitude*, 2nd ed. (London: Philip Wilson and National Maritime Museum, 1997), 44. The wording is that of the founding Royal Warrant.

2

Willem van de Velde the Younger (1633–1707)

Sea Battle of the Anglo-Dutch Wars

ca. 1700
Oil on canvas
44 ¾ x 72 ½ in. (113.7 x 184.2 cm)
Yale Center for British Art, Paul Mellon Collection, B1973.1.60

PROVENANCE: Baroness Lucas and Dingwall, by descent to Lt. Col. H. L. Cooper; Sotheby's April 8, 1970 (as *The Battle of Lowestoft*, 1665), bt by Paul Mellon

EXHIBITIONS: YCBA 1977–78 (3); YCBA 2008

LITERATURE: Robinson, *Van de Velde Paintings*, 1:221–24, cat. 71

BY THE TIME he painted this picture, Van de Velde had a substantial studio operation producing variants of earlier compositions for a growing market. Willem the Elder had died in 1693, shortly after he and his son moved into Westminster from their original base in the Queen's House at Greenwich. Willem the Younger had been joined by his own son, Cornelis, and possibly by Johann van der Hagen (whose daughter married Cornelis), among others. The studio probably continued for some time under Cornelis after his father's death in

1707. Though relatively few of his own distinctive works are now known, Cornelis certainly perpetuated the family reputation; he was among those later called in to judge the quality of James Thornhill's decorative work in the Painted Hall of Greenwich Hospital (now the Old Royal Naval College).

This is one of two known versions of a painting substantially by the Van de Velde studio rather than autograph. Neither can be convincingly identified as a specific action, although in the other example, which has more of Van de Velde's hand in it, the main English ship is closest to representing the two-decker *London* and flies a red flag at the fore. That marks it as the flagship of Sir John Harman, Vice Admiral of the Red (the red squadron) at the Battle of the Texel in 1673, when English and French forces tried to make a landing on the island of that name in North Holland.

In the present version, if this is the Texel, the *London* would be the ship in the far left distance, given the red flag at the fore seen there over smoke. However, it is the foreground flagship (center left) that has been nearly exactly copied from the other example, and here it flies the Union flag (of England and Scotland) at the main, which at the Texel was flown by Prince Rupert of the Rhine on the larger *Royal Sovereign*. The subject is therefore apparently a non-specific — or at least conflated — battle composition, more panoramic in format than the other canvas. The format suggests the precedent of Van de Velde the Younger's spectacular, larger, and largely autograph painting of the *Gouden Leeuw* at the Battle of the Texel, made for the Dutch admiral Cornelis Tromp while the artist was visiting Amsterdam in 1686–87 (fig. 97). — PVDM

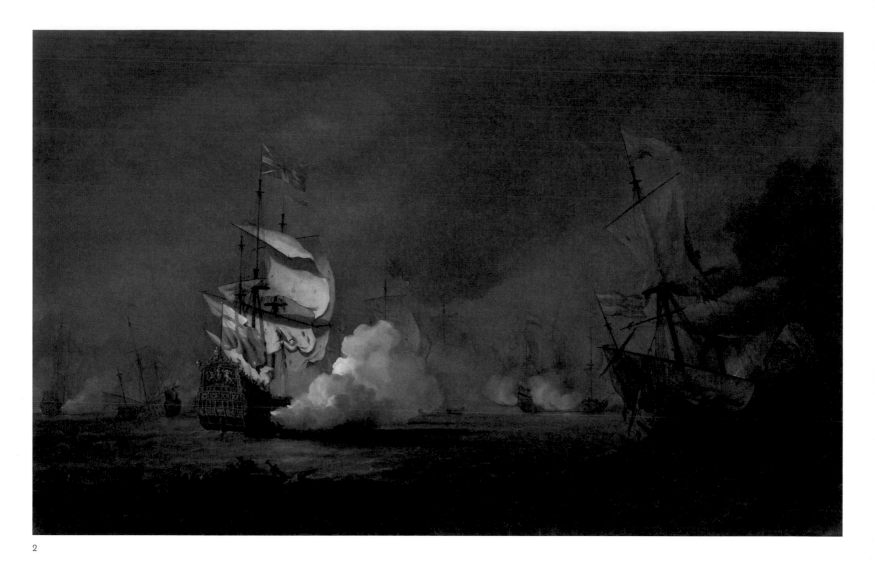

2

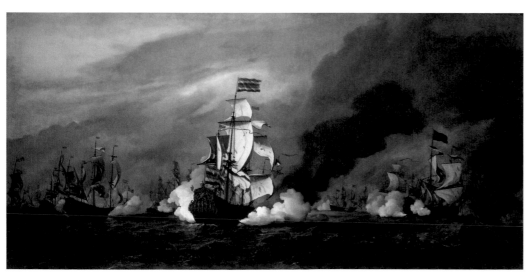

FIG. 97. Willem van de Velde the Younger, *The* Gouden Leeuw *at the Battle of Texel*, 1687, oil on canvas, 59 x 118 in. (149.8 x 299.7 cm). National Maritime Museum, Greenwich, London. Purchased with the assistance of the Art Fund and the Society for Nautical Research Macpherson Fund

3

Willem van de Velde the Elder (1611–93)

Celebration on the Thames near Whitehall

1685

Pen and ink, graphite, and gray wash on paper

11 ⅛ x 17 ⅛ in. (28.3 x 44.1 cm)

Yale Center for British Art, Paul Mellon Collection, B1986.29.496

PROVENANCE: Colnaghi, 1963; bt by Paul Mellon, 1963

EXHIBITIONS: Colnaghi 1963 (26); YCBA 2007 (8)

LITERATURE: John Baskett et al., *Paul Mellon's Legacy, A Passion for British Art: Masterpieces from the Yale Center for British Art* (New Haven and London: Yale Center for British Art and Royal Academy of Arts in association with Yale Univ. Press, 2007), 244, cat. 8.

4

Willem van de Velde the Elder (1611–93)

The Decorated Pontoon before Whitehall

1685

Pen and ink, graphite, and gray wash on paper

11 x 41 ¾ in. (28 x 106 cm)

National Maritime Museum, Greenwich, London, Caird Collection, PAJ2562

EXHIBITIONS: NMM 2012 (38)

LITERATURE: Robinson, *Van de Velde Drawings*, 145, cat. 608; *The Willem van de Velde Drawings in the Boymans–van Beuningen Museum, Rotterdam* (Rotterdam: Museum Boymans–van Beuningen Foundation, 1979), 76; Susan Doran with Robert J. Blyth, eds. *Royal River: Power, Pageantry and the Thames* (London: Scala Books with the National Maritime Museum, Greenwich, 2012), 70

THESE TWO SHEETS together form the second in a series of four views that Van de Velde drew of the celebrations surrounding the coronation of James II, in 1685. The coronation had taken place on April 23, but due to "the wearisomeness that the Fatigue of those Glorious Processions and stately Ceremonies of the Coronations had bred in their Majesties," as an observer reported, a display of fireworks was postponed until the next day, when "between five and six [o'clock] London seemed to have disembogued and emptied its Inhabitants into the Boats and onto the Shoars of the Thames."[1]

Van de Velde's views show the crowds of spectators gathered on the river and the decorated pontoon, stationed across the river from the Palace of Whitehall, where the fireworks were launched. The four numbered views indicate that the artist moved downriver to record the event from a succession of angles. The first (Boymans–van Beuningen Museum, Rotterdam) looks upstream; the third and fourth (Boymans–van Beuningen and National Maritime Museum, respectively) look downstream from a position farther upriver. The view made up of these two drawings is taken from directly opposite the pontoon, which is decorated with allegorical figures holding fireworks and a central structure with the monogram "JMR2," representing James and his queen consort, Mary. The drawings demonstrate Van de Velde's extraordinary facility in capturing various types of vessels — including ceremonial barges, yachts, and wherries — as well as the human figure in action, and his technique of working up from a pencil drawing made on the spot, adding a gray wash and reinforcing his lines with pen work, undoubtedly later in the studio. — EH

1. R. Lowman, *An Exact Narrative and Description of the Wonderfull and Stupendious Fire-works in Honour of Their Majesties Coronations, and for the High Entertainment of Their Majesties, the Nobility, and City of London: Made on the Thames, and Perform'd to the Admiration and Amazement of the Spectators, on April the 24th 1685* (London: Printed by N. Thompson, 1685).

5

Willem van de Velde the Younger (1633–1707) and Dominic Serres (1719–1793)

Charles II's Visit to the Combined French and English Fleets at the Nore, 5 June 1672

ca. 1675/1785

Ink and gray wash on paper

Sheet: 14 ¾ x 24 in. (37.5 x 60.8 cm); mount: 24 x 32 ⅝ in. (61.1 x 82.4 cm)

National Maritime Museum, Greenwich, London, PAH8400

EXHIBITIONS: YCBA/NMM 1987

LITERATURE: Quarm and Wilcox, *Masters of the Sea*, 16–17, cat. 37; Russett, *Dominic Serres*, 180

AN INSCRIPTION by John Thomas Serres on the back of this drawing indicates that his father, the marine painter Dominic Serres drew it in 1785. However, it appears originally to have been a drawing — possibly only a faint offset — by Van de Velde the Younger, later worked up and repaired by Serres, who owned other Van de Velde drawings. There are three more of these in the collection of the National Maritime Museum at Greenwich, with some touching by him, and here he drew in much of the sky in gray wash on a new backing sheet.

The subject replicates Van de Velde's large oil painting of *The Royal Visit to the Fleet in the Thames Estuary* (fig. 98). The event was a Council of War following the Battle of Solebay (Southwold Bay, Suffolk), on May 28, 1672;[1] the scene represents the moment when Charles II left his barge and boarded the *Prince* (right), flagship of his brother James, Duke of York (later James II), who commanded at Solebay in his role of Lord High Admiral. The *Prince* is shown flying the Admiralty flag at the fore, the Royal Standard at the main and the Union at the mizzen for the presence on board of, respectively, James, the king, and probably Prince Rupert of the Rhine (though James flew the Royal Standard when Charles was not present). The French also fought at Solebay, and French boats (flying white ensigns at the stern) are among those making their way toward the *Prince*, beyond which lies the *London* with the admiral's flag of Sir Edward Spragge (blue in the original painting), at the main. Several royal yachts are present, including the *Cleveland* (in port-broadside view, center left), normally used at this time by Charles, and the one in which he had come downriver.

While the original canvas was never in royal possession, it may have been one of the earliest intended for Charles or James by the Van de Veldes after they arrived in England in 1672–73. Neither of the artists saw the event, though the Elder recorded similar royal visits in 1673. This was the last such visit when James was present as Lord High Admiral, and Solebay was the last occasion on which a British royal prince commanded a fleet in action.[2] — PvdM

1. Julian calendar; the Gregorian date is June 5.

2. Robinson, *Van de Velde Paintings*, 2:922–33, cat. 414.

3

4

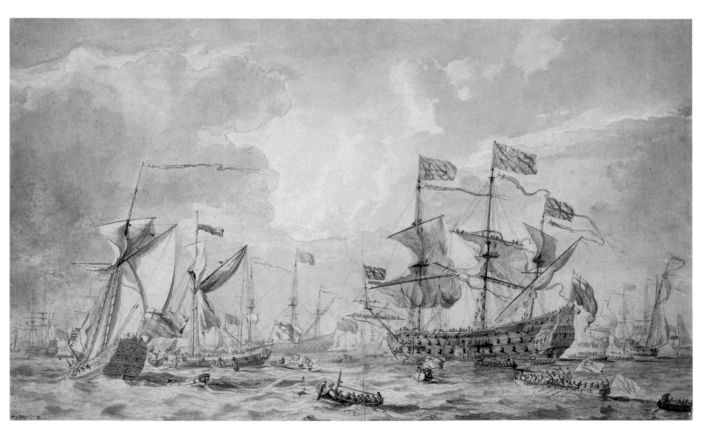

5

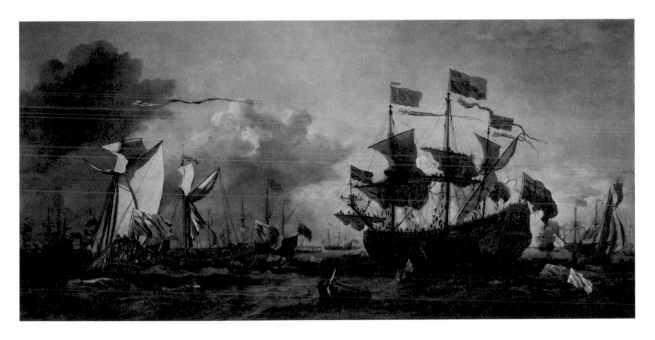

FIG. 98. Willem van de Velde the Younger, *A Royal Visit to the Fleet in the Thames Estuary, 1672*, 1696, oil on canvas, 65 x 130 in. (165.1 x 330 cm). National Maritime Museum, Greenwich, London, Caird Collection

6

Unknown maker

Model of the *Coronation*

1677
Boxwood, gold leaf, japanning, mica, brass, and varnish
49 x 22 x 53 in. (124.5 x 55.9 x 134.6 cm)
The Kriegstein Collection

PROVENANCE: John Vaughan, Earl of Carbery; acquired at his death by Sir Richard Gough Kent, Gough House, Chelsea; by descent to Mrs. Anstruther Gough Calthorpe, by whom sold to Rochelle Thomas, 1924; bt by Max Williams, from whom by Junius S. Morgan Jr.; bt at auction of his estate, 1974

LITERATURE: R. C. Anderson, "Comparative Naval Architecture, 1670–1720," *Mariner's Mirror* 7 (1921): 172–81; W. B. McCormick, "Model of H. M. S. Coronation," *International Studio* (May 1924): 152–53; Brian Lavery, *The Ship of the Line*, 2 vols. (London: Conway Maritime Press, 1983), 1:44, 244; John Franklin, *Navy Board Ship Models, 1650–1750* (London: Conway Maritime Press, 1989), 6, 23, 25, 36, 41–42, 48, 57, 181, 102–06; Kriegstein and Kriegstein, *17th and 18th Century Ship Models*, 44–55.

FOLLOWING THE THIRD Anglo-Dutch War (1672–74), the Royal Navy's fleet was depleted and aging. Samuel Pepys, then Secretary to the Admiralty, led efforts to persuade Parliament to grant £600,000 for the construction of thirty new ships of varying rates, or classifications, determined by the number of guns they carried; this model appears to have provided the design for a class of second rates of 1,100 tons, bearing three decks and between 90 and 100 guns. With its profusion of carved and gilded ornamentation, it gives an indication of the power and magnificence of the vessels that would come to assert Britain's dominance of the seas in the eighteenth century. Only one seventeenth-century model is known to survive with its rigging intact; the present example was re-rigged in 1920 and has its original guns, lanterns, masts, tops, and the majority of the yards. In 1911 it was displayed at the London Museum, Kensington Palace.[1]

Marine painters availed themselves of ship models — or parts thereof — in composing their works. A contemporary of Willem van de Velde the Younger wrote of the Elder that "for his better information in this way of Painting, he had a Model of the Masts and Tackle of a Ship always

before him, to that nicety and exactness, that nothing was wanting in it, nor nothing unproportionable. This model is still in the hands of his son."[2] Nearly a century later, the posthumous sale of the studio contents of the marine painter Richard Paton included "a remarkably compleat and beautiful MODEL of a MAN of WAR."[3]

The ship *Coronation* was built at Portsmouth dockyard by Isaac Betts and launched in 1685, the year of the coronation of James II (see cats. 3–4); it was the largest ship launched during his reign. In 1690 the *Coronation* saw action at the Battle of Beachy Head, where English and Dutch forces combined against the French fleet. On September 3, 1691, the *Coronation* sank in a storm off Plymouth with the loss of all but nineteen of its crew. The wreck was rediscovered in 1977. — EH

1. The *Coronation* model has been extensively documented; a complete list of sources can be found in Kriegstein and Kriegstein, *17th and 18th Century Ship Models*, 49.
2. Roger de Piles, *The Art of Painting, and the Lives of Painters . . .* (London: Printed for J. Nutt, 1706), 473.
3. *World*, March 27, 1792, 4.

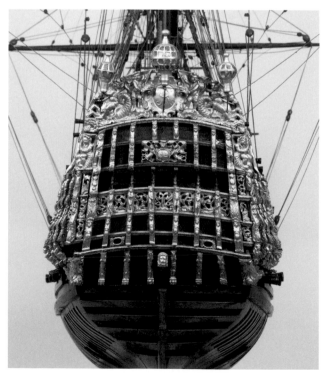

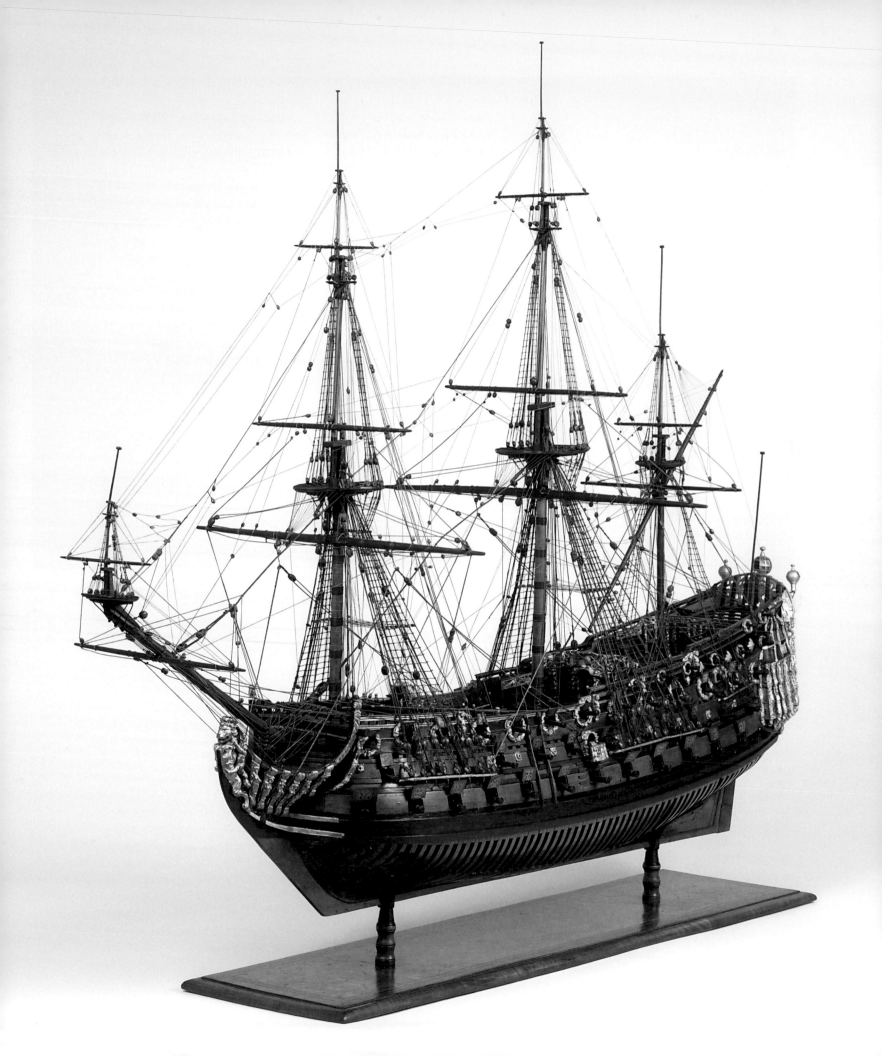

7

7

Willem van de Velde the Younger (1633–1707)

An Action between English Ships and Barbary Corsairs

ca. 1695

Oil on canvas

12 ⅝ x 19 ⅜ in. (32.1 x 49.2 cm)

Yale Center for British Art, Paul Mellon Collection, B1981.25.641

PROVENANCE: Christie's, 1848; bt by H. A. J. Munro of Novar between 1850 and 1865; sold at Christie's 1878 (139), bt by Cockerell; Christie's 1914 (59); with Leonard Koetser ca. 1967; at Pink & Son, London, 1968, from whom bt by Paul Mellon, 1968

EXHIBITIONS: YCBA 1977–78 (4); YCBA 2008

LITERATURE: Robinson, *Van de Velde Paintings*, 1:240–42, cat. 14; Hughes, "Guns in the Gardens," 95.

THE MUSLIM CITIES of the Barbary (Berber) Coast of North Africa, broadly from Saleh in Atlantic Morocco to Tunis, were a longstanding menace to European shipping. Though their seaborne raiders were called "Barbary pirates," they were corsairs, or privateers, working under the aegis of ruling powers and by their own lights legitimately seizing "infidel" shipping and taking seafarers for ransom, enslavement, and/or conversion. Most (excluding Morocco) owed allegiance to the Ottoman sultan, but they were largely autonomous and unreliable in keeping treaties made locally at different times to curtail these activities. In the early seventeenth century they raided as far as the coasts of Cornwall and Ireland, and it was only after general European peace was established in 1815 that punitive measures, including some by the American navy,

finally stopped their depredations. Among these measures the Anglo-Dutch bombardment of Algiers in 1816 is the best known.

By the time the Van de Veldes came to London in the early 1670s, both the Dutch and the English had significant trade in the eastern Mediterranean. The threat from Barbary raiders, among other enemies, required much of it to be in convoy under naval protection. In Britain this prompted the annual sailing of a summer "Straits" fleet, which by the early eighteenth century had become a year-round Mediterranean squadron. Sea fights against Barbary galleys and other ships, and occasionally coastal positions, were also one of the Van de Velde studio's regular subjects, though depictions were rarely of identified incidents. This is a slightly unusual example in the prominence it gives to

the conflict between small boats, one of which (right) displays a Union flag, while a Barbary galley engages a presumably English ship at rear left. The ship on fire at right is also English in form, although the green-and-white striped ensign (originally Tudor colors) and plain red jack at the bow are as yet unexplained.

The National Maritime Museum collection at Greenwich has at least three Van de Velde drawings of more closely involved fights with Barbary corsairs; a slight graphite one dated about 1675 has a galley and ship engagement sketched in at back left that is similar to what appears here.[1] —PvDM

1. National Maritime Museum, Greenwich, PAF6895.

8

Willem van de Velde the Younger (1633–1707)

A Man of War, Firing Guns

undated
Graphite on paper
8 7/8 x 6 1/4 in. (22.5 x 15.7 cm)
Yale Center for British Art, Paul Mellon Collection,
B1977.14.5605

PROVENANCE: Iolo A. Williams (as *Ship Firing Salute*); P & D Colnaghi, Aug. 1964, from whom bt by Paul Mellon

THIS SKETCH is a simplified version of a fine, fully autograph oil painting by Willem the Younger in the Rijksmuseum, Amsterdam.[1] The painting is traditionally called *The Cannon Shot*, but Michael Robinson, author of the catalogue raisonné of Van de Velde paintings, more accurately titles it *A Dutch Ship Getting Under Way and Firing a Salute* and dates it to about 1680, in the Van de Veldes' early English period.[2] In both images the disposition of sails is the same but the painting has a second ship in the left background, its foreground boat holds more men than are seen in the sketch, and it is being rowed to the left rather than the right. There are also differences in pennant size and disposition, and the representation of the anchor. The ship in the sketch looks slightly smaller and less decorated than the one in the oil, lacking its prominent port-quarter galleries and a middle

8

tier of guns fully run out, though here apparently closed. Whether this sketch predates the canvas, or is a later near copy by Van de Velde or a studio hand, is not yet clear. — PvDM

1. Rijksmuseum, Amsterdam, SK-C-244.
2. Robinson, *Van de Velde Paintings*, 1:292–96, cat. 56.

9

9

Willem van de Velde the Younger (1633–1707)

An English Frigate at Anchor Viewed from the Port Quarter

undated
Graphite on paper
8 x 16 ⅜ in. (20.3 x 41.6 cm)
Yale Center for British Art, Paul Mellon Collection,
B1977.14.4210

PROVENANCE: A. S. Cussons; Sotheby's Dec. 10, 1968 (62), where bt by John Baskett, from whom bt by Paul Mellon, 1968.

THE VAN DE VELDES made many studies of single ships at moorings but, if the large collection of drawings at the National Maritime Museum in Greenwich is indicative, the Younger did more studies of Dutch than of English frigates. This is an unusually detailed and apparently rapid sketch of an English one, possibly on an occasion yet to be identified. It flies both ensign (the large flag at the stern of the vessel) and jack (the Union flag at the bow), with all sails neatly stowed—rather than some hanging loose to air—and with the main and fore yards acockbill (tipped up) rather than crossed: this can be a form of salutation. The *W*, which may be the letter inscribed on the ensign for *wit* ("white," and here perhaps meaning the whole flag, not just the field of the St. George quadrant) suggests the ship may be a frigate attached to the van (forward) squadron of the fleet before the modern white ensign with a full St. George's Cross and the Union in its upper quadrant was introduced in the late 1690s.

The term "frigate" loosely describes relatively small and maneuverable vessels with their main armament on a single gun deck. The classic form, with the main armament on a continuous upper deck above a lower unarmed "gun deck" used for crew accommodation, did not emerge until the mid-eighteenth century. As can be seen in this drawing, the ship has a high foc's'le (forward part) and stern, also armed. The two are separated by a lower waist, and the gun deck is set low in the hull. —PVDM

10

10

Willem van de Velde the Younger (1633–1707)

English Warships Heeling in the Breeze Offshore

between 1673 and 1707
Oil on canvas
18 x 28 in. (45.7 x 71.1 cm)
Yale Center for British Art, The U Collection. In appreciation of Choh Shiu and Man Foo U, loving parents, and Dorothea and Frank Cockett, dear friends, B2008.30.2

PROVENANCE: Phillips, London, 1985 (4); F. B. Cockett; U Collection, by whom given to YCBA, 2008

EXHIBITIONS: YCBA 2009

LITERATURE: Robinson, *Van de Velde Paintings*, 2:941–43, cat. 410 (4).

FOUR KNOWN VERSIONS of this work were made by the Van de Velde studio around 1700. Another version, possibly by Van de Velde the Elder, from about 1685, is also on record. None of the ships are identified, but the two in the foreground are Royal Navy two-decker third rates: in this instance, ships of around 60 guns. Across the horizon four more ships run before the wind, and those in the foreground are under easy sail for the conditions (sails adjusted appropriately). This is a typical Van de Velde decorative "sea piece," painted in a warm gray, blue, blue-green, brown, and creamy-clouded tonal range. The low viewpoint, the carefully diminishing scale of the vessels against the towering sky, and the concentration of light in the background, compared to the dark foreground, with the foreground ship in shadow and that to the right caught by a shaft of sunlight on the surrounding sea, all build the painting's impressive sense of distant recession. Such examples provided the models that English marine painters, most notably Charles Brooking, would follow into the middle years of the eighteenth century.
—PVDM

11

12

11

Willem van de Velde the Younger (1633–1707)

An English Man of War, Starboard Bow View (The *Tiger*)

ca. 1675
Pen and ink with gray wash over graphite on paper
17¼ x 26½ in. (43.8 x 67.1 cm)
Yale Center for British Art, Paul Mellon Collection,
B1975.4.1964

PROVENANCE: Paul Sandby (Lugt 2112); Mrs. P. Gray;
Colnaghi, 1967, from whom bt by Paul Mellon

12

Willem van de Velde the Younger (1633–1707)

Portrait of the *Tiger*

ca. 1675
Graphite on paper
9 x 20 in. (22.9 x 51 cm)
National Maritime Museum, Greenwich, London,
PAG6229

PROVENANCE: Paul Sandby (Lugt 2112); Colnaghi, 1937

LITERATURE: Robinson, *Van de Velde Drawings*, 2:36,
cat. 1106

13

THE VAN DE VELDES developed a practice of making offsets to create multiple drawings that could then be used as the basis for paintings. A clean piece of paper was placed over a drawing and rubbed with an instrument to transfer the outline of the drawing onto the paper. The faint impression could then be worked up with pencil, wash, and ink, and certain elements (such as coats of arms) redrawn to appear correctly rather than in reverse.[1] The two works here depict the *Tiger* (or *Tyger*, as the inscription has it), a fourth-rate ship of 44 guns. *English Man of War* (cat. 11) was made as an offset from *Portrait of the* Tiger (cat. 12), which appears to have been drawn freehand and is signed "W. V. V. J."[2] Both of these drawings bear the collector's stamp of Paul Sandby, a central figure in the eighteenth-century London art world who was instrumental in founding the Royal Academy. He was also a close friend of the marine painter Dominic Serres, who had his own very large collection of Van de Velde drawings (see cat. 5). — EH

1. Robinson, *Van de Velde Drawings*, 1:18.
2. Robinson, *Van de Velde Drawings*, 2:36.

13

Elisha Kirkall (1682?–1742)
after Willem van de Velde the Younger (1633–1707)

Plate 3 from "Prints of Shipping"

1727
Mezzotint
12¾ x 15¾ in. (32.4 x 40 cm)
Yale Center for British Art, Paul Mellon Collection,
B1977.14.14211

PROVENANCE: Bt from Mendez, July 1975

14

Elisha Kirkall (1682?–1742)
after Willem van de Velde the Younger (1633–1707)

Plate 5 from "Prints of Shipping"

1727
Mezzotint
17⅜ x 12⅛ in. (44.1 x 30.8 cm)
Yale Center for British Art, Paul Mellon Collection,
B1977.14.14212

KIRKALL WAS ONE of the more enterprising printmakers and publishers of the early eighteenth century. He is best known for developing new techniques in metal engraving, used particularly for book illustrations and for publishing series of prints after old master paintings and drawings.[1] The present examples in mezzotint, printed in sea-green ink, are from a hugely successful set of sixteen Van de Velde seascapes that Kirkall published in 1726–27. They were issued by subscription at a price of two guineas and, according to George Vertue, an engraver who kept notebooks on British art of the period, they earned Kirkall nearly £1000.[2] Kirkall later made prints after works by the marine painter Peter Monamy, a series depicting whaling, and another of East India Company settlements.[3] He also profited from the publication by William Hogarth of *A Harlot's Progress* in 1732 by making a cheaper, pirated version of the series in mezzotint; such unauthorized copies prompted Hogarth to lobby for passage of the Engraving Copyright Act of 1735, to which his friend John

E. Collectione præ nobilis viri Thomæ Cook Vice-Camerarij.

14

FIG: 99. Willem van de Velde the Younger, *The English Ship* Royal Sovereign *with a Royal Yacht in a Light Air*, 1703, oil on canvas, 71 x 57 in. (180.3 x 144.7 cm). National Maritime Museum, Greenwich, London, Caird Collection

Pine would seek an addendum protecting his own publication, *The Tapestry Hangings of the House of Lords* (cats. 36–38).

Plate 3 reproduces a Van de Velde "calm" of the kind that Peter Monamy in particular emulated (cat. 20). Plate 5 is a version of the composition made most famous by Van de Velde's *The English Ship* Royal Sovereign *with a Royal Yacht in a Light Air* (fig. 99). — EH

1. See Timothy Clayton, "Elisha Kirkall (1681/2–1742)," in *Oxford Dictionary of National Biography*, Oxford Univ. Press, 2004: http//:dx.doi.org/10.1093/ref:odnb/15654 (accessed March 19, 2016).
2. Vertue, *Note-books*, 3:113.
3. See Richard Johns's essay in this volume.

15

Pierre-Charles Canot (ca. 1710–1777)
after Willem van de Velde the Younger (1633–1707)

A Brisk Gale

1763
Engraving
14 ¾ x 19 ¾ in. (37.5 x 50.2 cm)
Yale Center for British Art, Paul Mellon Collection,
B1977.14.14210

THIS ENGRAVING, issued in 1765 by the London print publisher John Boydell, is a reversed image of Van de Velde's late Dutch-period composition of about 1672, *A Dutch Flagship Coming to an Anchor Close to the Land in a Fresh Breeze*, which was owned by Sir Lawrence Dundas, first baronet.[1] The foreground ship is a two-decker that flies the flag of a rear admiral and a Dutch "triple-prince" nine-striped jack of red, white, and blue (as does the more distant ship on the far right). The main ship may be the *Utrecht*, when it was the flagship of Cornelis Evertsen the Younger, in 1665.[2] The small sailing vessels in the foreground are fishing pinks.

Dundas was a highly successful Scottish businessman and politician who became wealthy as an army contractor in the Seven Years' War, then in banking, real estate, and canal development. A member of the Society of Dilettanti, a London club with the goal of improving public taste in the arts, he held a number of Dutch seventeenth-century marines in his picture collection, as seen in Johann Zoffany's portrait of him with his grandson in

the dressing room of his home on Arlington Street, London (fig. 100).[3] The Canot engraving is a telling pictorial demonstration of how collecting marine masters had established itself as a mark of sophistication by the mid-eighteenth century: those unable to afford originals could own fine prints like this one. — PVDM

1. James Taylor, "18th Century Maritime Painters, Printmakers and Publishers," in Joel, *Charles Brooking*, 70; Robinson, *Van de Velde Paintings*, 2:748–51, cat. 300. In 1985 the work was noted as still in private hands at Winslow Hall, Buckinghamshire.
2. Robinson, *Van de Velde Paintings*, 2:749. Robinson makes this suggestion with slight reservations.
3. Caddy Wilmot-Sitwell, "The Inventory of 19 Arlington Street, 12 May 1768," *Furniture History* 45 (2009): 73–99.

16

James Watson (ca. 1739–1790)
after Willem van de Velde the Younger (1633–1707)

A Storm

ca. 1770
Mezzotint
18 ⅝ x 21 in. (47.3 x 53.3 cm)
Yale Center for British Art, Paul Mellon Collection,
B1970.3.672

THIS MEZZOTINT is an early state of a print that was published by Robert Sayer with the inscription: "From an Original Picture by Vandervelde, in the Possession of Mr. Reynolds." The painting

on which it was based, now known as *An English Ship Running onto Rocks in a Gale*, appears to have been owned by Sir Joshua Reynolds; it later entered the collection at Warwick Castle, where it remains.[1] A guidebook published in 1815 lists "A Storm and Wreck — by William Vandervelde the younger — superlatively excellent — a favorite picture of Sir Joshua Reynolds."[2] Reynolds was knighted in 1769, which may help to date this work.

The print shows a ship in distress, its crew climbing the rigging to escape the waves that have engulfed its hull. The ship's boat is pulling for the shore, and a third vessel, in the left background, appears to be succumbing to the heavy seas. The setting may be the Eddystone Rocks, site of innumerable shipwrecks, which prompted the construction of a lighthouse in the late seventeenth century (see cat. 19).[3]

Watson was born in Ireland and moved to London, where he became a skilled engraver in mezzotint, working primarily for the major print sellers, including John Boydell and Robert Sayer. He produced over fifty mezzotints after portraits by Reynolds, and others after paintings by Thomas Gainsborough and other contemporary artists, and by old masters including Anthony van Dyck and Peter Paul Rubens. This work bespeaks the continued popularity, long after his death, of paintings by Van de Velde the Younger and of scenes of storm and shipwreck, which are further discussed in Christine Riding's essay in this volume. — EH

1. Robinson, *Van de Velde Paintings*, 2: 1064–67.
2. W. Field, *Historical and Descriptive Account of the Town & Castle of Warwick* (Warwick: Printed by and for H. Sharpe, 1815), 197, cited in Robinson, *Van de Velde Paintings*, 2:1065. There is evidence that Reynolds also painted a copy of the Van de Velde; see *The Art of the Van de Veldes: Paintings and Drawings by the Great Dutch Marine Artists and Their English Followers*, exh. cat. (London: National Maritime Museum, 1982), 120, cat. 126.
3. Robinson, *Van de Velde Paintings*, 2:1064.

FIG. 100 Johann Zoffany, *Sir Lawrence Dundas with His Grandson*, 1769–70, oil on canvas, 40 x 50 in. (101.6 x 127 cm). The Zetland Collection

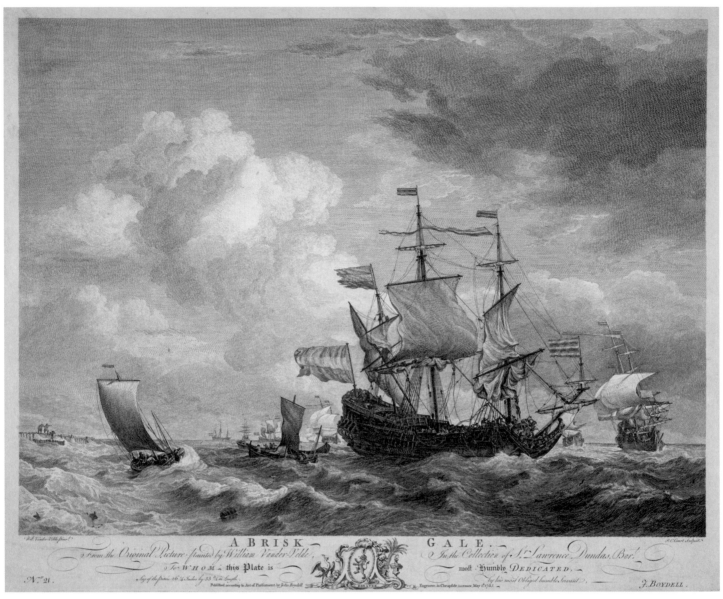

A BRISK GALE.
From the Original Picture painted by William Vander Velde,
To WHOM this Plate is most Humbly DEDICATED.
In the Collection of S.ʳ Lawrence Dundas, Bar.ᵗ

N.º 21.
Size of the Picture 26 ¼ Inches by 33 ½ in Length.
Published according to Act of Parliament by John Boydell.
Engraver in Cheapside London May 1.ˢᵗ 1765.

by his most Obliged humble Servant
J. BOYDELL.

15

16

"Second Only to Van de Velde"

THE FIRST BRITISH MARINE PAINTERS

Mr Peter Monamy, painter of ships & sea prospects . . . haveing an Early affection to drawing of ships and vessels of all kinds and the Imitations of the famous masters of paintings in that manner, Vandevelds &c, by constant practice he distinguisht himself and came into reputation. . . . To remember his fame his picture was painted & done in mezzotint print under writt: Petrus Monamy Navium et prospectum marionorum Pictor VandeVeldo soli Secondus *(Peter Monamy, Painter of Shipping and Marine Views, Second Only to Van de Velde).*

— George Vertue, *Note-book*, 1749

The first generations of British marine painters to follow Willem van de Velde the Younger both emulated models set by Dutch artists and began to find new ways of representing maritime subjects. They copied paintings and drawings by the Van de Veldes and later made prints after their works, but also adapted and updated their compositions to include British ships of the early to mid-eighteenth century. In addition, they participated in projects that helped to forge a modern art world centered in London. Peter Monamy contributed to the decoration of the supperboxes at Vauxhall Gardens and, along with Samuel Scott and Charles Brooking, to a program promoting native artists at the Foundling Hospital. The outbreak of war in 1739 provided the first opportunity to depict contemporary naval engagements since the Treaty of Utrecht had ended the War of Spanish Succession in 1714; it was a chance both to respond to and to shape public interest in the battles waged to assert and maintain Britain's mercantile empire. Artists' attention did not turn to conflict alone, however; depictions of coastal views as well as vessels and the disasters that could befall them helped form the nation's identity as a maritime power.

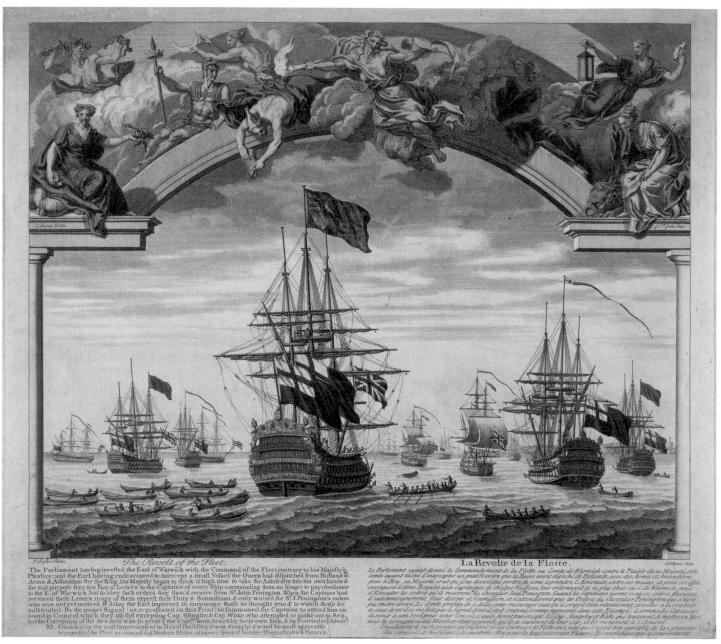

The Revolt of the Fleet.

La Revolte de la Flotte.

The Parliament having invested the Earl of Warwick with the Command of the Fleet contrary to his Majesty's Pleasure; and the Earl having endeavoured to intercept a small Vessel the Queen had dispatched from Holland w. Arms & Ammunition for the King, his Majesty began to think it high time to take the Admiralty into his own hands & for that purpose sent his Royal Letters to the Captains of every Ship commanding them no longer to pay obedience to the E. of Warwick, but to obey such orders they shou'd receive from S. John Penington. When the Captains had received these Letters, many of them express'd their Duty & Submission, & only waited for S. J. Penington's orders who was not yet arrived, & delay the Earl improved to encourage those he thought true & to watch those he mistrusted. By the proper Signal (as represented in this Print) he summoned the Captains to attend him on board in Council which they all did excepting Cap. Slingsby & Cap. Wake who attempted to make out to Sea, but the Corruption of the Sea-men was so great y the Cap. were seized by their own Men, & by y carried to Admiral.

N.B. Considering the vast Improvement in Naval Building it was thought it wou'd be most agreeable to represent the Fleet as compos'd of Modern Ships, at to pare several suitable Hieroglyphick Figures.

17

17

John Harris
after Thomas Baston (active ca. 1702–1721),
with figures by Louis Chéron (1660–1713?)

The Revolt of the Fleet, 1642

ca. 1710
Engraving tinted with watercolor
14 ⅛ × 17 ½ in. (35.9 × 44.5 cm)
Yale Center for British Art, Paul Mellon Collection,
B1977.14.11074

THIS PRINT, curious for its substitution of contemporary ships in the depiction of a historical incident, seems to have been made during the reign of Queen Anne (r. 1702–1714), since it shows her Royal Standard (slightly inaccurately), flown as the flag of the Lord High Admiral, who was her husband Prince George of Denmark until his death in 1708. That practice was discontinued in 1709. The main three-decker flagship may be based on Van de Velde's representation of the *Royal Sovereign*, shown from the same angle,

which was probably made to commemorate Prince George's dining on board at Spithead in 1702 (fig. 99, p. 150). The many ships' boats in the foreground suggest that the fleet captains have been called on board by the commander-in-chief, for which the second red ensign in the mizzen (sternmost) rigging is probably the signal.

The story is told in the text below the image, but as applied to much earlier events, in the spring of 1642, when Robert Rich, Earl of Warwick, assumed command of the fleet by Parliamentary ordinance, displacing Sir John Pennington, who was Charles I's appointed admiral. That popular move proved crucial in securing most of the navy's allegiance to Parliament in the Civil War that followed, ending with the deposition and execution of Charles in 1649. The disjunction between image and narrative is intriguingly and brazenly explained in the last two lines: "NB Considering the vast improvement in Naval Building it was thought it would be most agreeable to represent the fleet as compos'd of Modern Ships." The less than explicit symbolism of the "several suitable Hieroglyphick Figures" at the top alludes to the fleet's disaffection over Charles I's delays in paying its seamen, but the crowned and weeping female figure on the right seems to be a portrait of the widowed Queen Anne rather than Charles's queen, Henrietta Maria. Anne, last of the Stuart dynasty, is perhaps lamenting its earlier ruin under Charles I, who was her grandfather.

Thomas Baston may have been a dockyard draftsman, but practically all known of him is that his drawings were the basis for a set of twenty-two nautical prints — including some of major Royal Navy ships — that appeared about 1721. Louis Chéron, who added the emblematic figures, was a French painter who worked in England from about 1690, occasionally with James Thornhill, who decorated the Painted Hall of the Royal Hospital for Seamen, Greenwich, and the dome of St. Paul's Cathedral, London. — PVDM

18

John Faber the Younger (ca. 1695–1756)
after Thomas Stubly (active 1733–1738)

Petrus Monamy Navium et Prospectum marionorum Pictor Vandeveldo Soli Secundus

1731
Mezzotint
Sheet: 15 x 10 ⅜ in. (38 x 26.4 cm);
plate: 14 x 9 ¾ in. (35.6 x 24.8 cm)
National Maritime Museum, Greenwich, London, PAF3374

ALTHOUGH LONDON-BORN, Peter Monamy came of Guernsey parentage and counted naval men of similar Channel Island background among his significant patrons. In 1704 he became a Freeman of the Painter-Stainers' Company after an eight-year apprenticeship to a leading London house painter, but George Vertue, who kept notebooks on the British art world, recorded that Monamy had "an Early affection to drawing of ships and vessels of all kinds and the Imitations of other famous masters of paintings . . . in that manner." He focused his art entirely on marine subjects and from constant practice was soon "by many . . . much esteemd especially sea-faring people, officers and other marchants &c," though never very prosperous, as he operated substantially through dealers.[1] His output of calms and storms as well as shipping, battle, and coastal pieces was initially influenced by the relatively minor Dutch émigré artist Isaac Sailmaker, but more significantly by the Van de Veldes. The fact that, after Willem the Younger's death in 1707, Monamy was the first notable English-born painter of marines is indicated by the Latin inscription on this portrait, which translates as "Peter Monamy, painter of shipping and marine views, second only to Van de Velde."

Portraits of early marine painters are rare, and the oil portrait after which this engraving was made is the first of an English practitioner.[2] Like Godfrey Kneller's portraits of the Van de Veldes, it conveys gentlemanly self-presentation, devoid of any taint of the dockyard. Monamy supports and gestures toward one of his own compositions of storm

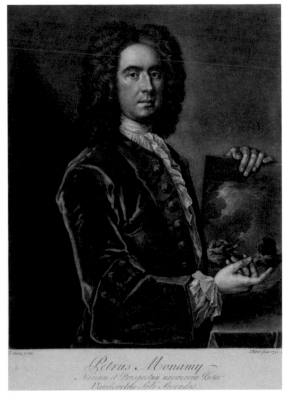

Petrus Monamy
Navium et Prospectum marionorum Pictor
Vandeveldo Soli Secundus

18

and shipwreck on the Van de Velde model (see, for example, cat. 35). His claim to being the Younger's main emulator remained plausible into the mid-1730s, when the talents of Samuel Scott and, later, Charles Brooking began to emerge. The contents of Monamy's Westminster studio, sold after his death, included ship models and many prints and drawings, some by the Van de Veldes. Like them he was part of an artistic family: in 1749 his daughter, Mary, married the marine painter Francis Swaine, and their second son, Monamy Swaine, was a good but lesser-known practitioner of marine painting who undertook other subjects as well. — PVDM

1. Vertue, *Note-books*, 3:145.
2. For the oil portrait of Monamy (private collection), see Cockett, *Peter Monamy*, 19, pl. 2. Kneller's Van de Velde portraits are now known only from prints; see also the Van de Velde portrait by Lodewijck van der Helst (Rijksmuseum, Amsterdam; fig. 11, p. 20, in this volume).

19

19

Peter Monamy (1681–1749)

Winstanley's Lighthouse

ca. 1725
Oil on canvas
24 ¼ x 54 in. (61.6 x 137.2 cm)
Yale Center for British Art, Paul Mellon Collection,
B1981.25.450

PROVENANCE: Cobbold Esq. of the Lodge,
Felixstowe, Suffolk; by descent to P. W. Cobbold,
Esq., of Tattingstone Park, Ipswich, Suffolk; by
descent to A. P. Cobbold, Esq.; by descent to R.
Cobbold, Esq.; Gooden and Fox, Ltd., from whom
bt by Paul Mellon, Nov. 1967.

EXHIBITIONS: YCBA 1977–78 (5)

LITERATURE: Harrison-Wallace, *Peter Monamy*,
n.p.; Cockett, *Peter Monamy*, 37; Mike Palmer,
Eddystone: The Finger of Light (Woodbridge, UK:
Seafarer, 2005), 21

FOR CENTURIES the Eddystone Rocks, off the
coast of Cornwall, had caused the wreck of
ships approaching Plymouth, and in 1692 the
Admiralty issued a call for designs for a light-
house to be built there. The venture would be
risky: the architect selected would finance the
construction himself, with costs recouped only
after the structure's completion, by charging
fees to vessels sailing up the English Channel.[1]

By the mid-1690s, the artist, inventor, and
engineer Henry Winstanley had the experience
to address the unique engineering challenges
posed by the project. His expertise in construct-
ing mechanical and hydraulic devices was
recognized among contemporary architects
and engineers and celebrated by the public. His
house in Littlebury, Essex, known as "Win-
stanley's Wonders," was filled with distorting
mirrors, mechanical moving chairs, and other
automated curiosities, and patronized by such
esteemed visitors as Charles II.[2] In the 1690s the
inventor opened "Winstanley's Water-works" in
Piccadilly, a tourist attraction featuring hydrau-
lic entertainments and pyrotechnics. When
the Eddystone Lighthouse competition was
announced, he had recently learned of wrecks
on the Rocks of two ships attached to a com-
mercial enterprise in which he had invested.

Winstanley was awarded the project, and
construction began in 1696. While on the reef
on June 25, 1697, he was taken prisoner by a
French privateer; only after Louis XIV ordered his

release was construction completed, in November 1698. Winstanley enlarged the structure in 1699, expanding the wooden octagon into a dodecagon and raising the height of the tower so that its light could be seen over the cresting waves. The lighthouse was successfully in use until 1703, when that year's "Great Storm" destroyed it, perhaps fulfilling Winstanley's desire to be inside his lighthouse during "the greatest storm that ever blew under the face of the heavens," but killing him in the process.[3]

This oil painting is one of at least three depictions by Monamy of a lighthouse on the site. The version in the collection of the Plymouth City Museum and Art Gallery is similarly composed. A third version represents the structure that replaced Winstanley's lighthouse, designed by John Rudyard and completed in 1709.[4]

It has been assumed that this painting and the one at Plymouth depict Winstanley's first lighthouse, before it was enlarged in 1699. A more complicated pictorial legacy, however, is suggested by a close examination of the variety of prints and drawings of the subject circulating in the first quarter of the eighteenth century. They include an engraving of the first lighthouse by John Sturt after Jaaziell Johnston, issued in about 1700; etchings made by Thomas Baston of both Winstanley's lighthouses around 1702; a print of an etching by Winstanley himself that was accompanied by a written description of the lighthouse's construction, in circulation by 1702 and published in different versions until late in the eighteenth century (fig. 101); and a sketch attributed to Van de Velde the Younger of "The Eddystone lighthouse drawn probably immediately after its completion," which also appears to combine elements of Winstanley's first and second lighthouses.[5] One further source indicates the form of Winstanley's first lighthouse: a saltcellar, commissioned in honor of the opening of the lighthouse and cast by Plymouth goldsmith Peter Rowe, is an exact replica of the model Winstanley used.[6]

In the painting reproduced here, a ladder runs up the right side of the lighthouse's stone base, ending at the bottom of the octagonal wooden structure, which is adorned with decorative mullions and windows and a balcony. The balcony is topped with a glass lantern that could house up to sixty candles, crowned with a decorative weathervane reinforced by a coiled wrought-iron bracket. These details appear to have been copied from the engraving after Johnston's painting. However, the arm that displays a red ensign and the narrower shape of the turreted tower, not present in Johnston's image, appear in Winstanley's print of the second lighthouse. This assemblage suggests it is a composite image, with inspiration culled from various printed materials available to the artist long after the original structure was destroyed. The absolute calm in Monamy's painting belies the history of and reasons for the lighthouse's construction. — SL

1. Adam Hart-Davis and Emily Troscianko, *Henry Winstanley and the Eddystone Lighthouse* (Stroud: Sutton, 2002), 10.

2. Hart-Davis and Troscianko, *Henry Winstanley*, 53.

3. John Smeaton, *A Narrative of the Building and a Description of the Construction of the Edystone [sic] Lighthouse with Stone: To Which Is Subjoined, an Appendix, Giving Some Account of the Lighthouse on the Spurn Point, Built upon a Sand* (London: Printed . . . by H. Hughs . . . , 1791), 10.

4. See Cockett, *Peter Monamy*, 34–37.

5. For the Winstanley print, see Alison Barnes, *Henry Winstanley: Artist, Inventor and Lighthouse-Builder, 1644–1703* (Saffron Walden, UK: Saffron Walden Museum, Uttlesford District Council, and Plymouth City Museum and Art Gallery, 2003), 19. Van de Velde's drawing (ca. 1699) is in the collection of the National Maritime Museum, Greenwich (PAF6986).

6. Hart-Davis and Troscianko, *Henry Winstanley*, 145. The saltcellar is in the collection of the Plymouth City Museum and Art Gallery.

FIG. 101. After Henry Winstanley, *Eddystone Lighthouse*, ca. 1703, engraving, 39½ x 28 in. (100.3 x 71.1 cm). Yale Center for British Art, Paul Mellon Collection

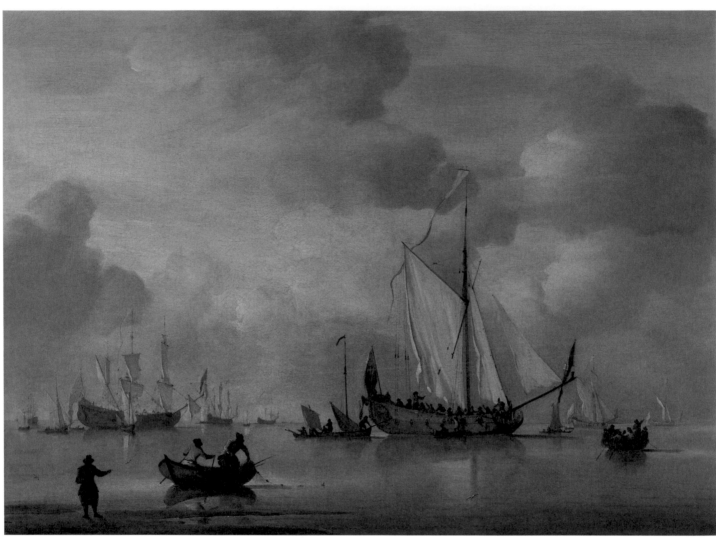

20

20

Peter Monamy (1681 — 1749)

An English Royal Yacht Standing Offshore in a Calm

before 1730
Oil on canvas
28 x 38 in. (71.1 x 96.5 cm)
Yale Center for British Art, The U Collection. In appreciation of Choh Shiu and Man Foo U, loving parents, and Dorothea and Frank Cockett, dear friends, B2008.30.8

EXHIBITIONS: YCBA 2009

THIS IS CLASSIC, creamy-toned Monamy "calm," focusing on a single vessel in the near foreground, with others of various sizes carefully disposed to set it off on a limpid, reflective sea and against a soaring sky. The mundane activity of fishermen tending nets close to the sandy shoreline, the low horizon, and the diminishing scale of the vessels receding toward it all hark back to Dutch seventeenth-century models (not least the Van de Veldes). Although the shipping is clearly English, it is at latest of the period 1710–30, and probably earlier. Royal yachts were used for court transport but, since they were naval vessels, they also carried orders, dispatches, and diplomatic and other VIP passengers, as required: here there seems to be a considerable group on board. It is hard to imagine where such a scene of expansive stillness would be found on English seas; many Dutch calms had been inspired by the enclosed and relatively sheltered waters of the Zuyder Zee. The whole is an English *capriccio* in the Dutch tradition, well calculated to appeal not only to the taste of naval and other seafarers but also, in its peaceful, decorative refinement, to that of their wives and other female relatives and friends. — PvDM

21

Paul Fourdrinier (1698–1758)
after Peter Monamy (1681–1749)

A Sea Engagement between the English and the Algerines

ca. 1743 (early 19th-century restrike)

22

Remi Parr (1743–after 1750)
after Peter Monamy (1681–1749)

The Taking of the *St. Joseph*, a Spanish Carracca Ship, Sept. 23 1739, by the *Chester* and *Canterbury* Men of War, This Prize Was Valued at Upwards of £150,000

1743 (early 19th-century restrike)

23

Paul Fourdrinier (1698–1758)
after Peter Monamy (1681–1749)

Sweet William's Farewell to Black Eyed Susan

1743 (early 19th-century restrike)

24

Remi Parr (1743–after 1750)
after Peter Monamy (1681–1749)

The Taking of Porto Bello by Vice-Admiral Vernon on the 22nd of Novr. 1739 with Six Men of War Only

1743 (early 19th-century restrike)

Hand-colored engravings
12½ x 18 in. (31.8 x 45.7 cm)
Yale Center for British Art, Paul Mellon Collection, B1995.13.133, 134, 141, 138

EXHIBITIONS: (cat. 22) YCBA 2006

LITERATURE: Cockett, *Peter Monamy*, 24, 85–86; David Coke and Alan Borg, *Vauxhall Gardens: A History* (New Haven and London: Published for the Paul Mellon Centre for Studies in British Art by Yale Univ. Press, 2011); Hughes, "Guns in the Gardens," 78–99.

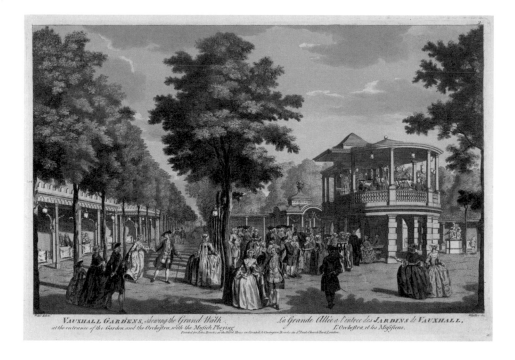

FIG. 102. J. S. Muller after Samuel Wale, *Vauxhall Gardens, Shewing the Grand Walk at the Entrance of the Garden, and the Orchestra, with Musick Playing*, 1751, hand-colored engraving, 10⅛ x 15¾ in. (25.6 x 40 cm). Yale Center for British Art, Paul Mellon Collection

IN 1732 Jonathan Tyers reopened the pleasure gardens at Vauxhall, which had fallen into disrepair and disrepute in the late seventeenth century, as a venue for polite entertainment. Among his improvements were supperboxes where the clientele could dine while enjoying music (fig. 102). By the early 1740s these were decorated with paintings executed by Francis Hayman and his studio from designs by Hayman, Hubert-François Gravelot, and William Hogarth, a scheme that made Vauxhall one of the first public arenas for the display of contemporary British art. A small but potent disruption of the themes of rustic pastimes and games, the four marine paintings by Peter Monamy, now known only through these prints, brought intimations of politics, nation, and empire onto the gardens' menu of refined pleasure.

A Sea Engagement between the English and Algerines (cat. 21), adapted from variations on the subject by Van de Velde (see cat. 7) reflects a still current concern with the predations of corsairs from the Barbary coast on merchant shipping in the Mediterranean, threatening capture, conversion, and enslavement of passengers and crew. In the background four British ships — three heavily damaged, one sinking — engage a squadron of Barbary ships, identifiable by their lateen-rigged (triangular) mainsails;

in the foreground, where one of the vessels is sinking, the combat is brought to the scale of the human figure, as crews from the opposing forces struggle to occupy a boat. The immediate inspiration for including this image at Vauxhall may have been the publication in 1739 of a highly successful captivity narrative, *The History of the Long Captivity of Thomas Pellow in South Barbary*. As Linda Colley has observed, "Barbary corsairing alarmed and angered out of all proportion to its actual extent because it seemed the negation of what England and ultimately Britain and its empire were traditionally about."[1] Just as Hayman's depictions of rustic pleasure helped to define Vauxhall's ideal visitors as polite and refined, this image served to reinforce the image of a nation defined by Protestantism, liberty, and naval and commercial supremacy.

The latter theme is transposed to Atlantic waters in *The Taking of the* St. Joseph, *a Spanish Carracca Ship* (cat. 22), which shows the

relatively bloodless capture of a particularly lucrative prize in 1739, as reported in the press: "She is since arrived in Portsmouth . . . and 1900lb wt. of silver, taken out of her, lodged in the bank of England, also 1,467,648lb of cocoa, in the Excise warehouse."[2] Given that the value of such a prize was shared among the entire crew of the capturing vessel(s), this image must have served in effect as a recruitment poster for the navy, joining the incentive of prize money to patriotic interest.

Sweet William's Farewell to Black Eyed Susan (cat. 23) takes its subject from John Gay's poem of 1713, in which William parts from his lover to go to sea with the navy. In this engraving after Monamy's picture, Susan waves from the boat that is pulling away from the three-decker on which the figure of William is visible. The ship's sails are just beginning to fill with wind; the oarsmen in the boat are at full reach, about to pull on their oars. The image is thus poised in the instant when the lovers are still perhaps within earshot of each other. In the next moment, as would have been apparent to contemporary viewers, the two vessels will draw apart, the ship rejoining the fleet in the distance, and Susan heading for shore. Viewers familiar with the poem would have been accustomed to its theme of fidelity ("Change as ye list, ye Winds, my heart shall be / The faithful Compass that still points to thee") and the separations occasioned by service in the navy.

By far the most famous of contemporary naval events was the capture of Puerto Bello, the Spanish trading post on the coast of present-day Panama. Admiral Edward Vernon, a fierce critic of Prime Minister Robert Walpole and what he saw as insufficiently assertive policies with regard to national trade and the maintenance of the navy, had boasted to Parliament in 1729 that he could take Porto Bello, as it was then known, with "six ships only." Mounting hostilities between Britain and Spain in the 1730s broke out into war, and in 1739 Vernon made good on his promise. News of the capture reached London in March 1740, and Monamy's painting appears to have been installed at Vauxhall in a matter of weeks: Frederick, Prince of Wales (son of George II), and his wife, Augusta, viewed it there on May 19.[3]

21

22

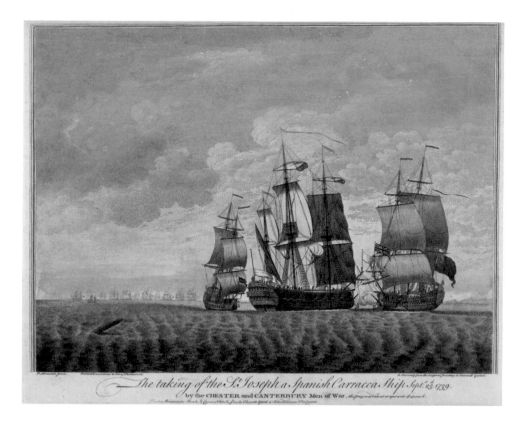

The taking of the St Joseph a Spanish Carracca Ship Sept. 23. 1739.
by the CHESTER and CANTERBURY Men of War.

23

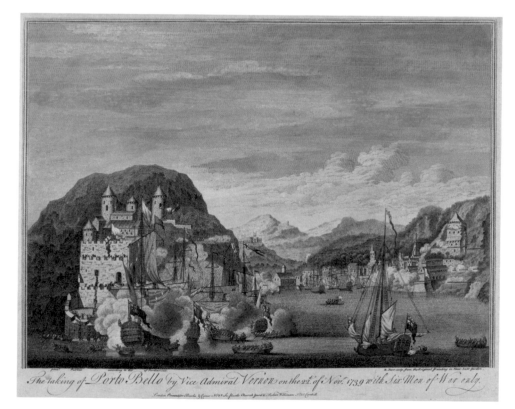

The taking of Porto Bello by Vice Admiral Vernon on the 22. of Nov. 1739 with Six Men of War only.

24

Monamy's composition (cat. 24) provides a legible depiction of the action as it was described in published reports. Despite careful planning, the British ships were thwarted from entering the harbor by a change in wind direction and, instead of proceeding directly toward the town, focused their attack on the Iron Castle (Castillo de Todofierro), which protected its entrance:

As the Boats came near the Admiral's ship, he call'd down to them to go directly on Shore under the Walls of the Fort. . . . This answered as was expected, by throwing the Enemy into a general Consternation, the Officers and Men who had stood to the lower Battery, flying to the upper part of the Fort, where they held up a White Flag. . . . In the mean time the Seamen had climb'd up the Walls of the lower battery and struck the Colours, and then drew the Soldiers up after them, to whom the Spaniards, who had retired to the upper Part of the Fort, soon after surrendered at Discretion.[4]

The town surrendered the next day. Monamy's painting was one of a range of cultural productions (see cats. 25–30) that celebrated Vernon as a national hero, including ballads sung and sold at Vauxhall Gardens. — EH

1. Colley, *Captives*, 47.
2. *Scots Magazine* (1739), 481.
3. *Daily Post*, May 20, 1740.
4. *London Magazine*, March 13, 1740; *Monthly Chronologer* (1740), 147–48.

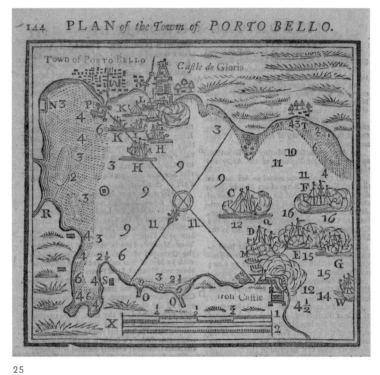

25

26

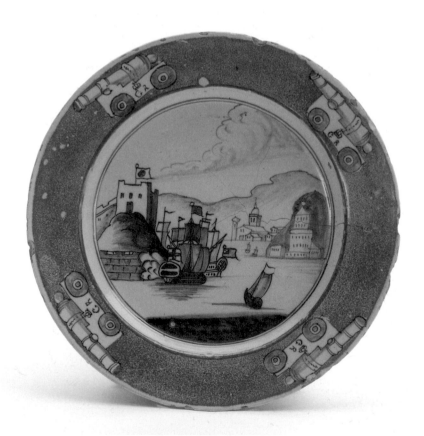

27

25

After Philip Durell (1707–1766)

Plan of the Town of Porto Bello

In *Gentleman's Magazine*, 1740, pages 144–45
London: John Nichols
Yale Center for British Art, Paul Mellon Collection,
S11 1740 vol. 10

26

Unknown maker

Porto Bello Commemorative Bowl

ca. 1740
Stoneware
2 1/8 x 3 1/2 in. (5.5 x 9 cm)
National Maritime Museum, Greenwich, London,
AAA4355

27

Unknown maker

Porto Bello Commemorative Plate

ca. 1740
Earthenware
1 1/8 x 9 in. (3 x 23 cm)
National Maritime Museum, Greenwich, London,
AAA4352

28

Unknown maker

Porto Bello Commemorative Medal

Copper and silver alloy

Obverse: THE BRITISH GLORY REVIV'D BY
ADMIRAL VERNON

Reverse: THE [*sic*] TOOK PORTO BELLO WITH
SIX SHIPS ONLY / NOV 22 1739

1½ in. (3.67 cm) diam.

Collection of Stephen K. and Janie Woo Scher

29

Unknown maker

Porto Bello Commemorative Medal

Copper alloy

Obverse: THE BRITISH GLORY REVIV'D BY
ADMIRAL VERNON / FORT CHAGRE

Reverse: WHO TOOK PORTO BELLO WITH
SIX SHIPS ONLY / NOV 22 1739

1⅝ in. (3.71 cm) diam.

Collection of Stephen K. and Janie Woo Scher

30

Unknown maker

Porto Bello Commemorative Medal

Copper alloy

Obverse: THE PRIDE OF SPAIN HUMBLED BY AD:
VERNON / DON BLASS

Reverse: HE TOOK PORTO BELLO WITH SIX SHIPS
ONLY / NOV 22 1739

1⅝ in. (3.73 cm) diam.

Collection of Stephen K. and Janie Woo Scher

FOLLOWING ADMIRAL VERNON'S capture
of Puerto Bello (see cat. 24), Captain James
Rentone, who had acted as pilot during the
action, was given the honor of sailing back to
England in a captured Spanish vessel to deliver
news of the victory, while the rest of Vernon's
fleet proceeded to capture the town of Chagres.[1]
Rentone brought with him a plan of Puerto Bello
drawn by Lieutenant Philip Durell, which was
published in the *Gentleman's Magazine* along
with Vernon's official description of the action
(cat. 25). This plan, which was also issued as
a more sophisticated single print engraved by
William Henry Toms, provided the basis not
only for paintings of the event by Monamy and
Samuel Scott, but also for the decoration of an

28 OBVERSE

28 REVERSE

29 OBVERSE

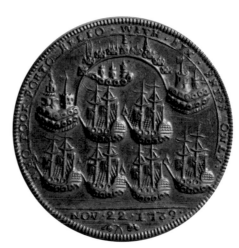

29 REVERSE

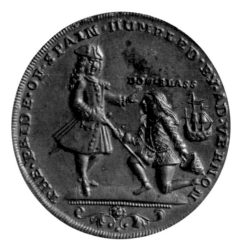

30 OBVERSE

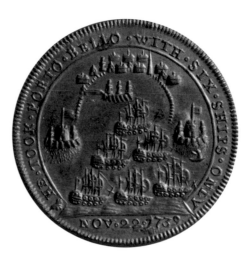

30 REVERSE

array of commemorative objects that included prints, fans, glassware, ceramic bowls, tankards, plates, and teapots.[2] They were part of an extraordinary popular response to the victory — out of all proportion to the strategic significance of the event — that lionized Vernon as a national hero, even establishing annual celebrations of his birthday. This enthusiasm had much to do with political symbolism: the capture of Puerto Bello by an outspoken critic of Robert Walpole's administration was seen as a triumph for the opposition and helped bring down the government.[3]

Many commemorative objects, like the plate, bowl, and medals included here, presented the geography of the bay and town in schematic form, based on the published plan, as well as representations of Vernon's six ships, often with the legend "He took Porto Bello with six ships only." At least 102 commemorative medals were struck between 1740 and 1743 — more than for any other eighteenth-century figure.[4] Some bear portraits of Vernon holding a telescope (cat. 28), emphasizing his authority and the visual acuity that informed his judgment; others are more martial in tone, showing Vernon's full-length figure, holding a sword and baton, superimposed on his conquest (cat. 29) or accepting the sword of "Don Blass" (Blas de Lezo y Olavarrieta, the Spanish admiral) in surrender. Very often, as in all the examples shown here, the reverse of the medal repeats the legend along with a schematic representation of Puerto Bello, based on Durell's plan, including the forts protecting the harbor, the town at its far end, and Vernon's six ships.[5] The persistence of such representations in fine art and popular culture strongly suggests that a wide swath of the public was cognizant not only of the victory but also of the way in which it was achieved. — EH

1. *Monthly Chronologer* (1740), 149; see also Cyril Hughes Hartmann, *The Angry Admiral* (London: William Heinemann, 1953), 32.

2. Wilson, *Sense of the People*, 143–47.

3. Wilson, *Sense of the People*, 142.

4. Wilson, *Sense of the People*, 146.

5. See John W. Adams and Fernando Chao, *Medallic Portraits of Admiral Vernon* (Gahanna, OH: Kolbe and Fanning, 2010), 77, PBv 42-PP; 152, FCv 12-Q; 130, PBvl 2-B.

31

Charles Grignion (1721–1810)
after William Hogarth (1690–1764)

Canvassing for Votes, Plate 2 from An Election

1757
Engraving
Sheet: 18½ x 24 in. (47 x 61.1 cm);
plate: 17⅛ x 21⅞ in. (43.6 x 55.6 cm)
Lewis Walpole Library, Yale University, lwlpr22322

THIS PLATE from Hogarth's series *An Election* is key to understanding how the naval engagements that helped to shape the course of the British Empire were represented and understood. The series — published at the beginning of the Seven Years' War, which was marked by a number of disastrous naval operations, including the loss of Minorca to the French in 1756 — shows the progress of a fictional election, in which order is constantly threatened by the potential chaos of the mob.[1] The vignette on the left refers back to Admiral Edward Vernon's capture of the Spanish trading post of Puerto Bello in 1739 (see cats. 24–30), the last outright British naval victory, no doubt included to contrast with current uncertainties. Hogarth in effect offers three versions of the event: a pictorial view in the form of the inn sign at left; the six pieces of pipe stem on the table below it, diagramming the ships in the action; and the narrative being relayed by one disheveled character to the other. Together, the versions suggest that pictorial representations were constructed and understood in relation to published narratives and plans, and were intended for the retelling of events. — EH

1. See Paulson, *Hogarth*, 3:166.

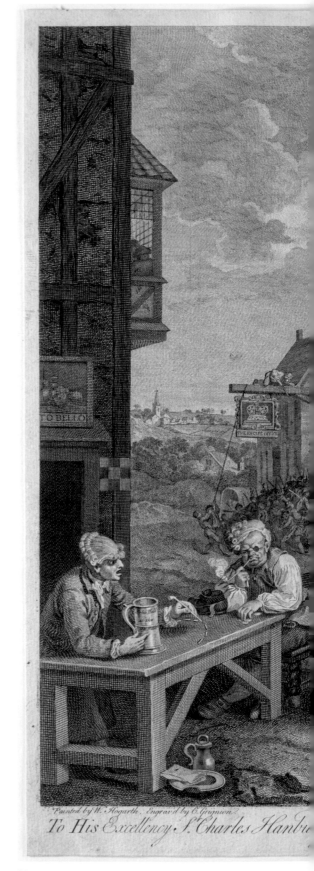

31

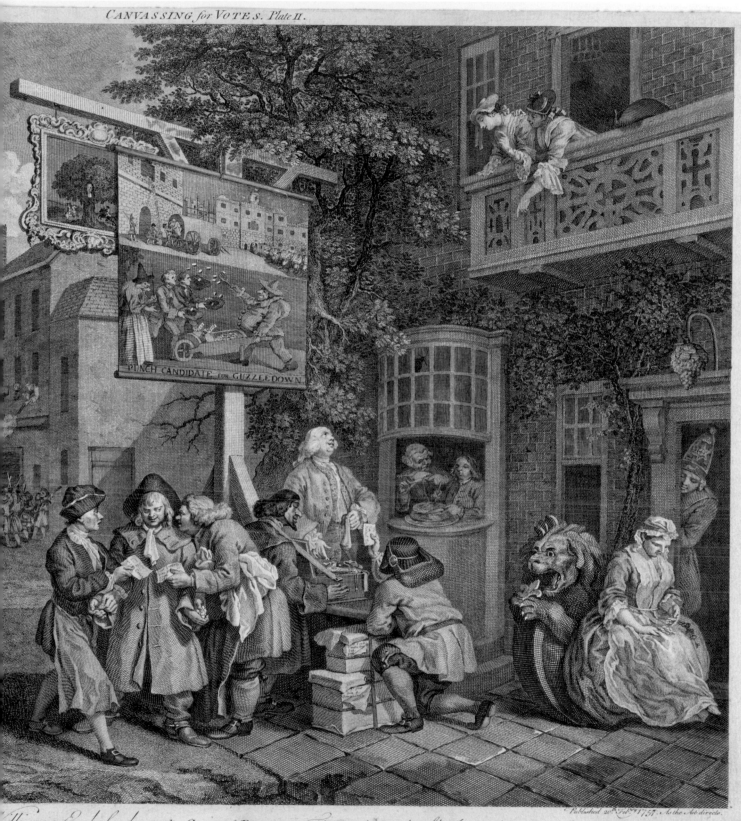

PUNCH CANDIDATE for GUZZLEDOWN

...lliams Embassador to the Court of RUSSIA. This Plate is most humbly Inscrib'd By his most Obedient humble Servant.

Will.m Hogarth.

Published 20.th Feb.ry 1757. As the Act directs.

32

Pierre-Charles Canot (ca. 1710–1777)
after Peter Monamy (1681–1749)

Morning, or Sun Rising

1745
Engraving
Sheet: 15 x 21 ⅞ in. (38.1 x 55.5 cm);
plate: 12 x 15 ⅞ in. (30.3 x 40.2 cm);
image: 10 ⅝ x 15 in. (27 x 37.9 cm)
Yale Center for British Art, Paul Mellon Collection,
B1977.14.11968

33

Pierre-Charles Canot (ca. 1710–1777)
after Peter Monamy (1681–1749)

Moon Light

1745
Engraving
Sheet (cropped to plate): 11 ⅞ x 15 ¾ in.
(30.2 x 40 cm); image: 10 ⅝ x 15 in. (26.9 x 38 cm)
Yale Center for British Art, Paul Mellon Collection,
B1977.14.11971

34

Pierre-Charles Canot (ca. 1710–1777)
after Peter Monamy (1681–1749)

Night & a Ship on Fire

1745
Engraving
Sheet: 15 x 21 ½ in. (37.9 x 54.5 cm);
plate: 12 x 15 ⅞ in. (30.5 x 40.2 cm);
image: 10 ¾ x 15 in. (27.2 x 38 cm)
Yale Center for British Art, Paul Mellon Collection,
B1977.14.11973

35

Pierre-Charles Canot (ca. 1710–1777)
after Peter Monamy (1681–1749)

Shipwrack

1745
Engraving
Sheet (cropped to plate): 11 ⅞ x 15 ⅞ in.
(30.2 x 40.4 cm); image: 10 ⅝ x 15 ⅛ in.
(26.9 x 38.2 cm)
Yale Center for British Art, Paul Mellon Collection,
B1977.14.11976

32

33

Night & a Ship on fire. *Nuit & Vaisseau en feu.*

34

Shipwrack. *Naufrage.*

35

PRINTS AFTER marine paintings increased in popularity during the eighteenth century, as their audience extended beyond those involved in the navy and trade to the mercantile classes with a general interest in Britain's maritime fortunes. Most print publishers preferred to stock reproductions after the seventeenth-century Dutch marine painters, particularly the Willem van de Veldes, father and son, who dominated the maritime print market until the late eighteenth century. However, the leading publishers — Henry Overton, John Bowles, Robert Sayer, and John and Josiah Boydell — also promoted prints after "sea pieces" by British marine painters, including Peter Monamy, Samuel Scott, John Cleveley and his sons John and Robert, Robert Dodd, Francis Swaine, and Dominic Serres.[1]

John Bowles published a set of ten engravings by the prominent engraver Pierre-Charles Canot, a French émigré, after paintings by Monamy. Their inscriptions in French as well as English suggest that he expected a Continental as well as a domestic market for them. Primarily generic sea pieces rather than depictions of specific places, events, or vessels, the set resonates with artistic tropes, particularly "times of day," a seventeenth-century Continental tradition here adapted to maritime subjects.[2] Prints depicting morning (cat. 32), noon, evening, and night (cat. 33) allowed painter and engraver to demonstrate their skill in depicting the effects of atmosphere and light. The set also provides a number of prints expressing the contrast between calm and storm, and the enduring interest in disaster and shipwreck. The subject of a ship on fire at night (cat. 34) appears to have been irresistible to marine painters (see cat. 44). Monamy's *Shipwrack* (cat. 35) portrays a similarly desperate situation, which may have arisen, as in Van de Velde the Younger's depiction (cat. 16), off the Eddystone Rocks, a setting Monamy had evoked in calmer conditions several decades earlier (cat. 19). — EH

1. James Taylor, "18th Century Maritime Painters, Printmakers and Publishers," in Joel, *Brooking*, 65.
2. See Christine Riding's essay in this volume.

36-37

John Pine (1690–1756)

The Tapestry Hangings of the House of Lords: Representing the Several Engagements between the English and Spanish Fleets in the Ever Memorable Year MDLXXXVIII . . .

London: John Pine, 1739
Yale Center for British Art, Paul Mellon Collection, Folio A 2009 81 Copies 1 and 2
Copy 1, shown: Map
Copy 2, shown: Tapestry IV

38

John Pine (1690–1756)

The Tapestry Hangings of the House of Lords: Representing the Several Engagements between the English and Spanish Fleets in the Ever Memorable Year MDLXXXVIII . . .

London: John Pine, 1739
Lewis Walpole Library, Yale University, Folio 49 3552
Shown: Charts III and IV

PROVENANCE: Horace Walpole; Strawberry Hill Sale, 1842, day 8, bt by Colonel Durrant; Sotheby's Nov. 3, 1952 (105) from whom bt by Maggs for Wilmarth Sheldon Lewis

39

Hubert-François Gravelot (1699–1773)

Charles Howard, Second Baron Howard of Effingham and First Earl of Nottingham

ca. 1739
Graphite over red chalk; gold leaf, watercolor, pen and black and red ink on paper
Sheet: 2 ¼ x 1 ¾ in. (5.7 x 4.4 cm); mount: 15 ⅜ x 11 in. (39.1 x 27.9 cm); contemporary drawn border: 3 ⅞ x 3 ⅜ in. (9.8 x 8.6 cm)
Yale Center for British Art, Paul Mellon Collection, B1975.4.463

PINE'S *Tapestry Hangings of the House of Lords* was one of the great collaborative publishing enterprises of the eighteenth century: Horace Walpole, who owned one of the present examples, called it "a book rivalling the splendid editions of the Louvre."[1] This magnificent work sought to preserve the appearance of a set of tapestries depicting the defeat of the Spanish Armada in 1588. Made in the 1590s for Lord

36

Howard of Effingham, who had commanded the English fleet against a Spanish invasion force, the tapestries were designed by the Dutch marine painter Hendrick Cornelisz. Vroom and woven in the workshop of Frans Spierincx, in Delft, at a cost of £1,582. Howard sold them to James I in 1616, and in the mid-1640s they were hung in the House of Lords, where they remained, with some rotations, until they were destroyed in the fire of 1834.[2]

The Tapestry Hangings of the House of Lords was, therefore, primarily an antiquarian enterprise: "Because Time, or Accident, or Moths may deface these valuable Shadows, we have endeavored to preserve their likeness in the preceding prints, which, by being multiplied and dispersed in various hands, may meet with that Security from the Closets of the curious, which the originals must scarce always hope for, even from the sanctity of the place they are kept in." In addition to sumptuous engravings of the tapestries, reproduced in green ink after drawings by Charles Lempriere, Pine included an opening map (cat. 36) showing the course of the Armada around the British Isles and charts indicating the locations of key episodes in the arrival, pursuit, and dispersal of the Armada. Based on a series published by Augustine Ryther in 1590,

the map and charts were modernized, refined, and embellished with rococo ornament by the French engraver Hubert-François Gravelot, who during the same period designed supperbox paintings for Vauxhall Gardens (see fig. 102, p. 161). Pine likewise commissioned from Philip Morant a new history of the events, which refers the reader to the tapestries and charts at appropriate moments in the narrative. This was a peculiarly interactive volume in which the reader was meant to page back and forth between narrative, plan, and pictorial representation.

Five of the ten plates reproducing the tapestries are, Morant points out, "an exact Representation of the Border to the Tapestry-Hangings, which is ornamented with the Portraits of the principal commanders" (for example, cat. 37a); however "for more Variety" Pine commissioned Gravelot to devise new borders for the other five (see cat. 37b) and for the charts. These grand rococo devices, as Karsten Harries notes, effectively "re-present what they frame," drawing attention to what might otherwise have become overly familiar by incorporating reproductions of medals and "other ornaments," for which Morant also provides explanation.[3] The profile of Queen Elizabeth surmounting the first two charts, for example, is taken from a miniature

37a

37b

by Isaac Oliver. For the portrait that embellishes the surround of two of the charts (cat. 38), Gravelot made a drawing (cat. 39) from the full-length portrait of Howard by Daniel Mytens the Elder (fig. 103). The volume thus plays between different media — tapestry, print, painting,

medals, and miniatures — as well as evoking the allegorical and material culture of the maritime in Gravelot's rococo borders.

Likewise, the charts and tapestries themselves convey multiple registers of information. The third tapestry, for example (cat. 37b), shows

two sequential scenes in bird's-eye perspective, looking north toward the southern English coast: on the left, the English and Spanish fleets meet in a four-hour engagement as more English ships emerge from Plymouth; on the right, the English fleet pursues the Spanish eastward along the Channel. Four ships, led by Sir Francis Drake, are seen leaving the main English fleet, contrary to Howard's orders, to investigate a small group of ships to the south. In the corresponding chart, the same events are seen in a diagrammatic view, but with the addition of a map of the coast and an allegorical figure indicating the direction of the wind, one of the decisive factors in the fate of the Armada.

Pine was part of the circle of London artists that met at Old Slaughter's Coffee House and then the St. Martin's Lane Academy. Along with his friend William Hogarth he petitioned for the Engraving Copyright Act of 1735, which protected the designers and engravers of original prints from piracy for fourteen years following publication. Pine successfully applied for a special clause giving him the exclusive right to copy the tapestries, appearing before the House of Lords to argue his case in the very chamber in which the tapestries hung.[4] — EH

1. Horace Walpole, *Anecdotes of Painting in England, with Some Account of the Principal Artists*, rev. ed., 3 vols. (London: Chatto and Windus, 1876), 3:260–61.
2. See Stephen Farrell, "The Armada Tapestries in the Old Palace of Westminster," *Parliamentary History* 29, no. 3 (2010): 416–40; M. J. Rodríguez-Salgado and the staff of the National Maritime Museum, *Armada: 1588–1988* (New York: Penguin, 1988).
3. Karsten Harries, *The Broken Frame* (Washington, DC: The Catholic University of America Press, 1989), 67.
4. See Susan Sloman, "John Pine (1690–1756)," in *Oxford Dictionary of National Biography*, Oxford Univ. Press, 2004: http://dx.doi.org/10.1093/ref :odnb/22293 (accessed Oct. 28, 2013); Timothy Clayton, *The English Print, 1688–1802* (New Haven and London: Published for the Paul Mellon Centre for Studies in British Art by Yale Univ. Press, 1997), 86–88; David Hunter, "Copyright Protection for Engravings and Maps in Eighteenth-Century Britain," *Library* 9, no. 2 (June 1, 1987): 133–36.

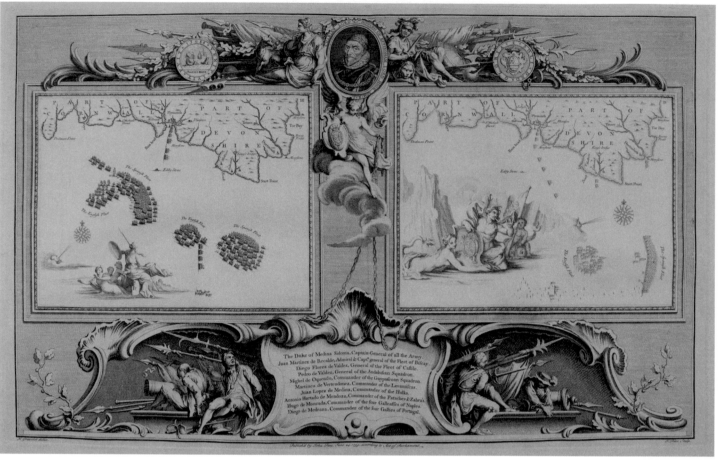

38

39

FIG. 103. Studio of Daniel Mytens the Elder, *Charles Howard, 1536–1624, First Earl of Nottingham*, ca. 1620, oil on canvas, 82 x 55 in. (208.5 x 139.5 cm). National Maritime Museum, Greenwich, London, Greenwich Hospital Collection

37a (DETAIL)

THE LORD ADMIRALL IN THE ARKE

THE EARLE OF COUMBERLAND IN THE LYON

THE LO THOMAS HOWARD IN THE LYON

SR FRANCIS DRAKE VICE ADMIRALL IN THE REVENGE

IV

HISPANIA THOMAS

SR CHARLES BLVNT

SR THOMAS SYCILL

CAP BENJAMIN GONSON

SR JOHN HAWKINS REAR ADMIRALL IN THE VICTORY

CAP CHRISTOPHER BAKER IN THE LYON

SR GEORGE BECTON IN THE DREADNOUGHT

MR KNEVET

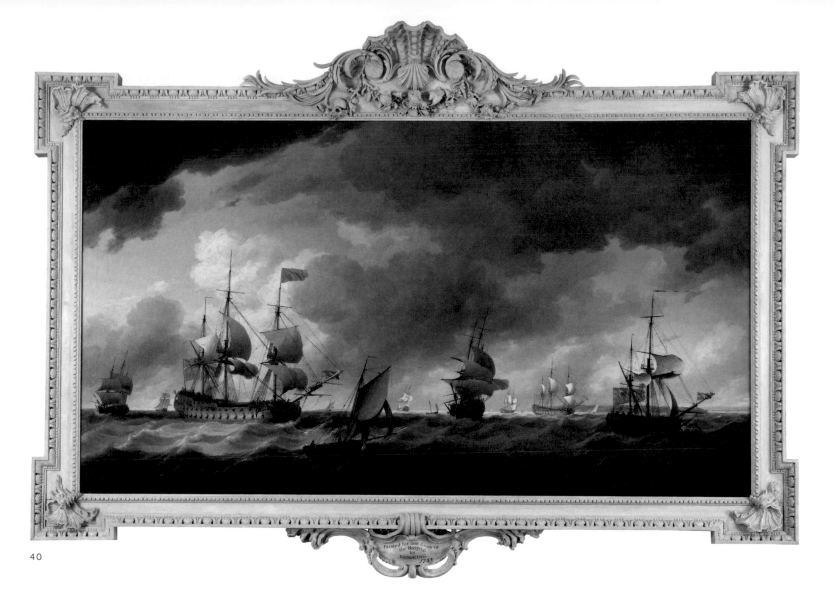

40

40

Charles Brooking (1723–1759)

A Flagship before the Wind under Easy Sail

1754
Oil on canvas
70 x 123 in. (177.8 x 312.4 cm)
Trustees of the Foundling Museum, London

PROVENANCE: Presented by Brooking to the
Foundling Hospital, 1754

EXHIBITIONS: BFAC 1929 (1); Aldeburgh/Bristol
1966 (4)

LITERATURE: Joel, *Charles Brooking*, 48–51,143

RELATIVELY LITTLE is known about the gifted
and influential but short-lived marine painter
Charles Brooking. His father is assumed to be
Charles Brooking the painter-decorator who
worked at Greenwich Hospital between 1729 and
1736 and from whom the younger Brooking could
have learned technical aspects of painting.[1]
According to his contemporary Edward Edwards,
Brooking "was bred in some department of the
dockyard at Deptford," and Joseph Farington
notes that he "had been much at sea."[2] Edwards
recounts that in the early 1750s Taylor White,
treasurer of the Foundling Hospital, spotted
Brooking's paintings in the window of a picture
dealer who tended to obliterate the artist's sig-
nature to preserve his own role as middleman.
White, "being struck with the merits of some
sea-pieces, desired to know [the artist's] name;
but . . . was only told that if he pleased they
would procure any that he might require from
the same painter." Then the artist brought in a
painting on an occasion when the dealer was
away, and the dealer's wife put it in the window
without removing the signature. White saw it,
"advertised for the artist to meet him," and
"from that time became his friend and patron."[3]

The Foundling Hospital, established by
Thomas Coram, an ex-merchant sea captain,
was intended for the protection of abandoned
children, all too common in the period. Coram's
friend and supporter William Hogarth, ever alert
to social concerns, saw the opportunity both to
promote native artists and to attract potential
supporters to the hospital. The marine painters
Peter Monamy and Samuel Scott were among
the first artists to agree to contribute works,
along with Thomas Gainsborough, Allan Ramsay,
Francis Hayman, Joshua Reynolds, and Richard
Wilson; each was in turn elected a governor
and guardian of the hospital. The plan was a
success, drawing visitors to a philanthropic
enterprise rendered polite and fashionable in

part through the first real exhibition of works by native artists.

Brooking produced this magnificent painting in 1754 at White's behest. Conceived as a pendant to Peter Monamy's contribution (missing for nearly a century but discovered in a private collection in the early 2000s) it was reportedly painted in situ, Brooking's quarters "not affording sufficient space," and completed in eighteen days.[4] If accurate, this assertion would suggest that Brooking based this work, the largest known in his oeuvre, on an earlier, smaller version (see cat. 41). The only one of the eighteenth-century marine paintings to remain at the Foundling Museum, it shows a number of contemporary merchant and naval vessels, including a two-decker (at left) flying the flag of a Vice Admiral of the Red at its foremast. This ship has been identified as that of the Honorable John Byng, the only Vice Admiral of the Red then sailing and a patron of Monamy. Brooking manages the vast scope of his composition with the horizontal framing devices of dark cloud and shadowed water in the foreground, which function as *repoussoir*, the way a tree would in contemporary landscape painting. The recession of the open water is articulated through bands of light and shadow that allow the vessels to be alternately illuminated and silhouetted against the sky. Indeed, different types of vessel are positioned to present the greatest variety of views, in a rhythmic, near-musical arrangement across the picture plane, not unlike George Stubbs's paintings of mares and foals, although here ranging far back into the pictorial space. The frame is said to have been designed and its production overseen by Hogarth. — EH

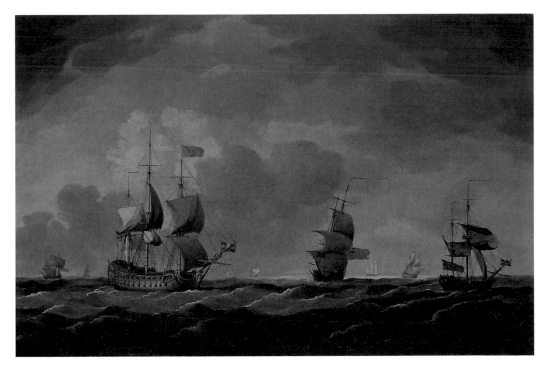

41

41

Charles Brooking (1723–1759)

An English Flagship under Easy Sail in a Moderate Breeze

ca. 1750
Oil on canvas
14 ½ x 22 ½ in. (36.8 x 57.2 cm)
Yale Center for British Art, Paul Mellon Collection, B1981.25.66

PROVENANCE: Oscar & Peter Johnson, from whom bt by Paul Mellon, Feb. 1964

EXHIBITIONS: YCBA 1977–78 (14)

LITERATURE: Joel, *Charles Brooking*, 146

THIS IS A SMALLER version of the painting that Brooking made for the Foundling Hospital (cat. 40); there are at least seven other versions of the composition, now at Tate, the National Maritime Museum, and in private collections. It may have been one of these, glimpsed in a dealer's window, that prompted Taylor White, treasurer of the Foundling Hospital, to seek out Brooking and commission from him the very large canvas that necessitated the addition of vessels not included in other versions. The success of the translation of the smaller composition to a far bigger canvas bespeaks Brooking's talent. Here, Brooking employs compositional techniques similar to those in the larger version, including the use of light and shade to provide a foreground, middle ground, and background to an otherwise featureless expanse of water. — EH

1. David Cordingly, "Charles Brooking (1723–1759)," in *Oxford Dictionary of National Biography*, Oxford Univ. Press, 2004: http://dx.doi.org/10.1093/ref:odnb/3562 (accessed April 27, 2012); Taylor, *Charles Brooking*, 6; Archibald, *Dictionary of Sea Painters*, 73.

2. Edwards, *Anecdotes of Painters*, 5; Farington, *Diary*, 3:766.

3. Edwards, *Anecdotes of Painters*, 5–6.

4. John Brownlow, *Memoranda, or, Chronicles of the Foundling Hospital, Including Memoirs of Captain Coram &c &c* (London: S. Low, 1847), 138.

42

Charles Brooking (1723–1759)

Groupes of Different Corallines Growing on Shells, Supposed to Make This Appearance on the Retreat of the Sea at a Very Low Ebbtide

Frontispiece in John Ellis, *An Essay towards a Natural History of the Corallines, and Other Marine Productions of the Like Kind, Commonly Found on the Coasts of Great Britain and Ireland. . . .*
London: Printed for the author; and sold by A. Millar, 1755
Beinecke Rare Book & Manuscript Library, Yale University, QL379 E55

IN HIS INTRODUCTION to this volume, the botanist and zoologist John Ellis writes: "In August 1752, I went to the Island of Sheppey on the coast of Kent; and took with me Mr. Brooking, a celebrated Painter of sea-pieces, to make the proper Drawings for me." The expedition aimed at a study of corallines, then understood to be plant-like animals that grow on the shells of mollusks, and that, according to Ellis, "had hitherto been considered by Naturalists as Marine Vegetables." Brooking and Ellis were further assisted in their study by "a very Commodious Microscope of Mr Cuff's, the optician in Fleet Street"— presumably the John Cuff immortalized in a portrait by Johann Zoffany now in the Royal Collection.[1] Other illustrations were provided by the botanical draftsman Georg Dionysius Ehret.

Aged twenty-nine at the time of the expedition, Brooking was by no means "celebrated"; however, by the time Ellis's book was published, in 1755, he had joined London's art establishment by contributing his masterpiece to the Foundling Hospital. Brooking's illustrations for Ellis, his earliest known commission, gesture to the array of activities undertaken by marine painters in the competitive eighteenth-century art market; given the skills of observation and delineation that characterized marine painting, the commission to illustrate a work on natural history is unsurprising and finds parallels in the career of at least one other marine painter.[2] In his frontispiece, charmingly, Brooking seems to have been unable to resist including a sailing ship in the distance. — EH

1. See Martin Postle, ed. *Johan Zoffany RA: Society Observed*, exh. cat. (New Haven: Yale Center for British Art; London: Royal Academy of Arts, in association with Yale Univ. Press, 2011), 227–28.

2. See Eleanor Hughes's essay on Nicholas Pocock in this volume.

AN
ESSAY
TOWARDS A
NATURAL HISTORY
OF THE
CORALLINES,
AND OTHER
MARINE PRODUCTIONS of the like Kind,
Commonly found
On the Coasts of GREAT BRITAIN and IRELAND.

To which is added
The DESCRIPTION of a large MARINE POLYPE taken near the *North Pole*, by the Whale-fishers, in the Summer 1753.

By *JOHN ELLIS*, F.R.S.

LONDON:
Printed for the AUTHOR;
And Sold by A. MILLAR, in the *Strand*; J. and J. RIVINGTON, in *St. Paul's Church-Yard*; and R. and J. DODSLEY, in *Pall-Mall*.
M.DCC.LV.

43

43

Charles Brooking (1723–1759)

A Lugger and a Smack in Light Airs

ca. 1750
Oil on copper
7 x 10 in. (17.8 x 25.4 cm)
Yale Center for British Art, Paul Mellon Collection,
B1981.25.62

PROVENANCE: Sir Iver Proctor Beauchamp; Spink &
Son, from whom bt by Paul Mellon, 1961

EXHIBITIONS: VFMA/RA/YUAG 1964–65 (RA/YUAG
only: 140, 17); Aldeburgh/Bristol 1966 (30)

LITERATURE: Joel, *Charles Brooking*, 123

WHAT DISTINGUISHED Brooking's work from
its Dutch antecedents, according to Basil Taylor,
was his "way of projecting the forms of sea,
ships and sky which was at once scrupulous
and lyrical. . . . His compositions often pres-
ent a most precarious equipoise, as if a film,
arrested at the point of a well designed frame,
is about to dissolve into the fluidity of motion.
He also shows a sense of light and atmosphere
which fifty years later in the art of a Crome or
a Constable was to become one of the most
expressive and influential attributes of the Eng-
lish school."[1] Indeed, unlike the many varieties
of "calm" on the Van de Velde model, this work
dispenses with a static shoreline and presents
a moment in which all elements suggest subtle
motion. In the slightest of breezes, the water
ripples; the lugger on the right (named for its
asymmetrical square lugsails), towing a dinghy,

causes minimal wake, rendered as a broken
line of white paint; and the ship on the horizon,
the focal point of the wedge created by the two
smaller vessels, is visible just before it vanishes,
dissolving into the light of the horizon.

This small and exquisite composition, signed
"CB" on a log in the foreground, is the kind of
"furniture" picture that Brooking sold through a
dealer prior to his discovery by Taylor White (see
cat. 40). The paint is relatively thickly applied
for a work by Brooking, perhaps because of
the support used: it is one of only two known
instances in which the artist painted on copper.
— EH

1. Taylor, *Charles Brooking*, 1966, 4.

44

Charles Brooking (1723–1759)

Ship on Fire at Night

ca. 1756
Oil on canvas
12½ x 17 in. (31.8 x 43.2 cm)
Yale Center for British Art, Paul Mellon Collection,
B1981.25.69

PROVENANCE: Christie's, Dec. 10, 1965 (7);
Colnaghi, from whom bt by Paul Mellon, 1965

EXHIBITIONS: Aldeburgh/Bristol 1966 (7); YCBA
1977–78 (16)

LITERATURE: Joel, *Charles Brooking*, 138

THE SUBJECT of the ship on fire originated
in the seventeenth century and continued in
popularity into the Romantic period. Signaling
potential loss of life and financial ruin, it also
conveyed sublime horror and aesthetic plea-
sure; for Brooking, the topic allowed a departure
from his usual palette of cool, silvery blues and
greens to an experiment in black and red. Here,
goods are salvaged from the two-decker in
flames near the shore by boats that are in turn
silhouetted and illuminated by flame. A ver-
sion of this was engraved by John Boydell and
published in 1756. The earliest known painting
by Brooking, signed "C Brooking pinxit aged 17
years," also depicts a ship on fire (fig. 104). — EH

44

FIG. 104. Charles Brooking, *A Two-Decker on Fire
at Night off a Fort*, ca. 1740, oil on canvas, 9 ⅝ x
11 ⅞ in. (24.4 x 30.2 cm). Yale Center for British Art,
Paul Mellon Collection

45

45

Charles Brooking (1723–1759)

Ship Wrecked on a Rocky Coast

1747–50
Oil on canvas
14 ½ x 22 in. (36.8 x 55.9 cm)
Yale Center for British Art, Paul Mellon Collection,
B1981.25.71

PROVENANCE: William Wells, 1890; Christie's, Nov.
1963 (33); Mrs. G. B. McKean, 1966; Leggatt Bros,
1967, from whom bt by Paul Mellon

EXHIBITIONS: YCBA 1977–78 (13)

LITERATURE: Joel, *Charles Brooking*, 165

THIS COMPOSITION, of which Brooking painted at least one other version, may depict a specific incident, the wreck of a Spanish vessel (known alternatively as the *Nympha* and as *Nuestra Señora de los Remedios*), which had been captured by a British privateer off the coast of Lisbon but then wrecked near Beachy Head, on the Sussex coast.[1] The publisher John Boydell made engravings after a version of this composition and of the capture of the ship.

Shipwrecks were of enduring interest to the maritime nation, and paintings by Willem van de Velde the Younger set a standard for depictions of the subject.[2] Through association with the Foundling Hospital, Brooking may have been in contact with Charles Jennens (librettist to George Frideric Handel), whose massive collection of old masters contained a number of seventeenth-century Dutch marines, including seventeen Van de Veldes. Brooking is certainly known to have studied and copied works by the Van de Veldes, Ludolf Backhuysen, Jan van Goyen, and Simon de Vlieger. However, as Basil Taylor argued, "any easy description of Brooking as the English van de Velde and explanation of his work in those terms, must be treated most critically as it may lead to neglect of his most personal qualities; for he was at least as significantly different from his Dutch ancestors as Samuel Scott was from Canaletto or as, say, Gainsborough's Cornard Wood was distinct from the Dutch landscape painting to which it may be referred."[3] A comparison of the present work with Van de Velde's *Mediterranean Brigantine*, for example (fig. 66, p. 92), demonstrates what Taylor describes as Brooking's departure from "the inflections and ornament of a prevailing pictorial rhetoric" toward a more matter-of-fact rendition of the subject, achieved in part through a more restrained palette and a composition less forced to extreme diagonals. — EH

1. George Walker, *The Voyages and Cruises of Commodore Walker*, ed. H. S. Vaughan (London: Cassell and Company, 1928).
2. See Christine Riding's essay in this volume.
3. Taylor, *Charles Brooking*, 1966, 4.

46

46

Charles Brooking (1723–1759)

A Smack under Sail in a Light Breeze in a River

between 1756 and 1759
Oil on canvas
14 ½ x 24 ½ in. (36.8 x 62.2 cm)
Yale Center for British Art, Paul Mellon Collection, B1981.25.67

PROVENANCE: J. H. Anderson by 1865, bought in at his sale, Christie's, May 30, 1879 (100) and remained in family until after 1945; Berwick sale Oct. 21, 1949 (18); Thos. Agnew & Sons, from whom bt by Paul Mellon, 1968

EXHIBITIONS: BI 1865 (170); RA Winter 1872 (203); YCBA 1977–78 (17)

LITERATURE: Joel, *Charles Brooking*, 125

COMPARED TO Peter Monamy and Samuel Scott, Brooking made few images of identifiable vessels or actions; the majority of his works are "generic" seascapes. However, these tend toward more intense explorations of mood and atmosphere than those of his contemporaries, as well as toward more original compositions. The insistent geometry of the present example underlies an otherwise subdued scene showing a cutter-rigged smack or cargo hoy traveling down a river, its current revealed by the wake of the boat anchored at the left. Farther downriver appear ships and perhaps buildings. It has been suggested that the sailing boat is one Brooking used, that it occurs in several of his paintings, and that Brooking himself appears in the boat, sketching. — EH

47

Charles Brooking (1723–1759)

Shipping in the English Channel

ca. 1755
Oil on canvas
35 ½ x 46 ⅜ in. (90.2 x 117.8 cm)
Yale Center for British Art, Paul Mellon Collection, B1981.25.65

PROVENANCE: J. G. Luard, sold Sotheby's Dec. 11, 1929 (151); Sir Bruce Ingram, until 1961; P & D Colnaghi, from whom bt by Paul Mellon, 1962

EXHIBITIONS: Ferens 1951 (26); VMFA/RA/YUAG 1963–65 (25, 166, 18); Aldeburgh/Bristol 1966 (14); YCBA 1977–78 (15)

LITERATURE: Yale Center for British Art, *Selected Paintings, Drawings & Books* (New Haven: Published on the occasion of the inauguration of the Yale Center for British Art by Yale Univ. Press, 1977), 20; Joel, *Charles Brooking*, 154

THE SETTING of this exuberant work can be identified as the area known as the Downs, off the southeast coast of England in the county of Kent. In the center of the composition are the white cliffs of the North Foreland, stretching off toward the south at the left of the canvas, beyond which are the port towns of Deal and, farther on, Dover. The Downs had long been used as a safe anchorage for shipping, sheltered to the north and west by the coast, and to the east by the ten-mile-long sandbanks known as the Goodwin Sands. These and other constantly shifting shoals in the area posed a hazard to vessels and necessitated the guidance of knowledgeable pilots to navigate the passage between safe anchorage and open water. The ship at right plunging toward the viewer has just dropped off a pilot and is headed out to sea, the fresh breeze filling the sails that are still being adjusted. To the left, a naval two-decker is possibly coming into the anchorage and about to take on its own pilot; other ships can be seen moored in the anchorage beyond it. A print version of this painting, published by John Boydell in 1755 and titled *Evening*, reverses the composition; in the painting, the morning light suffusing the canvas from the right casts a glow of optimism over the everyday proceedings. The painting reveals Brooking's interest not only in the details of the vessels and the activities of their crews, but also in the way the combination of sea haze and sunlight dissolves the forms of the ships and shoreline. Fifty years later J. M. W. Turner became interested in similar atmospheric effects, and eventually made this same stretch of coastline, from Sheerness to Downs, the subject of his own radical reconsideration of the sea. — EH

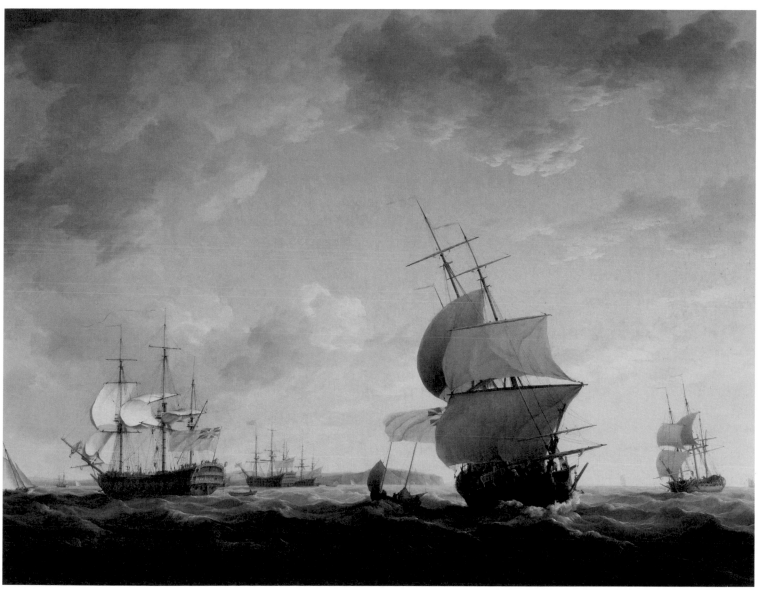

47

"The Whole Will Be a Kind of History"

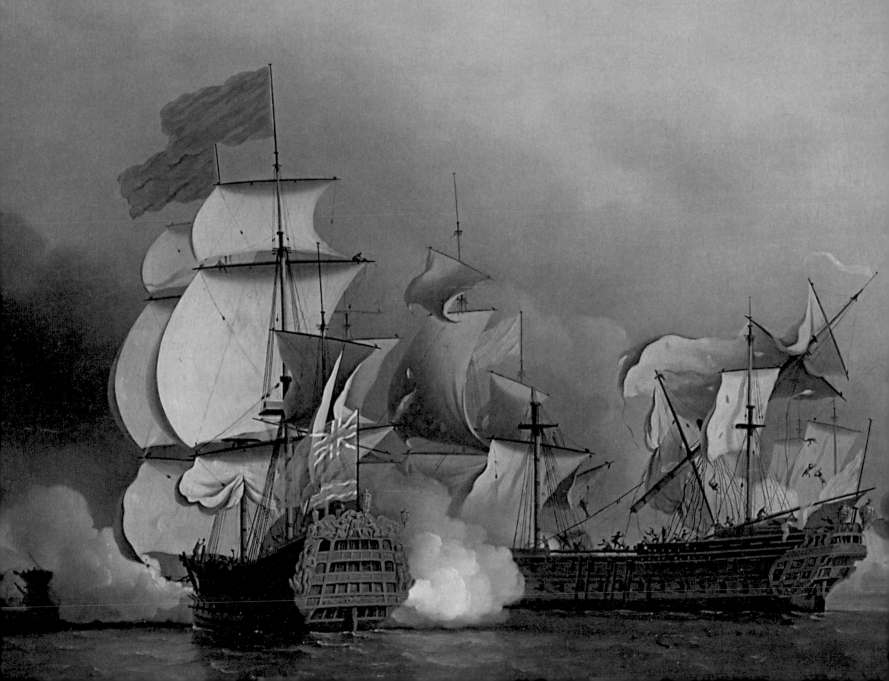

THE DISPLAY AT SHUGBOROUGH

The Hall [is] partly finished with the Sea-pieces, & Stucco . . . & the Prints removed into the Gallery, which is now a very spacious Room, by the management of the Recess made for the model of a Man of War: . . . The Action off Cape Finisterre is already up, & looks finely. . . . The burning of Payta is to be over the Chimney, the actions between the Centurion & the Galleon, & the Lyon & Elizabeth of each side of the Door into the room you dined in, & two other actions of Captains of my Lords in the War over the other Doors; so that the whole will be a kind of History, and with Gilding and Ornaments of Stucco will be vastly pretty.

—Elizabeth, Lady Anson, to Jemima Yorke, Marchioness Grey, Aug. 20 [1750]

IN AUGUST 1750 Elizabeth Anson wrote to her sister-in-law, Jemima Yorke, describing the refurnishing of Shugborough, the house belonging to the elder brother of her husband, Admiral George Anson. The decorative scheme included works celebrating Admiral Anson's illustrious career: a suite of paintings of his naval victories by the marine painter Samuel Scott; the model of the *Centurion*, the ship in which Anson circumnavigated the world in 1740–44; and a set of prints illustrating the account published in 1748, *A Voyage round the World, in the Years MDCCXL, I, II, III, IV*. Not mentioned in Lady Anson's letter but undoubtedly present at Shugborough were copies of the book, which included maps and charts. The display at Shugborough serves as a case study of the range of representational modes—pictorial, diagrammatic, narrative, and plastic—that were deployed throughout the century to construct "histories" of the events taking place on the oceans. The reassembly of a selection of the objects from Shugborough not only provides a rare example of the ways that marine paintings were displayed in domestic settings but also emphasizes the frequent role played by naval wives in the promotion of their husbands' reputations, sometimes through the commissioning and display of marine paintings.

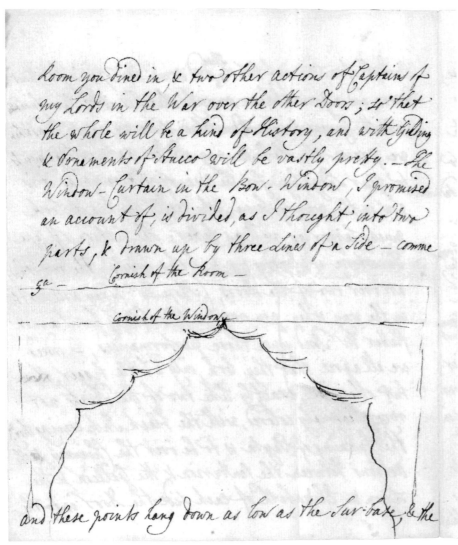

48 PAGES 6 AND 7

48 PAGE 8

Elizabeth, Lady Anson (1725–1760)

Letter to Jemima Yorke, Marchioness Grey, Aug. 20 [1750]

Correspondence to Jemima, née Campbell (1722–1797), Marchioness Grey and Baroness Lucas, Bedfordshire and Luton Archives and Records Service, L30/9/3/24

LITERATURE: Kingzett, "Catalogue of Works of Samuel Scott," 130

THIS LETTER provides a rare, highly detailed account of the domestic display of marine paintings in eighteenth-century England. In the summer of 1750, Admiral George Anson, Lord Anson, and his wife, Elizabeth, paid one of their frequent visits to Shugborough, country seat of Anson's elder brother, Thomas. At the house, work was underway on a new decorative scheme celebrating George's naval career, which included his circumnavigation of the globe between 1740 and 1744 and his victory against the French at the Battle of Finisterre in 1747. "This place is in high beauty," wrote Lady Anson, "& several new ornaments & improvements adding daily." Her correspondent was her sister-in-law, Jemima Yorke, Marchioness Grey, with whom she enjoyed a close friendship, based in part on a mutual enthusiasm for home and garden improvements. Here, Lady Anson credits the marchioness with suggesting the new installation in Shugborough's entrance hall: "when we praise the Hall we pay all due acknowledgements to your Ladyship for the idea of fitting up as it is now in the way of being, wch. really makes it look much larger as well as better."[1] This "idea of fitting up" included oil paintings of Anson's naval exploits by Samuel Scott (see cats 53, 55–56) and Arthur Pond, integrated into a rich decorative setting: "The whole will be a kind of History, and with Gilding and Ornaments of Stucco will be vastly pretty." Part of this letter was previously published by Richard Kingzett, who left out the mention of the gilded stucco ornaments and the description of the installation as "vastly pretty." Yet the decorative aspects of this program are essential for understanding the nature of the display at

Shugborough, which exemplifies the inter-penetration of the domestic and the imperial in eighteenth-century England. For example, Lady Anson referred to the new wallpaper she so enjoyed as "India" paper, evoking a world of luxury goods made available through British maritime exploration and naval force, an effort to which her husband had personally contributed.

Although Shugborough is preserved by the National Trust, the hall she refers to was later rebuilt and redecorated in the neoclassical style, trading overt celebration of imperial aggression for evocation of kinship with ancient empires. Lady Anson's letter therefore provides a precious record of an installation otherwise lost to history. — CACR

1. For the full passage, see Catherine Roach's essay in this volume, p. 118.

49

Richard Walter (1717–1785)

A Voyage round the World, in the Years MDCCXL, I, II, III, IV. By George Anson, Esq; Commander in Chief of a Squadron of His Majesty's Ships, Sent upon an Expedition to the South-Seas

1749
Beinecke Rare Book & Manuscript Library, Yale University, 1995 +62
Shown: "Chart of the Pacific Ocean"

50

Richard Walter (1717–1785)

A Voyage round the World, in the Years MDCCXL, I, II, III, IV. By George Anson, Esq; Commander in Chief of a Squadron of His Majesty's Ships, Sent upon an Expedition to the South-Seas

1767
Beinecke Rare Book & Manuscript Library, Yale University, Ecd +740Wf
Shown: "A View of Cape Espiritu Santo, on Samal, one of the Phillipine . . . ," Plate XL

A VOYAGE ROUND THE WORLD presents a detailed and deeply partisan account of an expedition carried out under the leadership of Commodore (later Admiral) George Anson between 1740 and 1744. During the War of the Austrian Succession, Anson led a force sent to harass Spanish settlements and trade routes on the Pacific coast of South America.[1] It was a difficult mission, made more so by the fact that many of the marines were infirm military pensioners, ill equipped to handle the debilitating effects of scurvy that set in on the long voyages between ports. Anson's beleaguered force took prizes and burned a city in South America before setting off across the Pacific in search of a valuable target. In 1743 Anson finally succeeded in capturing one of the trans-Pacific Spanish galleons carrying bullion from Acapulco to Manila, but not before being stranded on the island of Tinian, east of the Philippines, and antagonizing Chinese government officials in Canton.[2] Although he was hailed as a national hero on his return to England in 1744, some thought the human cost of the voyage had been too high, and Anson was soon embroiled in a lawsuit over prize money brought against him by officers who had served under him on the expedition.[3]

This publication implicitly rebukes those critics. Ostensibly the work of the expedition's chaplain, Richard Walter, *Voyage* seems to have been largely ghostwritten by a professional author with Anson's oversight.[4] Proclaimed as an accurate and valuable guide for future explorers, it is also propaganda for Anson; in this telling, each of the ghastly hardships described was met with resolution and courage on his part. He is acknowledged to have lost his composure only when stranded on Tinian: believing that his last remaining ship, the *Centurion*, had been destroyed after being blown out of harbor, "he was obliged (without speaking to anyone) instantly to retire to his tent, where he passed some bitter moments."[5] Even in despair, we are told, Anson hid his fears from his crew.

An extremely popular text, *Voyage* was published in multiple editions in various formats, from the deluxe folio to the modest octavo. The engraved illustrations, which could be purchased with the book or as a separate portfolio,

were based on drawings made by a lieutenant on the voyage, Peircy Brett. The preface boasts that these images "are not exceeded, and perhaps not equaled by any thing of this nature which has yet been communicated to the world." Their claim to this distinction lay in their reported precision: "For they were not copied from the works of others, or composed at home from imperfect accounts, given by incurious and unskillful observers (a practice too frequent in these matters) but the greatest part of them were delineated on the spot, with the utmost exactness, by the direction, and under the eye of Mr. *Anson* himself."[6] Tellingly, the text attributes the accuracy of the images to the admiral rather than the draftsman, an attitude typical of the publication as a whole. — CACR

1. Glyn Williams, *The Prize of All the Oceans: The Triumph and Tragedy of Anson's Voyage Round the World* (London: Harper Collins, 1999). On issues surrounding the attribution of the text, see the appendix, 237–40.
2. For *Voyage*'s selective account of Anson's time in China, see Stephen McDowall, "The Shugborough Dinner Service and Its Significance for Sino-British History," *Journal for Eighteenth-Century Studies* 37, no. 1 (2014): 1–17.
3. Williams, *Prize*, 208, 215.
4. Williams, *Prize*, 237–40.
5. *A Voyage round the World, in the Years MDCCXL, I, II, III, IV. By George Anson, Esq. . . .*, compiled and published by Richard Walter, 5th ed. (London: John and Paul Knapton, 1749), 323.
6. Richard Walter, preface to *Voyage*, unpaginated. Emphasis in original. See also Sarah Monks, "Our Man in Havana," 95–98.

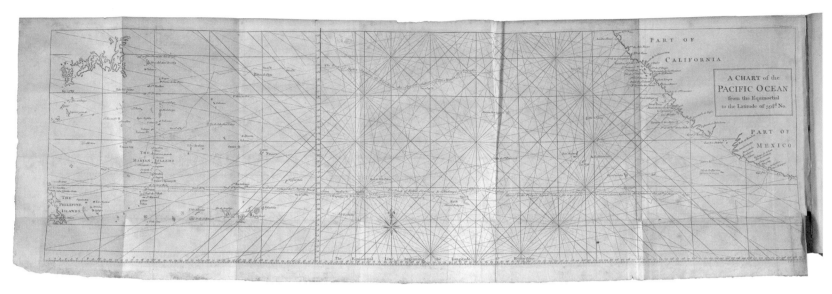

49

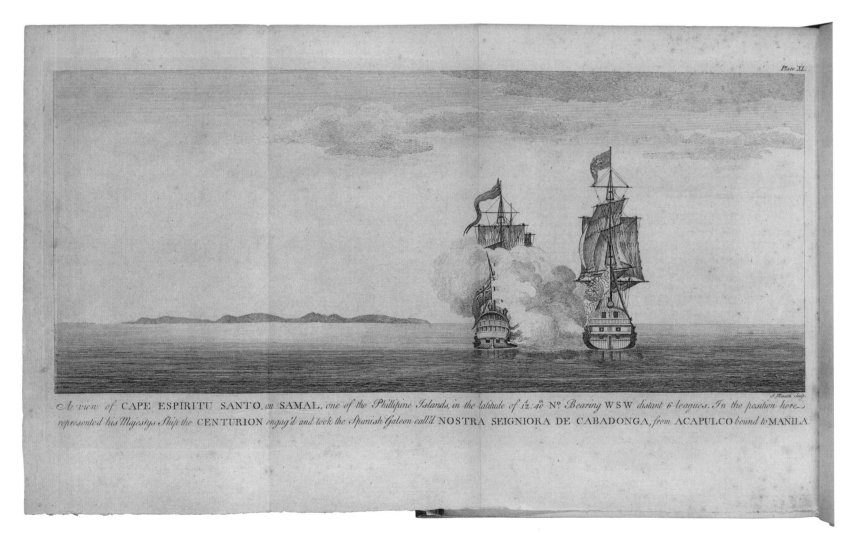

A view of CAPE ESPIRITU SANTO, *on* SAMAL, *one of the* Phillipine Islands, *in the latitude of* 12:40 N? *Bearing* WSW *distant 6 leagues. In the position here represented his Majestys Ship the* CENTURION *engag'd and took the Spanish Galeon call'd* NOSTRA SEIGNIORA DE CABADONGA, *from* ACAPULCO *bound to* MANILA.

50

51

Benjamin Slade (d. 1750)

Model of the *Centurion* (1732)

1747
Brass, cotton, mica, paint, paper, varnish,
and wood
44 x 54 x 20 ⅝ in. (111.5 x 137 x 52.5 cm)
National Maritime Museum, Greenwich, London,
Caird Collection, SLR0442

EXHIBITIONS: NMM 2014–15

LITERATURE: Mark Fletcher, ed., *The National Maritime Museum: The Collections* (London: Scala Publications, 1990), 16–17; Brian Lavery and Simon Stephens, *Ship Models: Their Purpose and Development from 1650 to the Present*, exh. cat. (London: Zwemmer; Greenwich: National Maritime Museum, 1995), 10, 35, 79–80, 86, 183, cat. 158; Clifton and Rigby, *Treasures of the National Maritime Museum*, 42; Richard Dunn and Rebekah Higgitt, *Finding Longitude: How Ships, Clocks and Stars Helped Solve the Longitude Problem* (Glasgow: Collins, 2014), 67, 77–82

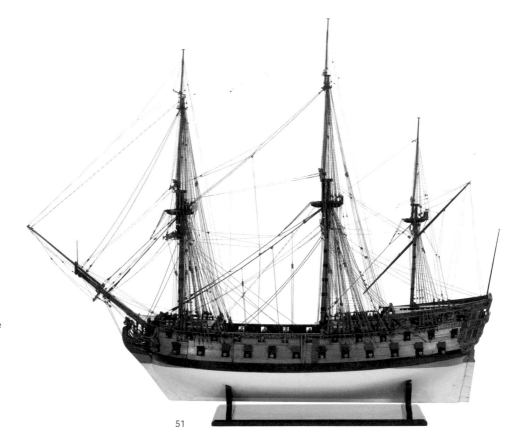

51

ADMIRAL LORD ANSON commissioned this model of his 60-gun flagship to commemorate its successful circumnavigation of the globe between 1740 and 1744. No other ships from Anson's original eight-vessel squadron were similarly commemorated, perhaps because none of them completed the journey: some turned back before reaching the Pacific, others were wrecked, and still others were deliberately scuttled so that Anson could concentrate his dwindling, scurvy-afflicted forces on his flagship. Anson's celebrated feat of navigation and leadership came at the cost of an estimated 1,400 lives.[1]

Benjamin Slade, the creator of this model, was employed in the Plymouth dockyard. In 1747 he wrote to Anson to report that he had "finished the hull of the model, spun the rigging, made & set the masts, cast & turned the brass guns"; he was at work on the gun carriages, and "when they are done shall only have the blocks to make & put the rigging over head."[2] The result was a miniature version of the massive logistical and technical achievement that was the eighteenth-century warship. The model's orderly rigging and smoothly planed woodwork

belies the actual state of the flagship during the circumnavigation, when it was repeatedly damaged and patched.

The model was displayed at the family seat, Shugborough, Anson's favorite country retreat between 1748 and 1752; the interior decor there celebrated his career.[3] So important was the model to this display that a room was designed around it: Shugborough's gallery included a semicircular "Recess" built specifically to house the model.[4] The gallery also contained numerous engravings produced as illustrations to a publication about the circumnavigation, *A Voyage round the World* (see cats. 49–50).[5] Thus viewers in the gallery could have looked from this three-dimensional representation of the ship to engravings depicting the same vessel in transit and in battle.

One incident related in *Voyage* but not shown in the prints was Anson's temporary loss of the *Centurion*. After a perilous journey from South America, the ship reached safe haven on the island of Tinian, east of the Philippines, in August of 1742. Then disaster struck: the *Centurion* was blown out to sea with only a few hands on board, leaving Anson and much of the crew

still ashore. Anson's voyage might easily have ended there, a largely ignominious footnote in the conflict with Spain. After almost three weeks, however, the *Centurion* reappeared, and the voyage resumed.[6] In the miniature and ideal-ized form of this model, displayed in the gallery at Shugborough, the *Centurion* was returned to the symbolic control of the captain who had once been left ashore as it drifted away. — CACR

1. Glyn Williams, *The Prize of All the Oceans: The Triumph and Tragedy of Anson's Voyage Round the World* (London: Harper Collins, 1999), 202.

2. Benjamin Slade to Admiral Lord Anson, November 10, 1747, transcribed by Thomas Francis Anson, third Earl of Lichfield. Staffordshire Record Office, Records of the Anson Family of Shugborough, Earls of Lichfield, D615/P(S)/1/4/53.

3. See Catherine Roach's essay in this volume.

4. Elizabeth, Lady Anson, to Jemima Yorke, Marchioness Grey, Aug. 20 [1750]. Correspondence to Jemima, née Campbell (1722–1797), Marchioness Grey and Baroness Lucas, Bedfordshire and Luton Archives and Records Service, L30/9/3/24.

5. See also Catherine Roach's essay in this volume.

6. Williams, *Prize*, 147–48.

52

52

John Faber the Younger (ca. 1695–1756) after
Thomas Hudson (1701–1779)

**Samuelis Scott, Navium et prospectum
marinorum Pictor**

ca. 1731–33
Mezzotint
Sheet (cropped inside plate): 12½ x 9½ in.
(31.6 x 23.9 cm); image: 11⅜ x 9½ in.
(28.9 x 23.9 cm)
Yale Center for British Art, Paul Mellon Collection,
B1977.14.12607

THE COLLECTOR and antiquarian Horace Wal-
pole, who owned more works by Samuel Scott
than by any other living artist, described him
as "one whose works will charm in every age. If
he was but second to Vandeveld in sea pieces,
he excelled him in variety."[1] The son of a Covent
Garden barber-surgeon, Scott began painting
seascapes and views of naval engagements in
the mid-1720s, and joined the circle of artists
who met at Old Slaughter's Coffee House in
London. He was elected a governor and guard-
ian of the Foundling Hospital in 1746, and was on
the committee that, in 1755, proposed founding
the Royal Academy. In 1732 he accompanied

William Hogarth and others on a trip to Kent
that became the subject of a journal, the *Five
Days' Peregrination*, to which he contributed
illustrations (cat. 57), and from the 1730s he
began producing paintings of London scenes,
almost invariably based on the Thames. The
outbreak of war in 1739 presented new oppor-
tunities for Scott, as it did for his contemporary
Peter Monamy. The families of Edward Vernon,
George Anson, and John, fourth Earl of Sand-
wich became his principal patrons for views of
sea battles, and he also received commissions
from a number of aristocratic families, including
the Walpoles (Robert, Edward, and Horace), and
from the East India Company (see cats. 64–66).[2]

This print, based on one of the earliest
known portraits by Thomas Hudson (Tate),
shows Scott at the outset of his career. In a
costume and pose that communicates gentle-
manly ease rather than painterly activity (his
palette lies to the right of the image), he holds
a drawing that appears to be a version of Van
de Velde's *Royal Sovereign* (see fig. 99, p. 150),
which could be an original or a copy. Scott was
a prolific collector of Van de Velde; his post-
humous studio sale lists several hundred of his
drawings.[3] Without making the explicit claim
that Scott is "second only to Van de Velde,"
this portrait surely responds to the print, also
by Faber, of Thomas Stubly's portrait of Peter
Monamy (cat. 18). Faber's mezzotint engravings
of portraits circulated widely, some of them
becoming models for colonial portraitists. John
Singleton Copley based the composition of his
portrait of the merchant and trader John Amory
(Museum of Fine Arts, Boston) on this print,
replacing the drawing in Scott's hand with a let-
ter and introducing a view of a ship under sail in
the background at right. — EH

1. Horace Walpole, *Anecdotes of Painting in
England*, 5 vols. (London: W. Nichol for J. Major,
1826–28), 4:108–09.
2. Richard Kingzett, "Samuel Scott (1701/2–1772)," in
Oxford Dictionary of National Biography, Oxford
Univ. Press, 2004: http://dx.doi.org/10.1093/ref
:odnb/24910 (accessed April 27, 2012).
3. See Kingzett, "Catalogue of Works of Samuel
Scott," 120–29.

53

Samuel Scott (1701/2–1772)

**Vice Admiral Sir George Anson's Victory
off Cape Finisterre**

1749
Oil on canvas
40 x 71 in. (101.6 x 180.3 cm)
Yale Center for British Art, Paul Mellon Collection,
B1981.25.559

PROVENANCE: Earls of Hardwicke by descent;
Christie's, June 30, 1888 (22, as *Battle of La Hogue*),
bt by Vokins; Lt. Col. C. Holloway, by whom
presented to Junior United Services Club, 1889;
Spinks (1421), from whom bt by Paul Mellon, 1969

EXHIBITIONS: Royal Hospital 1891 (329); Guildhall
1955 (5); RA 1955–56; Guildhall 1972 (29); YCBA
1977–78 (9)

LITERATURE: Kingzett, "Catalogue of Works of
Samuel Scott," 34–35; Elizabeth Einberg and Judy
Egerton, *The Age of Hogarth: British Painters Born
1675–1709* (London: Tate Gallery, 1988), 184–87;
Solkin, *Art in Britain*, 124.

DURING THE WAR of the Austrian Succession
(1740–48), a pan-European conflict that pitted
Britain and Austria against France, Prussia,
and Spain, British naval forces were tasked
with blocking communication between France
and its colonies in North America. On May 3,
1747, a fleet under Admiral George Anson set
upon a convoy of merchant ships under escort
by French naval vessels off Cape Finisterre
(northwest Spain) and captured six men-of-
war and four merchant ships. For his role in
the battle, Anson was created Baron Anson of
Soberton, making him the first in his family to be
elevated to the peerage. Anson's naval career
was celebrated in elaborate form at the family
seat, Shugborough (see cats. 48–51, 55–56).
A painting of the Battle of Finisterre was the
centerpiece of this display: "the Action off Cape
Finisterre is already up, & looks finely," reported
Lady Anson.[1] Scott painted three known ver-
sions of this composition, of which this may
have been the one at Shugborough; both this
and the version now at Tate descended through
Lady Anson's relatives, the Earls of Hardwicke.[2]
Whichever canvas hung at Shugborough, it
seems likely that it was placed directly opposite

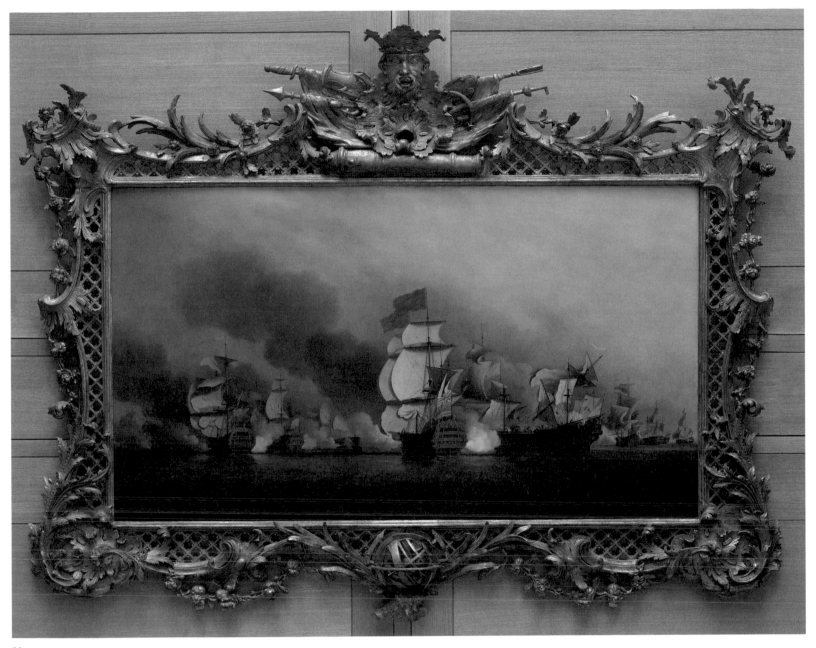

53

the entrance to the hall, presenting an immediate and impressive visual statement on the Anson family's contributions to national naval efforts.

While its detailed rendition of the ships is persuasive of the accuracy of the depiction, Scott presents a composite view of events that enable the recounting of a narrative of chase, attack, and surrender. The British ship in the center of the composition is Anson's flagship, the *Prince George*, identifiable by the blue

ensign of Vice Admiral of the Blue flying at its foretopmast. At 2 p.m. on the day of the battle the *Prince George* signaled the fleet to "chace to the S.W." by flying the red, white, and blue flag visible below the blue ensign. The red signal flag at the mainmast head communicated the order given at 3 p.m. to attack without regard for the line of battle. The *Prince George* itself joined the action only just in time to receive the surrender of the *Invincible,* seen to the right of *Prince George* with its mainmast shattered and falling,

its crew in disarray; the rest of the French ships surrendered between 6 and 7 p.m. Horace Walpole mocked the conceit:

[Anson] has lately had a sea-piece drawn of the victory for which he was lorded, in which his own ship in a cloud of cannon was boarding the French admiral. This circumstance, which was true as if Mademoiselle Scudery had written his life (for he was scarce in sight with the Frenchman struck to Boscawen)

has been so ridiculed by the whole tar-hood, that the romantic part has been forced to be cancelled, and only one gun remains firing at Anson's ship.[3]

The British ship at left on the canvas, with its taffrail (upper stern rail) carved into the image of a castle flanked by allegorical figures, has long been identified as the 66-gun *Yarmouth*, commanded by Peircy Brett, who had sailed with Anson on the circumnavigation and whose drawings served as the basis for the illustrations of the published account of the voyage. Brett undoubtedly provided Scott with information for the painting, which makes the notion of his inclusion via the *Yarmouth* attractive. However, the similarity of the taffrail to that of a 74-gun ship has led to the suggestion that it may be the *Namur*.

The extraordinary frame, with its rococo ornamentation, trophies and instruments of navigation, and allegorical figure of Neptune, may be the work of Isaac Gosset. Like John Pine's *The Tapestry Hangings of the House of Lords* (cats. 36–38) and the series of Royal Dockyard prints issued in the 1750s (cats. 68–73) it reveals a moment in which the framing of an apparently straightforward pictorial representation could bring into play multiple registers of representation. — EH/CACR

1. Elizabeth, Lady Anson, to Jemima Yorke, Marchioness Grey, Aug. 20 [1750]. Correspondence to Jemima, née Campbell (1722–1797), Marchioness Grey and Baroness Lucas, Bedfordshire and Luton Archives and Records Service, L30/9/3/24. See Catherine Roach's essay in this volume.
2. Kingzett, "Catalogue of Works of Samuel Scott," 34.
3. Horace Walpole to Horace Mann, March 23, 1749. *The Yale Edition of Horace Walpole's Correspondence, ed. W. S. Lewis,* 48 vols. (New Haven: Yale University Press, 1937–83), 20:38. Madeleine de Scudéry was an eighteenth-century French novelist derided by some members of the Paris intellectual elite. As well as serving at the Battle of Cape Finisterre, Edward Boscawen was at the capture of Puerto Bello (see cats. 24–30); he later distinguished himself during the Seven Years' War.

54

Jonathan Greenwood

The Sailing and Fighting Instructions, or, Signals as They Are Observed in the Royal Navy of Great Britain

[London,] 1715
Yale Center for British Art, Paul Mellon Collection, V285.G7 G74 1715

IN THE AGE OF SAIL, flag signals were used to communicate orders from a commanding officer to other ships in a squadron or fleet. The signals, which were accompanied by the firing of a predetermined number of guns, ranged from general principles of conduct to very detailed orders. Their meanings were issued in a publication known as the *Fighting Instructions*, each instruction accompanied by an illustration of the signal and the number of guns to be fired to accompany a signal or to acknowledge it. Once battle was joined, signals were often hard to make out through the noise and smoke; in large fleet engagements, "repeating" frigates were stationed at a distance from the melee in order to relay instructions from the flagship to the ships of the line of battle. Before the Battle of Trafalgar, Admiral Horatio Nelson sent a memorandum to the commanding officers in the British fleet: "In case signals can neither be seen nor perfectly understood, no captain can do very wrong if he places his ship alongside that of an enemy."[1]

The *Fighting Instructions* went through many editions during the eighteenth century. This copy shows signals similar to those flown by Admiral George Anson during the Battle of Cape Finisterre and included in Samuel Scott's depiction, where they provide a coded narrative of the engagement (see cat. 53). Anson made his own additions to the *Fighting Instructions* around the time of that battle; they provide the signals by which ships of the line should "regulate themselves by bearing on some particular point of the compass."[2] — EH

1. Quoted in Davies, *Fighting Ships*, 22.
2. Julian S. Corbett, *Fighting Instructions, 1530–1816* (London: Printed for the Navy Records Society, 1905), 216–17.

54

55

55

Samuel Scott (1701/2–1772)

The Capture of the *Nuestra Señora de Cavadonga* by the *Centurion*, 20 June 1743

ca. 1743
Oil on canvas
40 ½ x 59 ½ in. (102.9 x 151.1 cm)
National Maritime Museum, Greenwich, London, Caird Collection, BHC0360

AFTER YEARS OF fruitless patrolling in Pacific waters, the crew of the *Centurion* under the command of Commodore George Anson managed in 1743 to capture a spectacular prize: the Spanish galleon *Nuestra Señora de Cavadonga*, which carried trade goods and precious metals between Manila and Acapulco. According to the account published under Anson's direction, "he had reason to expect that his men would exert themselves after a most extraordinary manner, when they had in view the immense wealth of these *Manila* galleons."[1] The spoils were indeed immense, including over a million pieces of eight; as commanding officer, Anson was entitled to the largest share of the prize money.[2]

He gave some of this money to his elder brother, Thomas, who transformed the family seat, Shugborough, into a showplace worthy of the family's newfound affluence and status. As part of these renovations, Samuel Scott was commissioned to paint a series of pictures of Anson's exploits, including this canvas. The paintings were shown in Shugborough's entrance hall, where this work was hung as a pendant to another by Scott, depicting the single-ship action between the *Lion* and the *Elizabeth* (see cat. 74).[3]

One visitor to the house, William Gilpin, theorist of the picturesque, was not impressed by the display, commenting: "The Hall is adorned with the naval achievements of lord Anson by

Scot; in which the genius of the painter has been regulated by the articles of war. The *line of battle* is a miserable arrangement on canvas; and it is an act of inhumanity in an admiral to injoin it."[4] Far from being stifled by the terms of the commission, however, Scott brilliantly exploited them. His compositions were based on drawings made by an officer on the expedition (Lieutenant Peircy Brett), which also served as the basis for engraved illustrations of a publication on the voyage (cats. 49–50, fig. 105). Scott altered and improved these designs, creating visual drama at the expense of strict accuracy. In his depiction of the capture of the Spanish galleon, he compressed the composition, reduced the amount of land visible in the distance, and increased the amount of smoke so that it fully frames the British ship. By bringing the Spanish ship closer to the viewer, Scott also exaggerated the size difference between the two ships, making the *Centurion* appear to be a scrappy underdog, when in fact it was larger and more powerful.[5] — CACR

1. *A Voyage round the World, in the Years MDCCXL, I, II, III, IV. By George Anson, Esq. . . .*, compiled and published by Richard Walter, 5th ed. (London: John and Paul Knapton, 1749), 371. Emphasis in the original.

2. "George Anson, Baron Anson (1697–1762)," in *Oxford Dictionary of National Biography*, Oxford Univ. Press, 2004: http://dx.doi.org/10.1093/ref:odnb/574 (accessed Sept. 9, 2015). The piece of eight was an eight-*real* silver coin, also known as the "Spanish dollar."

3. For *The* Lion *and the* Elizabeth, see Kingzett, "Catalogue of Works of Samuel Scott," 31; Christie's, *Works of Art from the Bute Collection*, July 3, 1996, lot 121.

4. William Gilpin, *Observations, Relative Chiefly of Picturesque Beauty, Made in the Year 1772, on Several Parts of England*, 2nd ed., 2 vols. (London: R. Blamire, 1788), 1:71.

5. Kingzett, "Catalogue of Works of Samuel Scott," 28.

56

Samuel Scott (1701/2–1772)

The Burning of Payta, November 1741

mid-18th century
Oil on canvas
38 ¾ x 54 ⅜ in. (98.5. x 138 cm)
National Maritime Museum, Greenwich, London, Caird Collection, BHC0358

IN 1740, during the War of the Austrian Succession, Anson and his squadron of eight ships launched an attack on the Spanish settlement of Payta, on the Pacific coast of South America. *Voyage round the World*, which was published under Anson's supervision, emphasizes the supposedly humorous aspects of this act of war. Reportedly, some sailors took the opportunity to cross-dress in the inhabitants' clothes.[1] Another sailor drank himself senseless and barely escaped the fire, but the author claims that, "to the honour of our people . . . though there were great quantities of wine and spirituous liquors found in the place, yet this man was the only one known to have so far neglected his duty, as to get drunk."[2] This claim should be viewed with suspicion: other contemporary sources reported widespread drunkenness, as well as violence including rape.[3] The British sank six Spanish ships in the bay and took £32,000 in plunder. When the governor of Payta escaped, Anson threatened to burn the town unless he surrendered; the governor refused, and Anson made good on his threat.

One of the officers on the expedition was Lieutenant Peircy Brett, whose drawings would later be reproduced as engraved illustrations to *Voyage*. The book includes an account of his sketching at Payta: "The whole town on fire at once, especially where the buildings burnt with such facility and violence, being a very singular spectacle, Mr. Brett had the curiosity to delineate its appearance, together with the ships in

the harbor."[4] The engraving made with the help of this drawing emphasizes the many prizes taken by the admiral's flagship, the *Centurion*, arrayed in a line across the foreground (fig. 105). Samuel Scott's painting uses the same composition as a starting point but increases the visual drama, an aesthetic celebration of an act of imperial aggression. The distant cloud of smoke seen in the engraving becomes a fiery conflagration that frames the *Centurion* and the two prizes at left, which are here set at an angle, creating a sense of depth and emphasizing the greater size of Anson's flagship. Scott uses color, the painter's primary advantage over the medium of engraving, to great effect: streaks of red flame rhyme visually with the British ship's flags, particularly the red pennant of the flagship that is silhouetted against billowing black smoke.

This painting was installed above the fireplace in the entrance hall at Shugborough, the country house of Anson's elder brother, Thomas, as part of a larger program commemorating Anson's career.[5] There, Scott's painting acted in a similar fashion to the official publication of the voyage, promoting the reputation of the commanding officer. — EH/CACR

1. *A Voyage round the World, in the Years MDCCXL, I, II, III, IV. By George Anson, Esq. . . .*, compiled and published by Richard Walter, 5th ed. (London: John and Paul Knapton, 1749), 195.

2. *Voyage*, 200.

3. Glyn Williams, *The Prize of All the Oceans: The Triumph and Tragedy of Anson's Voyage Round the World* (London: Harper Collins, 1999), 116.

4. *Voyage*, 201.

5. See also Catherine Roach's essay in this volume.

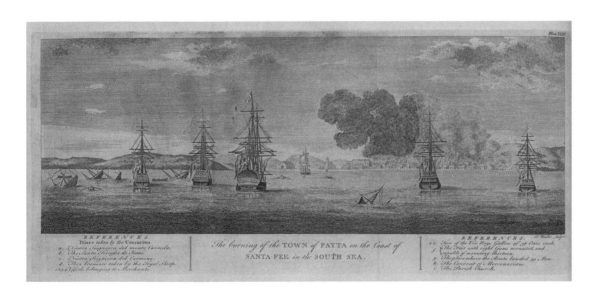

FIG. 105. J. S. Muller, *The Burning of the Town of Payta on the Coast of Santa Fe in the South Sea*, from Richard Walter, *Voyage round the World*, 1748, engraving, 19 ½ x 8 ½ in. (49.5 x 22 cm). Beinecke Rare Book & Manuscript Library, Yale University

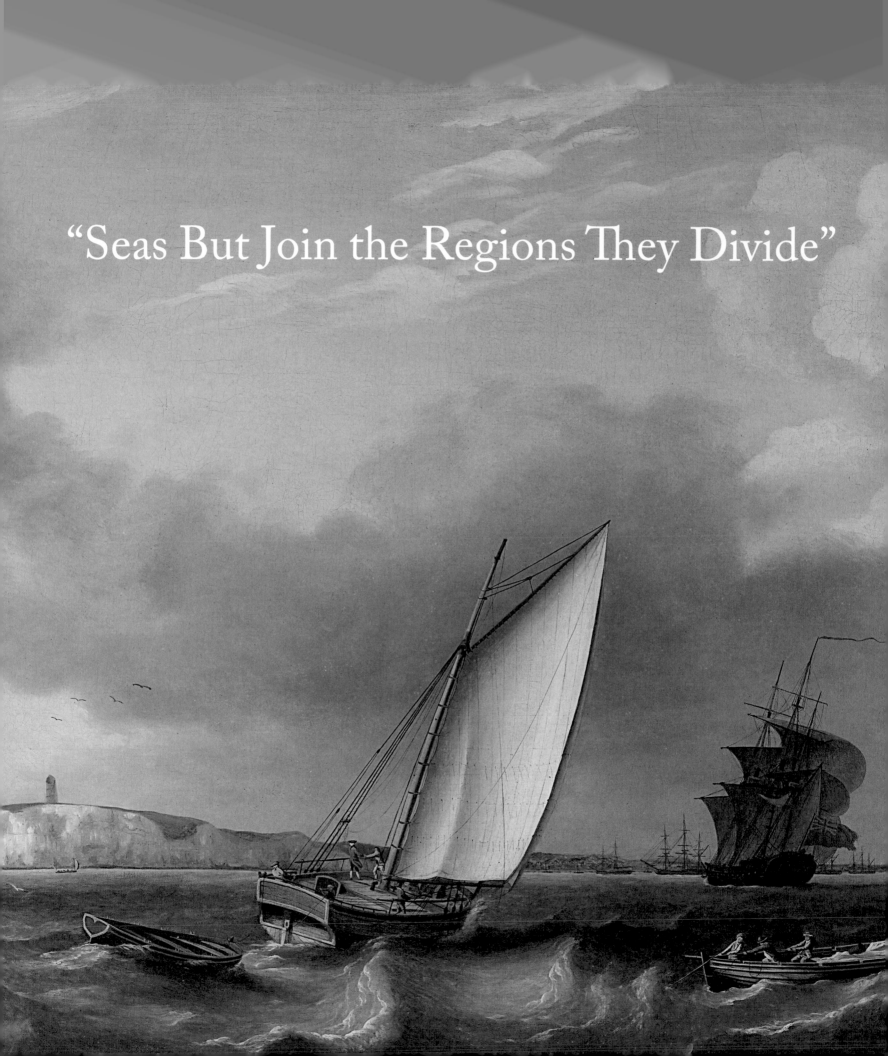

"Seas But Join the Regions They Divide"

DOCKYARDS, COASTS, AND PORTS

Thy trees, fair Windsor! now shall leave their woods,
And half thy forests rush into my floods,
Bear Britain's thunder, and her cross display
To the bright regions of the rising day;
.
The time shall come, when, free as seas or wind,
Unbounded Thames shall flow for all man-kind,
Whole nations enter with each swelling tide,
And seas but join the regions they divide.

—Old Father Thames, in Alexander Pope, "Windsor Forest," 1713

FOR AN ISLAND NATION with an expanding empire, coastlines were of enormous cultural significance, and where land and sea met, so did artistic and naval practice. The passage of ships in and out of dockyards and anchorages was reported daily in the press, and a large proportion of seascapes by British marine painters show vessels in these and other coastal waters. The forts and settlements of overseas territories were likewise the subject of paintings and prints, in views often taken from the water with naval vessels superimposed on the terrain. The accurate recording of coastal profiles was crucial to navigation, and naval officers were trained in draftsmanship for this purpose. Supporting these endeavors were the dockyards that built and maintained the ships of the Royal Navy, located along the Thames and Medway Rivers, and along the south coast, which was the first line of defense against invasion from Europe. By the mid-eighteenth century, the Royal Dockyards at Deptford, Woolwich, Chatham, Sheerness, Portsmouth, and Plymouth constituted the world's largest industrial complex and the state's biggest investment. Dockyards were a subject of touristic, literary, and artistic interest throughout the eighteenth and into the nineteenth century.

Guernsey
Ushant
Quiberon Bay
Cape Finisterre
Gibraltar
Cape Trafalgar
• Paris
Brest
Port Mahon
Barbary Coast
Mediterranean Sea
Aboukir Bay
Nile
Chandernagore
Macau
Telicherry
(Thalassery)
Fort St. George
(Chennai)

Chesapeake Bay
Charleston
Dominica
Puerto Bello
Atlantic Ocean

• Payta

Rio de Janeiro

Cape of Good Hope

Indian Ocean

• Cape Horn

Bristol
Avon

Island and Empire:

Maritime Locations Cited

Teignmouth

PLYMOUTH

Eddystone Rocks
Bolt Head
Start Point

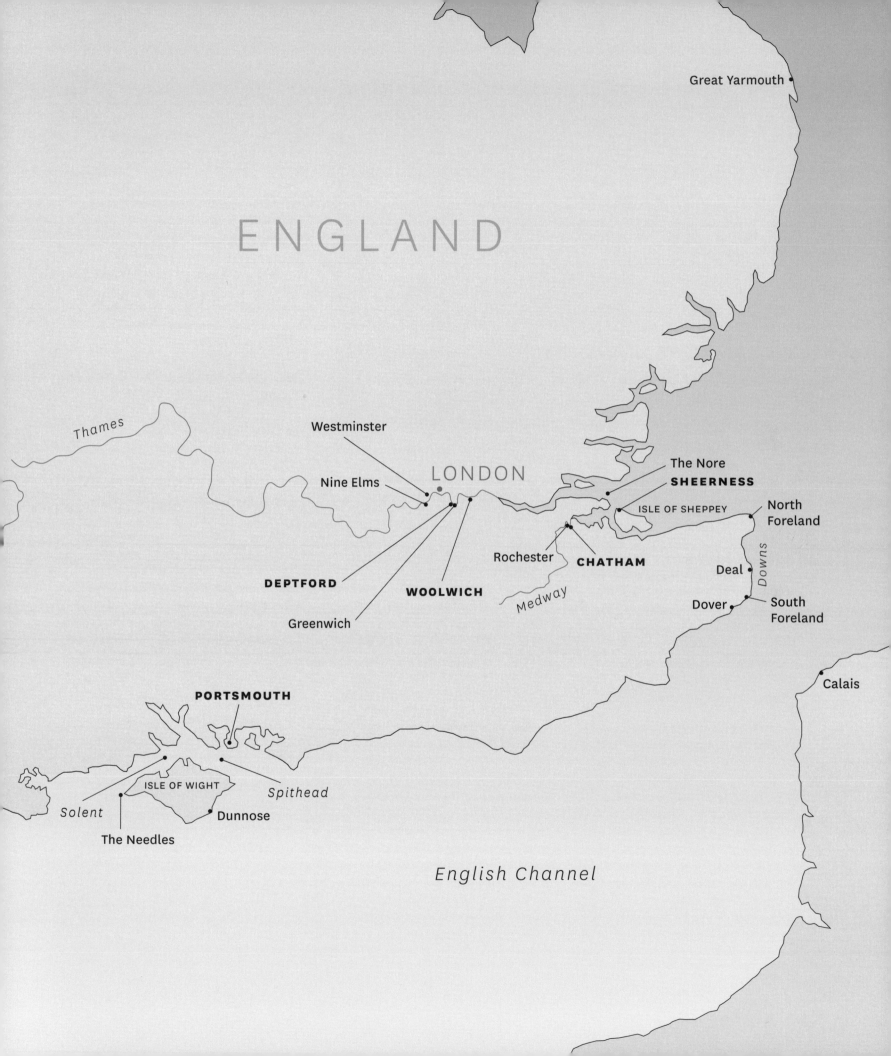

UPNOR CASTLE.

57

57

Ebenezer Forrest (bap. 1700, d. 1793)

An Account of What Seemed Most Remarkable in the Five Days' Peregrination of . . . Messieurs Tothall, Scott, Hogarth, Thornhill, and Forrest

London: Printed for R. Livesay, 1782
Lewis Walpole Library, Yale University,
Folio 75 H67 782 Copy 2 in the exhibition
Shown: Upnor Castle, f. 13

THE *FIVE DAYS' PEREGRINATION* is the mock-heroic account of a journey taken in 1732 by William Hogarth and a group of friends: his brother-in-law, John Thornhill; William Tothall, an ex-seaman turned merchant; Ebenezer Forrest, the lawyer and writer who wrote the account; and the marine painter Samuel Scott. The party traveled by boat from London down the Thames to Gravesend, on foot overland to Rochester and Chatham on the Medway, then on to the Isle of Sheppey, taking in the towns and villages along the way. The manuscript, now in the British Museum, was published by Richard

Livesay in 1782, with reproductions in aquatint after the original illustrations. Bound into the copy shown here are proofs of the prints before the final lettering was added.

Apart from antiquarian pretensions — the cohort visited churches and made drawings of monuments and records of their inscriptions — and rambunctious humor, the outing had a distinctly maritime character. Departing from Rochester, the travelers noted "a fine River and some of the Noblest Shipps in the World." At Chatham they toured the Royal Dockyard. Eight years earlier, on his own tour, Daniel Defoe had noted that "the buildings here are indeed like the ships themselves, surprisingly large, and in their several kinds beautiful: the ware-houses, or rather streets of ware-houses, and store-houses for laying up the naval treasure are the largest in dimension, and the most in number, that are any where to be seen in the world."[1] Forrest would seem to concur, calling the store-houses and dockyard "Very Noble." The party toured some of the great ships of the line then in dock: "Wee Went on Board the Marlbroh and the Royall Soveraign which last is reckoned One

of the Finest Shipps in the Navy, Wee saw the London the Royall George and Royall Anne, all First Rate Men of Warr." Traveling from Sheppey back to Gravesend by boat, Scott and Hogarth became seasick, and the expedition was imperiled when their boat ran aground.

Throughout the text of the *Peregrination*, Scott is described as drawing at every opportunity: In Chatham, recording a view of the river, he "wondred at people's Staring at him, till he recollected it was Sunday"; on the boat from Gravesend to Billingsgate at the end of the trip, he is soaked by an errant wave while "taking a drawing of some Shipping." At Upnor, "Hogarth made a Drawing of the Castle and Scott of some Shipping Riding near it," and the resulting illustration, on which the two are assumed to have collaborated, depicts Scott sketching the ships at anchor.

The *Peregrination* has been treated largely as an amusing incident at the turning point of Hogarth's career — a jaunt to celebrate the success of *A Harlot's Progress*.[2] During the same year, Scott was collaborating with George Lambert on a set of six pictures for the East India Company (see cats. 64–66). But the *Peregrination* also contributes to the substantial evidence of dockyards as sites of spectacle and leisure as well as industry and labor.[3] Finally, it provides textual and visual evidence for Scott's practice of making sketches and drawings on the spot. — EH

1. Daniel Defoe, *A Tour through the Whole Island of Great Britain*, rev. ed., 2 vols. (London: Dent, 1962), 1:105–08.
2. See Paulson, *Hogarth*, 1:319–23.
3. See, for example, Pierre Grosley, *A Tour to London; or, New Observations on England and Its Inhabitants*, 2 vols. (London: Printed for Lockyer Davis, 1772); William Mavor, ed., *The British Tourists: or Traveller's Pocket Companion, through England, Wales, Scotland and Ireland* (London: Printed for E. Newbury, 1798), vol. 4.

58

Samuel Scott (1701/2–1772)

Two Boats with Crews, Study for *A First-Rate Shortening Sail*

ca. 1736
Brushed black ink, gray wash, and graphite
on paper
Sheet: 5 ¾ x 10 ¾ in. (14.6 x 27.3 cm)
Yale Center for British Art, Paul Mellon Collection,
B1977.14.5136

PROVENANCE: L. A. Dorant; Christie's, Feb. 23, 1951 (10-part), bt by Colnaghi; L. G. Duke; Colnaghi, from whom bt by Paul Mellon, 1961

EXHIBITIONS: Guildhall 1955 (87); NGA 1962 (78); Colnaghi/YUAG 1964–65 (67)

LITERATURE: W. R. Jeudwine, "Old Master Drawings — VI," *Apollo* (Nov. 1956): 149–51; Martin Hardie, *Water-Colour Painting in Britain*, 3 vols. (London: Batsford, 1966–68), 1:236; Kingzett, "Catalogue of Works of Samuel Scott," 92–93.

58

THIS DRAWING is one of several preparatory sketches for the painting now known as *A First-Rate Shortening Sail*, which is signed and dated 1736 (fig. 106). The painting, which was probably commissioned by William Fitzwilliam, third Earl Fitzwilliam, is thought to commemorate an expedition to Portugal led by Sir John Norris, commander-in-chief in the Channel, in 1735. Because Norris's flagship, the *Britannia*, remained in Lisbon until 1737, Scott used a model of another ship, the *Royal William*, as his visual reference for the painting.[1] Although the modern title for the painting suggests that the ship is shortening sail to slow its progress, it may be shaking out its sails to get underway; the two boats in the drawing, then, are either coming alongside the ship or pushing off from it.[2]

Scott amassed a collection of hundreds of Van de Velde drawings; his interest in showing sailors in a variety of activities and poses recalls the elder Van de Velde's crowd scenes (see cat. 4). Like Van de Velde, Scott sketched the outlines of a drawing in pencil and then worked it up with layers of gray wash. He clearly experimented with a number of positions for the figure on the far left, who wields a boat hook, before settling on the one that is finished here with wash and is replicated in the final painting. —EH

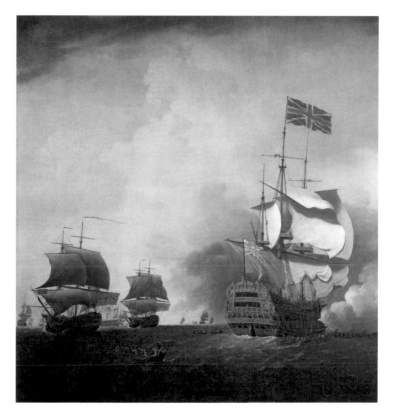

FIG. 106. Samuel Scott, *A First-Rate Shortening Sail*, ca. 1736, oil on canvas, 90 x 86½ in. (228.6 x 219.7 cm). National Maritime Museum, Greenwich, London, Caird Fund

1. Kingzett, "Catalogue of Works of Samuel Scott," 20.
2. National Maritime Museum, Greenwich: http://collections.rmg.co.uk/collections/objects/12531.html.

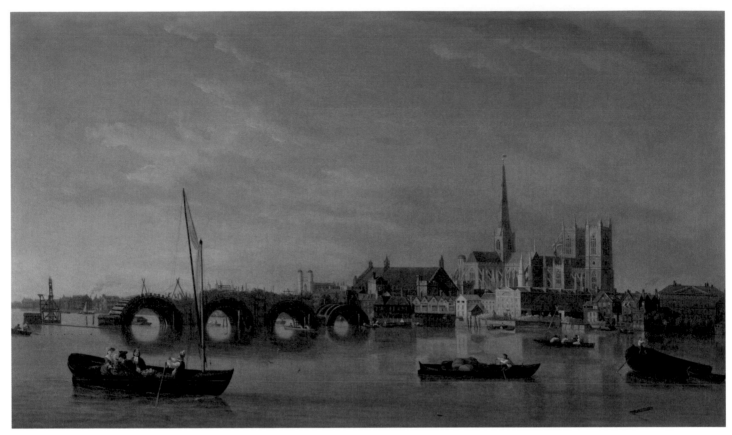

59

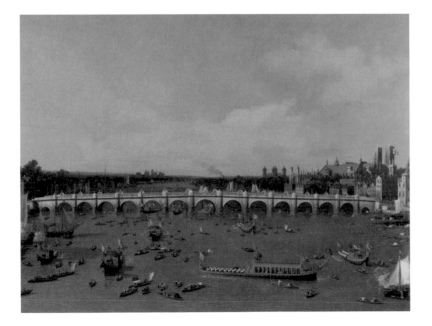

FIG. 107. Canaletto, *Westminster Bridge, with the Lord Mayor's Procession on the Thames*, 1747, oil on canvas, 43 ⅝ x 56 in. (95.9 x 127.6 cm). Yale Center for British Art, Paul Mellon Collection

59

Samuel Scott (1701/2–1772)

The Building of Westminster Bridge

ca. 1742
Oil on canvas
27 x 47 in. (68.6 x 119.4 cm)
Yale Center for British Art, Paul Mellon Collection,
B1974.3.33

PROVENANCE: The Wauchope Settlement Trust;
Christie's, Dec. 5, 1950 (102), from whom bt by
Bernard; Sir Harald Peake; Agnew, from whom bt
by Paul Mellon, 1975

LITERATURE: Kingzett, "Catalogue of Works of
Samuel Scott," 57; Markman Ellis, "River and
Labour in Samuel Scott's Thames Views in the
Mid-Eighteenth Century," *London Journal* 37, no. 3
(Nov. 2012): 152–73

SCOTT HAS FREQUENTLY been characterized as a marine painter who became a "follower" of Antonio Canal (called Canaletto), producing landscape views of Thames-side London under the influence of the Venetian painter, who lived in the city from 1746 until 1755. While Canaletto demonstrated that there was a market for these water views, it would be very strange for Scott, a native of Covent Garden and a frequenter of dockyards and shipping, not to have realized the artistic potential of the Thames on his own. Indeed, Scott's earliest drawings of Westminster Bridge date from 1742–44, and he finished and dated paintings of the bridge and of the Tower of London in the year Canaletto arrived. As Brian Allen has noted, for his first few years in London Canaletto appears to have "remained a largely invisible figure, except to a small coterie of aristocratic patrons."[1] He may, then, have been more aware of Scott than the English artist was of him, and more a rival than a model. Certainly, Canaletto's Thames-side prospects, executed with a technical confidence born of Continental artistic training, have what has been called a "factitious sparkle" in their evocation of the brilliance of Venetian light.[2] With Scott, as David Solkin puts it, "in place of Canaletto's calligraphic bravura, we are given a palpably material facture that lends . . . pasty solidity to the objects it describes."[3] There is a parallel distinction in viewpoint: Canaletto's works tend to adopt a high vantage point (fig. 107), whereas Scott's are often from the water — the viewpoint of a native.

Both artists painted multiple views of Westminster Bridge, one of the most spectacular engineering feats of the eighteenth century. The need to relieve congestion on the Old London Bridge had long been felt. In 1736 Parliament passed a bill to support the construction of a new bridge, which was carried out under the direction of a Swiss architect, Charles Labelye. The first stones were laid in 1739 and the final pier completed in 1744, although the bridge would not open until 1750.[4] Scott painted six versions of this particular view, from one of the many timber yards that lined the south bank of the Thames and serviced the construction of London's West End.[5] The only version that does not show the timber yard itself, this painting

includes the towers then under construction on Westminster Abbey, dominating the skyline at right, as well as a spire that was never built but was shown in a print published in 1739.[6] At the extreme left of the picture are two technological innovations that facilitated the bridge's construction: a horse-powered pile driver and a sinking caisson that was used to build the piers.

Canaletto's views tended to present the Thames as a place of polite refinement, populated by barges and wherries. *The Building of Westminster Bridge*, on the other hand, is as much concerned with commerce and labor on the river as it is with construction of the bridge over it: figures engage in fishing and in ferrying passengers, produce, barrels, and bales. As Solkin has observed of the version now at the Metropolitan Museum of Art, "If the Abbey stands proud as a symbol of Britain's illustrious past, it does so in seamless continuity with an ever-improving present."[7] — EH

1. Brian Allen, "The London Art World of the Mid-Eighteenth Century," in *Canaletto in England*, ed. Charles Beddington (New Haven: Yale Univ. Press, 2006), 31.
2. Ellis Waterhouse, *Painting in Britain, 1530 to 1790*, 5th ed. (New Haven: Yale Univ. Press, 1994), 159.
3. Solkin, *Art in Britain*, 122.
4. Beddington, *Canaletto in England*, 101, cat. 23; Mark Hallett, "Framing the Modern City: Canaletto's Images of London," in *Canaletto & England*, ed. Michael Liversidge and Jane Farrington (London: Merrell Holberton, 1993), 47.
5. Sheila O'Connell, ed. *London 1753* (London: British Museum Press, 2003), 103.
6. Kingzett, "Catalogue of Works of Samuel Scott," 57.
7. Solkin, *Art in Britain*, 122.

60

Samuel Scott (1701/2–1772)

The Thames with Montagu House and Westminster Bridge

ca. 1750
Watercolor, graphite, pen and black ink, and gouache on paper
15 ¾ x 35 in. (40 x 88.9 cm)
Yale Center for British Art, Paul Mellon Collection, B2009.5.1

61

Samuel Scott (1701/2–1772)

Westminster Bridge

1749
Gray wash, graphite and pen and black ink on paper
Sheet: 14 ⅛ x 28 ⅜ in. (35.9 x 72.1 cm);
mount: 16 ¾ x 31 ¼ in. (42.5 x 79.4 cm)
Yale Center for British Art, Paul Mellon Collection, B2009.5.4

62

Samuel Scott (1701/2–1772)

Buildings on the Thames

ca. 1750
Watercolor, graphite, and pen and black ink on paper
14 ⅜ x 33 in. (36.5 x 83.8 cm)
Yale Center for British Art, Paul Mellon Collection, B2009.5.6

63

Samuel Scott (1701/2–1772)

A Wood Yard on the Thames at Nine Elms

ca. 1750
Watercolor, graphite, and pen and black ink on paper
Sheet: 13 ¾ x 35 ⅛ in. (34.9 x 89.2 cm);
mount: 15 ¾ x 38 in. (40 x 96.5 cm)
Yale Center for British Art, Paul Mellon Collection, B2009.5.3

THESE WORKING DRAWINGS appear to have been made on or near the Thames as part of Scott's practice of sketching *en plein air*. They demonstrate his interest in landmark structures and the picturesque details of riverside

60

61

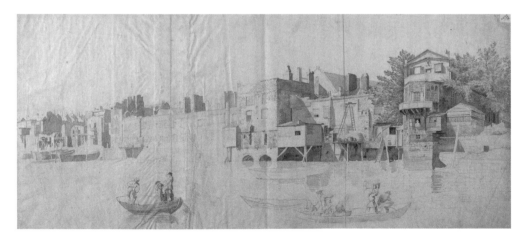

62

buildings, as well as in passing vessels and their occupants. Unusually large for sketches, they may have been inspired by the practice of Willem van de Velde. Scott's collection of Van de Velde drawings could have included examples of the Elder's panoramic sketches (see cats. 3–4), which were similarly constructed by combining sheets of paper. Scott appears to have made several of these from the river. They are drawn with graphite and then filled in, probably in Scott's studio, with thin washes of watercolor. For *The Thames with Montagu House and Westminster Bridge* (cat. 60), he used a compass to draw the arcs of the bridge: the pin marks are visible.[1]

Although Scott produced a number of paintings of Westminster Bridge and the grand houses adjacent to it on the west bank of the Thames (the river runs north at that point), none correspond exactly to the composition of *The Thames with Montagu House and Westminster Bridge*.[2] Prominent at right in the drawing are the mansions built on the site of the former Palace of Whitehall, including the white summer house of Joshua Smith and, behind it, the imposing façade of Montagu House. This view is taken from the terrace adjoining the houses of Jane, Countess of Portland, and Andrew Stone, who in 1761 would be appointed Treasurer of the Queen's Household.[3] On the river are a number of small vessels including a ferry, a barge carrying bales, and a boat from which figures are fishing. The last is a ubiquitous feature of Scott's views: in the eighteenth century, herring, flounder, salmon, and sturgeon were all sourced from the Thames.[4] Even a working drawing, then, proves Scott's interest in the Thames as a zone of intersection between commerce, labor, and refinement, with the neoclassical form of Westminster Bridge providing a point of focus and a frame.[5]

Before the bridge could open to the public, one of its piers settled, sinking nearly three feet below the level of the others. In the spring of 1749, the pier and its neighboring arches were dismantled and rebuilt, as shown in *Westminster Bridge* (cat. 61).[6] While the bridge and laborers form the focus of the drawing, Scott is equally insistent on the presence of polite spectators. A third drawing (cat. 62) lavishes attention on the details of wharves and buildings probably

63

FIG. 108. Samuel Scott, *A Sunset, with a View of Nine Elms*, ca. 1750–60, oil on canvas, 20¼ x 37¾ in. (51.5 x 95.9 cm). Tate, Presented by the Friends of the Tate Gallery 1970

located farther downriver. In addition to the washerwoman and fishermen, Scott registers the textures and details of the architectural landscape and its accretions — flowerpots, ladders, brick, glass, wood, and stone — as well as shadows and reflections. It is a remarkably vivid and rare capture of the unremarkable fabric of mid-eighteenth-century London.

Only one of these drawings can be identified as the preparatory sketch for a painting: *A Wood Yard on the Thames at Nine Elms* (cat. 63), which served as the basis for *A Sunset, with a View of Nine Elms* (fig. 108). The south bank of the Thames in the eighteenth century was lined with industries, including the timber yards on the stretch of bank facing Westminster. The yard at Nine Elms is farther upriver, just west of Vauxhall, and looks toward Battersea. Scott records the different types of wood in the yard, from a great trunk to sawn planks; the kiln visible over the roofs of the shed may have been for drying

wood. In addition to the meticulous attention Scott pays to the yard itself, he appears to have used this working sheet to record passing small vessels, without particular attention to their scale or placement on the fictitious surface of the water. — EH

1. I am grateful to Soyeon Choi, Chief Paper Conservator at the Yale Center for British Art, for sharing with me the results of her technical study of these drawings.
2. See Kingzett, "Catalogue of Works of Samuel Scott," 60–62.
3. Hugh Phillips, *The Thames, about 1750* (London: Collins, 1951), 211.
4. Markman Ellis, "River and Labour in Samuel Scott's Thames Views in the Mid-Eighteenth Century," *London Journal* 37, no. 3 (Nov. 2012): 153.
5. Sarah Monks, "The Visual Economies of the Downriver Thames in Eighteenth-Century British Art," *Visual Culture in Britain* 7 (2006): 1–20.
6. Canaletto made a drawing of the same subject, at a slightly later moment in the repairs, now in the Royal Collection. Charles Beddington, ed., *Canaletto in England: A Venetian Artist Abroad, 1746–1755*, exh. cat. (New Haven: Yale Univ. Press, 2006), 108–09.

64

Gerard van der Gucht (1696–1776)
after Samuel Scott (1701/2–1772)
and George Lambert (1700–1765)

The Cape of Good Hope

1736

65

Gerard van der Gucht (1696–1776)
after Samuel Scott (1701/2–1772)
and George Lambert (1700–1765)

Fort St. George

1736

66

Gerard van der Gucht (1696–1776)
after Samuel Scott (1701/2–1772)
and George Lambert (1700–1765)

Tellicherry

1736

Colored line engravings
18 x 23 ½ in. (45.7 x 59.7 cm)
Yale Center for British Art, Paul Mellon Collection,
B1978.43.271–.273

THESE ENGRAVINGS derive from a series of
six pictures painted by George Lambert and
Samuel Scott for the Court of Director's Room
at East India House, effectively the boardroom
from which the East India Company's vast
network of commercial endeavors was run. The
"Company of Merchants of London, trading to
the East Indies" was granted a royal charter
by Queen Elizabeth on December 31, 1600. For
the next two and a half centuries it controlled
English (and, after the union of parliaments in
1707, British) trade east of the Cape of Good
Hope. By the middle of the nineteenth century,
it was described as "the wealthiest and most
powerful commercial corporation of ancient or
modern times."[1] Commodities imported by the
company — such as tea, porcelain, and a daz-
zling array of textiles — fundamentally altered
ideas of taste and fashion for millions of British
people. All of this trading was conducted by
sea, and the history of the East India Company is

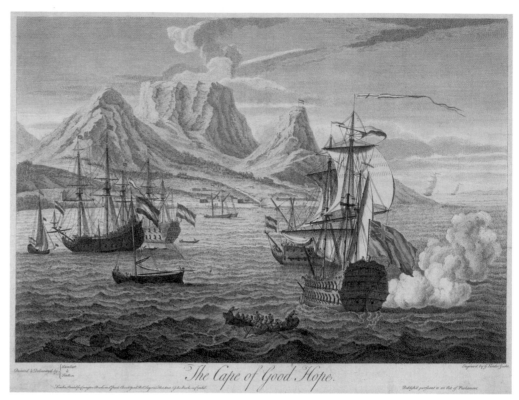

64

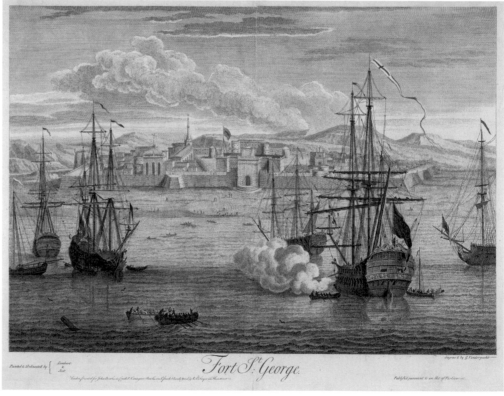

65

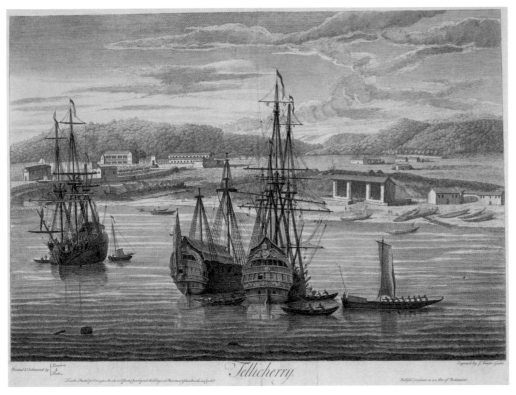

Tellicherry.

66

profoundly linked to the maritime world on which its wealth, power, and status depended.

Details of the commission for the paintings were recorded in the company minutes for November 1732, which noted that a total of six pictures had been ordered from George Lambert and Samuel Scott, at a cost of fifteen guineas each. Lambert was primarily an architectural and landscape painter, whose adoption of the principles of harmonious composition earned him the accolade of "the English Poussin."[2] Scott specialized in ships and marine painting. Of the six paintings, four represent fortified factories, or "warehouses," on the coast of India: Tellicherry (known today as Thalassery), Fort St. George (Madras), Fort William (Calcutta), and Bombay (Mumbai). The fact that the remaining two paintings represent St. Helena and Cape Town underlines the importance of way stations along the route to India. Because of the long distances involved, ships traveling to Asia needed secure places to pick up supplies and effect repairs en route.

The image of Cape Town depicted by Lambert and Scott (cat. 64) seems to have been based on a seventeenth-century painting of Table Bay,

with the dominant image of Table Mountain in the background, the walled fortification and warehouses on the shore, and Dutch ships in the bay. The salute fired by the British ship in the foreground, signaling its arrival in port, focuses attention on the crucial role played by the settlement in maintaining the company's commercial endeavors in Asia. The area around Cape Town was first settled by the Dutch East India Company in 1652, when it established a base there to provide its vessels with fresh provisions and water. By the eighteenth century, ships of all nations and companies were taking advantage of Cape Town's harbor and onshore facilities. The British government sent an expeditionary force to seize the colony in 1795, during the war with Revolutionary France. Although it was returned briefly to the Batavian (Dutch) Republic in 1803 following the Treaty of Amiens, the Cape was taken once again in 1806, and it remained British throughout the nineteenth century. Ultimately, British intervention in southern Africa was based on the fear that, as one naval officer put it, "what was a feather in the hands of Holland, will become a sword in the hands of France."[3]

The engraving of Fort St. George (cat. 65) depicts a settlement that was established by the East India Company on the west coast of India in 1639. The fort, and the city of Madras that developed around it, became one of the most important trading stations in India. The area around Madras (present-day Chennai) initially attracted both the Portuguese and the Dutch, who had settled in the region before the arrival of the English East India Company in the early seventeenth century. The first English settlement was officially established when a fortified enclosure was completed on St. George's Day, April 23, in 1640. The eighteenth-century city of Madras developed through the gradual assimilation of Fort St. George into the so-called "Blacktown" inhabited by Tamil- and Telugu-speaking merchants, Armenians, and Indo-Portuguese.[4] This was the East India Company's principal settlement in India until 1774, when Calcutta was officially declared to be the seat of the government.

The British presence at Tellicherry (cat. 66) dates to 1683, when it was the first regular settlement on the Malabar (southwestern) coast of India. The fort was completed in 1708 by the Kolattiri Rajah and handed to the East India Company for the protection of their factory. When Lambert and Scott were painting, in the early 1730s, Tellicherry was still envisaged as an important part of the company's infrastructure in India. By 1776, however, the factory was reduced in status to a "Residency," and it was abolished entirely in 1794. — JM

1. "The East India House," *Leisure Hour*, Sept. 5, 1861, 567.

2. Quoted in Elizabeth Einberg, "George Lambert (1699/1700–1765)," in *Oxford Dictionary of National Biography*, Oxford Univ. Press, 2004: http://dx.doi.org/10.1093/ref:odnb/34383 (accessed Sept. 18, 2015).

3. John Blankett to Evan Nepean, January 25, 1795, The National Archives (TNA), WO1/329, 48.

4. C. A. Bayly, ed., *The Raj: India and the British, 1600–1947*, exh. cat. (London: National Portrait Gallery, 1990), 106; P. J. Marshall, *Bengal, The British Bridgehead: Eastern India, 1740–1828* (Cambridge: Cambridge Univ. Press, 1988), 159–60.

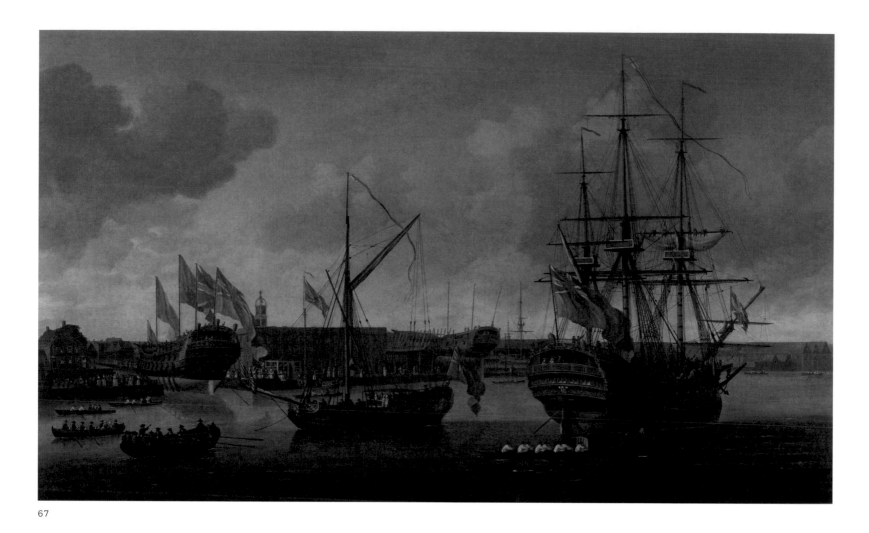

67

67

John Cleveley the Elder (ca. 1711–1777)

Launching at Deptford

ca. 1757
Oil on canvas
41 ¾ x 70 ½ in. (106 x 179.1 cm)
Yale Center for British Art, Paul Mellon Collection,
B1981.25.108

PROVENANCE: Gooden & Fox, from whom bt by
Paul Mellon, 1961

EXHIBITIONS: VMFA/RA/YUAG 1963–65
(VMFA/RA only: 23, 51); YCBA 1977 (18)

IN 1810 J.T. BARKER preached a sermon at the
launching of the *Queen Charlotte* at Deptford
that could easily describe the scene painted fifty
years earlier by Cleveley:

The day is come; multitudes are assembled;
and bustle and clamour for awhile prevail.
The moment approaches, expectation is all
awake, the loud strokes of the axe become
louder and more frequent; and as the props
and shores are successively falling, hopes and
fears alternately depress or elevate the whole
soul. At length the signal is given, and the
very last shore is "knocked away". She moves;
and all the hearts of the spectators are moved
with her. What solemnity; what concern, what
solicitude is depicted on the countenances
of the gazing thousands! But she enters the
watery element; enters slowly, but safely and
majestically.[1]

This painting depicts the launch of one of the
many great warships built at the Royal Dockyard
at Deptford. Cleveley reused the composition
with different ships, examples of which are in
the National Maritime Museum at Greenwich,
the Science Museum, and the Government Art
Collection, London. In this version the ship being
launched from the double dock, to the left of the
Great Storehouse that occupies the center of the
composition, has not been identified. Cleveley's
view of the dockyard published in 1753 (cat. 69)
shows the *Cambridge*, a larger ship, under
construction in the same dock. In the docks to
the right of the Great Storehouse are vessels in
various stages of construction. Cleveley's picture
emphasizes the presence of spectators, male
and female, who watch from the quay, from
the windows of the Great Storehouse, from the
house of the Master Shipwright to the left of the
ship being launched, and even from the stern

gallery of the ship itself. Henry Fielding identi-
fied the attraction of such scenes in 1750: "the
yards of Deptford and of Woolwich are noble
sights: and give us a just idea of the great per-
fection to which we are arrived in building those
floating castles."[2]

John Cleveley and his two sons were among
the several marine painters who had experience
working in dockyards prior to or concomitant
with careers as marine painters. John Clev-
eley the Elder was apprenticed to a joiner and
became a ships' carpenter, remaining in Dept-
ford until his death in 1777. He undertook several
commissions for the Admiralty, among them a
series of views of Royal Dockyards (cats. 68–73)
and the repainting of the wind dial (still extant)
in the boardroom of the Admiralty, which indi-
cated the direction of the wind to occupants of
the room by means of a weather vane mounted
on the roof of the building.[3] His son John (see
cats. 134–35) briefly trained as a shipwright, and
his son Robert (see cat. 138) became a caulker,
then a naval clerk and purser. — EH

───────────────

1. John Theodore Barker, *The Ship Launch: The
 Substance of a Sermon, Preached at Deptford on
 Occasion of the Launching of the Queen Charlotte,
 July 17, 1810* (London: T. Conder, 1810), 25.
2. Henry Fielding, "The Journal of a Voyage to
 Lisbon," in *The Complete Works of Henry Fielding,
 Esq.*, 16 vols. (London: William Heinemann, 1903),
 3:208.
3. The National Archives, ADM 106/1069/3.

68

Pierre Charles Canot (ca. 1710–1777)
after Thomas Milton (active 1739–1755)
and John Cleveley the Elder (ca. 1711–1777)

**A Geometrical Plan, and West Elevation of
His Majesty's Dock-Yard, near Plymouth,
with the Ordnance Wharfe, &c.**

1756
Engraving
18 ¾ x 25 ⅞ in. (47.6 x 65.7 cm)
Yale Center for British Art, Paul Mellon Collection,
B1978.43.280

69

Pierre Charles Canot (ca. 1710–1777)
after Thomas Milton (active 1739–1755)
and (?)John Cleveley the Elder (ca. 1711–1777)

**A Geometrical Plan, & North East Elevation
of His Majesty's Dock-Yard, at Deptford,
with Part of the Town, &c.**

1753
Engraving
18 ½ x 25 ⅝ in. (47 x 65.1 cm)
Yale Center for British Art, Paul Mellon Collection,
B1978.43.277

70

Pierre Charles Canot (ca. 1710–1777)
after Thomas Milton (active 1739–1755)
and (?)John Cleveley the Elder (ca. 1711–1777)

**A Geometrical Plan, and North Elevation
of His Majesty's Dock-Yard, at Woolwich,
with Part of the Town, &c.**

1753
Engraving
18 ¾ x 25 ¾ in. (47.6 x 65.4 cm)
Yale Center for British Art, Paul Mellon Collection,
B1978.43.282

71

Pierre Charles Canot (ca. 1710–1777)
after Thomas Milton (active 1739–1755)
and (?)John Cleveley the Elder (ca. 1711–1777)

**A Geometrical Plan, & West Elevation of
His Majesty's Dock-Yard, near Portsmouth,
with Part of the Common, &c.**

1754
Engraving
18 ¾ x 25 ¼ in. (47.6 x 64.1 cm)
Yale Center for British Art, Paul Mellon Collection,
B1978.43.279

72

Pierre Charles Canot (ca. 1710–1777)
after Thomas Milton (active 1739–1755)
and John Cleveley the Elder (ca. 1711–1777)

**A Geometrical Plan, & West Elevation of His
Majesty's Dock-Yard and Garrison, at
Sheerness, with the Ordnance Wharfe, &c.**

1755
Engraving
18 ⅞ x 25 ⅝ in. (47.9 x 65.1 cm)
Yale Center for British Art, Paul Mellon Collection,
B1978.43.278

73

Pierre Charles Canot (ca. 1710–1777)
after Thomas Milton (active 1739–1755)
and John Cleveley the Elder (ca. 1711–1777)

**A Geometrical Plan, & North West Elevation
of His Majesty's Dock-Yard, at Chatham,
with ye Village of Brompton Adjacent**

1755
Engraving
18 ¾ x 25 ⅝ in. (47.5 x 65.1 cm)
Yale Center for British Art, Paul Mellon Collection,
B1978.43.281

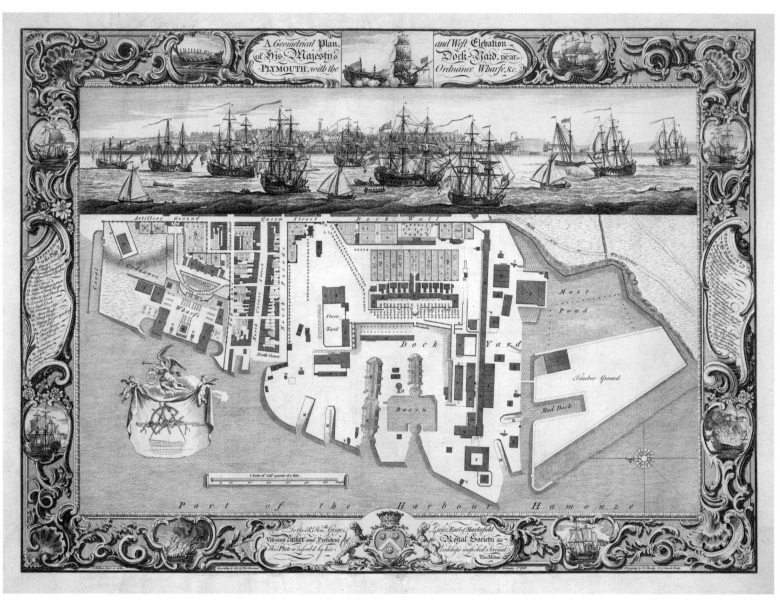

68

IN 1749 the Lords of the Admiralty undertook a series of visits to inspect the six Royal Dockyards: Deptford, Woolwich, Sheerness, Chatham, Plymouth, and Portsmouth. What they found was disappointing — ships and storehouses in poor condition, excessive numbers of employees, accounts in arrears, and insufficient oversight — and they made a number of recommendations for reform.[1] This extraordinary series of prints of the Royal Dockyards, engraved and published by Pierre Canot between 1753 and 1756, appears to have been commissioned to project a view of the dockyards as orderly, efficient, and rational.[2]

Each dockyard is shown in two views: a plan of the docks and buildings, drawn by one Thomas Milton, and above it a panoramic view from the water, a format similar to topographical coastal views with vessels in the foreground and the hills and trees of the surrounding countryside in the distance. The marine painter John Cleveley the Elder, who had previously worked for the Admiralty, is named on three of the prints, and surely also drew the panoramic views for the other three. In November 1750, when employed at the Deptford dockyard, he wrote to the Navy Board (which oversaw the dockyards) to notify them that he had, "In

Pursuance to your Order of the 28 of September," traveled to Sheerness to make a drawing of the *Amazon*, "and also a sketch of that Port," for which service he was paid 6s 8d per day; it is tempting to surmise that the sketch was made for the purpose of the dockyard views.[3]

For each dockyard the plan and elevation align with each other and are presented as technical renderings. Surrounding and inset within the plans are representations in a more decorative register. Superimposed on the plan of Plymouth (cat. 68), for example, is a cartouche in the form of a drapery swag, supported by putti and surmounted by a winged figure holding a shield

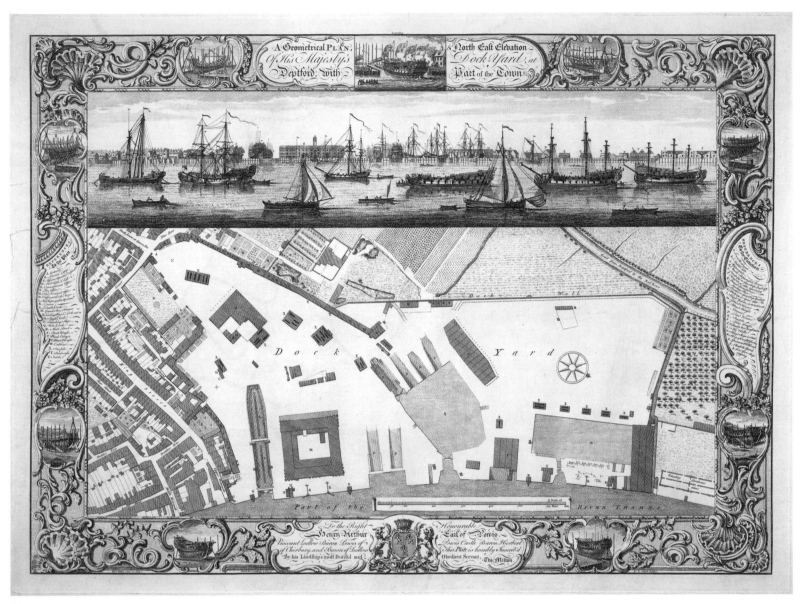

69

bearing a coat of arms. Depicted on the swag itself is a device formed by a compass, right angle, protractor, and plumb line, the legs of the compass measuring the length of a ship plan in elevation, and the whole a reference to the tools of the shipwright's trade. The empirical delineation of buildings juxtaposed with an allegorical cartouche had an immediate precedent in John Rocque's map of London, published in 1747 by John Pine, who had masterminded *The Tapestry Hangings of the House of Lords* (cats. 36–38).

The prints bear further resemblance to Pine's earlier publication. Surrounding the main body of each print is a highly ornate border of rococo foliage and scrolls, with a headpiece announcing the title and dedication of the print, and nine vignettes of ships, all different. The vignettes directly refer to the functions of each dockyard, which were contingent on location. Deptford and Woolwich dockyards, close to London on the Thames, were too far from the coast to be naval bases, and so were used for shipbuilding and storing masts and timber. The Deptford vignettes (cat. 69) show the stages in the building of a ship, with its launch at the headpiece. In the Woolwich vignettes (cat. 70), the ship is seen first under construction, then launched, getting its masts in, preparing to sail, under sail, engaging the enemy, taking a prize in tow, undergoing a storm, and wrecked. They suggest a ship's "biography," a trope often used as an allegory of human life.[4] The relationship of the vignettes to the central plan and elevation in these prints is implicit: they suggest the trajectory of the ship once it has left the dockyard and the hazards it will face that will require it to return for repairs. The exception is the print of Portsmouth (cat. 71), which has inscribed within its cartouche "References to Eight of the Twelve Capital Ships taken from the French the 3rd of May and 17th of October 1747 as Drawn in the Border." The ships illustrated in the border

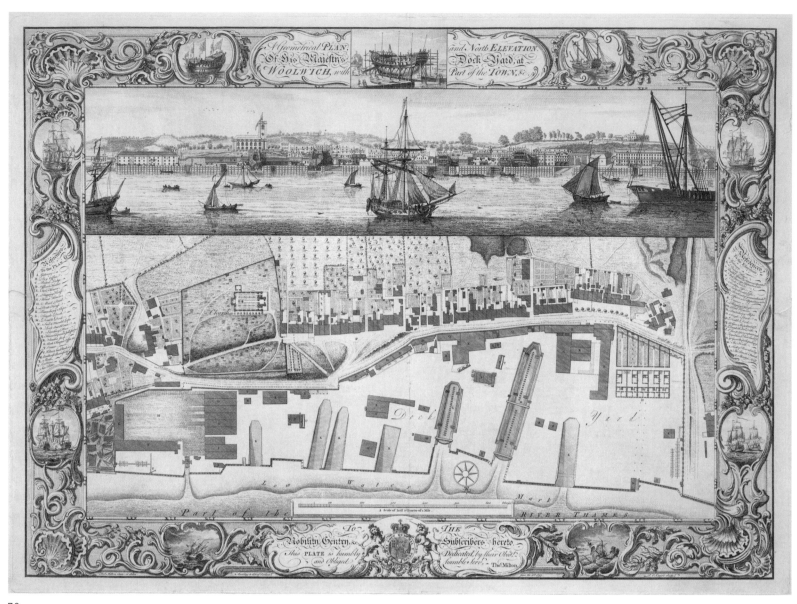

70

vignettes serve as a record of the activities of the dockyard at a particular moment.

Chatham, on the Medway, was used as a strategic naval base during the Anglo-Dutch Wars of the seventeenth century. Sheerness, at the mouth of the Medway, was built to take some of the pressure off Chatham, so that ships needing minor repairs did not have to travel the length of the river. The Sheerness vignettes (cat. 72), accordingly, show methods of repair and upkeep, including a view of a ship "heaving down" at Port Mahon, the navy's main base in the Mediterranean (see cat. 79). When France

replaced the Netherlands as Britain's major rival in the late seventeenth century, Plymouth and Portsmouth became the more strategically significant yards, serving as naval bases and rendezvous points for campaigns in the Atlantic and the Channel, respectively.[5] Chatham, Plymouth, and Portsmouth, where the fleets moored during the winter or while on reserve, became employed in repairs more than shipbuilding. Chatham's vignettes (cat. 73), accordingly, display a combination of dockyard practice ("Sheathing in the dock"), maneuvers ("Laying to under balanc'd mizzen"), and disasters ("Jamb'd

in between rocks," "Wreck'd on the sands"). The vignette set into the headpiece of the Plymouth print shows a naval engagement, while the eight surrounding vignettes depict ships undergoing maneuvers ("About ship," "Haul maintopsail," "Flying to windward close hauled") and disasters ("Breaking up," "Blown up," "Burnt to the water's edge," "Taken all aback").

As a group, then, these prints combine multiple registers of representation and conception of the ship: in plan view and elevation, as constructed and destroyed object, and as the hero of its own narrative. Underlying all, and

71

indeed providing the impetus for the survey that prompted the making of the prints, was the issue of timber for shipbuilding. Of note in the plans of the dockyards, in addition to offices and apartments, sail lofts and rigging houses, is the array of structures for the storage and treatment of timber: sheds, mast ponds, saw pits, and kilns for bending planks. In the age of sail, the procurement of timber was of primary concern for the Royal Navy. Apart from construction, repairs were constantly needed due to rot, battle damage, and ordinary wear. Maintaining sufficient supplies of timber in the dockyards

was a perpetual challenge for the Navy Board, which was responsible for obtaining and storing the wood.

Timber supply and sea power were inextricably linked; for example, the fir trees needed for making masts would not grow in Britain, necessitating the maintenance of open trade routes to the Baltic and New England, and, in times of war, cutting off the enemy's supply. The need for mast timber had far-reaching effects, governing commercial and foreign policy in the Baltic region and promoting the settlement of new colonies in Canada and northern New England. In 1778

Vice Admiral Augustus Keppel was questioned during a court martial (he was ultimately acquitted) about his alleged reluctance to engage the French fleet because he judged that supplies of masts and stores were too low to sustain such a conflict: "Whether we could ever repair the Loss is not very clear to me when I consider the State of our Naval Stores at that time, and the extreme Difficulty of a Supply as long as the French should continue superior in the Channel."[6]

As great a problem, but one with far more cultural resonance, was the shortage of English oak, creating "the great oak panic of the

eighteenth century."[7] The maritime countries of Europe preferred oak for building hulls; according to the diarist and gardener John Evelyn, it was "tough, bending well, strong and not too heavy, nor easily admitting water."[8] Because of its high tannic acid content, it was also resistant to *Teredo navalis*, or shipworm, and the fact that it did not splinter easily made it particularly suitable for warships. *Quercus robur* grows throughout Europe, but the Royal Navy thought English oak, particularly from Sussex, to be the most desirable. Ships required a range of shapes of timber, straight and "crooked," and

the most difficult to procure were the "great" and "compass" timbers, used in the frame of the ship. Such elements were made from single pieces of wood for strength, and so had to come from trees that had passed the stage when it was most profitable to cut them.[9] They tended also to be found in hedgerows rather than forests, with room to grow lateral branches and develop strength from withstanding winds. It has been observed that these trees "became fetishized as more than simply the construction fabric of the navy": "In countless eighteenth-century broadsides, pamphlets, ballads, inn

signs, and allegorical engravings, the 'Heart of Oak' became the bulwark of English liberty, all that stood between freeborn Englishmen and Catholic slavery and idolatry. . . . Even the quirkiness of *Quercus robur*, with its crooked, angular pieces crucial for the construction of hulls, was contrasted with the more predictably uniform 'foreign' timber."[10] Unlike French oak, specifically, which grew in forests and was constrained to grow upward rather than outward, English oak grew unfettered and at liberty, developing strength and individuality. — EH

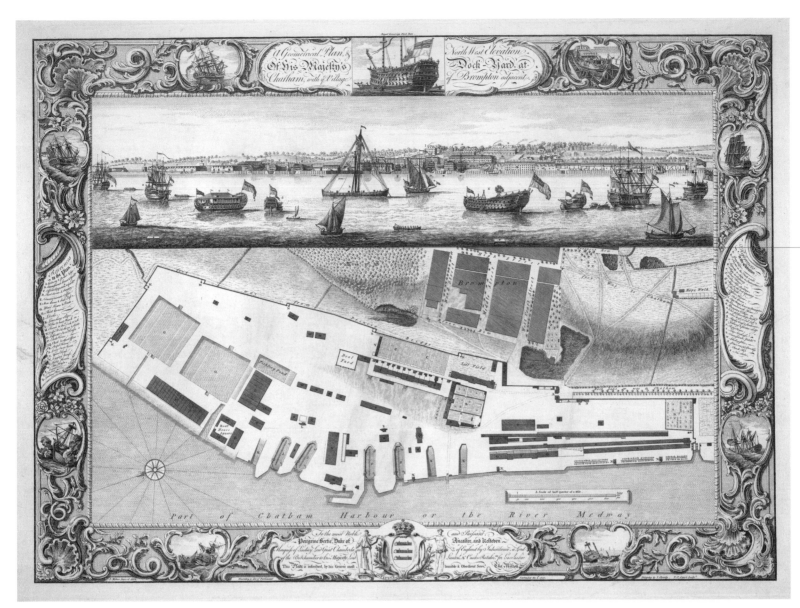

73

1. Richard Middleton, "The Visitation of the Royal Dockyards, 1749," *The Mariner's Mirror* 77 (1991): 21–30.

2. See Celina Fox, *The Arts of Industry in the Age of Enlightenment* (New Haven: Yale Univ. Press, 2009), 66–67.

3. The National Archives, ADM 106/1080/222.

4. See, for example, Russell, *Visions of the Sea*, 62.

5. Coad, *Royal Dockyards, 1690–1850*; MacDougall, *Royal Dockyards*; Morriss, *Royal Dockyards during the French Revolutionary and Napoleonic Wars*.

6. *The Defence of Admiral Keppel* (London: Printed for J. Almon, 1779), 12.

7. Simon Schama, *Landscape and Memory*, 1st ed. (New York: A. A. Knopf, 1995), 616.

8. John Evelyn, *Silva: or, a Discourse of Forest-Trees* (1664; London: Printed for J. Walthoe et. al., 1729), 22.

9. Albion, *Forests and Sea Power*, 7.

10. Schama, *Landscape and Memory*, 163–64.

74

Unknown maker

Model of the *Lion*

ca. 1738

Boxwood, gold leaf, japanning, mica, brass, and varnish

With baseboard: 13 x 42 x 12⅝ x 42 in. (33 x 106.7 x 32 cm)

The Kriegstein Collection

PROVENANCE: Given by E. E. Rushworth to Royal United Services Institution, 1911; by 1973 with Parker Gallery, from whom bt by private collector; bt 1978

LITERATURE: John Franklin, *Navy Board Ship Models 1650–1750* (London: Conway Maritime Press 1989), 29, 31, 38, 57, 154–56; Kriegstein and Kriegstein, *17th and 18th Century Ship Models*, 130–141.

74

ORIGINALLY BUILT at Chatham dockyard by Benjamin Rosewell, the *Lion* was rebuilt at Deptford dockyard in 1738. This exquisite model represents the ship as it was rebuilt, under the supervision of Richard Stace. It is left partly unplanked, though the lower-hull framing is stylized, and features "japanned" decoration in imitation of Chinese lacquer work.

On July 20, 1745, the 58-gun *Lion* encountered a French ship, the *Elizabeth*, of 64 guns, which was escorting the sloop *Du Theilly*. On board the latter was Charles Edward Stuart, the Young Pretender, on his way to Scotland, whence the Jacobite rebellion would attempt to restore the Stuart line as rulers of Britain. The *Lion* was commanded by Captain Peircy Brett,

who had served as first lieutenant on board the *Centurion* during Commodore Anson's circumnavigation of the world. Brett produced the drawings of the voyage that served as the basis for the engravings that accompanied the published account and for Samuel Scott's paintings for the Anson family (see cats. 49–50, 55–56). Although outgunned, the *Lion* gave chase to the *Elizabeth*, and the two ships engaged in a ferocious duel that lasted five hours, until the *Lion* was so disabled that both French ships were able to escape. Brett made drawings of the action, from which Samuel Scott painted three versions of the subject (all in private collections). One of those is the work Lady Anson described in a letter as hanging on one side of the doorway into the dining room at the family home, Shugborough (see cat. 48). Brett later commanded the *Yarmouth* at the Battle of Cape Finisterre, in 1747 (cat. 53). — EH

75

75

Francis Holman (1729–1784)

The Frigate *Surprise* at Anchor off Great Yarmouth, Norfolk

ca. 1775
Oil on canvas
30 x 57 in. (76.2 x 144.8 cm)
Yale Center for British Art, Paul Mellon Collection,
B1981.25.364

PROVENANCE: Gooden & Fox, Ltd., from whom bt
by Paul Mellon, 1962

EXHIBITIONS: VMFA/RA/YUAG 1963–65 (VFMA
only: 24); YCBA 1977–78 (24)

HOLMAN'S FATHER and one of his brothers
were sea captains at Ramsgate, east Kent, just
south of the Thames estuary, and the artist lived
and worked all his life in Thames-side Wap-
ping, London. He was primarily a painter of ship
portraits for captains and owners, which he
extended into coastal views, mainly from Kent
round to East Anglia; Thames shipyard scenes;
and, later, more distant naval and battle pieces

of the American Revolution. He exhibited at the
Free Society of Artists from 1767 to 1772, and at
the Royal Academy from 1774 to 1784. By 1773 he
had taken on an apprentice, Thomas Luny, who
also first exhibited from Holman's address (see
cat. 76).

This coastal view is an example of Holman's
common formula for large works: a panoramic
scene in wide rectangular format, with the
horizon set no more than a third of the way from
the bottom. Above, protruding into an expan-
sive sky, are not only ships' masts but also the
salient features of the often quite distant coast,
such as the Yarmouth church spires here, much
as navigators would have first seen them when
approaching land. The one on the right is the
large Yarmouth parish church of St. Nicholas
(now Great Yarmouth Minster, but no longer
with the pointed spire). While the town lacked
a shipping harbor, Yarmouth Roads was a good
offshore anchorage within outer sandbanks for
both merchant ships and, in wartime, North Sea
naval squadrons. Yarmouth was also signifi-
cant in traffic up the east coast and for packet

services to Dutch and north German ports.

The vessels shown here are all relatively
small, even the frigate *Surprise*, which was of
28 guns and launched at Woolwich in 1774. Its
topsails are half lowered and look all aback
(pressed backward by a light headwind). The
ship is presumably held in position by its star-
board bower anchor, and may have just dropped
it, with the many crew on deck about to go
aloft and take in canvas. Men at its side may be
preparing to receive the fishing boat approach-
ing the bow, possibly to deliver fresh provisions.
The cutter running in under the stern, with
Yarmouth on the transom, is probably a local
pilot vessel. Two substantial rowboats traverse
the anchorage in the foreground, and at far left
is a small merchantman of the type, built on the
English northeast coast, that James Cook was
using for his Pacific voyages at this time. Why
and when *Surprise* would have been at Yarmouth
is unclear: in the spring of 1775 it sailed for
Newfoundland and spent practically all of its
career on the North American station, until it
was broken up in 1783. — PVDM

76

Thomas Luny (1759–1837)

A Packet Boat under Sail in a Breeze off the South Foreland

1780
Oil on canvas
33 x 56 in. (83.8 x 142.2 cm)
Yale Center for British Art, Paul Mellon Collection,
B1981.25.434

PROVENANCE: Gooden & Fox, 1964, from whom bt
by Paul Mellon

EXHIBITIONS: YCBA 1977–78 (23)

THE LARGE CUTTER in stern view at center, towing a boat, is probably a packet, running official postal and passenger service on a regular route. The large ship's boat in the right foreground carries men who are raising its anchor (or recovering one). Beyond it, on the left, is a small merchant ship, and to the right, a frigate sails toward shipping anchored in the Downs. This is the roadstead off Walmer and Deal, between the east Kent coast and the Goodwin Sands, which was the main sailing anchorage and rendezvous between the Thames and the English Channel. A Royal Navy two-decker at far right flies the flag (red at the fore) of a Vice Admiral of the Red, possibly as senior officer stationed there. The South Foreland light is prominent on the chalk cliffs, with Dover Castle seen above those further west, at far left.

By 1773, Luny was a pupil of Francis Holman, a marine painter in London (see cat. 75), and he later set up there himself doing general marine views, ship portraits, scenes of the Thames, and naval battle paintings of the American Revolution and the Anglo-French wars. He exhibited at both the Society of Artists (from 1777) and the Royal Academy (from 1780). Surviving sketchbooks in the collections of the National Maritime Museum, Greenwich, and the Yale Center for British Art show he was a close observer of shipping on the Thames and that he visited Paris in 1777. He prospered, never married, and in 1807 moved to Teignmouth, Devon, where his prolific output continued despite his gradual disablement by arthritis, which eventually meant he could paint only with a brush tied to his hand. Until 1817 he had an arrangement for selling work through a frame-maker and dealer called Thomas Merle, on Leadenhall Street in London (which, as the location of East India House, was a place where seafarers and shipowners easily saw them). After his move to Teignmouth, picturesque local coastal scenes largely replaced his London and Thames subjects, of which this is a fairly early example, signed and dated 1780: an original inscription on the back (now covered) reads "South Foreland / View of the Downs."—PVDM

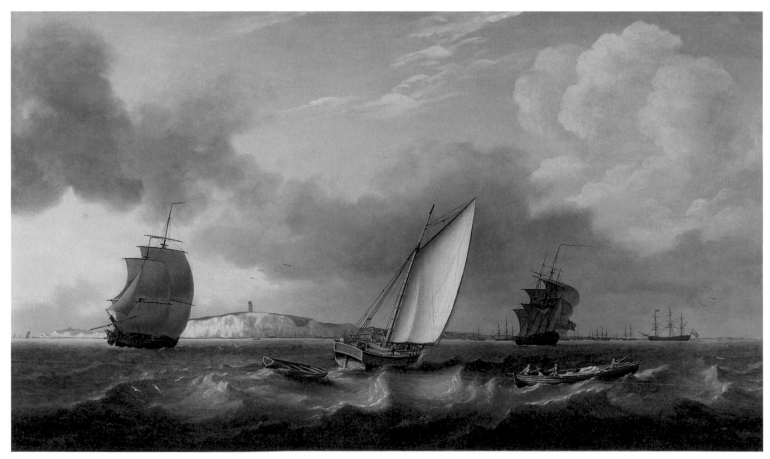

76

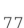

77

Henry William Parish (active 1790s)

**Sketches by Captain Parish on the Voyage
from England to China in 1793–4 [sic] with
Lord Macartney's Embassy**

Graphite and watercolor, or graphite, pen and ink,
and watercolor on paper
Yale Center for British Art, Paul Mellon Collection,
B1981.25.2164–.2179
Shown: B1981.25.2171

THIS ALBUM contains sixteen views from
the outward voyage of George Macartney's
diplomatic mission to China, an attempt to
persuade the Chinese imperial court to broaden
its trade policies with Britain. The naval ship
Lion and an East India Company vessel, the
Hindostan, departed Portsmouth in September
1792, intending to sail around the Cape of Good
Hope and eastward into the Indian Ocean. Trade
winds forced them to cross the Atlantic to South
America, and they remained for several weeks
in Rio de Janeiro, where Parish made the view
displayed here. Recrossing the Atlantic, they
arrived at Macau in June 1793.

Parish was a lieutenant in the Royal Artillery
and a trained draftsman. His sketch of Rio, then
the heavily fortified Portuguese colonial capital
and entrepôt for sugar, gold, and gems, com-
bines the kind of coastal profile the Royal Navy
relied upon for navigation (see cats. 82–86) and
a military interest in the embrasures (openings
for gun placements) of the port's defenses.

Macartney's embassy attempted to create
interest in British manufactured products to
offset the trade deficit caused by British demand
for Chinese goods, particularly tea and silk.
While the mission famously failed in these aims,
the visual and textual descriptions of the expedi-
tion brought back new knowledge of Chinese
people and customs. The official draftsman on
the expedition was the artist William Alexan-
der, who to his lifelong disappointment was
left behind in Beijing when Macartney traveled
inland for his audience with the emperor, and
missed seeing the Great Wall. Parish, however,
made detailed technical drawings, now in the
British Library. — EH

78

William Anderson (1757–1837)

Cavalry Embarking at Blackwall

1793
Oil on canvas
18½ x 24 in. (46.4 x 61 cm)
Yale Center for British Art, Paul Mellon Collection,
B2001.2.181

PROVENANCE: Sotheby's, March 15, 1967 (95),
from whom bt by Paul Mellon through P & D
Colnaghi

EXHIBITIONS: Museum of the Horse 2003

LITERATURE: Ellis Waterhouse, *The Dictionary of
British 18th Century Painters in Oils and Crayons*
(Woodbridge, UK: Antique Collectors' Club, 1981),
29; *All the Queen's Horses: The Role of the Horse in
British History*, exh. cat. (Lexington, KY: Kentucky
Horse Park, 2003), 181, cat. 45.1; R. J. B. Knight,
*Britain against Napoleon: The Organization of
Victory, 1793–1815* (London: Allen Lane, an imprint
of Penguin Books, 2013), cover image.

THE SETTING of this painting is Perry's Bruns-
wick Dock, Blackwall, London, a yard that was
privately owned at the time by the Perry family
of shipbuilders. The embarkation of cavalry

78

underway is part of the mobilization of troops in response to Britain's entry into the French Revolutionary Wars. Although Britain had been able to remain neutral during the early years of the French Revolution, the expulsion of the French ambassador following the execution of Louis XVI in January 1793 prompted France to declare war on Britain. The troops in Anderson's paintings are believed to have been sent to Ostend to support Britain's participation in the War of the First Coalition (Spain, Holland, Austria, Prussia, England, and Sardinia allied against France).

Contemporary newspapers reported three embarkations of cavalry from the Brunswick dock in the spring of 1793: on April 24, May 8, and May 24. The first embarkation received the most fanfare, with the Prince of Wales, Duke of York, and Duke of Gloucester in attendance, as described in the *Times*.[1] These distinguished spectators viewed the embarkation from a

platform that the Perrys had constructed for "persons of rank and fashion." King George III and Queen Charlotte were also expected but were unable to attend because of the "indisposition" of one of the princesses. The absence of royal onlookers in Anderson's painting suggests that the scene depicted may be one of the May dates. The May 24 departure was well documented in *Lloyd's Evening Post*.[2] That morning, four troops of the Second (Queen's) Regiment of Dragoon Guards and two of the Seventh (Queen's Own) Regiment of Light Dragoons set off. Soldiers depicted in the foreground of this canvas, preparing their kits and saying their farewells, may have belonged to these regiments.

Ships were taken into the basin so that the cavalry horses could be easily brought on board. In the background, the animals are lined up to be hoisted in a canvas sling, like the horse just to the right of the composition's center. In the

distance, looking south, the Greenwich Hospital for Seamen is visible on the small stretch of the horizon line at left. Another version of this subject is now in the collection of the National Maritime Museum, Greenwich. It has been suggested that this was in fact the April 24 embarkation, which Perry may have commissioned Anderson to commemorate, and that, when the king and queen failed to appear, the artist adapted his composition to include Perry and his wife, perhaps shown from behind in the lower right of the canvas, observing the scene.[3] — SL

1. *Times*, London, April 25, 1793.

2. *Lloyd's Evening Post*, May 22–24, 1793.

3. National Maritime Museum, Greenwich: http://collections.rmg.co.uk/collections/objects/13285.html (accessed Dec. 24, 2015). My thanks to Pieter van der Merwe for sharing his research on these pictures.

79

John Thomas Serres (1759–1825)

Port Mahon, Minorca, with British Men of War at Anchor

1795
Oil on canvas
20 ⅜ x 30 ¼ in. (51.8 x 76.8 cm)
Yale Center for British Art, Paul Mellon Collection, B1976.7.68

PROVENANCE: Ackermann, from whom bt by Paul Mellon, 1971

EXHIBITIONS: YCBA 1977–78 (22)

PORT MAHON, on the island of Minorca, was the main British naval base in the Mediterranean, first captured in 1708 and made a British possession by the Treaty of Utrecht in 1713; a Royal Dockyard was established there in 1715. Port Mahon was lost and recaptured numerous times during the wars of the eighteenth century: surrendered to the French in 1756 during the Seven Years' War, regained in 1763, then lost again to Franco-Spanish forces during the American Revolution and made a Spanish possession in 1783. Serres's painting of 1795 shows British ships anchored in the natural harbor during the period of the French Revolutionary Wars known as the First Coalition, in which an uneasy alliance existed between Britain and Spain. The following year, Spain was persuaded to become an ally of France, but in 1798 the British again recaptured the island, which was finally ceded to Spanish control in 1802. The view shown here is from the north toward the town of Mahon, with the church spire of Santa Maria barely visible in the haze. Just out of frame to the left is Isla del Rey, the site of the first British Royal Naval Hospital, founded in 1711.

John Thomas was the son of Dominic Serres, a founding member of the Royal Academy (see cat. 89). He was the only eighteenth-century marine painter to undertake a Grand Tour to Italy, partly funded by a sale in 1790 of paintings and drawings from his father's extensive collections.[1] His travels in the Mediterranean undoubtedly brought him to Port Mahon, where he would have made the sketches on which this view is based. On Dominic Serres's death in 1793, John Thomas succeeded him in the honorific positions of marine painter to George III and to the Duke of Clarence. In 1800 he was appointed marine draftsman to the Admiralty, in which capacity he continued to make coastline views, an essential aid to navigation (see cats. 82–86).
—EH

1. Russett, *Dominic Serres*, 199.

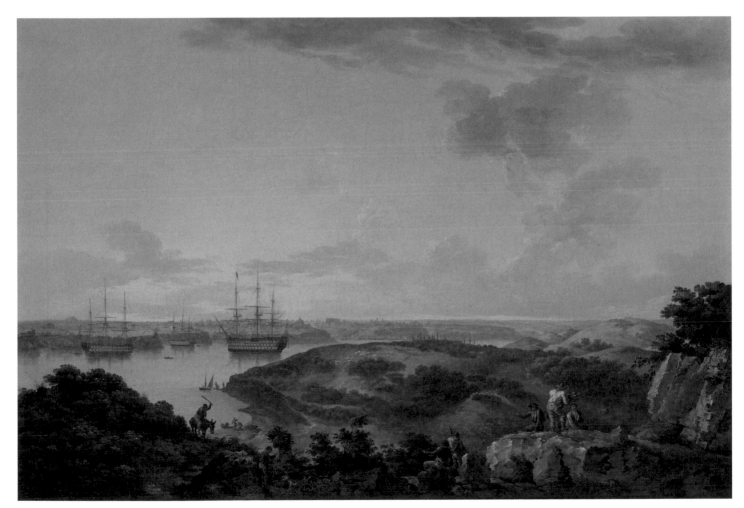

79

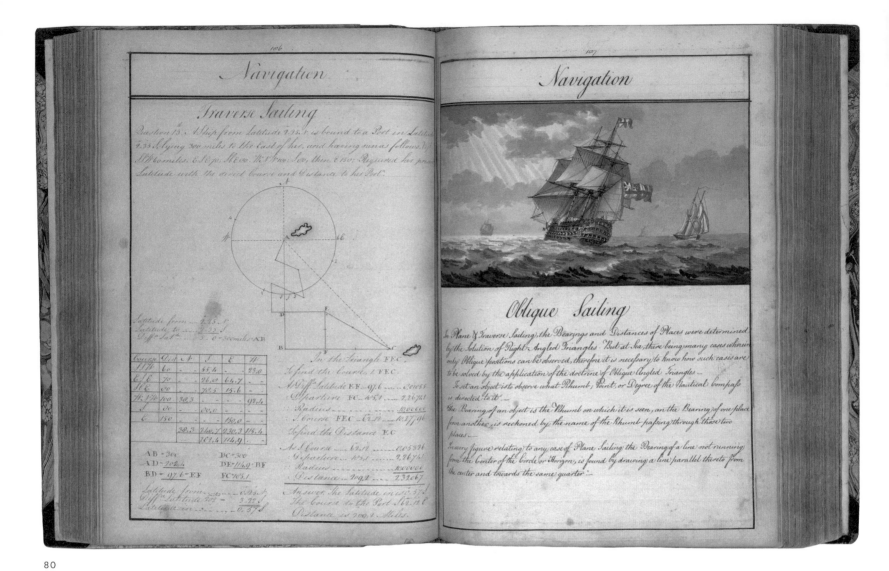

80

80

Edmund Nagle Rice (d. 1801)

"A Plan of Mathematical Learning Taught in the Royal Academy, Portsmouth"

1798–99
Yale Center for British Art, Paul Mellon Collection,
V522.P67 R53 1798+
Shown: pages 186–87

THIS EXERCISE BOOK reflects the officer training provided at the Royal Naval Academy in Portsmouth: it contains notes on geography, astronomy, navigation, fortifications, and gunnery, along with hundreds of diagrams, charts, plans, and maps, and drawings of landscapes and seascapes. The book belonged to Edmund Nagle Rice and was clearly an exceptional specimen of its kind: a note on one of the drawings reveals that Richard Livesay, the artist and publisher who served as drawing master at Portsmouth from 1796 to 1811 (see fig. 82, p. 114, and cat. 57), had shown the drawings to Earl Spencer, First Lord of the Admiralty, who was "pleased to honour them with his approbation." Having completed his training, Rice was assigned to the *Topaze* in 1799 and died of yellow fever in the West Indies in 1801. The academy at Portsmouth was established in 1733 to train boys as officers, but its program was often judged inferior to training at sea. It became the Royal Naval College in 1806, with a later focus on naval architecture, and stopped training youth in 1837. — EH

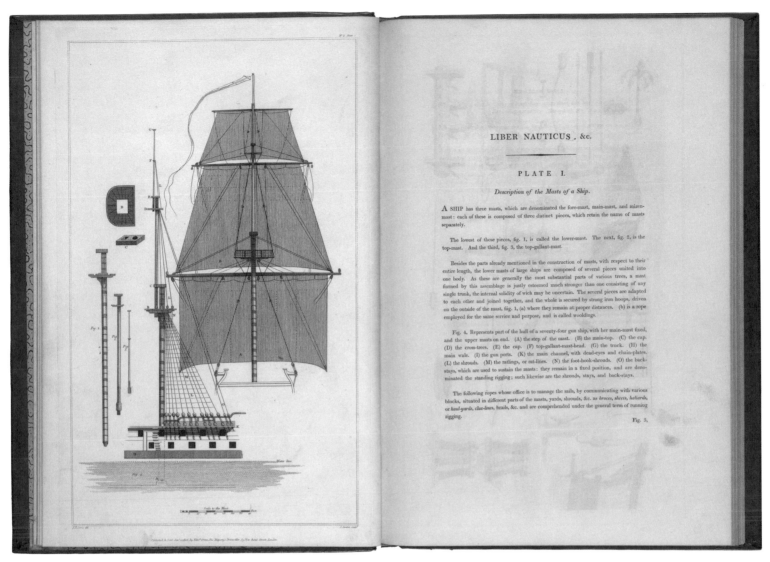

81

81

John Thomas Serres (1759–1825) and Dominic Serres (1719–1793)

Liber Nauticus and Instructor in the Art of Marine Drawing

London: Edward Orme, 1805–06
Yale Center for British Art, Paul Mellon Collection,
L 345 (Folio A)
Shown: Plate 1

THE MARINE PAINTER John Thomas Serres assembled the *Liber Nauticus* (Book of Seafaring) after the death of his more celebrated father in 1793; the title echoes Claude Lorrain's *Liber Veritatis* (Book of Truth), of 1635. According to Alan Russett, author of monographs on both Dominic and J. T. Serres, the *Liber Nauticus* was intended to be "a handbook for artists and connoisseurs (or 'amateurs' in contemporary parlance)," and it offered illustrated examples for that purpose. The younger Serres, unlike his father, had worked as a professional drawing master, and he supplied seventeen engraved instructional plates, with minimal commentary, for the *Liber*'s "Part First." "Part Second" comprises twenty-four plates after drawings his father had done much earlier "expressly for the instruction of a Nobleman," by whose permission they were reproduced, also with minimal captioning. Many of these replicated elements of Dominic's more general painting output. As Russett observes, "Analytical and instructive books had been published previously, but this was the first dedicated to marine art and its appearance demonstrated the prevalence and popularity the genre had achieved by the turn of the century."[1] The fact that J. M. W. Turner subsequently published an engraved *Liber Studiorum* of his own work (1806–19), including "Marine" as one of its categories, may indicate more than just his own admiration for Claude: when he first occupied 64 Harley Street as a studio in 1799, he shared two upper rooms there with J. T. Serres (until 1802). — PvDM

1. Russett, *Dominic Serres*, 197.

82

John Thomas Serres (1759–1825)

The Start Point, North East by North

ca. 1799
Watercolor, graphite, and pen and ink on paper
Sheet: 3 ⅛ x 10 ¼ in. (7.9 x 26 cm);
image: 2 x 9 ¼ in. (5.1 x 23.5 cm)
Yale Center for British Art, Paul Mellon
Collection, B1975.4.1589

82

83

John Thomas Serres (1759–1825)

The Bolt Head, West North West

ca. 1799
Watercolor, graphite, and pen and ink on paper
Sheet: 3 ⅛ x 10 ½ in. (7.9 x 26.7 cm);
image: 2 x 9 ¼ in. (5.1 x 23.5 cm)
Yale Center for British Art, Paul Mellon
Collection, B1975.4.1590

83

84

John Thomas Serres (1759–1825)

Dunnose, West by North

ca. 1799
Watercolor, graphite, and pen and ink on paper
Sheet: 3 x 10 ¼ in. (7.6 x 26 cm);
image: 2 x 9 ¼ in. (5.1 x 23.5 cm)
Yale Center for British Art, Paul Mellon
Collection, B1975.4.1591

84

85

John Thomas Serres (1759–1825)

Dover Castle, North East, ½ North

ca. 1799
Watercolor and graphite on paper
Sheet: 3 x 10 ⅜ in. (7.6 x 26.4 cm);
image: 1 ⅞ x 9 ¼ in. (4.8 x 23.5 cm)
Yale Center for British Art, Paul Mellon
Collection, B1975.4.1592

PROVENANCE: (cats. 82–85) H. Storey,
from whom bt by Paul Mellon, 1966

85

86

John Thomas Serres (1759–1825)

The Little Sea Torch

London: Published for the Author by J. Debrett, 1801
Yale Center for British Art, Paul Mellon Collection, L 344 (Folio A)
Shown: Plate 4

IN 1799 JOHN THOMAS SERRES was commissioned by the Admiralty "to go out in one of the ships from Plymouth for the purpose of taking views of Brest and the environs and to continue at sea." Brest, the main base for the French fleet at the entrance to the Channel, was a focus of British strategic efforts to hinder the French navy during the Revolutionary War, and yet very little intelligence on the region was available to the Admiralty: "It is somewhat extraordinary," noted the First Secretary to the Admiralty Board, "that . . . there is not one view of that port or any part of the coast in its vicinity to be found in this or any other of the public offices, though every possible search has been made, and . . . views of that description give landsmen a better idea than the best constructed charts."[1] Coastal profiles were part of officer training at the Naval Academy in Portsmouth and were mentioned in instructions issued by the Admiralty to those sailing on enemy coasts: "where there shall be Artists on board sufficiently qualified, you are to add Drafts or Plans, for the better illustration of the above particulars with proper References and Explanations."[2] They were based on careful measurements, with vertical scale in general and landmarks in particular exaggerated to increase visibility and allow for more detail.

These profiles of landmarks on the south coast of England (cats. 82–85) appear to have served as the basis for those published in *The Little Sea Torch* (cat. 86), a translation of an earlier work, *Le petit flambeau de la mer* (1684), by Le Sieur Raulin Bougard. The original was a pocket-sized aid to navigation illustrated with woodblock prints. *The Little Sea Torch* is illustrated with twenty plates of coastal profiles and twelve plates of charts, engraved by J. Stadler after Serres's drawings, although Stadler also acknowledges two naval captains "for the honor

of their communications, and the use of their drawings."[3] Serres's work for the Admiralty was incorporated into Hydrographic Office charts, some of which were not superseded until the late nineteenth century. —EH

1. Quoted in Barritt, *Eyes of the Admiralty*, 17.
2. Barritt, *Eyes of the Admiralty*, 22.
3. Barritt, *Eyes of the Admiralty*, 113.

86

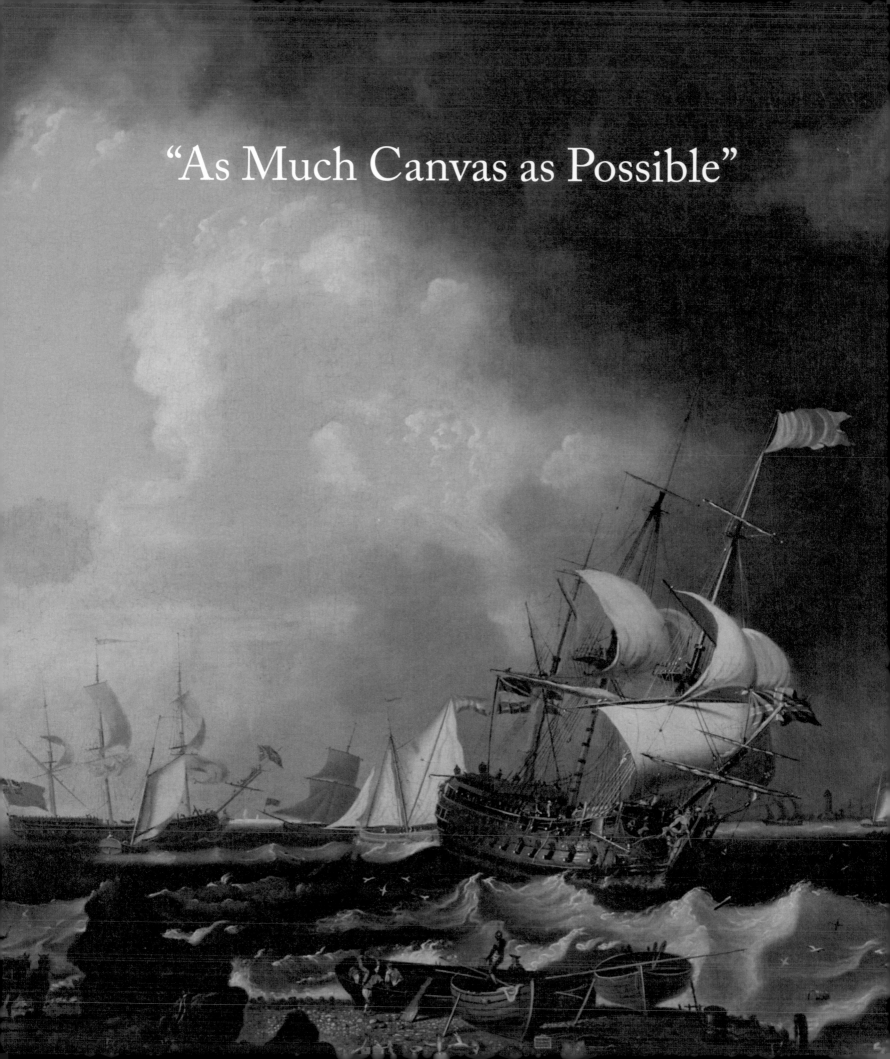

"As Much Canvas as Possible"

MARINE PAINTINGS EXHIBITED

Though it may be very laudable to put to fight three sail . . . and take two, as the chronological catalogue of the Royal Academy sets forth; yet it is surely too much to give one event three times over in aqua-historic painting . . . to shew that the Captain of an English frigate was employed in fighting from sun-rise to ten o'clock at midnight! As the frigate . . . is said . . . to have borne down upon her . . . enemy with a press of sail, it may account for the artist having spread as much canvas as possible to exhibit her various manoeuverings upon!

—*Morning Herald and Daily Advertiser*, May 19, 1783

ANNUAL EXHIBITIONS at public institutions in London, beginning with the Society of Arts in 1760, provided a new and competitive arena for contemporary artists, including marine painters. The naval aspects of Britain's involvement in the Seven Years' War (1756–63) provided subject matter for the works shown at these early exhibitions and during the first years of the Royal Academy, founded in 1768, where marine painters exhibited prolifically. Their works appeared alongside portraits, landscapes, and the emerging genre of modern history painting. From 1779 the naval and artistic spheres drew closer when the Royal Academy occupied premises at Somerset House, where the Admiralty had its administrative offices. The Academy was well established as the official center for the exhibition of art in London by the mid-1780s, when the annual number of marine paintings exhibited reached its peak with views of naval engagements of the American Revolution.

With the first exhibitions came press criticism, which revealed the extent to which public exposure raised the stakes for marine paintings, posing the question of their position in a hierarchy of genres that privileged the human figure. At the same time, marine paintings, particularly at the Royal Academy, represented activities of national interest in a way that no other genre did, contributing to a public discourse on cultural and imperial ascendance.

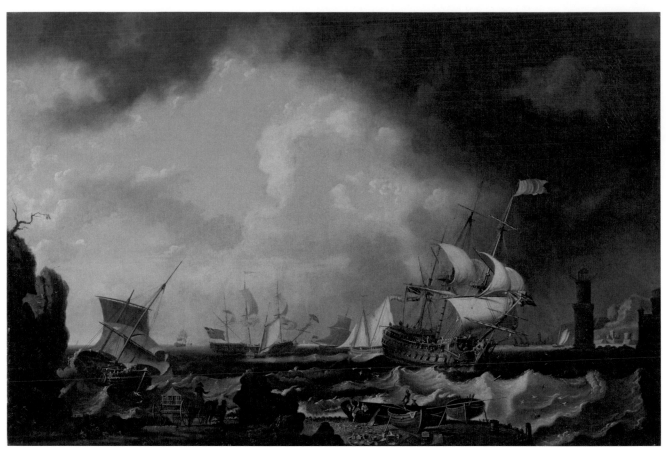

87

87

Richard Wright (1735–1775)

The Fishery

1764
Oil on canvas
35½ x 53 in. (90.2 x 134.6 cm)
Yale Center for British Art, Paul Mellon Collection,
B1981.25.723a

PROVENANCE: Sotheby's Nov. 23, 1966 (42), from
whom bt by Paul Mellon through P & D Colnaghi

LITERATURE: Edwards, *Anecdotes of Painters*, 48;
Ellis Waterhouse, *The Dictionary of British 18th
Century Painters in Oils and Crayons* (Woodbridge,
UK: Antique Collectors' Club, 1981), 430; Sarah
Monks, "Fishy Business: Richard Wright's *The
Fishery* (1764), Marine Painting, and the Limits of
Refinement in Eighteenth-Century
London," *Eighteenth-Century Studies* 41 (Spring
2008): 405–421; Alex Kidson, *Earlier British
Paintings in the Walker Art Gallery and Sudley
House* (Liverpool: Liverpool Univ. Press, 2012),
298, fig. 123

THIS WORK, Wright's best known, was completed in response to a call for submissions "for the best original Painting of a Sea Piece" by the Society for the Encouragement of Arts, Manufactures and Commerce, known as the Society of Arts. *The Fishery* took the first premium in that competition in 1764 and was subsequently engraved by William Woollett. The print, executed as a reverse of Wright's painting, circulated internationally. According to Sarah Monks, of fifteen identified painted variations of the theme, only the present example has dimensions that match exactly the size specified by the society in its competition announcement; it is now believed to be the prize-winning work.

Wright's composition, with the cart prominently labeled "Fish Machine" advancing toward the water, has long been understood to acknowledge the Society of Arts' failed "Land-Carriage Fish Scheme," designed by John Blake and based in Liverpool, to supply Londoners with fresh fish at low cost by bringing live fish from the coast in water-filled carriages. Other elements in the painting, including the transposition of this specifically English enterprise to a Mediterranean setting, are less easy to decipher. The subject evidently presented Wright with compositional difficulties, most apparent in the awkward passage from foreground to middle ground, so that the British man-of-war appears to be on a collision course with the shore. Three fishing boats are drawn up on the pebbly beach, their paltry catch fanned out in front of them and their crews sitting idly; their catch would in no way fill the carriage in keeping with the distribution scheme. All the elements of *The Fishery*—the storm, the men-of-war, the Mediterranean coast, the fisherman—are familiar tropes of eighteenth-century marine painting. However, it is their combination in one canvas, though not seamless, that likely earned Wright the "best original Painting" premium. Through circulation of the print, his composition was viewed by thousands. —SL

88

Samuel Scott (1701/2–1772)

A View of the Tower of London, Supposed on His Majesty's Birthday

1771
Oil on canvas
39 ¾ x 76 in. (101 x 193 cm)
Yale Center for British Art, Paul Mellon Collection,
B1976.7.147

PROVENANCE: Lottery sale, Mr Gydes Great Room, Bath, Dec. 4, 1772; Studio Sale, January 13, 1773 (101); The Hon. G. R. Vernon; Agnew's, 1906; Walter S. M. Burns; Knoedler's, 1927; Sir Harald Peake; Sotheby's, March 24, 1965 (91), from whom bt by P & D Colnaghi for Paul Mellon

EXHIBITIONS: RA 1771 (179); BFAC 1926 (17); Guildhall 1965 (18); YCBA 1977–78 (23)

LITERATURE: Whitley, *Artists and Their Friends*, 205; Kingzett, "Catalogue of Works of Samuel Scott," 51–52; Markman Ellis, "River and Labour in Samuel Scott's Thames Views in the Mid-Eighteenth Century," *London Journal* 37, no. 3 (Nov. 2012): 155–56

SIGNED AND DATED 1771, this painting is the last of five versions, of which the earliest was produced in 1746 (private collection). Scott exhibited only sporadically at the Society of Artists in the 1760s; this is the only painting he exhibited at the Royal Academy, in the year before his death. The view is taken from Bermondsey, on the south bank of the Thames, looking across to the Tower of London. Immediately to the left of the mast in the foreground is the Monument to the Great Fire of London, and to its left, St. Paul's Cathedral. The vessel in the foreground is a Dutch galliot, about to take on a cargo that includes barrels, bales, and jars. The naval frigate moored alongside the Tower fires a salute in recognition of the king's birthday, likewise acknowledged by the Royal Standard flown from the White Tower.

The image thus realizes the vision of London, and by extension of Britain, suggested in Scott's riverine sketches (cats. 60–63): a confluence of church, state, crown, and commerce. The part of the river shown here is the Pool of London, the area below London Bridge, lined with wharves and quays, where all cargo entering the Port of London was unloaded and inspected. The density of shipping in the Pool became a potent image of the volume and extent of British commerce throughout the eighteenth century. In his *Tour thro' the Whole Island of Great Britain* (1727), Daniel Defoe estimated that the Pool contained over two thousand vessels "of all sorts, not reckoning Barges, Lighters or Pleasure-Boats, and Yachts; but of Vessels that really go to Sea."[1] Lydia Melford, a character in Tobias Smollett's *The Expedition of Humphrey Clinker*, published in the same year that Scott's painting was exhibited, comments that "the whole surface of the Thames is covered with small vessels, barges, boats, and wherries, passing to and fro; and below the three bridges, such a prodigious forest of masts, for miles together, that you would think all the ships in the universe were here assembled."[2] The Pool's inadequacy for the volume of commerce led at the turn of the nineteenth century to construction of the West and East India Docks, which drastically reduced the time it took to discharge cargo and enabled ships to make more trading voyages within a given season. — EH

1. Daniel Defoe, *A Tour thro' the Whole Island of Great Britain . . . ,* 2 vols. (London: Cass, 1968), 1:349–50.
2. Tobias Smollett, *The Expedition of Humphrey Clinker* (Oxford: Oxford Univ. Press, 1984), 90–91, cited in Ellis, "River and Labour," 157.

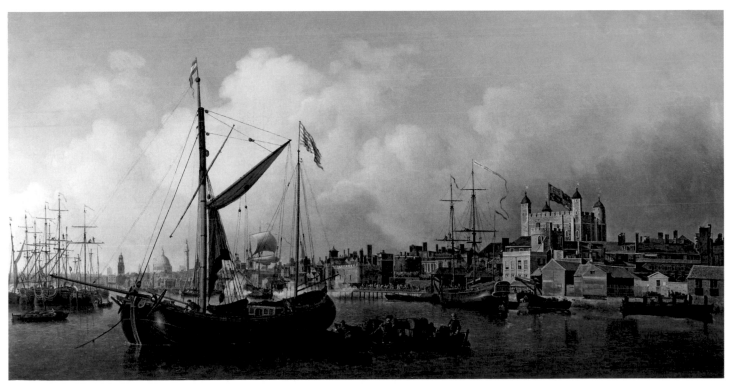

88

89

William Daniell (1769–1837)
after George Dance (1741–1825)

Dominic Serres

between 1808 and 1814
Graphite with red pencil on paper
Sheet: 9 ⅝ x 7 ½ in. (24.4 x 19.1 cm)
Yale Center for British Art, Paul Mellon Collection,
B1977.14.4190

PROVENANCE: Gerald M. Norman Gallery, from
whom bt by Paul Mellon, 1974

GEORGE DANCE drew Serres's profile on March 11, 1793, as part of a series of portraits of Royal Academicians. William Daniell later engraved and published the series, and this drawing is the copy he made in preparation for engraving.[1] Born in France in 1722, Serres received a classical education at the English Benedictine college in Auch, but went to sea to avoid the priesthood. Working on trading vessels, he traveled in the Mediterranean, where he produced early views, and crossed the Atlantic to Havana. While serving on a Spanish ship during the War of the Austrian Succession, he was captured by the English and spent time in prison in London. He ultimately married an Englishwoman and established himself as a painter of landscapes and marine views.[2]

The Seven Years' War brought a demand for views of engagements, particularly during the *annus mirabilis* of 1759, which saw naval victories at the battles of Lagos and Quiberon Bay. Serres exploited this demand both by producing paintings and by associating himself with print publishers who could disseminate his work. He began exhibiting at the Society of Arts in 1761 and with the Society of Artists of Great Britain in 1765. In the same year he moved to Golden Square, a neighborhood popular with artists; his circle of friends included Paul and Thomas Sandby, who brought him into contact with patrons. Serres was one of the founding members of the Royal Academy (1768) and, adept at languages, became its librarian in 1792.[3]

In addition to extensive naval commissions, Serres received a royal commission for paintings of the naval review of 1773, an occasion of great pomp, when George III visited the fleet at

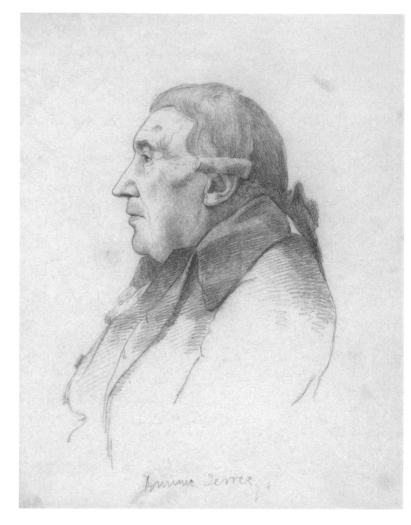

89

Portsmouth and Spithead. In 1780 Serres was appointed to the honorific position of marine painter to the king; in the same year he moved again, to a more exclusive address north of Hyde Park and next door to his close friend Paul Sandby. Throughout his professional life Serres appears to have been an avid collector of art: the posthumous sale of his collection included European old masters as well as works by his contemporaries, including Peter Monamy, Charles Brooking, and Samuel Scott. He also owned several hundred drawings by the Van de Veldes (see cat. 5) and would no doubt have known those owned by Sandby (cats. 11–12).
—EH

1. Russett, *Dominic Serres*, 212.
2. Meslay, "Dominique Serres," 289.
3. Edwards, *Anecdotes of Painters*, 215.

90

Dominic Serres (1719–1793)

The Taking of Chandernagore by the Admirals Watson and Pocock, March 1757

1771
Oil on canvas
45 x 72 in. (114.3 x 182.8 cm)
National Maritime Museum, Greenwich, London,
Greenwich Hospital Collection, BHC0378

PROVENANCE: Mrs. Leedham White

EXHIBITIONS: RA 1771

LITERATURE: Russett, *Dominic Serres*, 88–91

A FRENCH TRADING fort had existed at Chandernagore (today's Chandannagar), on the banks of the Hooghly River, since the late seventeenth century. By the middle of the eighteenth century,

90

it was the administrative center for French commercial activity in Bengal and posed a financial and strategic threat to the British establishment at Calcutta, barely twenty miles downriver. When the Seven Years' War broke out in 1756 between the two emerging global superpowers, Chandernagore was an obvious target. Its capture by British forces in March 1757 represented the first step in driving the French from Bengal and establishing British control over the province. By expelling the French from Chandernagore, Britain not only undermined their power in Asia but also destroyed their trade.[1]

A detachment of Royal Navy ships, under the command of Rear Admiral Charles Watson, led the assault. The surrender of the settlement followed a bombardment, depicted here, that lasted for ten days. The painting shows Watson's ships — the *Kent*, the *Tiger*, and the

Salisbury — firing on the fort and the surrounding town from an anchored position. The *Kent*, at center, with a couple of boats under its stern, is flying Watson's flag on the foremast. The red flag flying at the main is giving the signal to engage.[2]

Victory at Chandernagore was the prelude to an even more important British success in Bengal, when Robert Clive defeated the nawab, or local ruler, at the Battle of Plassey on June 23, 1757. These military conquests gave the British East India Company effective control of a province that in its "extent . . . and its possible resources" was, according to Warren Hastings, the first governor-general of Bengal, "equal to those of most states in Europe."[3] Events in Bengal in 1757 marked a key stage in the company's transformation from a trading corporation into a territorial empire. As the dominant European power in India, it was well placed to

take advantage of the weakening political and economic power of the Mughal Empire. — JM

1. Charles Rathbone Low, *History of the India Navy (1613–1863)*, 2 vols. (London: Richard Bentley, 1877), 1:138.
2. Daniel Baugh, *The Global Seven Years War, 1754–1763: Britain and France in a Great Power Contest*, 1st. ed. (Harlow, UK: Longman, 2011), 290–93. See also John Henry Grose, *A Voyage to the East Indies*, 2 vols. (London: S. Hooper, 1772), 2:255–58.
3. Warren Hastings to Court of Directors, East India Company, Nov. 11, 1773, in *Memoirs of the Life of the Right Hon. Warren Hastings, First Governor-General of Bengal*, ed. G. R. Gleig, 3 vols. (London: Richard Bentley, 1843), 1:368.

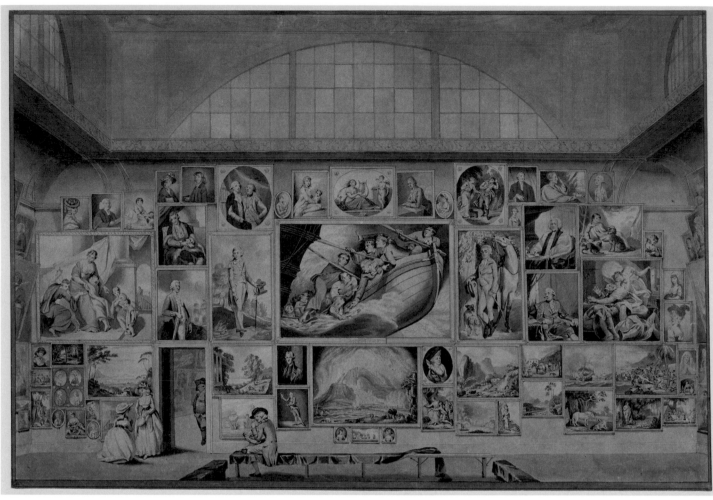

91

91

Edward Francis Burney (1760–1848)

West Wall, The Great Room, Somerset House

1784
Pen and ink, wash, and watercolor on paper
13 1/8 x 19 3/8 in. (33.5 x 49.2 cm)
British Museum, 19,040,101.10

PROVENANCE: Montague Guest, from whom purchased by the British Museum, 1904

EXHIBITIONS: RA 1951–52 (742); BM 1969 (4)

LITERATURE: Patricia Crown, "An Album of Sketches from the Royal Academy Exhibitions of 1780–1784," *Huntington Library Quarterly* 44 (Winter 1980): 65–66; Solkin, *Art on the Line*, 24–25, 83; Hughes, "Ships of the 'Line,'" 143, 148–50.

THE ROYAL ACADEMY exhibition of 1784 was remarkable for the number and prominence of marine paintings, many of which depicted the naval engagements of the recently ended American Revolution. The views of the Great Room in that year by Edward Francis Burney, who was then a student in the Royal Academy Schools, provide a unique record of the appearance of an early hang at Somerset House. They show marine paintings displayed alongside portraits, landscapes, and history paintings, several of them hung on the "line," with their bottom edge eight feet from the floor, where the most important paintings were placed for maximum visibility. Their placement highlights the vital ways in which the walls of the Academy served as a modern reflection of national and imperial concerns.

The arrangement of pictures on the west wall centered on James Northcote's modern history subject *Portraits Painted from Life, Representing Capt Englefield with Eleven of his Crew Saving Themselves in the Pinnace, from the Wreck of the Centaur, of 74 Guns, Lost Sept 1782.*[1] Below it is a small painting by Nicholas Pocock depicting an engagement between the *Fame* and "four large ships." Another painting by Pocock, a seascape of shipping in a gale, can be seen below the line at the right end of the wall, next to Johan Ramberg's painting of the death of Captain Cook in Kealakekua Bay. On either side of the doorway at left are paintings by Robert Dodd (cats. 92–93), one of which is being examined by a young woman who appears to be holding a copy of the exhibition catalogue (cat. 94). The seated figure on the bench, holding a sketchbook and pencil, is probably a self-portrait. — EH

———————————

1. See Christine Riding's essay in this volume.

92

Robert Dodd (1748–1815)

L'Amazone of 36 Guns, 301 Men, after an Hour and a Quarter's Engagement, Striking to His Majesty's Frigate *Santa Margarita* of 36 Guns, 255 Men, Elliott Salter Commander, on the Evening of the 29th July, 1782

ca. 1783

93

Robert Dodd (1748–1815)

The *Santa Margarita* Cutting Her Prize Adrift the Next Morning at Day-Break, on the Appearance of 13 Sail of the Enemy's Line of Battle Ships

ca. 1783

Oil on canvas
30 ½ x 48 in. (77.5 x 122 cm)
National Maritime Museum, Greenwich, London, Presented by Eric Miller through the Art Fund, BHC0449–0450

PROVENANCE: (cats. 92–93) Sir Eric Miller by whom given to the National Maritime Museum through the Art Fund, 1947

EXHIBITIONS: (cats. 92–93) RA 1784 (235, 8); (cat. 93) YCBA/Ashmolean 2012–13 (Ashmolean only)

LITERATURE: (cats. 92–93) Hughes, "Ships of the 'Line,'" 148–50

94

The Exhibition of the Royal Academy of Arts

1784

Beinecke Rare Book & Manuscript Library, Yale University, J437 R81E no. 16 (1784)

THIS PAIR OF PAINTINGS by Robert Dodd can be seen in E. F. Burney's watercolor view (cat. 91) as they were displayed at the Royal Academy exhibition of 1784 and listed in the catalogue that accompanied it. Captain Elliot Salter, who commanded the *Santa Margarita*, described the action in a letter to the Admiralty that was published in both the *Universal Magazine* and the *London Magazine* for September 1782. On the morning of July 29, 1782, the *Santa Margarita*, cruising near the entrance to the Chesapeake Bay in Virginia, gave chase to a sail that proved to belong to a French frigate of equal force to its own, "but perceiving eight large ships bearing down for us under a great crowd of sail, two of which at no great distance, after consulting my officers, I . . . stood from her to the Northward, having not only an enemy but a lee-shore to encounter." A lee shore is a coast downwind from the ship, onto which the ship is thus in danger of being blown; to avoid any appearance of "shyness," Salter was making it clear that he was in no position to stand and fight, being outnumbered and in a difficult sailing position.

A French frigate then chased the *Santa Margarita* until both were out of sight of the enemy squadron, at which point "it was judged proper to tack and stand after her." A fierce fight ensued:

> At five o'clock, being within a cable's length of each other, she with her starboard and we with our larboard tacks on board, she opened her fire and gave us her broadside . . . : we reserved our fire till an opportunity offered to rake her . . . , which was effected with a well-directed fire from our starboard guns; then gradually closed each other within pistol-shot, keeping her on our starboard beam; and the action was continued in this manner warmly, on both sides, for an hour and quarter, when she struck her colours, and proved to be L'Amazonne [*sic*], mounting 36 guns, (long 12 and 6 pounders) and carrying 301 men commanded by the Viscomte de Montguiote, who was killed in the early part of the action.

Dodd's first painting shows the French ship in broadside view, its sails and rigging heavily damaged, and the English ship in three-quarter view, still firing. The sailors on board *L'Amazone* are raising the white flag of surrender and beginning to take in its damaged sails. Salter took possession of *L'Amazone* by sending over a lieutenant and a third of his crew, and he began transferring the French crew, now prisoners, to the *Santa Margarita*, all with only one boat. At the same time Salter's crew worked to repair the damage to both ships so they could avoid the French forces just over the horizon, which, the crew of *L'Amazone* assured him, consisted of thirteen warships, plus frigates. Salter, forced to take the French ship in tow because of its condition, sailed throughout the night in hopes of evading the other French ships. The following morning, however, Salter found himself in a potentially disastrous situation:

> By break of day we plainly discerned the whole fleet following us under a crowd of sail. I immediately recalled my officers and men on board, cut the hawser, and set adrift my boat, not being able to hoist her in, and abandoned the prize, after having ordered the remains of her fore rigging to be cut away. Had time and circumstances permitted me to have shifted all the prisoners, I should have ordered her to have been burnt, to prevent her being retaken by the enemy.[1]

Dodd's second painting depicts the remarkably tense moment of the *Santa Margarita*'s escape. Leaving the crippled *L'Amazone*, the *Santa Margarita* virtually strains to get away from the French fleet appearing to the left of the canvas; sailors visible in the rigging work to set all the tattered canvas that can be mustered, while the crew on deck looks anxiously astern.

Depicting an action in sequential pairs or longer series was an alternative to compressing events into a single canvas — both solutions to the problem of representing events that span time and space. Dozens of paired marine paintings were displayed at the Royal Academy in the eighteenth century, often depicting the beginning and end of an action; two further pairs were shown at the exhibition of 1784 alone. The numbering of the works in the catalogue began at the doorway into the Great Room and proceeded clockwise around the room; Dodd's pair, hanging on either side of the doorway so that the sequence of events took place from left

92

to right, was therefore listed in reverse order in
the catalogue, as numbers 235 (cat. 94b) and
8 (cat. 94a). Whereas titles for portraits and
landscapes were perfunctory, those for marine
paintings depicting engagements invariably
included the names of the ships, their captains,
and details of the events. The degree to which
titles dominated the pages of the catalogue
did not go unremarked by critics: "Mr Serres
endeavours to make us remark his shipping,
by filling half the side of the catalogue with a
long detail of whence they came, whither they
were going, and what they are laden with; but
it all will not do."[2] Salter's account, however,
demonstrates that even those detailed titles
reduced the actions to a few statistics regarding
guns and men, failing to convey the multitude
of factors impinging on the outcome of any
engagement. — EH

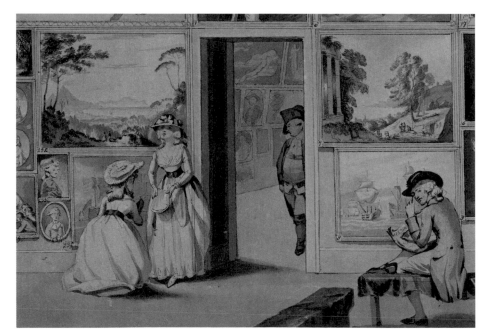

91 (DETAIL)

1. *Universal Magazine* 71, pt. 2 (1782): 172–73;
 London Magazine 51 (1782): 442–43.
2. *Universal Daily Register*, May 9, 1785, 2.

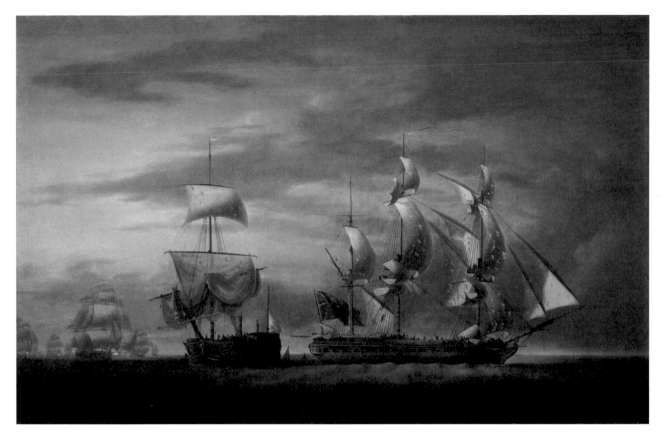

93

A

CATALOGUE.

☞ The PICTURES are numbered as they are placed in the Room. The First Number over the Door.

The PICTURES, &c. marked (*) are to be disposed of.

R. A. Royal Academician.

A. Associate.

H. Honorary.

1	PORTRAIT of a nobleman	J. Northcote
2	Portrait of a gentleman	J. Zoffany, R.A.
3	Portrait of a lady	J. Stewart
4	Portrait of a Westminster scholar	J. F. Rigaud, R.A. elect
5	Portraits of two gentlemen, half-length	B. Vandergucht
6	Portrait of a nobleman's son	J. Hopner
7	Landscape	S. Delane
8	The Santa Margarita cutting her prize adrift the next morning at day-break, on the appearance of 13 sail of the enemy's line of battle ships	R. Dodd
9	* Mr. Parson's as Sir Fretful Plagiary in the Critic	J. Alefounder
10	Portrait of a boy, crayons	J. Scouler
11	Engagement between the Fame privateer of Dublin and four large ships from Marseilles	N. Pocock
12	Portrait of a girl, crayons	J. Scouler
13	Medora and Angelica, from Ariosto	Mary Moser, R.A.
14	Portrait of a lady	Sir J. Reynolds, R.A.
15	The great eruption of Mount Vesuvius, in which the elder Pliny lost his life	—— Moore

[10]

209	A hunter	J. N. Sartorius
210	The action between La Magicienne of 32 guns, Capt. Greaves, and La Sybille of 36 guns	D. Serres, R.A.
211	The blind veteran	J. H. Ramberg
212	View of Lows-water in Cumberland	P. J. De Loutherbourgh, R.A.
213	* Landscape	A. Peiber
214	Portrait of a gentleman	F. Wheatley
215	Portrait of a lady, half-length	N. Hone, R.A.
216	Portraits of two children	J. Opie
217	Portrait of a lady	S. H. M. Howell
218	Portrait of a gentleman	Sir J. Reynolds, R.A.
219	Portraits of an old lady, aged 102, and her grand-daughter's daughter	J. Russell, A.
220	Portrait of a lady of quality, crayons	J. Russell, A.
221	Portrait of a lady	Elizabeth Carmichael
222	Portrait of a clergyman	J. Nixen, A.
223	Portrait of a child	R. M. Paye
224	Cornelia on her childrens coming in from school, replying to the lady who had boastingly displayed her jewels, These are the jewels of a mother—— Valerius Maximus	P. Hoare
225	Portrait of a lady	A young lady, H.
226	A family, in crayons	J. R. Smith
227	Portrait of a gentleman	T. Maynard
228	Portrait of a student, crayons	W. Palmer
229	Portraits of a lady and children	J. K. Sherwin
230	Four portraits in a frame	T. Powell
231	A landscape	A Gentleman, H.
232	Morning, view of Naples	T. Jones
233	Portrait of a lady in crayons	C. Borckhardt
234	Portrait of a gentleman	S. Hewson
235	L'Amazonne of 36 guns, 301 men, after an hour and a quarters engagement, striking to his Majesty's frigate Santa Margaritta of 36 guns, 255 men, Elliot Salter commander, on the evening of the 29th of July, 1782.	R. Dodd

MINIATURES,

94a 94b

95

95

Julius Caesar Ibbetson (1759–1817)

A Married Sailor's Adieu

ca. 1800
Oil on canvas
6 ¾ x 10 in. (17.1 x 25.4 cm)
Yale Center for British Art, Paul Mellon Collection,
B1977.14.60

PROVENANCE: Spink & Son, Ltd., from whom bt by
Paul Mellon, 1975

LITERATURE: Rotha Mary Clay, *Julius Caesar
Ibbetson* (London: Country Life, 1948), 47, pl. 57;
James Mitchell, *Julius Caesar Ibbetson (1759–1817):
"The Berchem of England"*, exh. cat. (London: John
Mitchell and Son, 1999), 37–38

IBBETSON, son of a Yorkshire clothier, was well
educated but largely self-taught as a landscape
and genre painter and occasional portraitist.
He was popular but never very prosperous,
despite gaining influential patrons and enjoying
a thirty-year history of exhibition at the Royal
Academy, beginning in 1785. He also had seafar-
ing experience, having accompanied Colonel
Charles Cathcart's uncompleted embassy to
China in 1787–88 as a draftsman. Sailors ashore
or at the interface of land and sea were among
his social history subjects, which included the
popular themes of their departure and return.
Other examples are the watercolor *Sailor's
Farewell* (Yale Center for British Art, New Haven)
and a pair of oils showing the return of a married
and an unmarried seaman (Tate). That pair was
exhibited at the Royal Academy in 1800 as part
of a quartet, though the four pictures were not
hung together. The others in the group were *An
Unmarried Sailor Shipwrecked* and *A Married
Sailor's Adieu*, all apparently intended as a
pictorial "lecture upon Nautical Domestic life."[1]
The present picture is probably too small to have
been that *Adieu*, though on the same theme,
since the two in Tate (both nominally 18 by 24
inches) suggest the four were a matching set.[2]

This canvas was previously called *A Sailor
Boy's Departure*, identifying the woman as a
mother parting from her eldest son rather than
a wife with three children (and possibly another
on the way) from husband and father.[3] However,
the latter seems more likely given that the ages
of the corresponding figures in Tate's "married
sailor's return" appear similar. Those shown here
are a respectably dressed family group, and the
vessel is a merchantman, so the man joining
it is perhaps of more authority and substance
than a common sailor. The scene is probably
in the lower Thames, since the hired boat is
a four-oared Thames wherry, with a spritsail
rigged for making extended passage in breezy,
open waters, as a similar boat is doing in the
background. A Thames waterman sits waiting
in the bow, with his right arm crooked on his
knee, bringing his official silver shoulder badge
into view. The departing man's sea chest and
his hammock, wrapped around bedding, are
being hoisted on board from above, alongside
the ship's belfry. The belfry appears oddly out of
scale and skewed in relation to the hull, to give
full prominence to the over-large bell. Perhaps
this is to suggest the months of watches the bell
will mark during the seaman's absence — or
that, given the risks of his calling, he may never
return. — PVDM

1. Clay, *Ibbetson*, 47.

2. The cited modern measurements are fractionally
 variant from distortion and relining.

3. Mitchell, *Ibbetson*, 38.

96

Julius Caesar Ibbetson (1759–1817)

Sailors Carousing

undated
Pen and ink and gray wash on paper
11 ⅞ x 16 ⅜ in. (30.2 x 41.6 cm)
Yale Center for British Art, Paul Mellon Collection,
B1977.14.4328

PROVENANCE: Sabin Galleries, Ltd., from whom bt
by Paul Mellon, 1974

LITERATURE: Rotha Mary Clay, *Julius Caesar Ibbetson* (London: Country Life, 1948), 48, 58; James Mitchell, *Julius Caesar Ibbetson (1759–1817): "The Berchem of England"*, exh. cat. (London: John Mitchell and Son, 1999), 74

SAILORS normally went to sea in boyhood (by about age thirteen) and were regarded, not least by themselves, as a race apart. As Thomas Trotter, a Royal Naval surgeon of the period wrote, they learned to endure

> the fatigues and perils of sea life . . . with a degree of contempt at danger and death that is met with nowhere else, and has become proverbial. . . . Their pride consists of being reputed a thorough bred seaman and they look on landmen as beings of an inferior order . . . ; their money is lavished with the most thoughtless profusion; fine clothes for his girl, a silver watch and buckles for himself are often the sole return for years of labour and hardship.[1]

Ibbetson produced a small number of images showing naval "Jack Tars" ashore, and this drawing relates to one of his best-known oil paintings of their often riotous behavior there (*Sailors Carousing*, 1802, National Maritime Museum, Greenwich). William Ward's mezzotint from the oil (1807) was dedicated to the Duke of Clarence, later William IV, called the "sailor king" because he had been a naval officer. This undated drawing is similar to the oil, but less detailed. The scene may be of a "long room" (assembly room) at a Portsmouth or Plymouth inn. At lower left sailors use watches to play "conkers" (a children's game of breaking horse chestnuts on strings). Other watches, in the skillet on the floor, allude to an incident of 1762, when a captured Spanish treasure ship produced so much prize money that sailors were reported to have fried them.[2] A man in a cocked hat behind and to the right dances with a Jewish peddler, who would have been a familiar source of fripperies for seamen to lavish on wives, sweethearts, and (no doubt here) "ladies of the town." In the oil version, tobacco pipes, playing cards, and coins join the empty bottle in the foreground and the prone drinker, details reinforcing the connection with Dutch seventeenth-century low-life scenes. At center rear in the drawing is a lattice window, rather than the oil's plain opening; beyond it a carriage brings more men. Through the door at rear left a popular boatswain or boatswain's mate is borne in on shipmates' shoulders. The oil and print more clearly show the "call" (whistle for giving orders) on a chain round his neck. —PvDM

1. Thomas Trotter, *Medicina Nautica*, c.1800, repr. in *The Health of Seamen: Selections from the Works of Dr. James Lind, Sir Gilbert Blane and Dr. Thomas Trotter*, ed. C. Lloyd (London: Navy Records Society, 1965), 265–66.
2. Clay, *Ibbetson*, 48.

96

"The Hero Scrupulously Directs"

PAINTERS AND PATRONS

It is become almost the fashion for a sea officer, to employ a painter to draw the picture of the ship which he commanded in an engagement, and where he came off with glory; this is a flattering monument, for which he pays with pleasure. The hero scrupulously directs the artist in every thing that relates to the situation of his vessel, as well in regard to those with whom, as to those against whom he fought.

—Jean André Rouquet, *The Present State of the Arts in England*, 1755

MARINE PAINTINGS depicting naval engagements—whether full fleet battles or the more limited actions involving individual ships or squadrons—required an unusual degree of collaboration between the officers who commissioned them and the artists who produced them. The functioning of a ship depended to a large degree on the ability of its officers and crew to perceive and act upon visual cues, determining the location of the ship through observations and identifying the nationality, firepower, and sailing power of other ships. Naval commanders wished to see such details reflected in these paintings, which were required to give as complete a picture as possible of the circumstances of their victories.

Nicholas Pocock's surviving letters and sketches provide unparalleled evidence of these interactions. They help to reveal a balance struck between accuracy and artistic agency in Pocock's finished works that can be traced throughout his career, first as a merchant sea captain and eventually as a prolific exhibitor at the Royal Academy and a founding member of the Society of Painters in Water Colours. One of Pocock's patrons was Edward Hawke Locker, whose patronage and collecting, like that of his father, William Locker, can be traced through evidence of the arrangement of pictures in his private collection and through the National Gallery of Naval Art that he founded at the Royal Hospital for Seamen at Greenwich, known as Greenwich Hospital.

97

Nicholas Pocock (1740–1821)

Logbook of the *Lloyd*, Kept on a Voyage from Bristol to South Carolina

1767
National Maritime Museum, Greenwich, London, LOG/M/72
Shown: pages 16–17

98

Nicholas Pocock (1740–1821)

Logbook of the *Lloyd*, Kept on a Voyage from Bristol to South Carolina

1768
National Maritime Museum, Greenwich, London, LOG/M/28
Shown: pages 17–18

99

Nicholas Pocock (1740–1821)

Logbook of the *Betsey*, Kept on a Voyage from Bristol to the Mediterranean

1770
National Maritime Museum, Greenwich, London, LOG/M/3
Shown: pages 24–25

PROVENANCE: (cat. 97) Presented by the artist to Richard Champion, by descent to Phyllis Rawlins, from whom acquired by NMM; (cat. 98) Presented by the artist to Richard Champion, by descent to Mrs. Robert Rawlins, from whom acquired by NMM; (cat. 99) Presented by the artist to Richard Champion, by descent to Mrs. Kate Rawlins, from whom acquired by NMM

EXHIBITIONS: (cat. 97) YCBA/NMM 1987 (26)

LITERATURE: Cordingly, *Nicholas Pocock*, 18–37; (cats. 97–98) Minchinton, "Richard Champion," 97–103; (cat. 99) Hughes, "Trade and Transport," 35

THESE ARE THREE OF SIX logbooks that Nicholas Pocock presented to his employer, Richard Champion.[1] Pocock used them to document the trading voyages he undertook as master of various ships Champion owned. As was standard practice, every two hours he recorded the vessel's speed (in knots), its course, and the wind direction. Less usual is Pocock's consistent use of the space ordinarily reserved for comments about the weather and any noteworthy incidents to make drawings of the ship, flora and fauna, and coastal profiles. Such drawings involve varying degrees of accurate observation and delineation, on the one hand, and artistic convention, on the other: the drawings of the ship are based

98

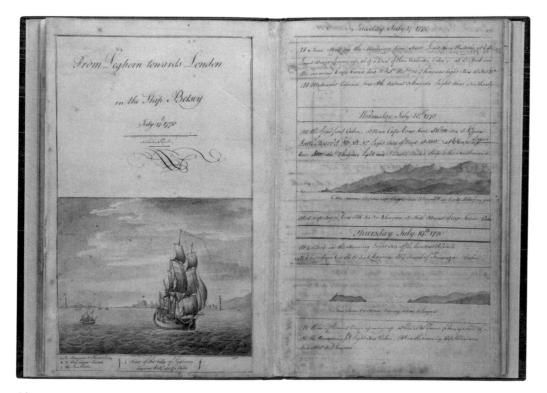

99

on a working knowledge of its parts and on traditions of depiction, while the studies of fish and birds clearly reflect firsthand observation. The coastline profiles indicate that Pocock had some training in drawing for navigational purposes. Such images were produced by taking careful measurements but introducing some exaggeration of vertical elements to make details more legible (see cats. 82–86).[2]

The first log (cat. 97) records a voyage from Bristol to Charleston, South Carolina. The *Lloyd*, a three-masted West Indiaman of about 150 tons burden (cargo capacity), left Bristol on June 21, 1767, with a crew of thirteen and arrived in Charleston on August 8. It began its homeward voyage on September 17, arriving at Bristol on November 4. The second log (cat. 98) records two further voyages on the same route in 1768. On his outbound voyages Pocock carried an array of manufactured products (textiles, ceramics, shoes, saddles, bridles, tinware), and he brought back cargoes of rice, turpentine, skins, and hemp. In 1770 he undertook a single trading voyage to the Mediterranean for Champion in the *Betsey*, a venture that proved particularly arduous (cat. 99). His drawing shows the *Betsey* in the harbor of Leghorn (Livorno), the major entrepôt on the west coast of Italy. Between 1771 and 1776 he made six voyages to the West Indies, also documented in three logbooks.[3] Like his voyages to Charleston, these were part of the ancillary trade supporting the sugar and slave economy of the West Indies and were brought to an end by the American Revolution. — EH

1. The other three logbooks are at the National Maritime Museum, Greenwich; the Bristol Records Office; and the Mariners' Museum, Newport News, VA.

2. For further discussion of the logbooks and Pocock's letters to his employer, see Eleanor Hughes's essay in this volume.

3. The Bristol Records Office logbook documents two voyages to Dominica on the *Lloyd*, in 1771–72; that at the Mariners' Museum, Newport News, covers three voyages on the *Minerva* in 1772–76. A recorded seventh logbook, now unlocated, covers a single voyage on the *Minerva* to Nevis and St. Kitts in 1776.

La Cigale from S.ᵗ Domingo. Le Compte D'Artois From the East Indies. S.ᵗ INNIS, Spanish Frigate from MANILLA Le Cantabre, from Martinique

THE RANGER PRIVATE SHIP OF WAR WITH HER PRIZES

N Pocock F. 1780

100

100

Nicholas Pocock (1740–1821)

The *Ranger*, Private Ship of War, with Her Prizes

1780
Pen and black ink over graphite with gray wash on paper
18 ⅛ x 23 ¾ in. (46 x 60.3 cm)
Yale Center for British Art, Paul Mellon Collection, B1977.14.4371

PROVENANCE: In the possession of Dr. F. H. H. Guillemard in 1930; The Parker Gallery, from whom bt by Paul Mellon, 1966

EXHIBITIONS: YCBA/Ashmolean 2012–13 (YCBA only)

LITERATURE: Hughes, "Trade and Transport," 42; Sánchez-Jáuregui and Wilcox, *The English Prize*, 167–68, cat. 4

DURING THE first two decades of his practice as an artist, while he was working as a mariner and captain, Pocock made numerous portrait drawings of ships in pen and ink and gray wash. This particularly fine example shows the *Ranger*, an American-built, Bristol-based privateer: a private ship of war with a license, known as a letter of marque, that gave its owners the sole right to the proceeds from enemy vessels and goods taken as prizes. Here the *Ranger* is shown in the center of the composition with its prey: from left to right, the *Cigale*, taken off Bristol en route to Nantes in October 1778; the *Comte d'Artois*, taken in April 1779; the huge Manila galleon *Santa Inés* (here called the "St. Innis" and seen towering over the *Ranger*), a highly lucrative capture made in August 1779 in the company of a Liverpool privateer; and the *Cantabre*, taken in late 1779. Pocock undoubtedly made drawings of the prizes as they were brought into Bristol and composed this imaginary grouping from the individual portraits.

The coat of arms below the image is that of James Rogers, co-owner (with Henry Garnett) of the *Ranger*, who presumably commissioned this portrait as well as a number of others from Pocock.[1] Rogers was a Bristol slave merchant, owning vessels that exported manufactured goods to West Africa in exchange for enslaved people, the majority of whom were taken across the Atlantic to work on West Indian and North American plantations producing sugar, cotton, and tobacco. For the first half of the eighteenth century, Bristol had rivaled and surpassed Liverpool and London as a slaving port, though Liverpool later took the lead; much of Bristol's wealth was based on the slave trade and related commerce with the colonies. The Society of Merchant Venturers, of which Pocock's employer, Richard Champion, was a member, lobbied at

FIG. 109. Nicholas Pocock, *The* Southwell *Frigate*, ca. 1760, graphite, pen and ink, and gray wash on paper. Bristol City Museum & Art Gallery

court and Parliament to protect the interests of the trade. Between 1758 and 1782, Pocock's time in Bristol, the city's ships undertook eighty-one voyages to Africa, bringing over 22,000 slaves to the Americas.[2] Rogers managed fifty-one such voyages between 1783 and 1792.[3]

Bristol residents were implicated in the slave trade even if not directly involved. As the *Ranger* commission suggests, Pocock, too, profited. One of his earliest known works, from around 1760, is a portrait of the *Southwell*, which, like many others, served as a slave ship in peacetime and a privateer in war (fig. 109). It includes two panels depicting the trading of goods for slaves on the coast of Africa.[4] On the left, manacled Africans are being taken by canoe to the ship, whose decks are already crowded with captives. Overseeing the process in the shade of a parasol are an Englishman — possibly the captain of the *Southwell* — and his African trading partner, or caboceer; clasped hands indicate their friendly relationship. On the right, armed Africans help

to unload trade goods from the ship's boat.[5] Little is known about Pocock's experience at sea before his first recorded voyage as master of Richard Champion's vessels; while he may have served in the African trade, no evidence has yet surfaced to confirm that.[6] The landscape in the *Southwell* panels is generalized, suggesting an invented rather than observed setting. — EH

1. J. W. Damer Powell, *Bristol Privateers and Ships of War* (Bristol: J. W. Arrowsmith, 1930), 281–82. Two further drawings by Pocock bearing the Rogers coat of arms are in the collection of the Yale Center for British Art (B2008.30.27–.28).
2. Kenneth Morgan, *Bristol and the Atlantic Trade in the Eighteenth Century* (Cambridge: Cambridge Univ. Press, 1993), 132–33.
3. Morgan, *Bristol and the Atlantic Trade*, 144.
4. Another portrait he made, of the *Jason*, a slaver and privateer owned by Becher and Co., includes two similar panels (Bristol City Museum & Art Gallery).
5. Madge Dresser, *Slavery Obscured: The Social History of the Slave Trade in Bristol* (Bristol: Redcliffe Press, 2007), 54–57, 103.
6. For Champion' and the Bristol slave trade, see Eleanor Hughes's essay on Pocock in this volume.

101

Nicholas Pocock (1740–1821)

The River Avon, with Passing Vessels

1785
Watercolor and pen and black ink over graphite on paper
16 ³⁄₈ x 22 ¹⁄₈ in. (41.6 x 56.2 cm)
Yale Center for British Art, Paul Mellon Collection, B1977.14.4372

PROVENANCE: The Parker Gallery, from whom bt by Paul Mellon, 1967

AFTER HE LEFT the employment of Richard Champion, Pocock made a specialty of scenes of Bristol, a number of them set in the Avon Gorge, the stretch of the river immediately west of the city. This idyllic scene shows a ship being towed downriver from the city to the Bristol Channel. It passes Hotwells, the complex of buildings seen here on the far side of the river that housed natural hot springs, then in their heyday as a spa. The structure perched atop the St. Vincent Rocks was at the time a derelict mill, used for grinding corn and then snuff, which had been damaged by fire in 1777; since 1828, the surviving structure has been the Clifton Camera Obscura and Observatory. Pocock used a very similar composition for one of a series of eight views of the Avon that he produced in aquatint in the 1780s and 1790s. In 1791 a Bristol sugar merchant, John Pinney, wrote to his son in Germany, "It is very difficult to get a set of Mr. Pocock's views, but as I have one by me which I purchased some time ago for my new house, I will get them framed and glazed and send them by way of Holland."[1]

The River Avon with Passing Vessels exemplifies the dramatic change in Pocock's work that took place during the early 1780s. The assurance of distance and perspective in the landscape and the placement of vessels and figures bespeak a far greater sophistication and knowledge of composition than are found in his earlier work. Aside from the studies of flora and fauna in his logbooks, these are his first works to depart from pen and ink and gray wash to a full palette in watercolor. The tight delineation of the ship portraits has relaxed, and Pocock has adopted a technique of loose dabs and wavy strokes of the brush to render foliage and water.

101

Much of this transformation may be attributable to the tutelage in the early 1780s of Coplestone Warre Bampfylde, whom Pocock credited with making him an artist.[2] In 1804 Pocock wrote to Richard Bright with advice for Bright's daughter on watercolor technique:

> If the drawing intended to be colour'd is small, the Paper, after the outline is traced upon it may be wetted well on both sides, then laid on the Carpet or a green baize cloth (not a bare table or board) until the water is so much absorb'd, as that the paper appears dry — yet containing a considerable degree of dampness — in this state you may begin to colour upon it. . . . The misty clouds exhaling are produced by a large brush dipp'd in the water (without colour) and squeez'd between the finger and thumb. It will in this dry state soften the Edges of the Clouds and vary the forms at pleasure by taking off the Colour from the mountain or the sky wherever fancy may choose to exercise itself.[3]

Watercolor would become Pocock's medium as much as oil; in 1804 he was one of the sixteen founding members of the Society of Painters in Water Colours, along with John and Cornelius Varley, William Sawrey Gilpin, and William Henry Pyne. He exhibited there prolifically, showing nearly two hundred works — landscapes and seascapes — between 1805 and 1817.[4] — EH

1. Quoted in Cordingly, *Nicholas Pocock*, 40.
2. See Eleanor Hughes's essay in this volume.
3. Quoted in Cordingly, *Nicholas Pocock*, 46–47.
4. See Randall Davies, "Nicholas Pocock, 1741–1821," *Old Water-Colour Society's Club* 5 (1927–28): 1–29.

102

Nicholas Pocock (1740–1821)

Landscape in Wales with a View of Dolbadarn Castle

1798
Oil on canvas
20½ x 26½ in. (52.1 x 67.3 cm)
Yale Center for British Art, Paul Mellon Collection, B1976.7.65

PROVENANCE: John Mitchell and Son, from whom bt by Paul Mellon, 1970

POCOCK'S AMBITIONS with regard to landscape painting extended beyond views of his native Bristol. In addition to the numerous works Pocock exhibited at the Royal Academy depicting locations he had visited and undoubtedly sketched as a merchant captain, he produced ambitious, finished landscapes with no maritime content. When he painted *Landscape in Wales*, he had been working in this vein for more than a decade, as can be seen from an earlier oil (fig. 110).

Like many other British artists in the late eighteenth century, particularly during periods when war hindered travel to the Continent, Pocock undertook sketching tours in England and Wales in search of picturesque and sublime landscapes. By 1792 he had traveled to north and south Wales, where he made sketches that formed the basis for numerous watercolors, as well as oils such as this view in the mountainous region of Snowdonia. Dolbadarn Castle, in the distance, is the round tower built by Llewellyn the Great in the thirteenth century; by the late eighteenth century it was an established stop on the touristic and artistic itinerary of north Wales. It evidences Pocock's familiarity with the classical landscape compositions of Claude Lorrain and Gaspard Dughet by way of British practitioners, most obviously the Welsh artist Richard Wilson, who had produced his own view of Dolbadarn in about 1762 (Amgueddfa Cymru — National Museum Wales, Cardiff). Pocock would have known the hugely successful engraving by William Woollett after Wilson's *The Destruction of the Children of Niobe* (fig. 111), which may have served as a source for this work. The grouping under the great twisting tree in the foreground substitutes for Niobe and her children a Welsh mother and child, perhaps the inhabitants of the cottage seen to the right, in conversation with a traveler. Dolbadarn, which appears in Wilson's *Niobe* at the top of the crag, is here restored to its place in the valley. This canvas may be the "landscape" that Pocock showed at the Royal Academy exhibition of 1798; he exhibited several other views of Wales there, including a view of Caernarvon from the Menai Strait in 1801. His travels in Wales also provided the source material for dozens of the views that he exhibited at the Society of Painters in Water Colours. — EH

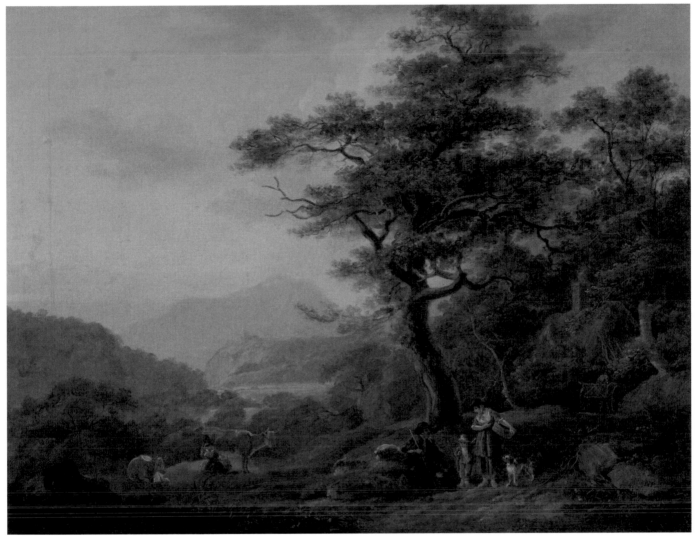

102

FIG. 110. Nicholas Pocock, *A Landscape with Figures on Horseback*, 1787, oil on canvas, 30 x 44½ in. (76 x 113 cm). Museo del Prado, Madrid

FIG. 111. William Woollett after Richard Wilson, *Niobe*, 1761, engraving and etching, 18⅞ x 23⅞ in. (48 x 60.5 cm). British Museum, London

103–05

Nicholas Pocock (1740–1821)

Memorandum and Designs for *Capture of the* **Résistance** *and* **Constance,** *French Frigates,* **Close in with Brest, March 9th 1797, by His Majesty's Frigates** San Fiorenzo, *Captain* **Sir H. B. Neale, Bart. and the** Nymphe, **Captain Cook**

1797
Graphite on paper
Mounts: 7 ½ x 7 ¼ in. (19.3 x 18.3 cm); 5 ⅞ x 9 ⅝ in. (15 x 24.6 cm); 9 ⅝ x 12 ¼ in. (24.6 x 31 cm)
National Maritime Museum, Greenwich, London, PAD8744–8746

106

Nicholas Pocock (1740–1821)

Capture of the *Résistance* **and** *Constance,* **French Frigates, Close in with Brest, March 9th 1797, by His Majesty's Frigates** *San Fiorenzo,* **Captain Sir H. B. Neale, Bart. and the** *Nymphe,* **Captain Cook**

1798
Oil on canvas
30 x 44 in. (76.2 x 111.8 cm)
National Maritime Museum, Greenwich, London, Macpherson Collection, BHC0495

EXHIBITIONS: RA 1798 (310)

103

TOGETHER these objects trace a commission that Pocock received in 1797, for a painting "for Lady Neale" of an action in which her husband, Sir Harry Burrard Neale, commander of the *San Fiorenzo,* captured two French frigates within sight of the French fleet moored in Brest harbor. They mark a progression from the slight sketch in the original memorandum (cat. 103) to a pair of drawings presented as alternative compositions — one more faithful to the facts, the other holding more artistic promise (cats. 104–05) — and the final painting (cat. 106).[1] Neale was one of the frigate captains who made their fortunes and reputations from such captures. Frigates were ships of at least 28 guns, faster than the great ships of the line of battle, and deployed on their own, in pairs, or in small squadrons to undertake a range of patrol and escort tasks.[2] There was a certain glamor to such commands during the period, deriving from the attractions of prize money from captured vessels, the autonomy that frigates allowed, and the potential for glory. During his seven-year term as a frigate captain, Neale seized a number of ships; in the year following the exhibition of *Capture of the* Résistance *and* Constance, he made another capture, which became the subject of a painting Pocock exhibited at the Royal Academy in 1800, *Engagement between His Majesty's Frigates* San Fiorenzo, *Sir H. Neale, Bart. the* Amelia, *the Hon. Capt. Herbert, and Three French Frigates and a Gun-boat, Close in with Belleisle, April 9th, 1799.* It can be supposed that a good proportion of the marine paintings depicting engagements were paid for with (or at least in the expectation of) the proceeds for the prizes taken.

Pocock received twenty-five guineas for this painting, evidence of his ability to command respectable if not spectacular prices. The works that he exhibited at the first exhibition of the Society of Painters in Water Colours in 1805 sold for an average of £13.[3] Dutch paintings brought considerably higher prices. For instance, when the collection of marine paintings belonging to the Earl of Bute was sold in 1796, the prices for its Dutch works went as high as £52 10s, for Albert Cuyp's *View on the Scheld,* and £30 9s, for a sea piece by Van de Velde. They far outstripped those paid for paintings by Peter Monamy, Samuel Scott, Charles Brooking, Richard Paton, Dominic Serres, Richard Wright, and Thomas Luny, which brought between £2 and £7 (the latter for a Brooking).[4] — EH

1. For details on the commission, see Eleanor Hughes's essay on Pocock in this volume.
2. Tom Wareham, *The Star Captains: Frigate Command in the Napoleonic Wars* (Rochester, UK: Chatham, 2001), 10.
3. Cordingly, *Nicholas Pocock,* 99.
4. Mr. Christie, *Catalogue of a Valuable and Capital Collection of Pictures, Late the Property of the Earl of Bute, Deceased: Brought from His Seat at Highcliffe . . . Saturday March 19, 1796* (London: James Christie, 1796). The copy at the Yale Center for British Art previously belonged to Christie's auction house and is annotated with the prices paid.

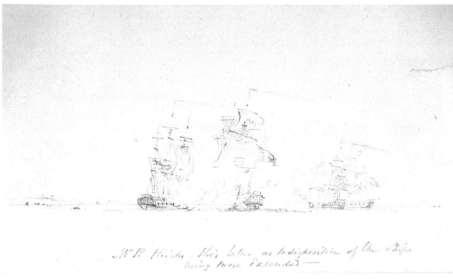

104

105

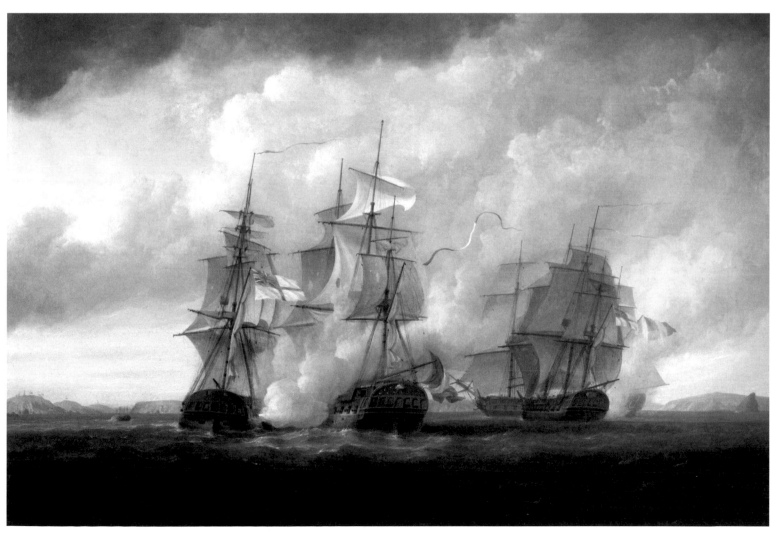

106

107

Nicholas Pocock (1740–1821)

Sir John Ross and Spanish Gun Boats

1805
Pen and ink and watercolor on paper
11⅛ x 14 in. (28.3 x 35.6 cm)
National Maritime Museum, Greenwich, London,
PAF5886

A VIVID REMNANT of an interaction between artist and patron, this drawing is annotated with questions posed by Pocock and responses from Sir John Ross, presumed to have commissioned a painting for which this is an early sketch. Pocock's queries refer to the respective sides of the action. English side: "Lugger firing at 2nd boat or not?" "not firing." Spanish side: "What dresses?" "White with straw hats and black ribbons." "Oars painted or not?" "Oars yellow with red [sketch of a wavy line on a rectangle] on the blades." Pocock also asks about the landscape: "Any change in the line of shore and distance?" Ross responds, "Cape to the left a little nearer & a Spanish flag on it." Ross added a note clearly intended to enhance his own actions: "NB: Make me standing about the 3rd rowlock and 3 men in the bow wounded and one killed[,] one fellow striking at me with oar, another trying to bayonet me."

If Pocock completed a painting based on this sketch and the information provided by Ross, it has not yet been located. Ross joined the navy at the age of nine and spent most of his career at sea. In 1803 he was assigned to the *Grampus*, under Admiral Sir James Saumarez. In the year that he collaborated with Pocock on this sketch, he was promoted to lieutenant, and he was later injured in an action off the coast of Bilbao, Spain.[1] This sketch may commemorate the latter. Ross is best known as an explorer: in the early nineteenth century he undertook three expeditions to the Arctic in search of a Northwest Passage and published accounts of two of them. —EH

1. In collaboration with Ernest S. Dodge, "Sir John Ross," in *Dictionary of Canadian Biography*, Univ. of Toronto/Univ. Laval, 2003: http://www.biographi.ca/en/bio/ross_john_8E.html (accessed Feb. 25, 2016).

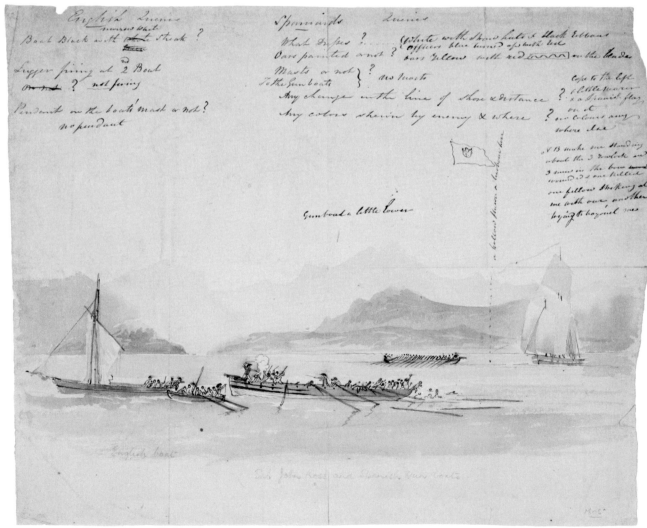

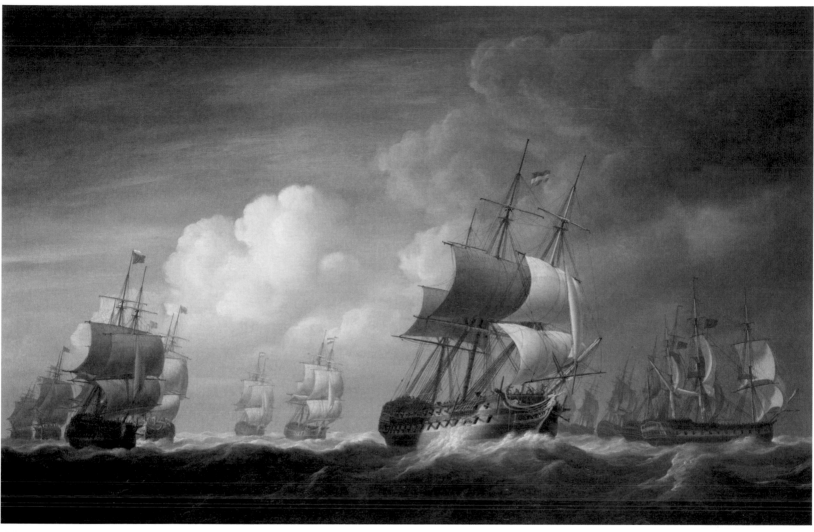

108

108

Nicholas Pocock (1740–1821)

The *Hindostan*, G. Millet, Commander, and Senior Officer of Eighteen Sail of East Indiamen, with the Signal to Wear, Sternmost and Leewardmost Ships First

1803
Oil on canvas
23 ⅞ x 36 ⅜ in. (60.8 x 92.3 cm)
National Maritime Museum, Greenwich, London, BHC1097

EXHIBITIONS: RA 1803 (201)

LITERATURE: Cordingly, *Nicholas Pocock*, 48; Clifton and Rigby, *Treasures*, 214–15

THIS ATMOSPHERIC PAINTING, now known as *A Fleet of East Indiamen at Sea*, was exhibited at the Royal Academy in 1803. It represents a maneuver of the fleet, a convoy of East India Company ships homeward bound from China in 1802. They sail toward the viewer from the left of the canvas, turning, rearmost ships first, toward the stormy weather looming on the horizon at right. The *Hindostan*, the ship at center, had been built in 1796 and made three voyages to China. At the start of its fourth voyage, in January 1803, it was wrecked on Margate Sands. At the same RA exhibition, which opened only a few months after the *Hindostan* was lost, Pocock also exhibited a work titled *Perilous Situation of* *the Hon. East India Company's Ship* Rockingham *Commanded by T. Butter, Esq. Having on an Expedition up the Red Sea Hit Dangerous Shoal.* As Christine Riding observes in her essay in this volume, such events fascinated contemporary viewers and were widely depicted. — EH

109

Dominic Serres (1719–1793)

Captain William Locker

1769
Oil on canvas
14½ x 12 in. (36.8 x 30.5 cm)
Yale Center for British Art, Paul Mellon Collection,
B1981.25.565

PROVENANCE: Christie's Nov. 22, 1963 (174);
bt by P & D Colnaghi, from whom bt by
Paul Mellon, 1963

EXHIBITIONS: VMFA/RA/YUAG 1963–65
(RA/YUAG only: 145, 161); YCBA 2007

LITERATURE: Russett, *Dominic Serres*, 82–84

110

Dominic Serres (1719–1793)

Saint Vincents, near West Malling, Kent

ca. 1779
Oil on canvas
12½ x 18 in. (31.8 x 45.7 cm)
Yale Center for British Art, Paul Mellon Collection,
B1981.25.566

PROVENANCE: Commissioned by Capt. William
Locker; possibly given by him to Stratford family;
Wingfield Stratford, Addington, Kent; his sale (date
unknown); bt by H. G. Hewlett; given by him to a
grandson of Capt. Locker; Christie's, April 17, 1964
(84); bt by P & D Colnaghi, from whom bt by Paul
Mellon 1964

EXHIBITIONS: YCBA 1979–80

LITERATURE: John Harris, *The Artist and the
Country House: A History of Country House and
Garden View Painting in Britain, 1540–1870*
(London: Sotheby Parke Bernet, 1979), 281

CAPTAIN WILLIAM LOCKER had a long and
distinguished career in the navy; after his death,
in 1800, he was described as "a good specimen
of the old English sea-officer — kind-hearted,
dignified, and free from all affectation." The
same author noted his reputation as "an ama-
teur of the arts."[1] Locker skillfully cultivated his
reputation as a patron of both artists and naval
officers through the commission and display
of artworks. His collection included images of
patrons who had advanced his own career, chief
among them Edward Hawke, who promoted
him to lieutenant (and for whom he named one
of his sons, Edward Hawke Locker, who later
founded the Naval Gallery). It also included
images of young officers whose careers he
had promoted, including Horatio Nelson, who
served as Locker's lieutenant on the *Lowestoft*.
In 1793 Locker, who for years had suffered
from injuries acquired in the line of duty, was
appointed to a desirable landside post, that
of lieutenant-governor of Greenwich Hospital,
which entitled him to apartments in the grand
hospital complex designed by Christopher
Wren. There he displayed his art collection and,
according to his grandson, "took an honest
pride in showing to his visitors these memorials
of his 'yonkers' [young sailors], relating some

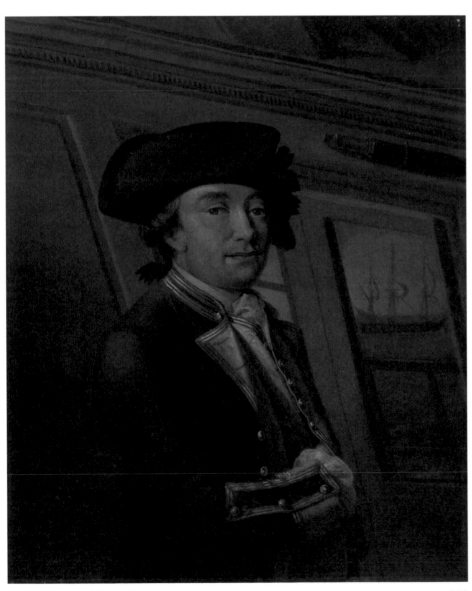

109

110

honorable trait of each of them in succession."[2]
Presumably among the works displayed in
Locker's official residence at Greenwich Hospital
were these two paintings by Dominic Serres.
The portrait, the only known example of the
genre in Serres's oeuvre, probably was commis-
sioned to celebrate Locker's advancement in
1768 to the rank of post captain. The landscape
shows Saint Vincents, the house built, almost
certainly on prize money, by Locker's father-in-
law, Admiral William Parry, who died in 1779,
the same year that Locker retired from active
service due to ill health.[3] The painting may have
been commissioned to mark the inheritance
of the property. The figures standing in front of
the house presumably include William; his wife
Lucy, who would die in 1780; and little Edward

Hawke Locker, born in 1777. Serres also painted
several naval engagements at Locker's behest —
works that became important elements in the
next generation's commemoration of the navy.
— EH/CACR

1. M. T. S. Raimbach, ed., *Memoirs and Recollec-
 tions of the Late Abraham Raimbach* (London: F.
 Shoberl, 1843), 20.
2. Frederick Locker-Lampson, *My Confidences: An
 Autobiographical Sketch Addressed to My Descen-
 dants* (New York: Charles Scribner's Sons, 1896),
 425.
3. W. H. Ireland, *A New and Complete History of
 the County of Kent*, 4 vols. (London: G. Virtue,
 1828–30), 3:617.

111

111

Edward Hawke Locker (1777–1849)

Dining Room Hand Screen

1830–43

112

Edward Hawke Locker (1777–1849)

Drawing Room Hand Screen

1830–43

Ink on paper

9 x 7 in. (22.9 x 17.8 cm)

Huntington Library, Art Collections, and Botanical Gardens, LR217

LITERATURE: (cats. 111–112) Roach, "Domestic Display," 411–28.

EDWARD HAWKE LOCKER came from a family with a strong tradition of naval service. He was the great-grandson of a commodore; grandson of an admiral; son of a captain, William Locker; and namesake of yet another admiral, his father's naval patron, Edward, Lord Hawke. In 1804 he went to sea, not as an officer, but as civil secretary to Admiral Edward Pellew (later Viscount Exmouth). After several voyages, Locker again followed in his father's footsteps, in 1819, by becoming secretary at Greenwich Hospital, the royally funded home for naval veterans, where his father had previously served as lieutenant-governor. As a child, Locker had seen his father proudly give tours of the family's art collection, installed in his official residence at the hospital. Edward Hawke Locker carried on that tradition, displaying the works he inherited from his father alongside new commissions. In the process, he created a complex visual program that celebrated the family's contributions to the nation's naval achievements.

At some time between 1830 and 1843, Locker made this pair of hand screens, which provide a visual guide to his domestic display.[1] Like fans, hand screens provided a convenient, portable decorative surface and were sometimes used as keys to the art collections in country houses.[2] One screen depicts the dining room, which contained mostly oil paintings (cat. 111). The other depicts the drawing room, where a mixture of watercolors, drawings, and oils were on display (cat. 112). The screens, now unmounted, would originally have been attached to frames with handles. The detailed diagrams reveal that Locker intermingled new and old pictures, emphasizing continuity across the generations. For example, on the east wall of the dining room hung the family's prize possession, John Francis Rigaud's portrait of Admiral Lord Nelson as a young man, just awarded the rank of post captain (fig. 112). As a young officer, Nelson had served under William Locker, whom he hailed as a mentor: "It is you who taught me

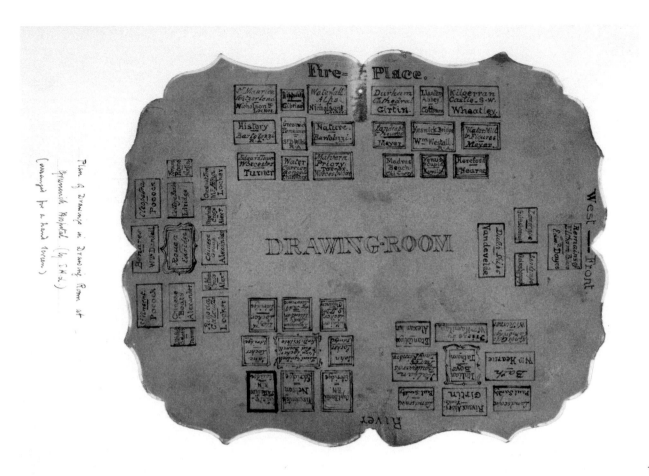

Fire—Place.

DRAWING-ROOM

West — Front

River

(with numerous small labeled boxes representing paintings, including names such as Nicholson & Locker, Gibtins, Nicholson, Girtin, Cotman, Wheatley, Bartolozzi, Stothard, Meyer, Wm Westall, Meyer, Turner, Owen, Hearne, Pococke, Eldridge, Alexander, Vandervelde, Nelson, Girtin, Paul Sandby, and others)

(Handwritten note on left side:) Plan of Drawings in Drawing Room at Greenwich Hospital by E.H.L. (arranged for a hand screen.)

112

how to board a Frenchman by your conduct when in the Experiment," wrote Nelson, "it is you who always told me 'Lay a Frenchman close and you will beat him'; and my only merit in my profession is being a good scholar."[3] To one side of Nelson's portrait hung a marine painting of the single-ship action referred to in this letter, Dominic Serres's Experiment *Taking the Télémaque, 1757* of 1769 (private collection; its pendant is cat. 113). To the other side, Edward Hawke Locker hung a more recent marine painting that he had commissioned from Nicholas Pocock, *The Battle of Quiberon Bay, November 20, 1759* (cat. 114). In this arrangement, he continued the eighteenth-century practice of displaying marine paintings as pendants. But he also introduced a new element, by combining works of different eras and encouraging visual comparisons between different styles and hands. The pairing of a work by Serres from 1769 with one by Pocock painted over forty years later emphasizes both the persistent memory of eighteenth-century naval achievements and the continued vitality of marine painting in Britain.

—CACR

1. They cannot have been created before 1830, when David Wilkie signed and dated the drawing *The Disabled Commodore* depicted on one of the screens, or after 1843, when Edward Locker's mental powers failed. For Locker's illness, see Sir Robert Peel to Eleanor Mary Elizabeth Boucher Locker, October 1, 1843. Huntington Library, Papers of Edward Hawke Locker, LR285.
2. See, for example, Giles Waterfield, *Palaces of Art: Art Galleries in Britain, 1790–1990*, exh. cat. (London: Dulwich Picture Gallery, 1992), 76–77.
3. Horatio Nelson, *The Dispatches and Letters of Vice Admiral Lord Viscount Nelson*, ed. Nicholas Nicolas, 7 vols. (London: Henry Colburn, 1845–46), 3:260.

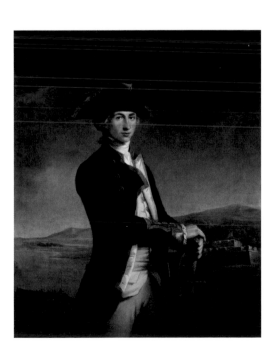

FIG. 112. John Francis Rigaud, *Captain Horatio Nelson*, 1781, oil on canvas, 50 x 40 in. (127 x 101.5 cm). National Maritime Museum, Greenwich, London, Caird Fund

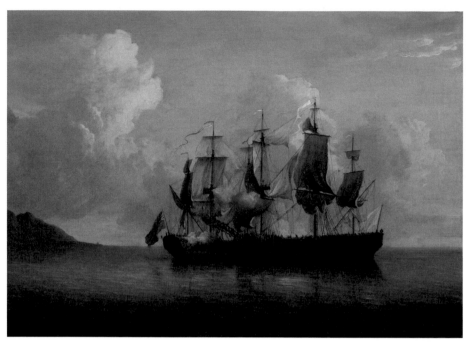

113

113

Dominic Serres (1719–1793)

Experiment Taking the _Télémaque_, 1757

1769
Oil on canvas
26 x 37 in. (66.1 x 94 cm)
National Maritime Museum, Greenwich, London,
Greenwich Hospital Collection, BHC0381

EARLY IN THE Seven Years' War between
Britain and France, the British ship _Experiment_,
under the command of Captain John Strachan,
encountered a French privateer, the _Télémaque_.
Twenty-six-year-old William Locker, only
recently promoted to lieutenant, led a boarding
party that successfully overwhelmed the French
crew. The capture was not reported in the naval
gazettes, a slight that Locker's son Edward
Hawke Locker later attributed to accident or
jealousy.[1] Perhaps compensating for this lack of
official acknowledgment, William Locker com-
missioned pendant paintings of the event from
Dominic Serres. The work seen here shows the
start of the action, with the larger _Télémaque_,
its decks teeming with combatants, crossing in
front of the _Experiment_; its pendant, bearing
the same name and now in a private collection,

depicts the battle's conclusion, reversing the
position of the two ships and showing the _Télé-
maque_ with badly damaged sails.

These pendants were inherited by Edward
Hawke Locker, who carried on the family tradi-
tion by displaying them in his home. But in 1830,
he extended his visual campaign for family glory
to a larger public. He broke up the set designed
by Serres, retaining the painting of the success-
ful conclusion of the action for the family home
(see cats. 111–12), and donating this picture to
the Naval Gallery of Greenwich Hospital, where
he served as curator in all but name. There it
was shown to a wide audience, inserting the
Locker family story into a collective celebration
of national naval glory. Thus an eighteenth-
century painting designed for domestic com-
memoration was repurposed for display in a
nineteenth-century gallery. The painting retains
its Naval Gallery frame and placards; as is
typical of the gallery's framing, the name of the
donor appears in larger type than that of the
commanding officer. — CACR

1. [Edward Hawke Locker,] "Biographical Memoir
 of Commodore William Locker, Late Lieutenant
 Governor of Greenwich Hospital," _Naval Chronicle_
 5 (1801): 100.

114

Nicholas Pocock (1740–1821)

**The Battle of Quiberon Bay, November 20,
1759**

1812
Oil on canvas
26½ x 42½ in. (67.3 x 107.9 cm)
National Maritime Museum, Greenwich, London,
Caird Fund, BHC0399

IN 1759, at the height of the Seven Years' War,
Admiral Edward Hawke led a fleet charged with
blockading the French navy at Brest harbor.
When the French fleet broke out under the
cover of stormy weather, Hawke and his forces,
including William Locker, then a lieutenant on
the _Sapphire_, cornered the enemy in Quiberon
Bay. The ensuing battle is considered one of
Britain's greatest naval victories and was a turn-
ing point in the war.[1] It was the most significant
action of William Locker's career, and twenty
years after the fact he commissioned a painting
of the battle from his favorite marine painter,
Dominic Serres (fig. 113). This kind of retrospec-
tive commission was fairly common, particularly
as officers rose through the ranks, made their
fortunes in prize money, and were able to afford
such visual testaments to their earlier achieve-
ments. In 1793 Locker donated that painting to
Greenwich Hospital, the royally funded charity
where he served as an administrator. His gift
publicly commemorated his participation in
the battle, but it also deprived the family of a
domestic memorial of the event. In 1812 William
Locker's son Edward Hawke Locker redressed
this absence by commissioning Nicholas Pocock
to create a new representation of the battle.
Pocock's depiction, created late in his career,
was influenced by recent stylistic develop-
ments, demonstrating both the persistence and
the evolution of the genre of marine painting.
This development would have been especially
visible when the work was displayed in Edward
Hawke Locker's family home at Greenwich,
where Pocock's work was hung as a pendant
to another work by Serres, Experiment _Taking
the_ Télémaque, _1757_ (private collection; see
cat. 113). — EH/CACR

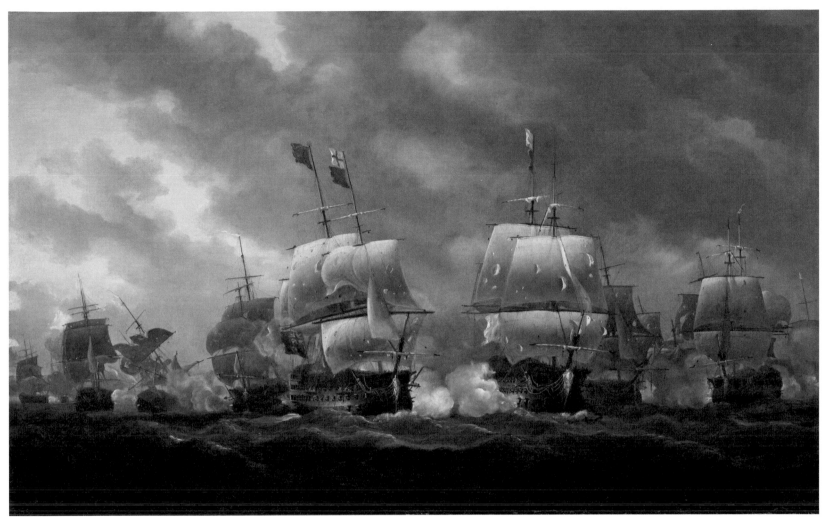

FIG. 113. Dominic Serres, *The Battle of Quiberon Bay, November 20, 1759*, 1779, oil on canvas, 45 × 72 in. (114.3 × 182.8 cm). National Maritime Museum, Greenwich, London, Greenwich Hospital Collection

1. J. K. Laughton, "William Locker (1731–1800)," rev. A. W. H. Pearsall, in *Oxford Dictionary of National Biography*, Oxford Univ. Press, 2004: http://dx.doi. org/10.1093/ref:odnb/16895 (accessed Sept. 11, 2015).

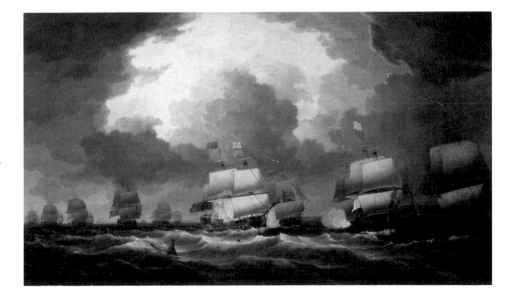

"On the Open Sea"

REVOLUTION AND TRADITION, CIRCA 1800

A Painting in the Panorama is shortly to be brought forward, which will give an exact representation of every ship in the English and french fleets, as they appeared at one o'clock P.M. on the first of June, 1794. Taken from the most correct observations made by Captain Barlow of the Pegasus, *Lord Howe's repeating frigate, and by Captain Seymour, who was signal officer at that time with Captain Barlow. The* Pegasus *being near the centre, the observers may suppose themselves on the open sea, and have the fleets scattered round them in every direction, as they really were at that time, the fire commencing on the* Queen *by nine French ships of the line.*

—Oracle and Public Advertiser, *April 30, 1795*

W HILE MARINE PAINTERS continued to exhibit at the Royal Academy in the 1790s, the battles of the French Revolutionary and Napoleonic Wars and the emergence of a national hero in the figure of Admiral Horatio Nelson attracted a wider range of artists to the subject of naval engagements. Artists such as Philippe-Jacques de Loutherbourg and J. M. W. Turner reconceived battles as events of high drama in which the fate of the nation could be seen to hang in the balance. They explored ways to create visual equivalents of these events, responding to calls such as that made by the *Whitehall Evening Post* in 1787, "to plunge the spectator at once in the heat of the battle" by, as the *Naval Chronicle* put it in 1799, "indulging in the rolling phrenzy of the imagination." At the same time, new genres and formats for depicting and exhibiting such events—the modern history painting, the panorama, the single-work exhibition—competed for the public's attention with more traditional modes of representation, particularly after the major battles of the Glorious First of June (1794), the Nile (1798), and Trafalgar (1805). Following the final naval defeat of the French, marine paintings all but disappeared from the walls of the Royal Academy. However, the genre's practitioners continued to exhibit, particularly at the Society of Painters in Water Colours, where seascapes became one of the prime expressions of the medium. As the national attitude toward the wars moved into a more commemorative mode, the National Gallery of Naval Art, opened in the Painted Hall at the Royal Hospital for Seamen (Greenwich Hospital) in 1824, celebrated the achievements of both the navy and the artists who depicted its heroes.

115

Nicholas Pocock (1740–1821)

His Majesty's Ship the *Brunswick* Engaging the *Vengeur* on the First of June

1795
Oil on canvas
54 ⅛ x 74 ¾ in. (137.5 x 190 cm)
National Maritime Museum, Greenwich, London, Caird Collection, BHC0471

PROVENANCE: Christie's, April 24, 1897 (85), bt by Moore; Captain Moore (represented by Captain Harry Parker), from whom bt by National Maritime Museum, November 1934

EXHIBITIONS: RA 1796; NMM/PEM 2013–14 (PEM: 12)

LITERATURE: Cordingly, *Nicholas Pocock*, 74–75; Hughes, "Vessels of Empire," 97–148; Hughes, "The Battle of the Pictures"; Riding and Johns, *Turner and the Sea*, 49, cat. 12

THE BATTLE of the Glorious First of June, the first major fleet engagement of the French Revolutionary War, was claimed as a victory by both the British and the French. Although the British fleet under Admiral Richard Howe, first Earl Howe, captured six French ships and sank one, the French fleet under Rear Admiral Louis Thomas Villaret-Joyeuse accomplished its objective, the safe arrival of a convoy of ships transporting grain from North America to France.

Pocock's grim painting depicts the bloodiest encounter of the battle, a four-hour duel at close range between the *Brunswick*, a 74-gun ship, and *Le Vengeur du Peuple*. The two ships became so entangled that the *Brunswick's* crew were unable to open their lower gun ports and had to fire through them. The painting shows the moment when another French ship, the *Achille*, came to the aid of the *Vengeur*, so that the *Brunswick* engaged both at once; it thus references a treasured trope, the outnumbered British force — "we happy few, we band of brothers" — prevailing over a stronger opponent.[1] The engagement ended with the sinking of the *Vengeur*, an extraordinary occurrence in naval warfare, in which the objective was to disable and capture enemy ships.

Pocock may have produced this painting on speculation; no details of a commission have so far come to light. It is dated 1795 but was not displayed until the Royal Academy exhibition of 1796, perhaps to capitalize on the publication of a pair of prints — engraved by Robert Pollard and dedicated "To the Memory of the Brave Captain Harvey," commander of the *Brunswick* — that appeared in February and July 1796. One print reproduces this painting; the other shows the scene after the action, as the inscription on the print indicates: the *Brunswick* "totally disabled," *Le Vengeur* "Dismasted, Waterlogged and Sinking" (fig. 114). Harvey had had a distinguished naval career.[2] During the engagement with *Le Vengeur* he suffered horrendous injuries, which were described in detail in the pamphlet accompanying the two prints:

With respect to Captain Harvey, he was wounded early in the action, by a musket ball passing through his right hand, which tore away part of it, with three fingers; but this he carefully concealed, by wrapping it up in his handkerchief: afterwards he received a violent contusion on the small of his back, which struck him down upon the deck. . . . He, however, recovered himself, and continued on the quarter deck directing and conducting the action, with the greatest coolness and intrepidity, till a double-headed shot splitting, the crown of it struck his right arm near the elbow, and shattered it to pieces. The loss of blood then compelled him to go below; but before he went down, he said every thing possible to encourage his men to persist in their duty.[3]

FIG. 114. Robert Pollard after Nicholas Pocock, *To the Memory of the Brave Capt John Harvey . . . the* Brunswick *and* Le Vengeur *after the Action on the First of June 1794*, published July 16, 1796, aquatint and etching, 21 ⅝ x 29 in. (54.9 x 73.7 cm). National Maritime Museum, Greenwich, London

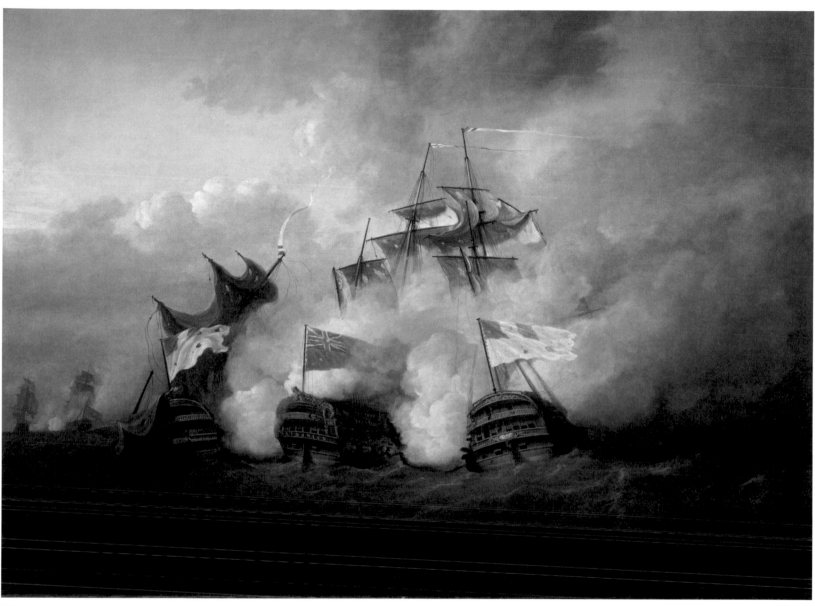

115

Harvey's right arm was amputated, and he finally succumbed to his wounds in Portsmouth on June 30. The attention to bodily mutilation and Harvey's stoic adherence to his responsibilities place him squarely within the contemporary discourse on physical sacrifice and heroic death.[4] Pocock's painting displaces the notion of the heroic body onto the ships themselves, which appear as animate entities, leaning into each other with the ferocity of their attack. This sense is heightened by the fact that the canvas is unusually large for such a subject (a size often reserved for portrayals of fleet engagements);

the scale of depiction gives the ships a corporeal relation to the viewer. Details such as the pall of smoke truncating *Le Vengeur*'s hull and the flash of the Brunswick's broadside reflecting off the waves between the two ships are painted with an intensity of focus befitting the outcome of the encounter. — EH

1. William Shakespeare, *Henry V*, act 4, sc. 3.
2. See "Biographical Memoir of the Late Captain John Harvey," *Naval Chronicle* 3 (1800): 241–59.
3. *Narrative of the Transactions on Board His Majesty's Ship,* the Brunswick, *Commanded by Captain John Harvey, From the 28th of May, to the Afternoon of the Memorable First of June, 1794. From Which the Subjects of Two Pictures Are Taken,* by Nicholas Pocock (London, 1796), 14–15.
4. See Hoock, *Empires of the Imagination,* 162–72.

116

116

Nicholas Pocock (1740–1821)

"Operations of the Grand Fleet under the Command of Lord Howe from 28th of May to the Total Defeat of the French Fleet on the 1st June 1794"

1794
National Maritime Museum, Greenwich, London, JOD/12
Shown: page 23

PROVENANCE: The artist; by descent to Captain Roger Pocock, by whom given to the National Maritime Museum, 1932

LITERATURE: Cordingly, *Nicholas Pocock*, 69–72, 109–16

THIS NOTEBOOK contains three narrative accounts and five diagrams—four of them hand-drawn and one a print, annotated (see fig. 58, p. 78)—of the Battle of the Glorious First of June, compiled as aids to the production of numerous paintings, drawings, and designs for prints on the subject of the battle. The authors of two of the narratives, officers who served on board the *Brunswick* and the *Orion*, are named; the third account, transcribed in Pocock's hand, describes the

events as witnessed from the *Pegasus*. Since the notebook entered the collections of the National Maritime Museum in the 1930s, this account has been taken as evidence that Pocock was an eyewitness to the battle and that the drawn diagrams are his records of the battle's progress.[1] Rather, the notebook should be seen as a singularly coherent example of the amassing of evidence and source material in order to construct paintings like that of the encounter between *Brunswick* and *Le Vengeur* (cat. 115). The author of the *Pegasus* account was most likely either Captain Robert Barlow or Lieutenant Philip Seymour. A repeating frigate, the *Pegasus* was stationed at a distance from the battle to transmit the signals flown by ships engaged but invisible to one another in the smoke and confusion. It would therefore have had a good view of the proceedings. Seymour and Barlow also supplied information to Robert Barker (see cats. 125–27) for his panorama of the First of June in Leicester Square. — EH

1. For more on the authorship of these drawings, see Eleanor Hughes's essay in this volume.

117

Nicholas Pocock (1740–1821)

The Battle of the First of June: *Brunswick* and *Le Vengeur*

1794
Watercolor with graphite on paper
Mount: 5½ x 7⅞ in. (14 x 20.1 cm)
National Maritime Museum, Greenwich, London, PAD8704

118

Nicholas Pocock (1740–1821)

View of the British Fleet and French Prizes after the Battle of the First of June

1794
Watercolor with graphite on paper
Mount: 7 x 12½ in. (18 x 31.7cm)
National Maritime Museum, Greenwich, London, PAD8703

LITERATURE: (cats. 117–18) Cordingly, *Nicholas Pocock*, 70–71

119

Robert Pollard (1755–1838) after Nicholas Pocock (1740–1821)

View of the Prizes Taken on the 1st of June by E. Howe at Anchor at Spithead

Engraving and aquatint on paper
In *Naval Chronicle*, vol. 1, 154–55
London: J. Gold, 1799
Yale Center for British Art, Paul Mellon Collection, Serials (8vo) 50

THESE EXAMPLES of Pocock's drawings related to the Battle of the First of June are executed with a characteristic fluidity of line that was noted by contemporaries; as Mary Hartley wrote to the painter and theorist William Gilpin, his drawings were "done in a very masterly and spirited manner, & with the utmost rapidity."[1] Unusually, these have been colored, adding a striking persuasiveness that has contributed to the notion that Pocock was present at the battle. The drawing of the *Brunswick* (previously identified as the *Defence*) and *Le Vengeur* (cat. 117) may be an early sketch for the painting that Pocock exhibited at the Royal Academy in 1796 (cat. 115). It shows the two ships engaged

in an intense duel from which clouds of smoke billow. The drawing of ships spread out in an expanse of water (cat. 118) has also been seen as convincing proof of Pocock's presence: "an unusual eye-witness view of the aftermath of a sea battle. Crippled and dismasted ships, and wreckage, are scattered across the sea as far as the horizon."[2] However, the composition and placement of the ships bears a strong resemblance to Pocock's view of the French prizes at Spithead, the anchorage near Portsmouth, published in the *Naval Chronicle* in 1799 (cat. 119), which suggests that this may instead be a preparatory drawing for that subject. Pocock may well have taken the opportunity while at Portsmouth to sketch out the initial composition for his painting of the engagement between the *Brunswick* and *Le Vengeur*.

Pocock provided the designs for most of the illustrations in the *Naval Chronicle's* first volume (as well as for later volumes). Four of them depict episodes in the battle; none of their captions mention his presence, although, as seen in this example, they do cite the sources of his information: "not drawn from the imagination, but faithfully and correctly copied from the sketches and minutes of officers in the action." The view of the prizes is the only illustration to mention Pocock's presence: "in the exact state they arrived, from the original sketch by Mr. Pocock. . . . The ships are all correct portraits." The *Naval Chronicle* was founded by James Stanier Clarke and John McArthur, who also published a life of Nelson for which Pocock provided the illustrations. — EH

1. Mary Hartley to William Gilpin, Dec. 29, 1788. Bodleian Library, Univ. of Oxford, MS. English Misc. D 572.
2. Cordingly, *Nicholas Pocock*, 70.

117

118

119

At M^r de POGGI'S *NEW ROOM, N°91, NEW BOND STREET* near Oxford Road, *Are now Exhibiting* **TWO LARGE PICTURES** *Painted by* M^r ROBERT CLEVELEY *of the* ROYAL NAVY, *representing the* GREAT *and* IMPORTANT VICTORY *Obtained by the* BRITISH FLEET, *under the Command of* EARL HOWE *Over the* FRENCH, *on* THE FIRST OF JUNE, 1794.

120

120

Antonio Cesare Poggi (active 1769–1836)

At Mr. de Poggi's New Room . . . Two Large Pictures Painted by Mr. Robert Cleveley of the Royal Navy: Representing the Great and Important Victory . . . on the First of June, 1794

1795
Engraving
Yale Center for British Art, Paul Mellon Collection, Eph Art 16

THE BATTLE of the First of June provided artists with the first opportunity to depict a contemporary major naval engagement since the American Revolution had ended, in 1782. The result was an unprecedented array of artistic responses and ways of exhibiting them. The marine painter Robert Cleveley, son of John Cleveley the Elder, exhibited his pair of paintings at the premises of the publisher Antonio Poggi. The single-work exhibition had been pioneered by John Singleton Copley in 1781, when he displayed his modern history painting *The Death of the Earl of Chatham*, and reached its culmination with

his display of *The Siege of Gibraltar* ten years later.[1] Such exhibitions took works away from the visual competition that crowded the walls of the Royal Academy; as in Cleveley's case, they were also marketing tools for engravings after the paintings. Like Nicholas Pocock and Philippe-Jacques de Loutherbourg, Cleveley traveled to Portsmouth to view the British fleet and its French prizes anchored at Spithead after the battle, in order, as one newspaper reported, to take "Portraits of the different ships of the British fleet, and of the six captured Line of Battle ships," and to collect "from the best authority a plan of the two fleets . . . and every other information requisite for the elucidation of so extensive a subject."[2]

Poggi's was a speculative venture, undertaken in an effort to overcome the depression in the international print market caused by the war: the diarist Joseph Farington, who had connections in artistic and naval spheres, heard from him that "if the Prints of the Naval engagement do not answer He shall be ruined."[3] Cleveley's pictures, however, were received with some acclaim. One critic wrote: "he has grouped both his pictures with admirable taste; all the

minutiae of the marine are rigorously preserved, and the effect of his atmosphere at morning and evening is strictly compatible with truth and harmony."[4] — EH

1. See Emily Ballew Neff and Kaylin H. Weber, "Laying Siege: West, Copley, and the Battle of History Painting," in *American Adversaries: West and Copley in a Transatlantic World*, ed. Emily Ballew Neff and Kaylin H. Weber, exh. cat. (Houston: Museum of Fine Arts, 2013), 208–35.
2. *Morning Chronicle*, June 18, 1794. See also Hughes, "Sanguinary Engagements," 95–101.
3. Farington, *Diary*, 2:339.
4. Anthony Pasquin [pseud.], *Memoirs of the Royal Academicians: Being an Attempt to Improve the National Taste* (London: H. D. Symonds, 1796), 109.

121

Robert Dodd (1748–1815)

To Admiral Earl Howe . . . This View of Their Gaining the Wind of the Enemy's Fleet on the Evening of the 29th of May 1794, Which Led to Their Splendid Victory on the 1st of June. . . .

1795
Published by Benjamin Beale Evans
Aquatint with watercolor on paper
Sheet: 20⅞ x 30⅛ in. (53.1 x 76.5 cm); image: 17⅛ x 27⅞ in. (43.5 x 70.6 cm)
Yale Center for British Art, Paul Mellon Collection, B1977.14.11454

122

Robert Dodd (1748–1815)

This View of the Action on the Morning of the 1st of June 1794 . . . Is Most Respectfully Inscribed. . . .

1795
Published by Benjamin Beale Evans
Aquatint with watercolor on paper
Sheet: 20⅞ x 30 in. (53 x 76.2 cm); image: 17¼ x 28 in. (43.8 x 71 cm)
Yale Center for British Art, Paul Mellon Collection, B1977.14.11455

ROBERT DODD partnered with the publisher Benjamin Beale Evans to produce these prints, published on January 25, 1795, and

then exhibited the pair of paintings on which they were based at the Royal Academy later that spring. They were listed in the exhibition catalogue as "The Queen man of war, in danger of being cut off by the enemy, is relieved by ships from the British fleet" and "A view of the action of the 1st of June." A review of the latter provides an interesting commentary on the profusion of representations of the battle:

> The many *exact* descriptions of this Action which appear on canvas, each of which so completely *differs* from the other, is a reproach to this species of composition, and we can therefore only regard such Pictures as Paintings, and not as faithful records of what they affect to represent. In the Picture before us, the Artist has had the boldness to make a cannon ball stationary; but exclusive of this outrage against sense or truth, the ships are painted with care, and the sea is admirably well described.[1]

Paired paintings were a common way of presenting the course of a naval engagement (see cats. 92–93). Dodd's sequence spans the days from the initial action between the French and British fleets on May 29 to the battle on the first of June. The first print (cat. 121), according to its inscription, shows "the *Queen* after having led the Van [vanguard] along the whole of the Enemy's line to leeward being so much disabled in her Sails & Rigging and at some distance from the body of the British Fleet, that the French Van bore up in a formed line with the intention to cut her off." The inscription goes on to explain that the *Royal Sovereign* came to the *Queen*'s rescue, causing the French fleet "to ware and bear away to leeward." Dodd's composition focuses on the *Queen* in the right foreground, a diagonal band of sunlight bringing attention to the ship's tattered sails and the sailors crowding the rigging to make repairs, with the British van coming up behind it, while the French fleet departs the scene to the right. The second print shows a key moment in the battle on the first of June, when the English fleet broke the French line of battle, gaining the advantage of the wind. — EH

1. *Morning Post and Fashionable World*, May 25, 1795. Emphasis in original.

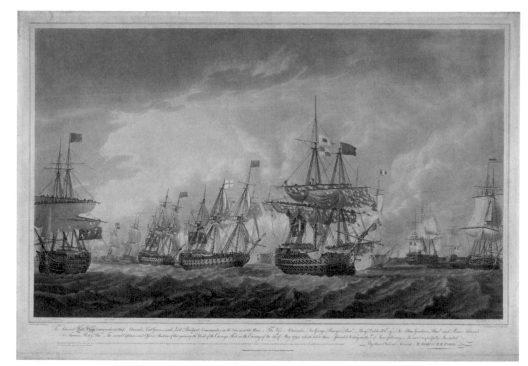

121

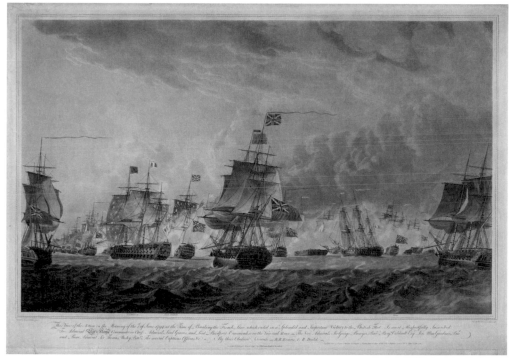

122

123

123

James Fittler (1758–1835) after
Philippe-Jacques de Loutherbourg (1740–1812)

The Glorious Victory Obtained over the French Fleet by the British Fleet under the Command of Earl Howe, on the First of June 1794

January 1, 1799
Engraving and etching
Sheet: 22 ⅞ x 31 ⅞ in. (58 x 81 cm);
mount: 29 ⅞ x 37 ⅞ in. (75.7 x 96.1 cm)
National Maritime Museum, Greenwich, London, PAJ2497

IMMEDIATELY FOLLOWING the Battle of the Glorious First of June, 1794, Philippe-Jacques de Loutherbourg was commissioned by the publishers Valentine and Rupert Green to paint a pendant to his success of the same year, *The Grand Attack on Valenciennes* (Hesketh Collection, Easton Neston). The Greens paid him

£500 for the commission, and together they, Loutherbourg, and the caricaturist James Gillray traveled to Portsmouth to see the British fleet and the French prizes after the battle. Loutherbourg made extensive sketches and notes at Portsmouth for what would be his first foray into maritime subject matter. They reveal his grappling with an array of information. One page, for example, combines notes on the numbers of guns carried by several ships, the sails rigged on the *Queen Charlotte*, and the progress of the action; a diagram of the lines of battle and a notation of its geographical location; drawings of flag signals, details of rigging, and a "French bouy made of Cork"; and a quotation, the words "of Capt. Tartu to his son — on board Le Juste": "Je meurs pour la Liberté, de mon pays, Je meurs content, apprenez a combattre pour elle et détestez toujour les Tyrans" ("I die for the liberty of my country; I die happy; learn to fight for it [liberty], and always detest tyrants"; fig. 115).

The depth of feeling reflected in

Loutherbourg's notes — for a subject most marine painters would treat in a more objective fashion — in part set the tone for the finished painting, on which Gillray assisted with the figures. It was exhibited as *Earl Howe's Victory over the French Fleet* (fig. 116) at the Historic Gallery in Pall Mall from March 2, 1795, in direct competition with Robert Cleveley's pair of paintings at A. C. de Poggi's establishment on Bond Street (see cat. 120). The exhibition of the painting was accompanied by a press campaign intended to attract not only visitors but also subscribers for the forthcoming print.[1] Loutherbourg's enormous canvas encompasses several episodes in the battle. Plunging toward the viewer from the background of the painting are the towering forms of the *Queen Charlotte*, the French flagship *La Montagne*, and the *Jacobin*, locked together in combat, the *Queen Charlotte* having just broken the French line. On the right an episode that occurred eight hours later is depicted: the sinking of *Le Vengeur* after

a lengthy duel with the *Brunswick* (see cat. 115). The description accompanying James Fittler's masterful engraving after the painting makes it clear, however, that the main focus of the work is the contrast between the French and British seamen: "Every minute attention has been paid . . . to a faithful representation of the national characters of the sailors." On the foredeck of the *Queen Charlotte*, troops are drawn up in orderly lines, and sailors go about the precarious task of clearing away damaged sails; on the deck of *La Montagne*, the French captain is "forcing the men to their duty," while two sailors have just fallen overboard. In the foreground, the drama is heightened: "Several English men of war's boats, with their crews, are represented saving their drowning enemies. . . . These form but a small portion of the traits of that noblest of sympathies, humanity, the active exertions of which so highly dignified the character of the British sailors in this most important and splendid victory."[2] Despite the work's attention to accuracy

in the details, critics objected to its compression of events: "Mr. Loutherbourg's picture on this popular subject is too licentious in the points of historic fact to please any nautical observer."[3]

Following their exhibition in Pall Mall, both *The Grand Attack on Valenciennes* and *Earl Howe's Victory over the French Fleet* were sold at Christie's to a T. Vernon of Liverpool in 1799 and were exhibited on tour. In the early 1800s the Prince of Wales purchased *Earl Howe's Victory over the French Fleet* for the Royal Collection. Following his accession to the throne, George IV commissioned J. M. W. Turner to paint *The Battle of Trafalgar* (see fig. 119, p. 281) as a pendant for Loutherbourg's painting, then hanging in St. James's Palace. Turner's canvas came under such criticism that in 1829 both works were given to the National Gallery of Naval Art at Greenwich (see cat. 140).[4]

Loutherbourg, a native of Strasbourg and member of the Académie française, settled in London at the behest of the actor David Garrick

and served as stage designer at the Theatre Royal, Drury Lane, from 1773 to 1783, for which he was paid £500 per annum. He became well known also as a landscape painter and was elected to the Royal Academy in 1781. — EH

1. See Hughes, "Sanguinary Engagements," 90–105.
2. Description published by Robert Cribb for Valentine and Rupert Green, January 1, 1799. The reverse of the sheet bearing the description includes a key to the ships in the painting and lists of the British and French ships.
3. Anthony Pasquin [pseud.], *Memoirs of the Royal Academicians: Being an Attempt to Improve the National Taste* (London: H. D. Symonds, 1796), 109.
4. Now at the National Maritime Museum: http://collections.rmg.co.uk/collections/objects/11962.html (accessed April 5, 2016).

FIG. 115. Philippe-Jacques de Loutherbourg, Sketch for *Earl Howe's Victory over the French Fleet*, 1794, pen and ink and watercolor on paper. British Museum

FIG. 116. Philippe-Jacques de Loutherbourg, *Earl Howe's Victory over the French Fleet*, 1795, oil on canvas, 105 x 147⅛ in. (266.5 x 373.5 cm). National Maritime Museum, Greenwich, London, Greenwich Hospital Collection

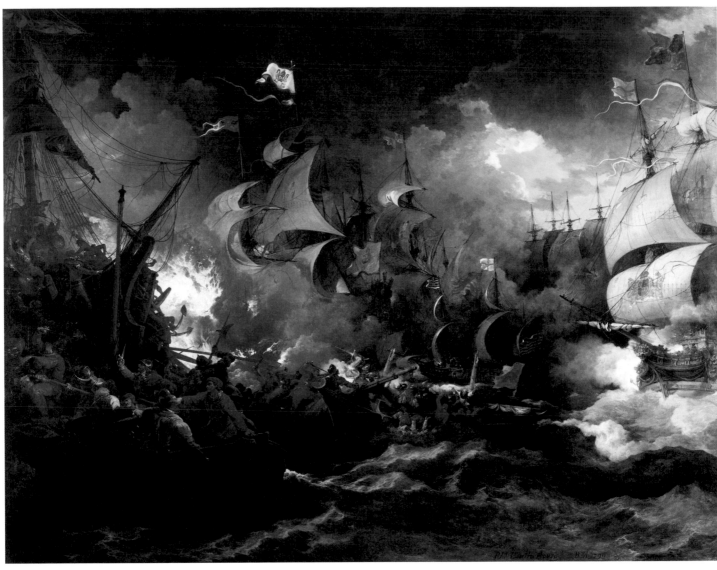

124

124

Philippe-Jacques de Loutherbourg (1740–1812)

The Glorious Defeat of the Spanish Armada

1796
Oil on canvas
84½ x 109½ in. (214.6 x 278.1 cm)
National Maritime Museum, Greenwich, London,
Greenwich Hospital Collection, BHC0264

PROVENANCE: Robert Bowyer, from whose lottery
won by Peter Coxe, May 30, 1807 (58); Sir Gregory
Osborne Page-Turner, 4th Bart, sold at Christie's,
June 7–9, 1824; George Dyson, sold at Christie's,
June 18, 1825, bt by Sir Charles Long, Lord
Farnborough, for presentation to the Naval Gallery
at Greenwich Hospital

EXHIBITIONS: European Museum 1808 (240), 1809
(484), 1810 (245), 1812 (128); Strasbourg 2012–13
(241)

LITERATURE: Lefeuvre, *Loutherbourg*, 168–69,
294–95, cat. 241

LOUTHERBOURG followed the success of his
first maritime subject, *Earl Howe's Victory over
the French Fleet* (see cat. 123) with this work,
painted the following year. Robert Bowyer, a
miniaturist, had conceived a plan to create a
gallery of works by contemporary artists that
would be engraved to illustrate an edition of
David Hume's *History of England*, first published
in 1754. The Historic Gallery in Pall Mall opened

in April 1793; the following spring, Rupert and
Valentine Green rented its ground floor for the
exhibition of Loutherbourg's *Grand Attack on
Valenciennes* and, in 1795, *Earl Howe's Vic-
tory*.[1] Bowyer commissioned five paintings from
Loutherbourg, three depicting land battles —
Hastings (1066), the Siege of Acre (1291), and
Bosworth Field (1495) — one of the Great Fire of
London (1666), and *The Glorious Defeat of the
Spanish Armada*, celebrating the repulsion of a
Spanish invasion force in 1588. The painting, for
which Loutherbourg was paid £500, depicts the
Battle of Gravelines, fought the day after English
fire ships attacked the Armada off the French
coast, near Calais. The battle lasted all day, until

the remaining ships of the Armada retreated and were forced to sail northward around Scotland to make their way back to Spain. In the center background, the Spanish flagship the *San Martin*, flying the papal standard, is illuminated by the blaze; the English fleet attacks from the right, the English flagship *Ark Royal* entering the frame with the arms of Elizabeth I on its sail.[2]

As in his earlier foray, Loutherbourg researched the topic extensively, with, according to the sale catalogue, "all the streamers and signals taken from the most authentic documents existing, and drawn at the time," and the armor of a Spanish commander drawn from a specimen at the Tower of London.[3] The posthumous sale of the contents of his studio included a copy of John Pine's *The Tapestry Hangings of the House of Lords* (cats. 36–38), which he doubtless used as a source for *The Glorious Defeat of the Spanish Armada*.[4] Like *Earl Howe's Victory*, the painting combines this purported historical precision with dramatic effects produced through scale, tone, and color, a hallmark of Loutherbourg's practice perhaps stemming in part from his work in the theater, and a radical departure from the treatment of such subjects by marine painters.[5] — EH

1. Farington, *Diary*, 2:294 (Jan. 19, 1795), cited in Lefeuvre, *Loutherbourg*, 163.
2. National Maritime Museum: http://collections.rmg .co.uk/collections/objects/11756.html (accessed April 5, 2016).
3. Bowyer sale, May 30, 1807, no. 58, cited in Lefeuvre, *Loutherbourg*, 168.
4. Loutherbourg sale, June 18, 1817, no. 196, cited in Lefeuvre, *Loutherbourg*, 168.
5. Lefeuvre, *Loutherbourg*, 167.

FIG. 117. Robert Mitchell (active 1782–1835), *Section of the Rotunda, Leicester Square, in which is Exhibited the Panorama*, 1801, colored aquatint. Private collection

125

Unknown maker

Panorama, Leicester-Square . . . A View of the Grand Fleet, Moored at Spithead, Being the Russian Armament in 1791

1793
Engraving
10 ⅞ x 17 ¾ in. (27.5 x 45 cm)
Yale Center for British Art, Paul Mellon Fund, Folio A 2011 28

126

Unknown maker

Panorama, Leicester Square: Short Account of Lord Nelson's Defeat of the French at the Nile

1799
Printed by James Adlard
Wood engraving
16 ½ x 13 ¾ in. (42 x 35 cm)
Yale Center for British Art, Paul Mellon Fund, Folio A 2010 4

127

Unknown maker

Panorama, Leicester Square: Battle of Trafalgar

1806
Printed by James Adlard
Wood engraving
17 x 13 ⅜ in. (43 x 34 cm)
Yale Center for British Art, Paul Mellon Fund, Folio A D 56

IN LEICESTER SQUARE in 1793 Robert Barker opened his panorama, a building with a circular chamber, ninety feet in diameter, for the display of 360-degree images, with another, smaller display above it (fig. 117). Barker had developed and exhibited in his native Edinburgh a method of perspective that was, as an early historian of the panorama noted, "peculiarly adapted to the concave surface of his picture, which should appear straight when viewed from a platform at a certain level in the center."[1] The panorama also extended above and below the viewing position, creating "a calculated confusion about the literal location of the painted surface as a way of enhancing its illusions of presence and

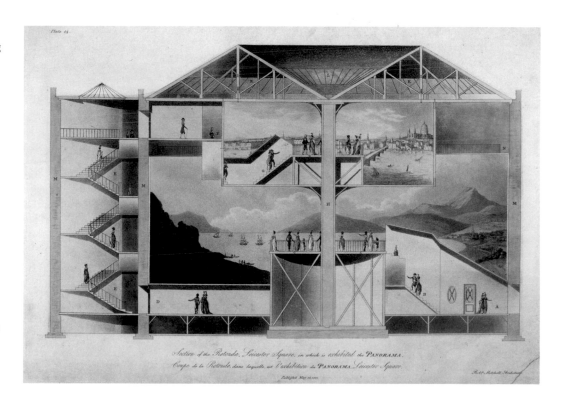

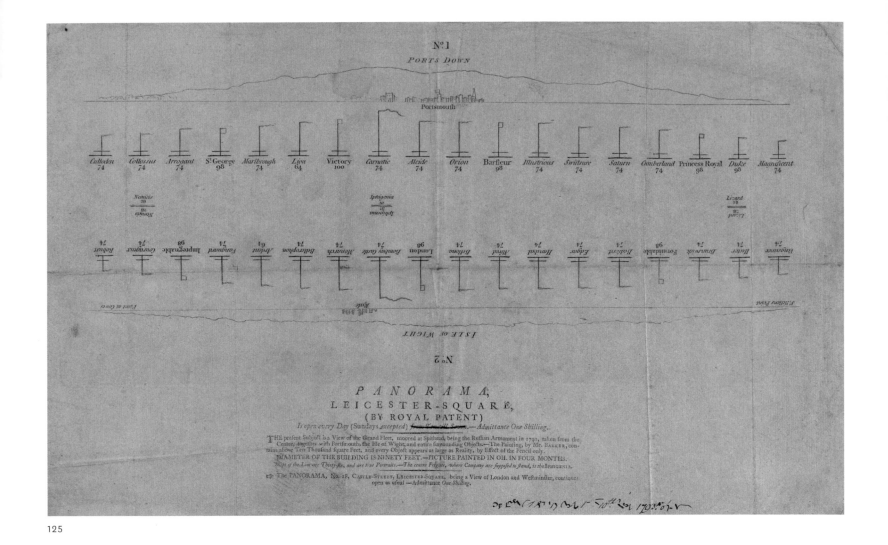

125

distance."[2] As Barker put it in his advertisement for the panorama of the Glorious First of June, which was the fourth display to open, in June 1795, "The observers may suppose themselves on the open sea."[3] To orient viewers, Barker provided engraved keys, now the only evidence of the panoramas' appearance.

From the outset, panoramas had a maritime focus. The first to be installed, in 1793, was a view of the naval fleet, including thirty-six ships of the line, standing ready in the anchorage at Spithead during the summer of 1791 for an expedition to the Baltic to put pressure on Russia, then at war with the Ottoman Empire (cat. 125). As the key explains, "the painting, by Mr. Barker, contains above ten thousand square feet, and every object appears as large as reality, by effect of the pencil only." Between 1793 and 1802,

during the French Revolutionary War, scenes involving the British fleet accounted for half of the subjects exhibited; during the Napoleonic Wars (1803–15) "nearly every image shown at the Panorama had to do with the movements of the Royal Navy or British army."[4] Beyond those depicting engagements, a large proportion represented coastal sites of geopolitical importance, such as Gibraltar, Malta, and Portsmouth.

Although the immersive and spectacular format of the panorama was new, such scenes were inevitably inflected by the eighteenth-century tradition of marine painting. As the surviving keys indicate, the compositional structure of panoramas mimicked both marine paintings and coastal profiles. Barker relied on similar sources for the accuracy of his depictions, and cited them in his advertising and on the accompanying

guides: the ships in the Spithead panorama are "true portraits," and the information for the First of June panorama was "taken from the most correct observations made by Captain Barlow of the Pegasus, Lord Howe's repeating frigate, and by Captain Seymour, who was signal officer at that time with Captain Barlow."[5] Like marine paintings, the panoramas were comprehended as part of the web of information provided in the aftermath of battles: narrative, diagrammatic, and pictorial. The keys sold by Barker made such information available on-site. The format of these varied: the key to the Battle of the Nile (cat. 126) includes a narrative at its center, relating the progress of the battle and calling attention to its climactic moment, depicted in the panorama: "at 10 Minutes after Nine, L'Orient caught Fire, and blew up about 10 o'Clock; and the Wreck of

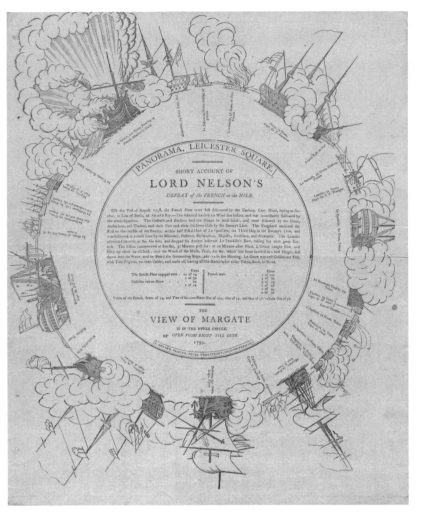

126

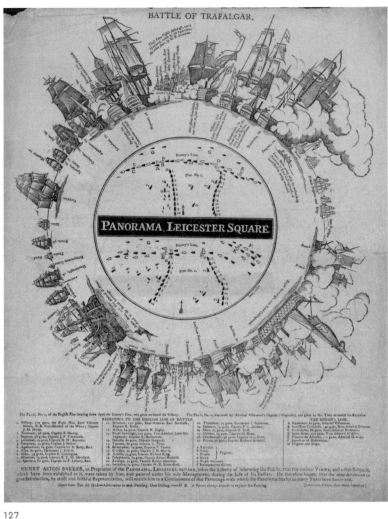

127

the Masts, Yards, &c. &c. Which had been carried to a vast Height, fell down into the Water, and on Board the surrounding Ships." The key to the panorama of Trafalgar (cat. 127) is far more elaborate. It incorporates two diagrams of the battle, one sourced "on-board the Victory" and the other "made by Admiral Villeneuve's Captain (Magendie), and given by Mr. Toby on-board the Euryalus"; details of the English and French lines of battle, with the number of guns on each ship and its commanding officer; and, on the image of the panorama itself, captions identifying each ship and in some cases giving a short account of its role in the action (for the *Redoutable*: "From the Tops of this Ship Lord Nelson received his Wound").

Robert Barker's chief assistant was his son Henry Aston Barker, who from 1799 traveled overseas to make drawings for the panorama. Visiting Naples in 1799 en route to Constantinople, Henry recalled, "I was introduced by Sir William Hamilton to Lord Nelson, who took me by the hand, saying he was indebted to me for keeping up the fame of his victory in the battle of the Nile for a year longer than it would have lasted in the public estimation."[6] The panorama served a similar function for the tropes and contexts of marine painting, extending the genre's relevance into the nineteenth century. — EH

1. George Corner, *The Panorama (Leicester Square), with Memoirs of Its Inventor, Robert Barker, and His Son, the Late Henry Aston Barker* (London: Robins, 1857), 4–5, repr. in *Panoramas, 1787–1900: Texts and Contexts*, ed. Laurie Garrison (London: Pickering & Chatto, 2013), 1:15–16. See also Scott Wilcox, introduction to *Panoramania! The Art and Entertainment of the "All-Embracing" View*, by Ralph Hyde (London: Trefoil, 1989), 13–29.

2. Jonathan Crary, "Géricault, the Panorama, and Sites of Reality in the Early Nineteenth Century," *Grey Room* 9 (2002): 19.

3. *Oracle and Public Advertiser*, April 30, 1795.

4. Oleksijczuk, *The First Panoramas*, 6. See also Hughes, "Sanguinary Engagements," 105–07.

5. *Oracle and Public Advertiser*, April 30, 1795.

6. Corner, *The Panorama*, 10, repr. in Garrison, *Panoramas*, 21.

128

Edward Orme (1775–1848)

The *Mars* and the *L'Hercule*, April 21, 1798: A Transparent Print

February 1, 1799
Yale Center for British Art, Paul Mellon Fund, Folio B 2011 43e

EDWARD ORME was a commercially successful London engraver, print seller, and, later, property developer. His first plate was published in 1794, and by the time this one appeared (as its inscriptions show) he had a shop in Conduit Street where, among other categories of goods, could "be had a great variety of Transparent Prints and every requisite for drawing them." The many single-ship actions as well as larger battles in this period of extensive naval warfare provided almost unlimited opportunities for printmakers to exploit intense public interest.

This clash occurred when the 74-gun British *Mars* (Captain Alexander Hood) cornered the 74-gun French *L'Hercule* (Captain Louis L'Héritier) on the coast near Brest. The latter vessel, which had just been built at L'Orient, was coming to join the French fleet for the first time. Evening was drawing in and L'Héritier, forced to anchor until the tide turned in his favor, had to defend himself in a stationary engagement. The *Mars* managed to secure itself alongside him, and for an hour the two crews fought muzzle-to-muzzle. French boarders were twice repulsed before *L'Hercule* surrendered, with about 290 men killed or wounded. The *Mars* had 30 killed or missing, with 60 wounded; one of the dead was Hood, talented scion of a naval family.

Orme's heavily inked stipple engraving is designed to be seen illuminated by a strong light from behind, making the crescent moon and the highlights it casts — on clouds, pennants, gun smoke, and the sea — stand out dramatically. Rather than an "art" engraving it is an early example of what we might now call interactive entertainment, in this case for drawing-room use. It was published on February 1, 1799, so probably already lettered when, on January 21, Orme was appointed "printseller in ordinary" (official supplier) to George III; he held a similar position under George IV from 1820. — PVDM

THE MARS AND THE L'HERCULE. *April 21. 1798.*
A Transparent Print

128

129

Joseph Mallord William Turner (1775–1851)

The *Victory* Returning from Trafalgar, in Three Positions

ca. 1806
Oil on canvas
26 3/8 x 39 1/2 in. (67 x 100.3 cm)
Yale Center for British Art, Paul Mellon Collection, B1981.25.634

PROVENANCE: Walter Fawkes of Farnley, bt from the artist; Fawkes sale Christie's 27 June 1890 (61) bt by Agnew for Sir Donald Currie; by descent to his granddaughter Mrs L. B. Murray; sold to Agnew, from whom bt by Paul Mellon, 1960

EXHIBITIONS: Possibly Turner's gallery 1806; RA Winter 1892 (22); Birmingham 1899 (8); Guildhall 1899 (10); VMFA/RA/YUAG 1963–65 (132, 167, 195); NGA 1968–69 (5); Birmingham 2003–2004 (3)

LITERATURE: Walter Armstrong, *Turner* (London: T. Agnew, 1902), 56, 232; A. J. Finberg, *Life of J. M. W. Turner, R. A.*, 2nd ed. (Oxford: Clarendon Press, 1961), 125, 467; Andrew Wilton, *The Life and Work of J. M. W. Turner* (London: Academy Editions, 1979), 258, no. P59; Martin Butlin and Evelyn Joll, *The Paintings of J. M. W. Turner*, rev. ed., 2 vols. (New Haven and London: Published for the Paul Mellon Centre for Studies in British Art and the Tate Gallery by Yale Univ. Press, 1984), 1:46–47, 69, cat. 59; Paul Spencer-Longhurst, *The Sun Rising through Vapour: Turner's Early Seascapes*, exh. cat. (Birmingham: Third Millennium in association with the Barber Institute of Fine Arts, 2003), 32–33; Riding and Johns, *Turner & the Sea*, 21, 61, 111, 112, 123, 184, fig. 20

THE *VICTORY*, a first-rate ship of the line, served in battles against the French and Spanish before and during the French Revolutionary and Napoleonic Wars. It was Admiral Augustus Keppel's flagship at Ushant (1778), Admiral Lord Howe's at Cape Spartel (1782), and Admiral Sir John Jervis's at Cape St. Vincent (1798).[1] *Victory* is best known, however, as Horatio Nelson's flagship at the Battle of Trafalgar (1805), where he was mortally wounded and later died below deck. The ship had been badly damaged in the battle and was towed to Gibraltar for repairs before carrying Nelson's body back to England. The present painting broadly marks this event and may have been shown the following spring

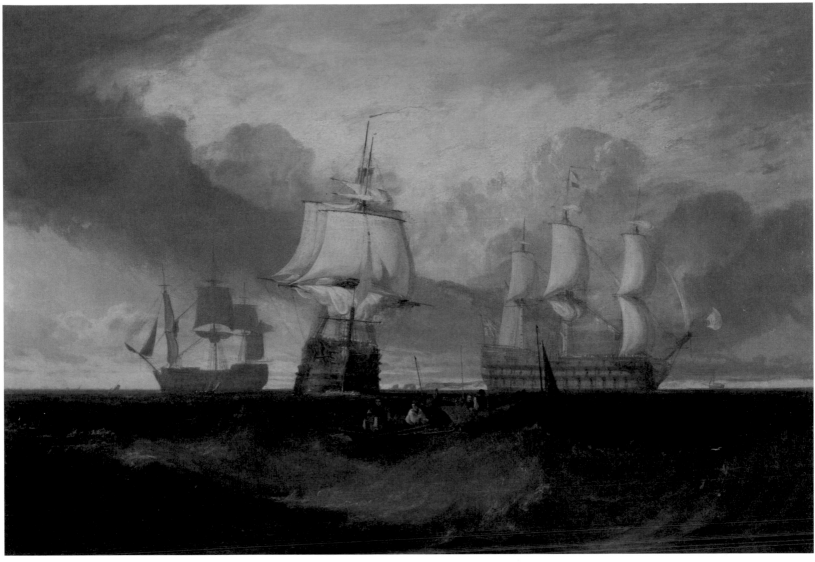

129

in Turner's gallery on Harley Street, alongside *The Battle of Trafalgar, as Seen from the Mizen Starboard Shrouds of the* Victory (cat. 130) in a display both topical and poignant. Naval historians have noted that the ship represented in this painting cannot positively be identified as the *Victory*, but the likelihood that Turner's friend and patron Walter Fawkes bought the painting directly from the artist has led art historians to accept the identification as stated in the traditional title, and a joint display would reinforce that view.[2]

Turner was engaging here with the conventions and visual language of marine painting, in particular ship portraiture, as practiced

in the seventeenth century and formulated by John Thomas Serres in his *Liber Nauticus and Instructor in the Art of Marine Drawing* in 1805–06 (see cat. 81). A relevant contemporary example of this approach is Nicholas Pocock's *Nelson's Flagships at Anchor* (1807; National Maritime Museum, Greenwich), an imagined scene at Spithead, the anchorage off Portsmouth, with the naval ships *Agamemnon*, *Vanguard*, *Elephant*, and *Captain* shown in various positions, juxtaposed with a port-quarter view of the *Victory* that dominates the composition on the right. Pocock's painting was commissioned by James Stanier Clarke and John McArthur and reproduced in their biography

The Life of Admiral Lord Nelson, K. B. (1809). The artistic conceit of a single ship represented several times within the same composition was standard practice in ship portraiture. Turner may also have been inspired by Anthony van Dyck's portrait of Charles I in three positions (1635–36; Royal Collection Trust). The image was well known through numerous copies but had been brought to public attention again by the portrait's return from Italy to England to be sold at Christie's, London, in 1804.[3]

Over and above these conventions, Turner was a keen observer of naval architecture and had sketched starboard, bow, port, and stern views of the *Victory* as it entered the River

Medway in December 1805.[4] He also completed a watercolor version, probably for inclusion in the marine category of his ambitious print project *Liber Studiorum*.[5] Rather than showing a ship that was battle scarred, with its ensign at half-mast out of respect for the dead admiral (as was the case in 1805), Turner depicts the *Victory* in its prime and under full sail, seemingly indomitable and triumphant. His departure from the known facts suggests that he sought to transcend "mere" portraiture to draw out the symbolic potential of the ship's name, conflating Nelson's celebrated vessel with an outcome of national significance. — CR

1. HMS *Victory*, the oldest commissioned warship in the world, is in Portsmouth Historic Dockyard, UK. It has a dual role as the Flagship of the First Sea Lord (Royal Navy) and as a museum of the Georgian navy.
2. Butlin and Joll, *Paintings of J. M. W. Turner*.
3. Christopher Brown and Hans Vlieghe, *Van Dyck, 1599–1641*, exh. cat. (London: Royal Academy, 1999), 292.
4. Nelson sketchbook, 1805 (Tate, D05446–D05490, D40701–D40705, D41427; Turner Bequest LXXXIX). See David Blayney Brown, "Nelson Sketchbook 1805," in *J. M. W. Turner: Sketchbooks, Drawings and Watercolours*, ed. David Blayney Brown, Tate Research Publication, Dec. 2012: https://www.tate.org.uk/art/research-publications/jmw-turner/nelson-sketchbook-r1108732 (accessed April 2, 2016).
5. *The Victory Coming up the Channel with the Body of Nelson*, c.1807–19 (Tate, D08183); see Gillian Forrester, *Turner's "Drawing Book" the Liber Studiorum*, exh. cat. (London: Tate, 1996), 16; Riding and Johns, *Turner & the Sea*, 57–63.

130

Joseph Mallord William Turner (1775–1851)

The Battle of Trafalgar, as Seen from the Mizen Starboard Shrouds of the *Victory*

1806, reworked 1808
Oil on canvas
67 ¼ x 94 in. (170.8 x 238.8 cm)
Tate, Turner Bequest

PROVENANCE: Remained with the artist; Turner Bequest 1856; transferred to the Tate Gallery, 1910.

EXHIBITIONS: Turner's gallery 1806; BI 1808 (359); Tate Gallery 1931 (25); RA 1974–75 (84); on loan to the National Maritime Museum, Greenwich, 1975–80; NGA/DMA/MMA 2007–2008 (42)

LITERATURE: Leo Costello, *J. M. W. Turner and the Subject of History* (Farnham, UK: Ashgate, 2012), 15–60; Quilley, *Empire to Nation*, 228–30; Ian Warrell, ed., *J. M. W. Turner*, exh. cat. (London: Tate, 2007), 76, 77, cat. 42; Martin Butlin and Evelyn Joll, *The Paintings of J. M. W. Turner*, rev. ed., 2 vols. (New Haven and London: Published for the Paul Mellon Centre for Studies in British Art and the Tate Gallery by Yale Univ. Press, 1984), 1:39, cat. 58.

NOT IN EXHIBITION

TURNER'S FIRST naval engagement — and the first of his works to represent a contemporary event — was exhibited at the Royal Academy in 1799: "Battle of the Nile, at 10 o'clock when L'Orient blew up, from the Station of the Gun Boats between the Battery and Castle of Aboukir." Seven years passed before he again exhibited on the subject of war. When Nelson's flagship, *Victory*, returned to England in December 1805, Turner made detailed drawings of the ship, as well as sketches of members of the crew and diagrams and annotations concerning the battle.[1] In the finished painting, however, he went beyond the detail and compositional conventions associated with naval battle imagery to engage with late-Georgian representations of the heroic "death tableau." The martial hero as secular martyr was heralded by Benjamin West's *Death of General Wolfe* (National Gallery of Canada, Ottawa), exhibited at the Royal Academy in 1770. Nelson seems to have been familiar with the painting and, as West was

later to claim, even expressed a hope that, should he die in battle, the artist would create a version for him.[2] In 1806 West obliged with his *Death of Nelson* (Walker Art Gallery, Liverpool), promoting the engraved version as a pair to the financially successful *Wolfe* print. West had elevated the subject of Wolfe's death by taking liberties with the historical facts and by using compositional devices from Christian iconography of the Passion.[3] John Singleton Copley and others developed West's highly successful (if fictionalized) form of heroic representation still further in the 1780s and 1790s, to the extent that by 1805 a formula existed within British visual culture for representing Nelson's death.

In his *Battle of Trafalgar* Turner incorporates West's focus on the figure of the swooning hero, here surrounded by officers and sailors, within a panoramic view of the action. He creates a novel pictorial middle ground between the intimacy of the death tableau associated with contemporary history painting and the more distant viewpoint of naval battle painting as practiced by Nicholas Pocock and others. Turner achieves this by adopting an unusual viewpoint, looking down from the mizzenmast of *Victory* toward the decks of the four enormous ships of the line, the British *Victory* and *Temeraire*, and the French *Redoutable* and *Bucentaure*, locked in combat. The resulting composition is a radical departure from convention, at once vertiginous — with a perspective drawn from the destabilizing viewpoint of the panorama, which extended below as well as around the viewer (see cats. 125–27) — and claustrophobic in its immediacy. The importance of such a view in shaping an audience's vicarious experience of war at sea is underscored by the title Turner assigned to the work. Geoff Quilley has suggested that this high vantage point puts the viewer in the position of an able seaman. In contrast to the broad perspectives typically commissioned by captains or admirals, it thereby presents both the battle and the fatal wounding of Nelson from the perspective of a "lower-deck sailor" who was in fact "the only person qualified to be aloft at such a moment."[4]

Turner's *Battle of Trafalgar* was executed within months of Nelson's funeral in January

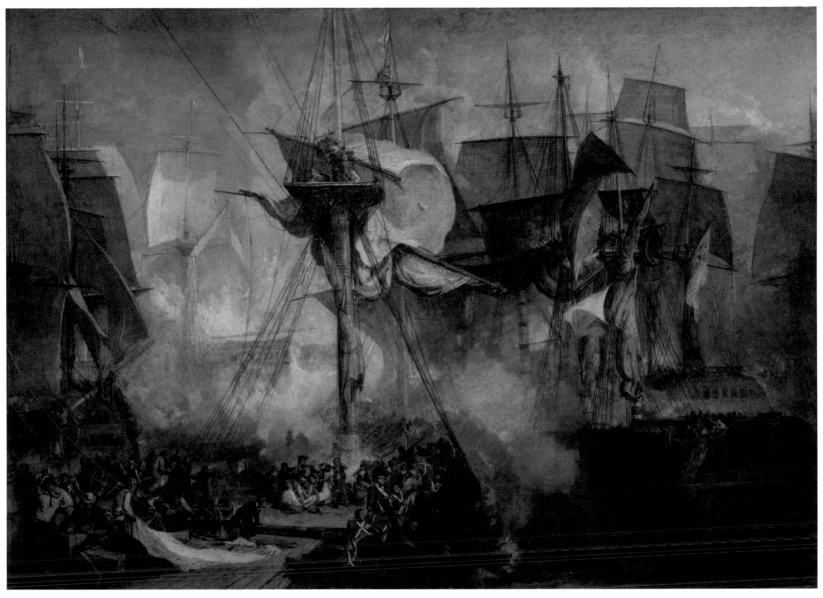

130

1806 and was executed and exhibited in an unfinished state at his Harley Street gallery, possibly alongside *The* Victory *Returning from Trafalgar, in Three Positions*, a work that depended on traditional — even archaic — modes of representation (cat. 129). Turner subsequently reworked *Battle of Trafalgar* and exhibited it at the British Institution in 1808. The novelty of his approach was discussed at length in the *Review of Publications of Art* (1806) by the engraver John Landseer, who called the painting "new in its kind . . . a *British epic picture.*" Drawing

parallels with Homer's epic poetry, standard source material for traditional history painting, Landseer noted that Turner had both detailed the death of the individual hero and suggested "the whole of a great naval victory . . . in a *single* picture."[5] — CR

1. Nelson sketchbook, 1805 (Tate, D05446–D05490, D40701–D40705, D41427; Turner Bequest LXXXIX). See David Blayney Brown, "Nelson Sketchbook 1805," in *J. M. W. Turner: Sketchbooks, Drawings and Watercolours*, ed. David Blayney Brown, Tate Research Publication, Dec. 2012: https://www.tate.org.uk/art/research-publications/jmw-turner/nelson-sketchbook-r1108732 (accessed April 2, 2016).

2. Helmut von Erffa and Allen Staley, *The Paintings of Benjamin West* (New Haven: Yale Univ. Press, 1986), 221.

3. Von Erffa and Staley, *Paintings of Benjamin West*, 57; Costello, *Turner and the Subject of History*, 15–60.

4. Quilley, *Empire to Nation*, 237.

5. John Landseer, *Review of Publications of Art* 1 (pamphlet, London, 1808), 83–84. Emphasis in the original.

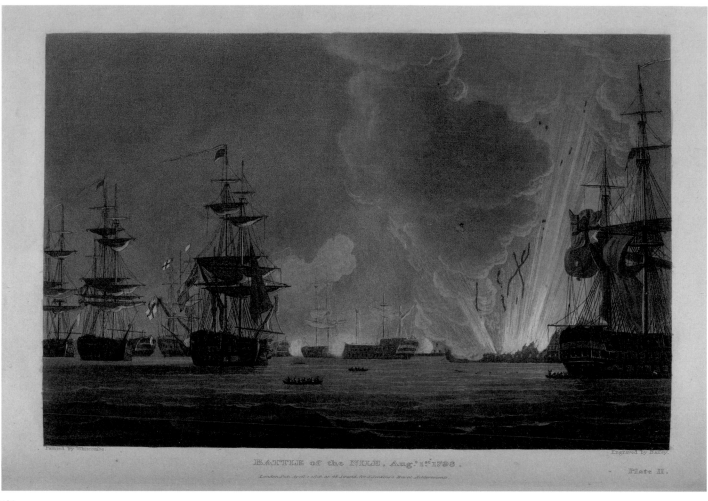

131

131

John Bailey (1750–1819)
after Thomas Whitcombe (ca. 1752–1824)

Battle of the Nile, Aug. 1st 1798

Hand-colored aquatint
In James Jenkins, *The Naval Achievements of Great Britain, from the Year 1793 to 1817*, plate 2
London: Printed for J. Jenkins, 1817
Yale Center for British Art, Paul Mellon Collection, DC153 .N38 1817+ Oversize

THE BATTLE OF THE NILE was one of the most decisive naval engagements of the eighteenth century in determining the course of the British and French empires. Napoleon Bonaparte had sought to invade Egypt as part of a campaign against the British in India and to achieve dominance in the Mediterranean. On August 1, 1798,

after a pursuit of several months, Nelson's fleet came upon Bonaparte's invasion fleet anchored in Aboukir Bay, twenty miles from Alexandria.[1] The French had expected the British arrival but, with their defensive anchored position strong and sunset falling, they did not expect an immediate assault in ill-charted shallow waters. Nelson, however, attacked without hesitation, and, when darkness fell, battle had been joined. By the following day, the British had captured or sunk eleven French ships of the line in a victory that, although it involved relatively small fleets, was ultimately more significant than Trafalgar. It cut off Napoleon's retreat, terminating the influence of the French navy in the eastern Mediterranean, and consecrating Nelson's status as a naval hero.

At the climax of the battle, the French flagship, *L'Orient*, caught fire and eventually exploded, an event that would become

emblematic of the battle as a whole. The perennially popular subject of a ship on fire was taken to new heights of sublime horror and national import as it became the subject of innumerable depictions, from popular prints issued in immediate response, to paintings displayed in a manner first seen after the battle of the First of June (see cats. 115, 121–23). At the Royal Academy exhibition in 1799 Nicholas Pocock and Robert Cleveley each showed a pair of Nile paintings that included a depiction of *L'Orient* blowing up. At the same exhibition, J. M. W. Turner exhibited his first foray into the portrayal of naval engagements, as "Battle of the Nile, at 10 o'clock when the L'Orient blew up, from the station of the gun boats between the battery and castle of Aboukir." In a radical and perhaps tactical departure from his competitors, Turner appended verses from Milton's *Paradise Lost* to

the title of his work in the exhibition catalogue. The painting was poorly received, however, and disappeared soon afterward: he would not attempt another naval engagement until Trafalgar (see cats. 129–30). Simultaneously with the Royal Academy exhibition the Barkers mounted a panorama of the battle at Leicester Square (cat. 126), and Philippe-Jacques de Loutherbourg exhibited a painting of the subject (Tate) by firelight to enhance the optical effect of the explosion.[2]

As John Bailey's print indicates, Thomas Whitcombe, like many others, attempted to capture the tremendous light and force of *L'Orient*'s explosion. According to contemporary accounts, the conflagration was visible at Rosetta, twelve miles away. Foreseeing the danger if the fire reached *L'Orient*'s powder magazines, the British ships in the vicinity, some of them heavily damaged and with little room or ability to maneuver, took measures to distance themselves. According to one contemporary description, at 10 p.m. *L'Orient* "blew up with a crashing sound that deafened all around her. The tremendous motion, felt to the very bottom of each ship, was like that of an earthquake. The fragments were driven such a vast height into the air that some moments elapsed before they could descend."[3] James Jenkins's book *Naval Achievements* was the first major account of the maritime events of the French Revolutionary and Napoleonic Wars, and was unprecedented in the number and quality of its illustrations: it included fifty-seven hand-colored aquatints after designs by Thomas Whitcombe and Nicholas Pocock, as well as plans and charts. — EH

1. This description of the battle is drawn from Brian Lavery, *Nelson and Nile: The Naval War against Bonaparte, 1798* (London: Chatham, 1998).
2. *Morning Chronicle*, May 20, 1799; cited in Scott Wilcox, introduction to Hyde, *Panoramania!*, 29.
3. Cooper Willyams, *A Voyage up the Mediterranean in His Majesty's Ship the Swiftsure . . . With a Description of the Battle of the Nile, on the First of August 1798* (London: Printed by T. Bensley for J. White, 1802), 55, cited in Lavery, *Nelson and the Nile*, 199.

132

Dominic Serres (1719–1793)

Warships Passing in the Channel

undated
Watercolor with pen and black ink on paper
12 x 19¼ in. (30.5 x 48.9 cm)
Yale Center for British Art, The U Collection. In appreciation of Choh Shiu and Man Foo U, loving parents, and Dorothea and Frank Cockett, dear friends, B2008.30.31

EXHIBITIONS: YCBA 2009

133

William Anderson (1757–1837)

A Frigate Awaiting a Pilot

1797
Watercolor with pen and brown ink on paper
7⅞ x 11¾ in. (20 x 29.8 cm)
Yale Center for British Art, Paul Mellon Collection, B1975.3.1090

PROVENANCE: Palser, from whom acquired by Thomas Girtin Jr., 1908; John Baskett, February 1970 (8), from whom bt by Paul Mellon

EXHIBITIONS: Fitzwilliam 1920 (50); Sheffield 1953 (3); YCBA/NMM 1987 (YCBA only: 58); YCBA 2001 (70)

LITERATURE: Quarm and Wilcox, *Masters of the Sea*, 92, cat. 58; Scott Wilcox et al., *The Line of Beauty: British Drawings and Watercolors of the Eighteenth Century*, exh. cat. (New Haven: Yale Center for British Art, 2001), 88.

134

John Cleveley the Younger (1747–1786)

An English Frigate and Other Shipping in the Solent off Calshot Castle

undated
Watercolor and pen and gray ink on paper
10¼ x 15 in. (26 x 38.1 cm)
Yale Center for British Art, Paul Mellon Collection, B2008.30.30

EXHIBITIONS: YCBA 2009

135

John Cleveley the Younger (1747–1786)

A Calm Day in the Anchorage

undated
Watercolor, graphite, and pen and gray ink on paper
10¼ x 14¼ in. (26 x 36.2 cm)
Yale Center for British Art, The U Collection. In appreciation of Choh Shiu and Man Foo U, loving parents, and Dorothea and Frank Cockett, dear friends, B2008.30.21

EXHIBITIONS: YCBA 2009

136

Samuel Atkins (active 1787–1808)

Men-of-War and Other Shipping on the Thames

undated
Watercolor, pen and black ink, and graphite on paper
4¼ x 11⅝ in. (10.8 x 29.5 cm)
Yale Center for British Art, Paul Mellon Collection, B1975.4.17

PROVENANCE: Leger Galleries, from whom bt by Paul Mellon, June 1964

137

John Thomas Serres (1759–1825)

View of Castle Cornet, Guernsey, Channel Islands, with Shipping

ca. 1799
Watercolor, pen with black ink over graphite on paper
9⅜ x 26¼ in. (23.8 x 66.7 cm)
Yale Center for British Art, Paul Mellon Collection, B1975.3.194

PROVENANCE: Frank T. Sabin, from whom purchased by Paul Mellon, December 1968

EXHIBITIONS: YCBA 1987 (60); YCBA 2001

LITERATURE: Quarm and Wilcox, *Masters of the Sea*, 92, cat. 60; Scott Wilcox et al. *The Line of Beauty: British Drawings and Watercolors of the Eighteenth Century* (New Haven: Yale Center for British Art, 2001), 72.

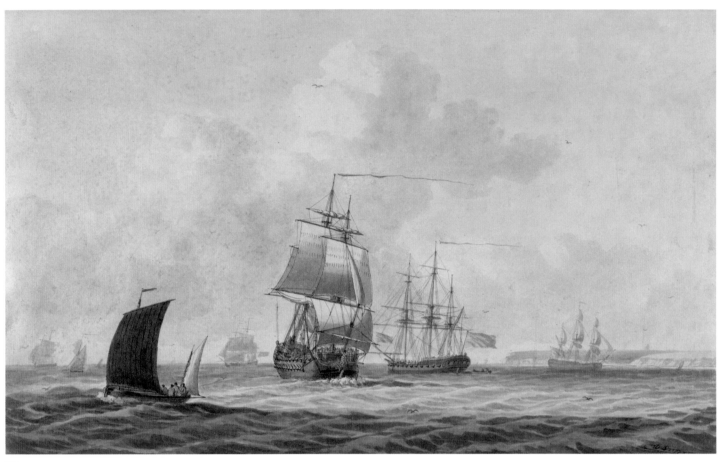

132

133

138

Robert Cleveley (1747–1809)

An English Man-of-War Taking Possession of a Ship

1783
Watercolor, pen and black ink, and graphite
on paper
13 ½ x 19 ¾ in. (34.3 x 50.2 cm)
Yale Center for British Art, Paul Mellon Collection,
B1975.4.1476

PROVENANCE: John Baskett, June/July 1970 (35)
from whom bt by Paul Mellon

EXHIBITIONS: YCBA 1980–81; AFA 1985–86 (12);
YCBA 2001 (69)

LITERATURE: Scott Wilcox et al., *The Line of
Beauty: British Drawings and Watercolors of the
Eighteenth Century* (New Haven: Yale Center for
British Art, 2001), 88.

EVEN AS MARITIME subject matter took on new
forms of representation and exhibition toward
the end of the eighteenth century, it remained
particularly associated with the medium of
watercolor. Marine painters, particularly from
mid-century onward, made presentation water-
color drawings on the same array of subjects as
oil paintings and the prints made after them.
Dominic Serres's view of a busy shipping lane
off the south coast, for example (cat. 132), can
be compared with Charles Brooking's *Shipping
in the English Channel* (cat. 47). In Brooking's
painting, a ship has just dropped the pilot who
guided it out of the anchorage and is setting off
to open sea; in William Anderson's watercolor
made forty years later (cat. 133), a ship awaits a
pilot, apparently in nearly the same spot.

Watercolor lent its expressive qualities
to the representation of weather conditions,
the sine qua non of marine painting, even in
largely topographical views. John Cleveley the
Younger's picture of shipping off Calshot Castle
(cat. 134) captures the light of a breezy day, with
its patches of sunshine and seagulls wheeling
overhead. The freshness of the representation
belies its geopolitical significance: the round
tower built by Henry VIII at the opening of the
River Solent, farther along the south coast, had
been in nearly constant use as a defensive struc-
ture since the sixteenth century, and, as the

134

135

smoke from its chimney and the activity around it suggest, was in use into the later eighteenth century. Cleveley's depiction of an anchorage occupied by a Dutch ship and another vessel in a flat calm (cat. 135) demonstrates a skill with the medium that enables him to convey both the specificity of rigging and the limpid quality of the water. John Cleveley the Younger trained with the topographical landscape artist Paul Sandby. The same specificity and precise delineation in his approach can be seen in Samuel Atkins's *Men-of-War and Other Shipping on the*

Thames (cat. 136), which shows a variety of vessels undergoing repair and maintenance on the river and in adjacent shore facilities. It conveys a sense of both scale and crowding, the latter often remarked by commentators but downplayed by artists for the sake of legibility. Also in the tradition of naval draftsmanship is John Thomas Serres's *View of Castle Cornet, Guernsey, Channel Islands, with Shipping* (cat. 137). Serres may have produced studies for this work when he set out in 1799 to draw topographical profiles of the coasts of France and England

(see cats 82–86). The ship in which he made the cruise, the *Clyde*, is shown to the left, along with other vessels of the squadron.[1]

In 1804 a group of artists formed the Society of Painters in Water Colours, a forum for the annual exhibition and sale of works and for the promotion of watercolor as a medium capable of the painterly effects of oils. Among the founding members was Nicholas Pocock, who exhibited prolifically with the society. While many of his exhibited watercolors were landscapes and generic seascapes, he also showed dozens of

136

137

watercolor views of engagements, for which there was clearly a market: they were less expensive than oil paintings but more exclusive than prints. Robert Cleveley's *An English Man-of-War Taking Possession of a Ship* (cat. 138), albeit made twenty years earlier, is part of the same practice and probably represents an episode during the American Revolution. An English ship has taken possession of another vessel following an action that caused major damage to the sails and rigging of both. A boat plies between the two ships, either bringing prisoners from the prize or transferring officers and crew to man it.

While such views were consistent with other eighteenth-century British marine paintings in their relation to naval draftsmanship, the following generations of artists in watercolor would place greater emphasis on the aesthetic and atmospheric possibilities of the medium. Among those artists were J. M. W. Turner, John Constable, Samuel Prout, Louis Francia, George Chambers, Augustus Wall Callcott, David Cox, and Edward William Cooke. Although, in the aftermath of the Napoleonic Wars, their focus shifted from the telling of a national story to a conception that, as Scott Wilcox has noted, "the sea and man's life on it could be picturesque, sublime, and potently symbolic," theirs was the medium in which marine painting continued to flourish into the nineteenth century.[2] — EH

1. Barritt, *Eyes of the Admiralty*, 112.
2. Scott Wilcox, "The Wider Sea: Marine Watercolours and Landscape Art," in Quarm and Wilcox, *Masters of the Sea*, 37.

138

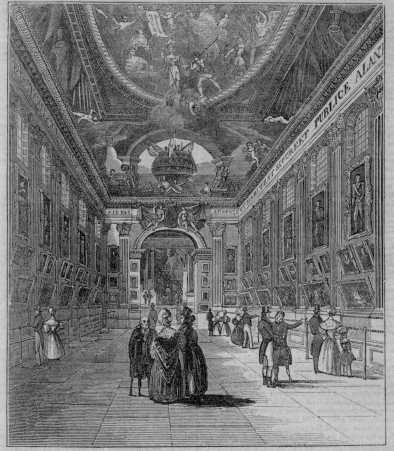

THE PENNY MAGAZINE

OF THE

Society for the Diffusion of Useful Knowledge.

370.] PUBLISHED EVERY SATURDAY. [JANUARY 6, 1838.

THE NAVAL GALLERY, OR PAINTED HALL, IN GREENWICH HOSPITAL.*

[Interior of the Painted Hall, Greenwich Hospital.]

THE "Painted Hall" in Greenwich Hospital is divided into three rooms, the whole of which are before the eye of the spectator as he enters the vestibule. The vestibule is surmounted by one of the two domes which adorn Greenwich Hospital—the great height of the lantern, and

the light thrown on the apartment below, give an air of grandeur to the room. A flight of a few steps leads to the principal room or hall, a noble oblong apartment, the roof of which is painted, and the walls are hung with the pictures constituting the NAVAL GALLERY. The

* Greenwich Hospital has been described in vol. i. p. 97 of the 'Penny Magazine.' Various biographical and other notices of men and events connected with our present subject have appeared in the 'Penny Magazine'—such as sketches of Blake, Cooke, and

VOL. VII.

Nelson, in vol. i.; of Exmouth in vol. ii.; a brief account of the Armada, in the description of the tapestry destroyed in the fire of the Houses of Parliament, in vol. iii.; and different accounts of the loss of the Royal George in vols. i., iii., and iv.

B

139

139

Unknown maker

Interior of the Painted Hall, Greenwich Hospital

in *Penny Magazine of the Society for the Diffusion of Useful Knowledge*, January 6, 1838
Beinecke Rare Book & Manuscript Library, Yale University, 2007 +S164 (vol. 7)

THE ROYAL HOSPITAL for Seamen at Greenwich, a royal charity housing naval veterans, was founded in the late seventeenth century and built on a grand scale, to compete with similar establishments recently erected in France. In 1795, at the height of the French Revolutionary War, Captain William Locker suggested that Greenwich Hospital, as it was called, host a public gallery celebrating naval achievement. Thirty years later, this vision was carried out by his son Edward Hawke Locker, who proposed that the hospital's Painted Hall, named for its elaborate decorations by Sir James Thornhill, "could form an admirable Gallery for Pictures, Sculptures and other objects commemorative of the distinguished Exploits of the British Navy."[1] In this new gallery, Edward Hawke Locker translated the eighteenth-century domestic display practices he had learned from his father for the purposes of a public museum. The resulting display combined gifts from the monarch with donations from naval officers' descendants of portraits and marine paintings originally designed as domestic commemorative objects. Combined with Thornhill's celebratory decorative scheme, these artworks became part of a statement on national maritime glory.

The National Gallery of Naval Art, known as the Naval Gallery, was designed to promote social unity and reverence for authority in the aftermath of the French wars, whose conclusion brought martial triumph but also severe economic hardship. As the nation struggled to return to a peacetime economy, injured and destitute veterans became a common and troubling sight in the cities.[2] A very fortunate minority of these veterans, known as Greenwich Pensioners, found refuge at Greenwich Hospital. As shown here, they served as guides in the gallery, collecting donations and discussing the

works on view. Their wounded bodies signified the human costs of the victories celebrated in the Naval Gallery, while their status as pensioners provided reassuring evidence of the state's care for its veterans. The article accompanying this engraving from the *Penny Magazine* addressed the apparent mismatch between these maimed bodies and the elaborate architectural spaces they occupied: "The appearance of these veterans, — some without a leg or arm, others hobbling from the infirmities of wounds or years, and all clothed in old-fashioned blue coats or breeches with cocked hats, — would oddly contrast with the splendor of the buildings which they inhabit, did not the recollection that these men were amongst the noblest defenders of their country, give a dignity to the objects that everywhere present themselves."[3] In the engraving, a youthful-looking pensioner converses with a top-hatted gentleman, directing the man's attention to the paintings on the wall with an emphatic arm gesture. His status as pensioner is indicated by both his uniform and his artificial leg; its pale, thin form rhymes visually with his gesturing hand, suggesting that his sacrifice gives him the right to speak.

Written accounts of the Naval Gallery, however, often treat the pensioners as sources of amusement or as pests, claiming the gallery for the elite who commissioned and donated works of art, rather than for the working-class veterans who sought to interpret the gallery for visitors.[4] — CACR

1. Edward Hawke Locker, "Memorandum," September 20, 1823. The National Archives, Public Record Office, 30/26/27, 19.
2. Timothy Jenks, *Naval Engagements: Patriotism, Cultural Politics, and the Royal Navy, 1793–1815* (Oxford: Oxford Univ. Press, 2006), 204.
3. "The Naval Gallery," *Penny Magazine of the Society for the Diffusion of Useful Knowledge* (Jan. 6, 1838): 97.
4. Ralph Nicholson Wornum, *The Turner Gallery: A Series of Sixty Engravings from the Principal Works of Joseph Mallord William Turner* (London: James S. Virtue, 1861), 16.

140

John Scarlett Davis

Interior of the Painted Hall, Greenwich Hospital

1830
Oil on canvas
44 3/8 x 56 1/2 in. (112.7 x 143.5 cm)
Walters Art Museum, 37.761

PROVENANCE: Charles Long, 1st Baron Farnborough; Henry Walters, by whose bequest given to the Walters Art Museum, 1931

EXHIBITIONS: BI 1831

LITERATURE: William R. Johnston, *The Nineteenth-Century Paintings in the Walters Art Gallery* (Baltimore: The Trustees of the Walters Art Gallery, 1982), 201, cat. 257

THIS PAINTING PROVIDES a rare representation of the National Gallery of Naval Art, installed in the Painted Hall at Greenwich Hospital, in its early years.[1] The artist, John Scarlett Davis, was seeking to establish himself as a specialist in gallery painting, a genre that originated in the sixteenth century and took on new significance with the advent of public museums.[2] Davis evidently created the painting on speculation, basing it on a drawing made in situ (fig. 118), but was assisted in finding a buyer by the gallery's curator (in all but name), Edward Hawke Locker. Locker recommended the artist to his friend Charles Long, Lord Farnborough, an influential patron of the arts and a close collaborator in developing the gallery's visual program. Long reported to his friend:

I saw Mr. Davis this morning and liked his Picture much — he asked me whether I would recommend it to any body — of course I asked him what he expected for it he said his utmost expectation was 100 G. but he would take less in short any thing I pleased, but if he did not sell at last he must put it into the hand of a dealer and take what he could get — for he

FIG. 118. John Scarlett Davis, *The Painted Hall of Greenwich Hospital from the Vestibule*, 1830, graphite with gray-blue wash on paper, 25 5/8 x 25 3/4 in. (65.2 x 65.4 cm). National Maritime Museum, Greenwich, London

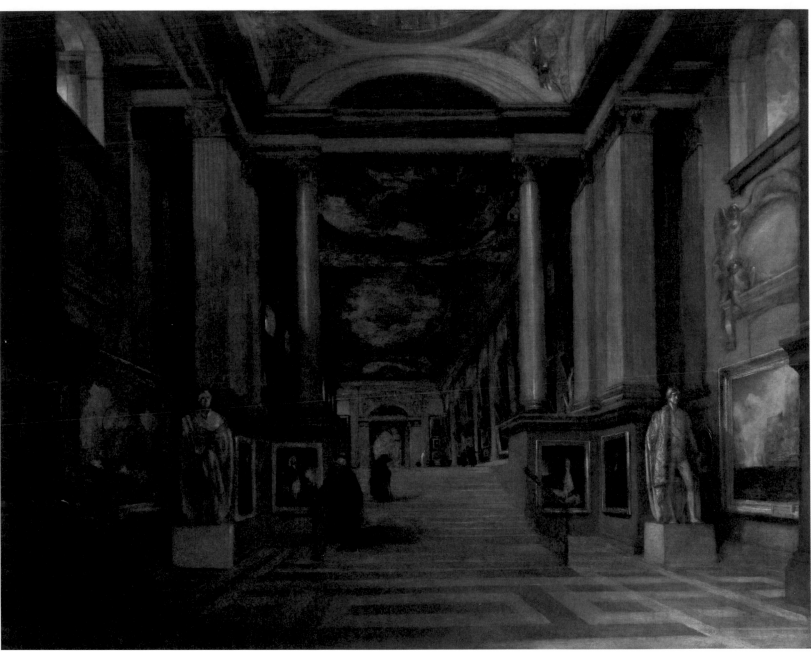

140

had lately sustained some losses by prints he had published — so I gave him his hundred Guineas and sent him away very happy — he seems to be very modest as to his own merits — it is really a very clever work of Art and he is ill paid for his time and labour in the sum he has received for it.[3]

The result was not only a clever work of art, but also an evocative image of this important site of

national memory, which commemorated the role of the navy — and, especially, its elite officers — in protecting the nation.[4]

Although in other gallery views Davis took great liberties, his depiction of the Naval Gallery largely accords with what is known of its early installations.[5] Framing the foreground are two monumental paintings recently donated to the gallery by George IV, depicting the first and last major naval conflicts of the French Revolutionary

and Napoleonic Wars. On the left is Philippe-Jacques de Loutherbourg's *Earl Howe's Victory over the French Fleet* of 1795, celebrating the battle of the First of June (see cat. 123), and on the right, J. M. W. Turner's *Battle of Trafalgar* of 1824 (fig. 119).[6] These images of actions are complemented by images of the officers who fought in them. Flanking Turner's painting is a plaster cast of John Flaxman's monument to Admiral Lord Nelson, one of a set of plaster

replicas after monuments in St. Paul's Cathedral. Nelson's likeness seems to gaze upon Turner's representation of the battle that confirmed his reputation as admiral of the age and also took his life. Although one would expect the statue at left to depict the victorious admiral of the First of June, Richard Howe, first Earl Howe, it is instead a cast of Richard Westmacott's monument to Admiral Adam Duncan, first Viscount Duncan, who had defeated the Dutch fleet in the Battle of Camperdown (1797).[7] However, another officer who fought on the First of June is represented: the elegantly posed portrait at far left is Sir Joshua Reynolds's depiction of Alexander Hood, first Viscount Bridport, who was third in command under Howe at the battle. Together, these paintings and sculptures provide a summation of Britain's naval struggles against France and its allies and of artists' efforts to commemorate those conflicts.

The portraits hanging to either side of the stairs celebrate a different aspect of Britain's maritime achievements: exploration. Both subjects were famous for circumnavigating the globe and exploring the Pacific islands. To the left hangs a portrait of Admiral George Anson, Lord Anson, and to the right, one of Captain James Cook. All of these works of art are juxtaposed

with the pensioners, who served as living relics and as reassuring symbols of state care at a time when many veterans were destitute. To the left, beneath the portrait of Bridport, stands a pensioner of African descent, marked out as different not only by his skin color, but also by his relative youth and lack of a visible walking aid. His is an ambiguous figure, at once a symbol and an agent of empire. He is possibly John Deman, who served with Nelson in the West Indies. In the center of the composition, an elderly pensioner pauses on the stairs next to Anson's portrait. Both pensioner and painted admiral extend a hand. While the admiral gestures in confident command, the pensioner leans on a rail for support — and yet their postures echo each other, forming a tightly linked compositional unit. This passage — present even in Davis's preparatory drawing — suggests an affinity between officers and working-class veterans that is rare in depictions of the Naval Gallery, most of which treat the pensioners as figures of fun or as anthropological curiosities. This painting depicts veterans both as contributors to maritime endeavors and as the natural audience for a museum celebrating those endeavors.

In the distance, two figures contemplate a smaller-scale marine painting, of the type

commissioned by Anson and other naval officers in the eighteenth century. In the wake of the Napoleonic wars, such images were not forgotten, but rather integrated into a larger public statement of the history of the navy. At the Naval Gallery there was room for both the sublime bombast of Loutherbourg and Turner and the evocative statements of Dominic Serres and Nicholas Pocock. — CACR

1. The earliest firmly dated diagram of the display is from 1839 and reflects a later phase in the gallery's development. For documents on the hang, see Cicely Robinson, "Edward Hawke Locker and the Foundation of the National Gallery of Naval Art (c. 1795–1845)" (PhD diss., Univ. of York, 2014).

2. Catherine Roach, "Images as Evidence? Morse and the Genre of Gallery Painting," in *Samuel F. B. Morse's Gallery of the Louvre and the Art of Invention*, ed. Peter John Brownlee (New Haven: Terra Foundation for American Art, 2014), 46–59.

3. Charles Long, Baron Farnborough, to Edward Hawke Locker, Aug. 20, 1830. Huntington Library, LR 250. Long's purchase was publicized the following year: "British Gallery," *The Literary Gazette*, April 16, 1831, 251.

4. On the gallery's conservative political aims, see Pieter van der Merwe, "'A Proud Monument of the Glory of England': The Greenwich Hospital Collection," in Quilley, *Art for the Nation*, 19–38.

5. For other Davis views, see Catherine Roach, *Pictures-within-Pictures in Nineteenth-Century Britain* (London: Routledge, 2016), chap. 1.

6. All paintings identified here are now in the Greenwich Hospital Collection, National Maritime Museum, Greenwich.

7. It is not clear whether the placement of the Duncan statue represents an early phase in the installation or was an intervention on Davis's part. An undated diagram of the vestibule created by Locker shows a total of four casts, with Howe's likeness in the position occupied by that of Duncan in Davis's painting. See Robinson, "Edward Hawke Locker," 2:fig. 33.

FIG. 119. J. M. W. Turner, *The Battle of Trafalgar, 21 October 1805*, 1822–24, oil on canvas, 103 x 145 in. (261.5 x 368.5 cm). National Maritime Museum, Greenwich, London, Greenwich Hospital Collection

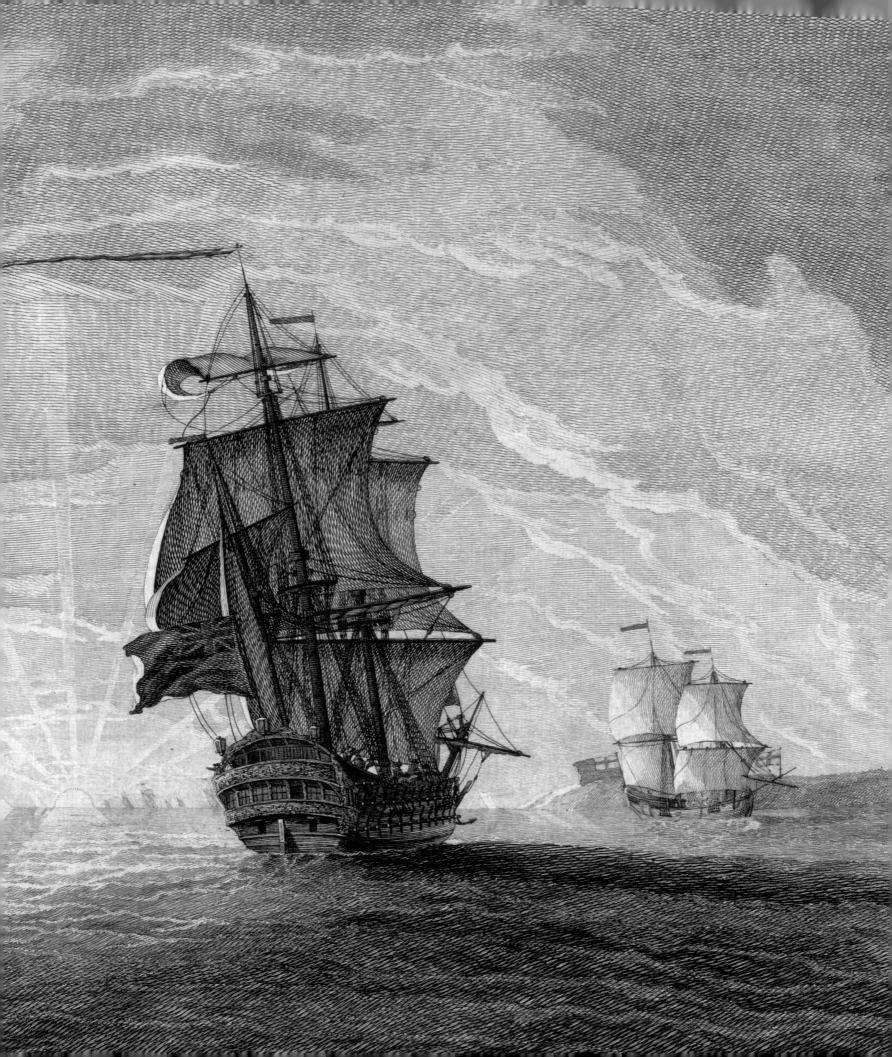

SELECTED BIBLIOGRAPHY

Albion, Robert Greenhalgh. *Forests and Sea Power: The Timber Problem of the Royal Navy, 1652–1862*. Cambridge, MA: Harvard Univ. Press, 1926.

Altick, Richard Daniel. *The Shows of London*. Cambridge, MA: Belknap Press of Harvard Univ. Press, 1978.

Archibald, E. H. H. *Dictionary of Sea Painters*. Woodbridge, UK: Antique Collectors' Club, 1980.

Barritt, M. K. *Eyes of the Admiralty: J. T. Serres, an Artist in the Channel Fleet, 1799–1800*. London: National Maritime Museum, 2008.

Beddington, Charles, ed. *Canaletto in England: A Venetian Artist Abroad, 1746–1755*. Exh. cat. New Haven: Yale Univ. Press, 2006.

Black, Jeremy, and Philip Woodfine, eds. *The British Navy and the Use of Seapower in the Eighteenth Century*. Leicester: Leicester Univ. Press, 1988.

Bold, John. *Greenwich: An Architectural History of the Royal Hospital for Seamen and the Queen's House*. New Haven and London: Published for the Paul Mellon Centre for Studies in British Art by Yale Univ. Press, in association with English Heritage, 2000.

Brook-Hart, Denys. *British 19th-Century Marine Painting*. Woodbridge, UK: Antique Collectors' Club, 1974.

Bruce, A. P. C., and William B. Cogar. *An Encyclopedia of Naval History*. New York: Facts on File, 1998.

Cable, James. *The Political Influence of Naval Force in History*. New York: Palgrave Macmillan, 1998.

Clifton, Gloria, and Nigel Rigby. *Treasures of the National Maritime Museum*. London: National Maritime Museum, 2004.

Clowes, William Laird. *The Royal Navy: A History*. 7 vols. Boston: Little, Brown and Company; London: S. Low, Marston & Company, 1897–1903.

Coad, Jonathan G. *The Royal Dockyards, 1690–1850: Architecture and Engineering Works of the Sailing Navy*. Aldershot, UK: Scholar Press, 1989.

Cockett, F. B. *Early Sea Painters, 1660–1730*. Woodbridge, UK: Antique Collectors' Club, 1995.

———. *Peter Monamy, 1681–1749, and His Circle*. Woodbridge, UK: Antique Collectors' Club, 2000.

Colley, Linda. *Britons: Forging the Nation, 1707–1837*. London: Vintage, 1996.

———. *Captives: Britain, Empire and the World 1600–1850*. London: Pimlico, 2003.

Coke, David, and Alan Borg. *Vauxhall Gardens: A History*. New Haven and London: Published for the Paul Mellon Centre for Studies in British Art by Yale Univ. Press, 2011.

Cordingly, David. *Marine Painting in England, 1700–1900*. London: Studio Vista, 1974.

———. *Nicholas Pocock, 1740–1821*. London: Conway Maritime Press, 1986.

David, Andrew C. F. "The Glorious First of June: An Account of the Battle by Peter Heywood." *Mariner's Mirror* 64, no. 4 (1978): 361–66.

Davies, David. *Fighting Ships: Ships of the Line, 1793–1815*. London: Constable, 1996.

Dening, Greg. *Mr. Bligh's Bad Language: Passion, Power, and Theatre on the* Bounty. Cambridge: Cambridge Univ. Press, 1992.

Deuchar, Stephen. *Concise Catalogue of Oil Paintings in the National Maritime Museum*. Woodbridge, UK: Antique Collectors' Club, 1988.

Duffy, Michael. *Soldiers, Sugar and Seapower: The British Expeditions to the West Indies and the War against Revolutionary France*. Oxford: Clarendon Press, 1987.

Duffy, Michael, and Roger Morris, eds. *The Glorious First of June 1794: A Naval Battle and its Aftermath*. Exeter: Univ. of Exeter Press, 2001.

Edelstein, T. J., ed. *Vauxhall Gardens*. New Haven: Yale Center for British Art, 1983.

Edwards, Edward. *Anecdotes of Painters Who Have Resided or Been Born in England, with Critical Remarks on Their Productions*. London: Leigh and Sotheby, 1808.

Farington, Joseph. *The Diary of Joseph Farington*. Edited by Kenneth Garlick and Angus Macintyre. 16 vols. New Haven and London: Published for the Paul Mellon Centre for Studies in British Art by Yale Univ. Press, 1978 onward; original ed. 1922–28.

Fordham, Douglas. *British Art and the Seven Years' War: Allegiance and Autonomy*. Philadelphia: Univ. of Pennsylvania Press, 2010.

Gaunt, William. *Marine Painting: An Historical Survey*. London: Secker and Warburg, 1975.

Grau, Oliver. *Virtual Art: From Illusion to Immersion*. Rev. and expanded ed. Cambridge, MA: MIT Press, 2003.

Harris, Rhian, and Robin Simon, eds. *Enlightened Self-Interest: The Foundling Hospital and Hogarth, an Exhibition at the Thomas Coram Foundation for Children*. London: Draig Publications and the Thomas Coram Foundation for Children, 1997.

Harrison-Wallace, Charles. "Peter Monamy." *Société Jersiase, Annual Bulletin* 23, no. 1 (1981): 97–113.

Hartman, Cyril Hughes. *The Angry Admiral: The Later Career of Edward Vernon, Admiral of the White*. London: Heinemann, 1953.

Hill, Richard. *The Prizes of War: The Naval Prize System in the Napoleonic Wars, 1793–1815*. Stroud, UK: Sutton Publishing in association with the Royal Naval Museum, 1998.

Hogarth, William. *The Analysis of Beauty*. Edited by Ronald Paulson. New Haven and London: Published for the Paul Mellon Centre for Britsh Art by Yale Univ. Press, 1997; original ed., 1753.

Hoock, Holger. *Empires of the Imagination: Politics, War, and the Arts in the British World, 1750–1850*. London: Profile Books, 2010.

Hughes, Eleanor. "The Battle of the Pictures." In Riding and Johns, *Turner and the Sea*, 52–54.

———. "Guns in the Gardens: Peter Monamy's Paintings for Vauxhall." In *The Pleasure Garden, from Vauxhall to Coney Island*, edited by Jonathan Conlin. Philadelphia: Univ. of Pennsylvania Press, 2013. 78–99.

———. "Sanguinary Engagements: Exhibiting the Naval Battles of the French Revolutionary and Napoleonic Wars." In *Exhibiting the Empire: Cultures of Display and the British Empire*, edited by John McAleer and John McKenzie. Manchester: Manchester Univ. Press, 2015. 90–110.

———. "Ships of the 'Line': Marine Paintings at the Royal Academy Exhibition of 1784." In *Art and the British Empire*, edited by Tim Barringer, Geoff Quilley, and Doug Fordham. Manchester: Manchester Univ. Press, 2007. 139–52.

———. "Trade and Transport: The *Westmorland* in Context." In *The English Prize: The Capture of the* Westmorland, *an Episode of the Grand Tour*, edited by María Dolores Sánchez-Jáuregui and Scott Wilcox. New Haven: Yale Center for British Art, 2012. 32–43.

———. "Vessels of Empire." PhD diss., University of California, Berkeley, 2001.

Hyde, Ralph, ed. *Panoramania! The Art and Entertainment of the "All-Embracing" View*. Exh. cat. London: Trefoil in association with Barbican Art Gallery, 1988.

Jenks, Timothy. *Naval Engagements: Patriotism, Cultural Politics, and the Royal Navy, 1793–1815*. Oxford: Oxford Univ. Press, 2006.

Joel, David. *Charles Brooking, 1728–1759, and the 18th Century British Marine Painters*. Woodbridge, UK: Antique Collectors' Club, 2000.

Jordan, Gerald, and Nicholas Rogers. "Admirals as Heroes: Patriotism and Liberty in Hanoverian England." *Journal of British Studies* 28, no. 3 (July 1989): 201–24.

Keyes, George S., ed. *Mirror of Empire: Dutch Marine Art of the Seventeenth Century*. Exh. cat. Minneapolis: Minneapolis Institute of Arts; Cambridge: Cambridge Univ. Press, 1990.

Kingzett, Richard. "A Catalogue of the Works of Samuel Scott." *Walpole Society* 48 (1980–82): 1–134.

Kriegstein, Arnold, and Henry Kriegstein. *17th and 18th Century Ship Models from the Kriegstein Collection*. 2nd rev. and expanded ed. Florence, OR: SeaWatch Books, 2010.

Lefeuvre, Olivier. *Philippe-Jacques de Loutherbourg, 1740–1812*. Preface by David Bindman. Paris: Arthéna, 2012.

Linebaugh, Peter, and Marcus Rediker. *The Many-Headed Hydra: Sailors, Slaves, Commoners, and the Hidden History of the Revolutionary Atlantic*. Boston: Beacon Press, 2000.

Lyon, David. *Sea Battles in Close-Up: The Age of Nelson*. Shepperton, UK: Ian Allan in association with the National Maritime Museum, Greenwich, 1996.

MacDougall, Philip. *Royal Dockyards*. Newton Abbot, UK: David & Charles, 1982.

Mahan, Alfred Thayer. *The Influence of Sea Power Upon History, 1660-1783*. Boston: Little, Brown and Company, 1890.

Meslay, Olivier. "Dominic Serres, peintre de marine du roi George III d'Angleterre." *Société archéologique et historique du Gers* (3e trimestre 1997): 288–321.

Minchinton, Walter E. "Richard Champion, Nicholas Pocock, and the Carolina Trade: A Note." *South Carolina Magazine* 70, no. 2 (April 1969): 97–103.

Monks, Sarah. "Fishy Business: Richard Wright's *The Fishery* (1764), Marine Painting, and the Limits of Refinement in Eighteenth-Century London." *Eighteenth-Century Studies* 41, no. 3 (2008): 405–21.

———. "Our Man in Havana: Representation and Reputation in Lieutenant Philip Orsbridge's *Britannia's Triumph*." In *Conflicting Visions: War and Visual Culture in Britain and France c. 1700–1830*, edited by John Bonehill and Geoff Quilley. Aldershot, UK: Ashgate, 2005. 85–114.

———. "Turner Goes Dutch." In *Turner and the Masters*, edited by David Solkin. Exh. cat. London: Tate Publications, 2009. 73–85.

Morriss, Roger. *The Royal Dockyards during the French Revolutionary and Napoleonic Wars*. Leicester: Leicester Univ. Press, 1983.

Nicolson, Benedict. *The Treasures of the Foundling Hospital*. Oxford Studies in the History of Art and Architecture. Oxford: Clarendon Press, 1972.

Oettermann, Stephan. *The Panorama: History of a Mass Medium*. New York: Zone Books, 1997.

Oleksijczuk, Denise. *The First Panoramas: Visions of British Imperialism*. Minneapolis: Univ. of Minnesota Press, 2011.

Padfield, Peter. *Maritime Supremacy and the Opening of the Western Mind: Naval Campaigns That Shaped the Modern World, 1588–1782*. London: John Murray, 1999.

Paulson, Ronald. *Hogarth*. 3 vols. New Brunswick, NJ: Rutgers Univ. Press, 1991–93.

Quarm, Roger, and Scott Wilcox. *Masters of the Sea: British Marine Watercolours*. Oxford and New Haven: Phaidon in association with the National Maritime Museum, Greenwich, and the Yale Center for British Art, New Haven, 1987.

Quilley, Geoff. "Art History and Double Consciousness: Visual Culture and Eighteenth-Century Maritime Britain." *Eighteenth-Century Studies* 48, no. 1 (Fall 2014): 21–35.

———, ed. *Art for the Nation: The Oil Paintings Collection of the National Maritime Museum*. London: National Maritime Museum, 2006.

———. *Empire to Nation: Art, History, and the Visualization of Maritime Britain, 1768–1829*. New Haven and London: Published for the Paul Mellon Centre for Studies in British Art by Yale Univ. Press, 2011.

———. "Missing the Boat: The Place of the Maritime in the History of British Visual Culture." *Visual Culture in Britain* 1 (2001): 79–92.

Reynolds, Joshua. *Discourses on Art*. Edited by Robert R. Wark. New Haven and London: Published for the Paul Mellon Centre for Studies in British Art by Yale Univ. Press, 1997; original ed., 1769–91.

Riding, Christine, and Richard Johns, eds. *Turner & the Sea*. Exh. cat. London: Thames & Hudson, 2013.

Roach, Catherine. "Domestic Display and Imperial Identity: A Visual Record of the Art Collections of Edward Hawke Locker." *Huntington Library Quarterly* 75, no. 3 (Autumn 2012): 411–28.

Robinson, M. S. *Van de Velde: A Catalogue of the Paintings in the National Maritime Museum Made by the Elder and the Younger Willem van de Velde*. Greenwich: National Maritime Museum, 1990.

———. *Van de Velde Drawings: A Catalogue of Drawings in the National Maritime Museum Made by the Elder and the Younger Willem van de Velde.* Cambridge: Cambridge Univ. Press, 1958.

Rodger, N. A. M. *The Wooden World: An Anatomy of the Georgian Navy.* London: Folio Society, 1986.

Rouquet, Jean André. *The Present State of the Arts in England.* Translated from French. 1755; facs. repr. London: Cornmarket Press, 1970.

Russell, Gillian. *The Theatres of War: Performance, Politics and Society, 1793–1815.* Oxford: Clarendon Press 1995.

Russell, Margarita. *Visions of the Sea: Hendrick C. Vroom and the Origins of Dutch Marine Painting.* Leiden: Published for the Sir Thomas Browne Institute by E. J. Brill and Leiden Univ. Press, 1983.

Russett, Alan. *Dominic Serres R. A., 1719–1793: War Artist to the Navy.* Woodbridge, UK: Antique Collectors' Club, 2001.

———. *John Thomas Serres, 1759–1825: The Tireless Enterprise of a Marine Artist.* Hampshire, UK: Sea Torch, 2010.

———. "Peter Monamy's Marine Paintings for Vauxhall Gardens." *Mariner's Mirror* 80, no. 1 (1994): 79–84.

Sánchez-Jáuregui, María Dolores, and Scott Wilcox, eds. *The English Prize: The Capture of the* Westmorland, *an Episode of the Grand Tour.* New Haven: Yale Center for British Art, 2012.

Solkin, David H. *Art in Britain, 1660–1815.* New Haven and London: Yale Univ. Press in association with the Paul Mellon Centre for Studies in British Art, 2015.

———, ed. *Art on the Line: The Royal Academy Exhibitions at Somerset House, 1780–1836.* New Haven and London: Published for the Paul Mellon Centre for Studies in British Art and the Courtauld Institute Gallery by Yale Univ. Press, 2001.

———. *Painting for Money: The Visual Arts and the Public Sphere in Eighteenth-Century England.* (New Haven and London: Published for the Paul Mellon Centre for Studies in British Art by Yale Univ. Press, 1992).

Sorensen, Colin. *Charles Brooking, 1723–1759: Paintings, Drawings and Engravings.* Exh. cat. Paul Mellon Foundation for British Art, Aldeburgh Festival of Music and the Arts, Bristol City Art Gallery. Printed by Westerham Press, 1966.

Sutherland, William. *The Shipbuilder's Assistant: or, Some Essays toward Compleating the Art of Marine Architecture . . .* London: Printed for R. Mount, A. Bell, and R. Smith, 1711.

Taylor, James. *Marine Painting: Images of Sail, Sea and Shore.* London: Studio Editions, 1995.

Vertue, George. *Note-books.* 6 vols. *Walpole Society* 18, 20, 22, 24, 26, 30 (1930–55).

Wareham, Tom. *The Star Captains: Frigate Command in the Napoleonic Wars.* London: Chatham Publishing, 2001.

Warner, Oliver. *The Glorious First of June.* London: Batsford, 1961.

Whitley, William T. *Artists and Their Friends in England, 1700–1900.* London: The Medici Society, 1928.

Wilson, Kathleen. *The Sense of the People: Politics, Culture and Imperialism in England, 1715–1785.* Cambridge: Cambridge Univ. Press, 1998.

NOTE ON TITLES

Works of art that were exhibited during the period under consideration have the titles they were given when first shown, but any factual errors in the original titles (such as dates of engagements) have been corrected. Format follows modern convention (italics, capitalization), and ship names have been adjusted to current spelling.

ABBREVIATIONS

CONTRIBUTORS

EH Eleanor Hughes
SL Sophie Lynford
JM John McAleer
CR Christine Riding
CACR Catherine Roach
PvDM Pieter van der Merwe

EXHIBITIONS

AFA 1985–86
British Watercolors: Drawings of the Eighteenth and Nineteenth Centuries from the Yale Center for British Art, American Federation of Arts, 1985–86

Aldeburgh/Bristol 1966
Charles Brooking, 1723–1759: Paintings, Drawings, and Engravings, Aldeburgh Festival, June 9–12, 1966; Bristol City Art Gallery, July 1–30, 1966

BFAC 1926
Burlington Fine Arts Club, London, 1926

BFAC 1929
Marine Art, Burlington Fine Arts Club, London, 1929

BI
Annual exhibitions, British Institution for Promoting the Fine Arts in the United Kingdom, London

Birmingham 1899
Loan Collection of Pictures and Drawings by J. M. W. Turner, R. A., Corporation of Birmingham Museum and Art Gallery, 1899

Birmingham 2003–2004
The Sun Rising through Vapour: Turner's Early Seascapes, The Barber Institute of Fine Arts, University of Birmingham, October 24, 2003–January 25, 2004

BM 1969
Royal Academy Draughtsmen, 1769–1969, British Museum, London, June 13–September 28, 1969

Bruce 1999–2000
The Art of Time, Bruce Museum, Greenwich, CT, December 18, 1999–March 19, 2000

Colnaghi 1963
A Loan Exhibition of English Drawings and Watercolours in Memory of the Late D. C. T. Baskett, P & D Colnaghi, London, 1963

Colnaghi/YUAG 1964–65
English Drawings and Watercolours from the Collection of Mr. and Mrs. Paul Mellon, P & D Colnaghi, London, December 14, 1964–January 22, 1965; Yale University Art Gallery, New Haven, April 15–June 20, 1965

European Museum
European Museum, King Street, London

Ferens 1951
Ferens Art Gallery, Hull, June–July 1951

Fitzwilliam 1920
Drawings by the Early English Watercolorists, Fitzwilliam Museum, University of Cambridge, 1920

Guildhall 1899
Guildhall Loan Collection of Pictures and Drawings by J. M. W. Turner, R. A., and of a Selection of Pictures by Some of His Contemporaries, Corporation of London Art Gallery, April–July, 1899

Guildhall 1955
Samuel Scott, Guildhall Art Gallery, London, July 6–August 12, 1955

Guildhall 1965
Canaletto and His Influence on London Artists, Guildhall Art Gallery, London, June 9–July 3, 1965

Guildhall 1972
Samuel Scott Bicentenary Exhibition, Guildhall Art Gallery, London, May 4–June 3, 1972

Museum of the Horse 2003
All the Queen's Horses, International Museum of the Horse, Lexington, KY, April 26–August 24, 2003

Royal Hospital 1891
Royal Naval Exhibition, Royal Hospital, Chelsea, May 2–October 24, 1891

NGA 1962

English Drawings and Watercolours from the Collection of Mr. and Mrs. Paul Mellon, National Gallery of Art, Washington, DC, February 18–April 1, 1962

NGA 1968–69

J. M. W. Turner: A Selection of Paintings from the Collection of Mr. And Mrs. Paul Mellon, National Gallery of Art, Washington, DC, October 31, 1968–April 21, 1969

NGA/DMA/MMA 2007–2008

J. M. W. Turner, National Gallery of Art, Washington, DC, October 1, 2007–January 6, 2008; Dallas Museum of Art, February 10–May 18, 2008; Metropolitan Museum of Art, New York, July 1–September 21, 2008

NMM 1982

The Art of the Van de Veldes, National Maritime Museum, Greenwich, 1982

NMM 2012

Royal River: Power, Pageantry and the Thames, National Maritime Museum, Greenwich, April 27–September 9, 2012

NMM 2014–15

Ships, Clocks & Stars: The Quest for Longitude, National Maritime Museum, Greenwich, July 11, 2014–January 4, 2015

NMM/PEM 2013–14

Turner & the Sea, National Maritime Museum, Greenwich, November 21, 2013–April 21, 2014; Peabody Essex Museum, Salem, MA, May 31–September 1, 2014

Penn State 1982

The England of William Penn, 1644–1718, Pennsylvania State University, State College, PA, September 8–October 31, 1982

RA

Annual summer exhibitions of contemporary art, Royal Academy, London

RA Winter

Annual winter exhibitions of old masters, Royal Academy, London

RA 1951–52

The First 100 Years of the Royal Academy, 1769–1868, Royal Academy, London, December 8, 1951–March 9, 1952

RA 1955–56

English Taste in the Eighteenth Century, Royal Academy, London, December 3, 1955–February 26, 1956

RA 1974–75

Turner 1775–1851, Tate Gallery and Royal Academy at the Royal Academy, London, November 1974–March 1975

Sheffield 1953

Early Water-Colours from the Collection of Thomas Girtin Jnr, Graves Art Gallery, Sheffield, 1953

Strasbourg 2012–13

Loutherbourg (Strasbourg 1740–London 1812): Torments and Chimeras, Musée des Beaux-Arts, Strasbourg, November 17, 2012–February 18, 2013

Tate Gallery 1931

Turner's Early Oil-Paintings (1796–1815), Tate Gallery, London, July–September 1931

VMFA/RA/YUAG 1963–65

Painting in England, 1700–1850, from the Collection of Mr. and Mrs. Paul Mellon, Virginia Museum of Fine Arts, Richmond, 1963; Royal Academy of Arts, London, Winter 1964–65; Yale University Art Gallery, New Haven, April–June, 1965

YCBA 1977–78

Seascapes, Yale Center for British Art, New Haven, October 21, 1977–April 16, 1978

YCBA 1979–80

Country Houses in Great Britain, Yale Center for British Art, New Haven, October 1979–January 1980

YCBA 1980–81

Selected Watercolors, Yale Center for British Art, New Haven, December 3, 1980–January 25, 1981

YCBA/NMM 1987

Masters of the Sea: British Marine Watercolors, 1650–1930, Yale Center for British Art, New Haven, June 10–August 2, 1987; National Maritime Museum, Greenwich, August 25–October 25, 1987

YCBA 2001

The Line of Beauty: British Drawings and Watercolors of the Eighteenth Century, Yale Center for Britsh Art, New Haven, May 17–September 2, 2001

YCBA 2006

Art and Music in Britain: Four Encounters, 1730–1900, Yale Center for British Art, New Haven, October 5–December 31, 2006

YCBA 2007

Paul Mellon's Legacy: A Passion for British Art, Yale Center for British Art, New Haven, April 18–July 29, 2007

YCBA 2008

Pearls to Pyramids: British Visual Culture and the Levant, 1600–1830, Yale Center for British Art, New Haven, February 7–April 27, 2008

YCBA 2009

Seascapes: Marine Paintings and Watercolors from the U Collection, Yale Center for British Art, New Haven, May 28–August 23, 2009

YCBA/Ashmolean 2012–13

The English Prize: The Capture of the Westmorland, An Episode of the Grand Tour, Ashmolean Museum of Art and Archaeology, University of Oxford, May 17–August 27, 2012; Yale Center for British Art, October 4, 2012–January 13, 2013

INDEX

Italicized page numbers indicate illustrations. Works of artists and authors are listed under their names. Named vessels are listed under "ships."

PHOTOGRAPHY CREDITS

Every effort has been made to credit the photographers and sources of all illustrations in this volume; if there are any errors or omissions, please contact Yale University Press so that corrections can be made in any subsequent edition.

Art Gallery of South Australia, Adelaide, Gift of James & Ann Douglas in memory of Sholto and Alison Douglas 2001: fig. 15

Bedfordshire Archives & Records Service: cat. 48

Beinecke Rare Book & Manuscript Library, Yale University: figs. 40, 65, 84, 86, 87, 105; cats. 42, 49, 50, 94, 139

© Bonhams: fig. 12

© Bristol Museum & Art Gallery, UK/Bridgeman Images: fig. 109

© Bristol Museum and Art Gallery, UK/Purchased, 1938./Bridgeman Images: fig. 7

Collection of Dr. Stephen K. and Janie Woo Scher/Photography Stephen K. Scher: cats. 28, 29, 30

© Coram in the care of the Foundling Museum, London: fig. 5; cat. 40

Courtesy Marquess of Zetland, © Eileen Tweedy/The Art Archive at Art Resource, NY: fig. 100

Courtesy MIT Museum, Cambridge: fig. 27

Courtesy of The Lewis Walpole Library, Yale University: fig. 1; cats. 31, 38, 57

© Museo Nacional del Prado: fig. 110

© National Gallery, London/Art Resource, NY: fig. 17

© National Portrait Gallery, London: fig. 6

©National Trust Images: fig. 71

© National Trust/Andrew Fetherston: fig. 70

© National Maritime Museum, Greenwich, London: endpapers; pages 16, 112, 236; figs. 2, 8, 10, 13, 16, 18, 31, 32, 46, 47, 48, 53, 54, 55, 56, 57, 58, 59, 60, 62, 63, 66, 75, 77, 79, 80, 81, 82, 83, 85, 89, 90, 92, 93, 94, 95, 96, 97, 98, 99, 103, 106, 112, 113, 114, 116, 118, 119; cats. 4, 5, 12, 18, 26, 27, 51, 55, 56, 90, 92, 93, 97, 98, 99, 103, 104, 105, 106, 107, 108, 113, 114, 115, 116, 117, 118, 123, 124

Photo © Christie's Images/Bridgeman Images: fig. 14

Photograph © 2016 Museum of Fine Arts, Boston: fig. 30

Photography, Incorporated, Toledo: fig. 69

Private collection/Bridgeman Images: fig. 117

Private Collection/Photo © Christie's Images/Bridgeman Images: fig. 74

Rijksmuseum, Amsterdam: figs. 11, 19

Royal Naval College, Greenwich, London, UK/Bridgeman Images: fig. 29

© RSA, London, UK/Bridgeman Images: fig. 39

Scottish National Gallery. Acquired from the Countess of Buckinghamshire's Trust, 1997: fig. 88

© Tate, London 2016: page 88; figs. 37, 43, 64, 67, 76, 108; cat. 130

© The Chapter of St Paul's Cathedral, London: fig. 31

© The Governor and Company of the Bank of England: fig. 34

The Huntington Library, Art Collections, and Botanical Gardens, San Marino, California: cats. 111, 112

The Kriegstein Collection: cat. 6

The Kriegstein Collection/Photography Marissa Ciampi: cat. 74

© The Metropolitan Museum of Art. Image source: Art Resource, NY: fig. 33

© The Trustees of the British Museum: page XIV; figs. 9, 21, 22, 23, 24, 26, 28, 49, 68, 78, 111, 115; cat. 91

The Walters Art Museum, Baltimore, MD/Susan Tobin: page VI; fig. 91; cat. 140

University of Glasgow Library, Special Collections: figs. 44, 45

Yale Center for British Art, Paul Mellon Collection/Richard Caspole: jacket; pages IX, X, XII, 40, 62, 134, 154, 182, 194, 224, 254; figs. 3, 4, 20, 25, 35, 36, 38, 41, 42, 50, 51, 52, 61, 72, 73, 101, 102, 104, 107; cats. 1, 2, 3, 7, 8, 9, 11, 13, 14, 15, 16, 17, 19, 21, 22, 23, 24, 25, 32, 33, 34, 35, 36, 37, 37a, 39, 41, 43, 44, 45, 46, 47, 52, 53, 54, 58, 59, 60, 61, 62, 63, 64, 65, 66, 67, 68, 69, 70, 71, 72, 73, 75, 76, 77, 78, 79, 80, 81, 82, 83, 84, 85, 86, 87, 88, 89, 95, 96, 100, 101, 102, 109, 110, 119, 120, 121, 122, 129, 131, 133, 134, 136, 137, 138

Yale Center for British Art, Paul Mellon Fund/Richard Caspole: cats. 125, 126, 127, 128

Yale Center for British Art, The U Collection. In appreciation of Choh Shiu and Man Foo U, loving parents, and Dorothea and Frank Cockett, dear friends/Richard Caspole: frontispiece; cats. 10, 20, 132, 135

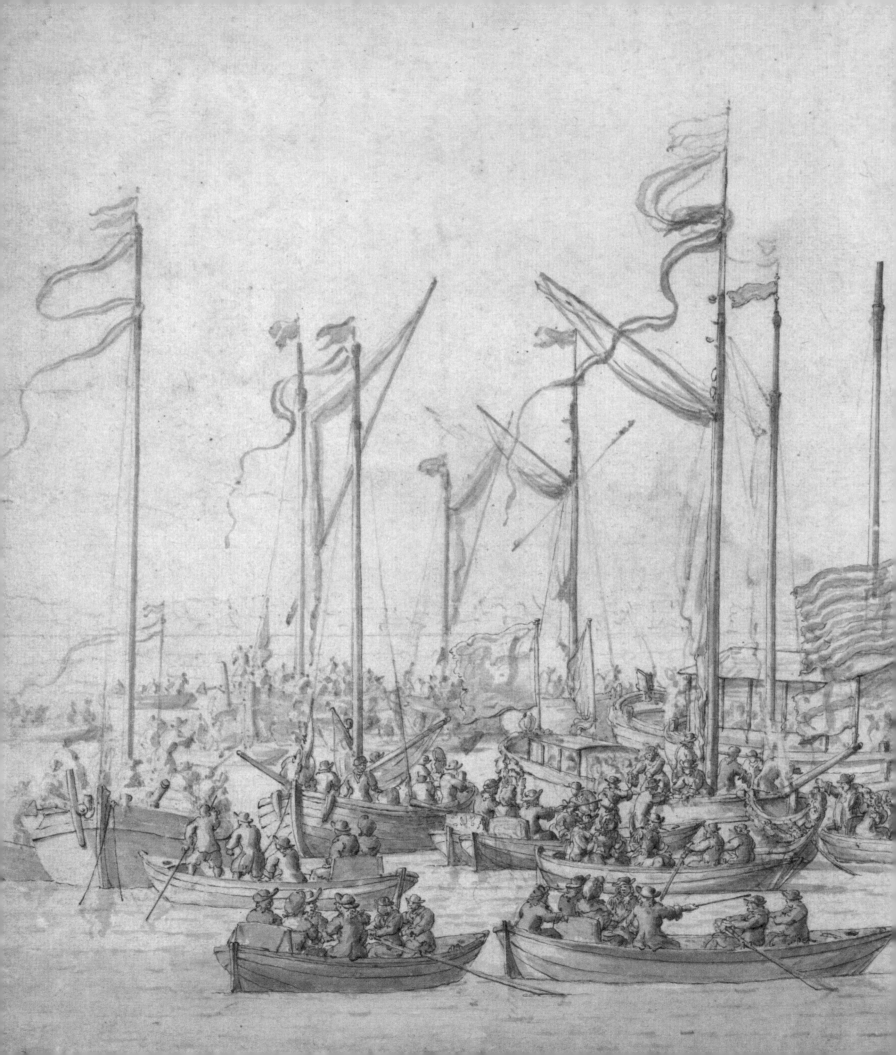